Lost Ballparks

LAWRENCE S. RITTER

Lost Ballparks

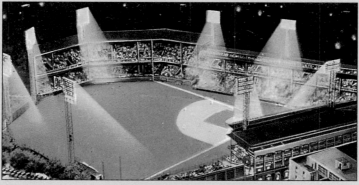

A Celebration of Baseball's Legendary Fields

VIKING
STUDIO
BOOKS

VIKING
Published by the Penguin Group
Viking Penguin, a division of Penguin Books USA Inc.,
375 Hudson Street, New York, New York 10014, U.S.A.
Penguin Books Ltd, 27 Wrights Lane, London W8 5TZ, England
Penguin Books Australia Ltd, Ringwood, Victoria, Australia
Penguin Books Canada Ltd, 10 Alcorn Avenue, Suite 300, Toronto, Ontario, Canada M4V 3B2
Penguin Books (N.Z.) Ltd, 182–190 Wairau Road, Auckland 10, New Zealand

Penguin Books Ltd, Registered Offices: Harmondsworth, Middlesex, England

First published in 1992 by Viking Penguin, a division of Penguin Books USA Inc.

1 3 5 7 9 10 8 6 4 2

Grateful acknowledgment is made for permission to reprint "Ball Parks Crumble, But Some Fans
Stay on the Field Forever" by William E. Schmidt, *The New York Times*, October 1, 1990.
Copyright © 1990 by The New York Times Company. Reprinted by permission.

Photo credits

(Codes: *t*: top; *c*: center; *b*: bottom; *r*: right; *l*: left; *tr*: top right; *tl*: top left; *br*: bottom right; *bl*: bottom left)

From the collection of Edward "Dutch" Doyle—8–9, 12–13; National Baseball Library, Cooperstown, N.Y.—10, 23, 40–41, 43*t*, 44, 47*t*, 52*b*, 53, 59*t*, 71*b*, 93, 96–97, 131*t*, 140*b*, 159*t*, 179*t*, 180, 181*t*, 191*b*; From the collection of Dennis Goldstein—14*t*, 45*t*, 58*c*, 60, 65*b*, 92*t*, 126, 176–77, 181*b*, 188; Temple University Urban Archives Center—14*b*, 15*c*; From the collection of Ray Medeiros—15*t*, 24*t*, 30*b*, 81, 88*t*, 104, 107*t*, 124*c*; The Bettmann Archive—16, 18–19, 22, 59*b*, 100–1, 131*b*, 166, 186–87; From the collection of Gordon C. Tindall—iii, 20*b*, 21*b*, 24*b*, 43*b*, 55, 65*t*, 69*b*, 95, 102, 107*b*, 112, 116*br*, 130, 134*b*, 136, 144*t*, 151*b*, 165*t*, 174, 182*t*, 191*t*, 201; *The Sporting News*—21*t*, 99*b*, 108, 122, 127, 183*t*, 183*b*, 196–97; Boston University Photo Service—27; George Brace Photo—28–29; *Sports Illustrated*/Photographer: Bill Smith—32; Courtesy of Chicago White Sox—35, 36*t*, 37*t*; Photographer: Scott Mlyn—36*b*, 37*b*, 38, 116*bl*, 117*t*, 117*b*, 119; Courtesy of The Cincinnati Historical Society—42; Courtesy of Cincinnati Reds—46; AP/Wide World Photos—47*b*, 58*t*, 66*b*, 75*b*, 79, 88*b*, 115, 120–21, 123, 124*t*, 124*b*, 128–29, 135*t*, 147*t*, 160–61*b*, 163*b*, 190*b*, 202–3; Courtesy of the New-York Historical Society—50–51,

156–57, 158*t*; Brown Brothers—52*t*, 90–91, 94*b*, 159*b*; TV Sports Mailbag—56, 193*t*; Carnegie Library of Pittsburgh—62–63, 67; Courtesy of Sotheby's, Inc., New York—64; Courtesy of Pittsburgh Pirates—69*t*; Photographer: Roger W. Duncan—71*t*, 71*c*; *Los Angeles Times* Photo—72–73; From the collection of Dick Dobbins—74, 75*t*, 171*b*, 172*bl*, 198*t*, 200*t*, 200*b*; From the collection of Jay Sanford—76–77, 172*tr*, 202*l*; Pomona Public Library, Frasher Collection—78; Culver Pictures—83*b*, 87; Courtesy of Paula Wright—85; Photographer: Nancy Hogue—116*t*; Courtesy of Montreal Expos—125; Photographer: Ronald C. Modra—134*t*, 145*r*; Minnesota Historical Society—140*t*, 141; Minnesota Historical Society and *Minneapolis Star Tribune*—142, 143*b*; Minnesota Historical Society and *Minneapolis Star Journal*—143*t*; From the collection of Shirley Crohn—144*b*; Courtesy of Minnesota Twins—147*b*; From the Collection of Joseph M. Overfield—148–49, 150, 151*t*, 153, 155*b*; Buffalo and Erie County Historical Society—152, 155*t*; Courtesy of R. Plapinger—161*t*; *New York Daily News* Photo—162; *San Francisco Chronicle*/Photographer: Joe Rosenthal—175*t*; Photographer: Thomas Rex Hardy—175*b*; Photographer: Bob Bartosz—185; Missouri Historical Society/Photographer: Pierce Hangge—189; Missouri Historical Society—190*t*; Missouri Historical Society/Photographer: Ted McCrea—194.

LIBRARY OF CONGRESS CATALOGING IN PUBLICATION DATA
Ritter, Lawrence S.
Lost ballparks/by Lawrence S. Ritter.
p. cm.
Includes bibliographical references and index.
ISBN 0-670-83811-X
1. Baseball fields—United States—History. I. Title.
GV879.5.R58 1992
796.357'06'873—dc20 91-32106

Printed in the United States of America · Set in Aldine 721 · Designed by Francesca Belanger

For

Donald Honig, Ray Medeiros, and Gordon Tindall

with Admiration and Affection

Acknowledgments

So many good friends have helped me with this book that it is misleading to have only one name on the title page. For generously sharing their vast knowledge about and photographs of long-gone ballparks, I am especially indebted to Donald Honig of Cromwell, Connecticut; Ray Medeiros of Montesano, Washington; and Gordon C. Tindall of Decorah, Iowa.

When I encountered problems regarding the details of a specific ballpark—which happened every two minutes—I was the fortunate recipient of assistance from a number of dedicated experts who went out of their way to be helpful about everything from the height of vanished fences to what now occupies the site where old ballparks used to be. Without their willingness to share their special knowledge, there is no way I could have completed this book. Many also assisted me in locating scarce photographs, most of which I would never have been able to find otherwise.

I owe special debts of gratitude to the following people for graciously helping me regarding each of the ballparks mentioned:

Baker Bowl: Edward F. "Dutch" Doyle
Braves Field: Paul Doherty
Comiskey Park: George W. Hilton and Richard C. Lindberg
Crosley Field: Jim Greengrass and Nancy Smith

Ebbets Field: Tom Knight
Forbes Field: Roger W. Duncan
Gilmore Field: Richard E. Beverage, Dick Dobbins, Catherine Lamas, and Charles Leanman
Griffith Stadium: Gordon M. Thomas
Hilltop Park: Marc Okkonen
Jarry Park Stadium: Alvin J. Guttman
League Park: Robert F. Bluthardt, Morris Eckhouse, and Dale Swearingen
Metropolitan Stadium: Stew Thornley
Montreal Stadium: Alvin J. Guttman and Rocky Nelson
Municipal Stadium: Jack Etkin
Nicollet Park: Stew Thornley
Offermann Stadium: Phil Kaufman, Hobie Landrith, and Joseph M. Overfield
Polo Grounds: Chub Feeney, Jim Greengrass, Don Mueller, Randye Ringler, and Ray Robinson
Seals Stadium: Dick Dobbins, Thomas R. Hardy, Gus Suhr, Kenneth Tilton, and Thomas M. Walsh
Shibe Park: Edward F. "Dutch" Doyle and Larry Shenk
Sportsman's Park: Jeffrey Copeland, Marc Okkonen, and Robert L. Tiemann
Wrigley Field: Richard E. Beverage, Dick Dobbins, Michael Gershman, Phil Kaufman, Catherine Lamas, Charles Leanman, Tim Mead, and Vic Pallos

• • •

Acknowledgments

Among those who helped me with photographs, I especially thank Nat Andriani (AP/Wide World), Michael P. Aronstein, Bob Bartosz, Jody Carpenter (*San Francisco Chronicle*), George W. Case III, Meredith Collins (Brown Brothers), Dr. Jeffrey Copeland, Shirley Crohn, Dick Dobbins, Dutch Doyle, Steve Gietschier (*The Sporting News*), Dennis Goldstein, Nancy Gutierrez, Nancy Hogue, Patricia Kelly (National Baseball Library, Cooperstown), Lisa Lewis (UPI/Bettmann), Kevin Lollar (*New York Daily News*), Scott McKinstry (*Oldtyme Baseball News*), Ron Menchine, Scott Mlyn, Joseph Overfield, Bobby Plapinger, Allen Reuben (Culver Pictures), Randye Ringler (New York Mets), Jay Sanford, George Tinker, Bob Watson (Houston Astros), and Paula Wright.

Finally, I am also grateful to Michael Fragnito, Joan Raines, and Al Silverman, all of whom helped launch and oversee this volume, and to my pal and buddy Igor, who fiercely guarded every page and picture from start to finish.

—*Lawrence S. Ritter*

Contents

Acknowledgments vii

Introduction xi

Lost Ballparks 1

BAKER BOWL (Philadelphia) 9

BRAVES FIELD (Boston) 19

COMISKEY PARK (Chicago) 29

CROSLEY FIELD (Cincinnati) 41

EBBETS FIELD (Brooklyn) 51

FORBES FIELD (Pittsburgh) 63

GILMORE FIELD (Hollywood) 73

GRIFFITH STADIUM (Washington, D.C.) 81

HILLTOP PARK (New York) 91

LEAGUE PARK (Cleveland) 101

MEMORIAL STADIUM (Baltimore) 111

MONTREAL STADIUM *and* JARRY PARK STADIUM (Montreal) 121

MUNICIPAL STADIUM (Kansas City) 129

NICOLLET PARK *and* METROPOLITAN STADIUM (Minneapolis) 139

OFFERMANN STADIUM (Buffalo) 149

Contents

POLO GROUNDS (New York) 157

SEALS STADIUM (San Francisco) 169

SHIBE PARK (Philadelphia) 177

SPORTSMAN'S PARK (St. Louis) 187

WRIGLEY FIELD (Los Angeles) 197

Bibliography 205

Index 207

Introduction

Lawrence Ritter's *Lost Ballparks* is a magical time warp that brings to life a world and an era not here and not now. Old ballparks rise in the memory like the faces of old friends, and I can see again the old center-field clubhouse in the Polo Grounds in New York, the mile-high press box on the roof of Shibe Park (later Connie Mack Stadium) in Philadelphia, the grassy slope rising to the left-field fence in Crosley Field in Cincinnati, the rickety roof of Sportsman's Park in St. Louis, to which, in the 1950s, the Cardinals' volatile general manager, Frank Lane, would retire during a ballgame to watch in relative solitude his often inept heroes cavorting on the field far below.

Even though I was raised a New York Yankees fan, my favorite old park was the Polo Grounds, and in time I switched allegiance from the Yankees to the New York Giants. Shaped, as Larry Ritter says, like an old-fashioned bathtub, the Polo Grounds created instant excitement—the excitement of anticipation, which is the essence of baseball. What will happen on this next pitch? Because of its odd shape, its short foul lines, its immense center field, anything could happen at any time in the Polo Grounds. The weakest batter could reach the seats near the foul lines; the longest hitter in the game could be contained in center field. Its idiosyncrasies made for incredible drama—Bobby Thomson's pennant-winning home run in 1951, Willie Mays's game-saving World Series catch in 1954.

The unanticipated shapes of these old parks gave each a distinctive personality and made each a particular test of players' skills. Casey Stengel when he managed the old Boston Braves (temporarily known as the Bees) referred to the breezes that came off the Charles River into the outfield at Braves Field (temporarily known as the Bee Hive) as "Old Joe Wind, my fourth outfielder." But Casey spiked complaints from his own slumping batters about the outfield gusts by saying, "Yes, I know. Rogers Hornsby played here one season and hit only .387 into that wind." Babe Ruth, boasting about his pitching ability long after he'd given up the mound for the home-run bat, scoffed at praise for pitchers who did well in Cleveland's huge Municipal Stadium. "Hell, that's not pitching," Ruth said. "That's just throwing. Now the Polo Grounds, with those short foul lines, that's pitching. You couldn't just throw the ball there. You had to think."

I loved those old parks, although I won't go so far as to say that all the old parks were better than all the new ones—new meaning those built after major league baseball reached the Pacific Coast in 1958. For instance, I never particularly liked Griffith Stadium in Washington (my old friend Shirley Povich of *The Washington Post* will scold me for saying that), and I'm inclined to believe that Dodger Stadium in Los Angeles is the best baseball park I've ever been in. But, then, there are one or two people from the good old days who don't mean

nearly as much to me as some of the friends I've made in recent years. In short, there is no flat law that says old is good, new is bad.

Nonetheless, as Ritter says so beautifully, "Ballparks were once built on a human scale that allowed spectators and players to share a common experience." Oh my, yes. In the old parks there was always the feeling that you were at home, that you knew the players and the other spectators, that in a sense you were living in the same neighborhood.

I don't mean that everyone was pulling for the home team and that players and fans were united in an all-out quest for victory. A win was what you wanted and a defeat hurt, but you *liked* visiting players and rival fans, too, or at least respected them. Without getting too hokey about it, it was the idea of the game that mattered even more than the idea of victory. Granted, I can't recall any-one's ever actually *saying* that he'd rather see his team lose a great game than win a dull one, but underneath, inside, whatever the result, a terrific ball game in an old ballpark left you with a great feeling of accomplishment, of being a part of some-thing that was done right.

For one thing, the crowds in the old parks seemed less monolithic than they do now, when all too often you hear deafening cheers for the home team and dead silence when an opposing player belts one or makes a superb play in the field. In the old ballparks you always applauded a great fielding play by an opponent, even when it hurt your team. You didn't cheer; you applauded. It was traditional, and it was the neighborly thing to do.

Almost always, it seems to me, there was a decent amount of vocal support for the visiting team. Per-haps that was because there were so many multi-team cities in the old days, with conflicting loyalties among the spectators as a result. A St. Louis Browns fan going to a Cardinals game in Sportsman's Park when the Browns were on the road was likely to root openly for the Cardinals' opponents.

Likes and dislikes for this team or that one, this hometown player, that visiting one, used to develop haphazardly—that is to say, naturally. Ritter talks of the "quirkiness" of the old, oddly shaped parks, and that quirkiness existed among fans, too. Everyone my age knows someone who was born and bred in Brooklyn when the Dodgers were in Ebbets Field who nevertheless grew up rooting against the Dodgers and for the New York Giants. In the sub-urban village where I grew up, my next-door pal, Dick Schulz, became a Chicago White Sox fan, even though we lived only ten miles from Yankee Sta-dium. When Dick went to the Stadium he rooted against New York, not at all an uncommon thing. I imagine it's far more difficult today for a kid to be that individualistic when mindless mechanis-tic message boards and bullying organists are constantly telling him when and how to cheer ("Ch-a-a-rge!" for God's sake).

A baseball crowd in an old park seemed like a community, a neighborhood; neighbors don't all think alike but they do have a common ground. Some of my fondest memories of baseball are of the boisterous, cheerful, back-and-forth rivalry that echoed through the stands. Everybody didn't vote the same way; that is, everybody wasn't a Bleacher Bum—a new development in an old park—rooting belligerently for the Cubs and throwing rival home runs back onto the field. There was a give-and-take. I remember sitting in the upper right-field stands in the Polo Grounds during an absolutely magnificent game between the Giants and the Dodgers. The Giants were within an out of win-ning 2–0 when Roy Campanella hit a two-run homer in the ninth to tie the score and send the game into extra innings (the Giants finally won it in the fourteenth).

When Campanella came to bat again in the eleventh or twelfth inning, Dodger fans rose and applauded, and so did a burly young blond-haired guy sitting near me who had been rooting loudly for the Giants all night.

"Hey," said the man sitting next to him, "I thought you was a Giant fan."

"I am," said the blond man in a splendid New York accent, "but you gotta give a woithy adversary his due."

Damn it, the game was the thing in the old

parks. Before Atlanta got the Braves, big games in Crosley Field in Cincinnati would draw baseball fans from hundreds of miles south of the Ohio River, from as far as Tennessee and northern Georgia and Alabama. They came not to root for the Reds but to see good baseball, to savor it. As Ritter points out, the stands in the old parks like Crosley were built close to the field, along the foul lines, near to home plate. Athletes talk of getting a crowd "into" the game. At places like Crosley Field it was hard for a fan *not* to be in the game.

One night in the 1950s an exceptionally good game between the Reds and the Milwaukee Braves, who were fighting for the pennant, had the diverse Crosley crowd cheering and hollering from start to finish. It was exhilarating. After the game Jimmy Dykes, then the third-base coach of the Reds, dressed and went to the small press room with manager Birdie Tebbetts to have a drink and chat with the writers. Dykes was sixty years old and had been in the big leagues as player, manager, and coach since 1918. He played on pennant winners, was on World Series championship teams, managed in both leagues. He'd seen it all.

Dykes was a quick-witted man with a sharp tongue whose comments on baseball could be caustically funny. He sat at a table with his drink listening as Tebbetts and the writers talked. I forget now whether the Reds had won or lost. What I do remember is that after a while a writer turned to Dykes and asked, "What did you think of the game, Jim?"

I expected a quip, a wisecrack, but the old coach just smiled.

"God, wasn't that a wonderful game?" he said. He sipped his drink and looked around the cozy little press box like a man sitting in his living room and said, "Games like that are what make me put a uniform on each spring."

Games like that—in old ballparks like Crosley.

—Robert W. Creamer

Lost Ballparks

In a nation that has had a century-long love affair with baseball, it is not surprising that ballparks play a special role in the lives of Americans. People have been born in them, gotten married in them, ritually taken their children to them, died in them, and even had their final remains scattered over them (the last apparently more often than we realize, according to the article from *The New York Times* reproduced on page 2).

For many older baseball fans, the first major league ballpark they ever entered occupies a hallowed niche in the corridors of memory, one of those few treasured childhood recollections that remain forever vivid. But such fond memories are of yesterday's ballparks, not today's. It is difficult to imagine the mammoth stadiums of the 1990s—cold and aloof—inspiring similar affectionate remembrances when the present generation of youngsters reaches maturity. Vast multipurpose arenas, many of today's stadiums have been constructed with the helmeted demands of professional football more in mind than the needs of baseball.

Differences between yesterday's and today's ballparks are dramatically clear to anyone who has had an opportunity to compare them. Yesterday's ballparks, built mostly between 1909 and 1915, were cozy idiosyncratic single-purpose structures, often double-decked around the infield and single-decked elsewhere. Since 90 percent of baseball action takes place in the 30-yard-square infield, old-time ballparks were constructed so that as many seats as possible were close to that part of the playing field.

On the other hand, professional football is played on a rectangular field 53⅓ yards wide by 120 yards long (including two 10-yard-long end zones). Seating in the form of an oval surrounds that large area, with one location just about as good as another so far as watching football is concerned. But not for baseball watchers. In such stadiums, a large proportion of the seats, even on ground level, are distant from the baseball infield, thereby shortchanging baseball spectators.

Upper-deck seats are even *farther* from baseball action in today's coliseums, requiring binoculars if upper-tier spectators are to distinguish between a stolen base and a double play. Stadium engineers are obsessed with getting rid of "obstructing columns" that in older parks supported upper-deck stands, enabling them to be directly above lower-deck ground-level seats. Elimination of obstructing posts has been achieved in today's stadiums by shoving the upper decks farther back from the field of play; instead of a few spectators seated behind posts on sellout occasions, everyone above ground level is now seated in the next county on every occasion.

Fortunately, Fenway Park in Boston and Wrigley Field in Chicago are living reminders that ball-

Ball Parks Crumble, But Some Fans Stay On the Field Forever

By WILLIAM E. SCHMIDT
Special to The New York Times

CHICAGO, Sept. 30 — With the final out of the final inning of the last game ever to be played in Comiskey Park, fans here today bid farewell to more than just 81 summers of baseball memories.

Amid the outfield grass, and mixed in the infield dirt of the nation's oldest major league stadium, soon to topple to the wrecker's ball, are the final remains of at least a dozen departed fans. Their ashes had been scattered there over the seasons by grieving relatives who believed at the time that they were bequeathing their loved ones a lasting place with their cherished White Sox.

"It's always sad when the season ends, and you think about the long winter ahead," said Billie Burke, a 74-year-old widow and lifelong White Sox fan who attended the season's last home game today, which the White Sox won, 2-1, defeating the Seattle Mariners.

She recalled how she had scattered the ashes of her husband, Bill, inside Comiskey Park in May 1987, barely a month after he died. "But now when I sit and look at the old place and think of Bill, well, you know, it's not easy."

For Mrs. Burke and others like her, there is some small solace in the fact that the infield dirt from old Comiskey will be moved to new Comiskey, a massive concrete shell rising across the street. The White Sox will open the 1991 season there next April. By then, the old park will be torn down and the site will be a parking lot.

Roger Bossard, the White Sox groundskeeper, said he spoke recently with a tearful woman in Gary, Ind., and sought to reassure her that some small part of her husband would almost surely remain with the team, when they rebuild the infield in the new ball park. He said her husband's cremated remains had been put in the infield in 1980, one of about a dozen scattered there in the last 10 years.

"She was surprised I called her back," said Mr. Bossard, whose father, Gene, was the team's groundskeeper before him. "But we owe so much to the fans, I think it is important we return their loyalty."

Although the practice is seldom discussed or rarely acknowledged, professional sports franchises around the country for years have been quietly affording some of their most loyal fans their final place in the grass.

Roger O'Connor, the grounds foreman at Wrigley Field, the crosstown home of the Chicago Cubs, said he has not only assisted several families who asked if they could scatter the ashes of relatives on the field, but has watched a few others do it alone, after sneaking through a gate and furtively dumping the urn on the closest piece of turf.

Her Father's Place

Once, Mr. O'Connor said, he honored the wishes of a longtime Cubs fan who asked that her earrings be buried in center field, after she died.

In Milwaukee, Harry Gill, the 69-year-old groundskeeper at County Stadium, recalls walking the outfield not long ago with a young woman, who wanted the ashes of her father, a longtime Brewers fan, spread around center field.

"She cried every step of the way, and I tried to ease her some," Mr. Gill said. "I told her how wonderful it would be, because every time she passed by the stadium, she would know her father was right where he wanted to be."

Mr. Gill paused then, and added: "That's just one more reason why it's hard when they tear down the old places, like Chicago. There's just no way these new stadiums can be what the old stadiums are."

Other clubs are either less willing to discuss the practice, or deny it flatly.

"Are you asking whether we bury people in Dodger Stadium?" asked an unidentified man who works in the stadium manager's office in Los Angeles. "We've married people in the stadium, but I don't think we've ever buried anyone. You must have it mixed up."

A spokeswoman for the Yankees also said the team does not honor requests to scatter ashes on the field, although others connected with the club conceded that the remains of many fans were now a permanent part of the stadium's turf.

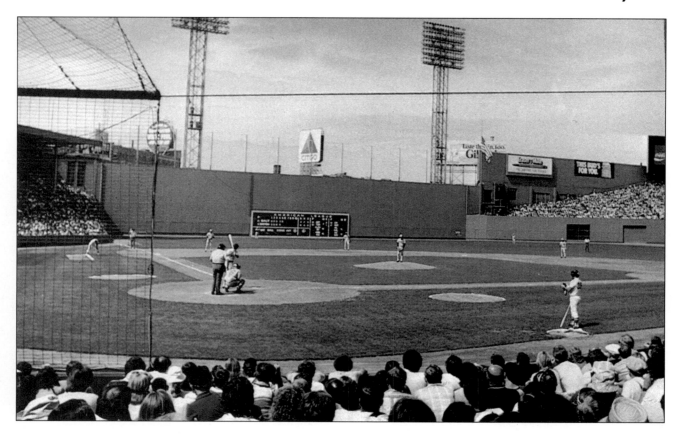

Fenway Park (Boston).

parks were once built on a human scale that allowed spectators and players to share a common experience. The quirkiness of the old parks added a flavorful dimension to a ball game.

Fenway Park, for instance, which was inaugurated in 1912, boasts the most famous left-field wall in baseball, past or present: 37 feet high and 315 feet from home plate down the foul line, the left-field wall dominates games played there psychologically as well as physically. Tempted by the beckoning Green Monster, right-handed batters who normally punch the ball to right field trying for singles and doubles tend to think *home run* as they approach the batter's box at Fenway.

Ballparks built in the early decades of the twentieth century had the notable feature of being integral parts of their host communities. There was no need to worry then about parking facilities, because transportation to the ballpark was typically by foot or trolley or streetcar. Indeed, since owners of ball clubs frequently had substantial interests in local streetcar franchises as well, ballparks were often located so as to maximize the number of passengers traveling on particular trolley lines.

Constructed in the midst of populated urban areas, ballparks had to conform to the configurations of the city blocks on which they were located. Thus, early parks took on unique and often surprising shapes as architects tried to shoehorn them into the fixed available space. Fenway Park's left-field wall (backed up against Lansdowne Street); the short right-field fence of Ebbets Field in Brooklyn (because of Bedford Avenue); the right-field wall at Baker Bowl in Philadelphia (due to Broad Street); and the strange contours of center field in Washington's Griffith Stadium (caused by the refusal of strategically located landowners to sell their property) are some examples of such architectural squeeze plays.

When ballparks were in the middle of a city, or in built-up suburbs, they melded into the daily life

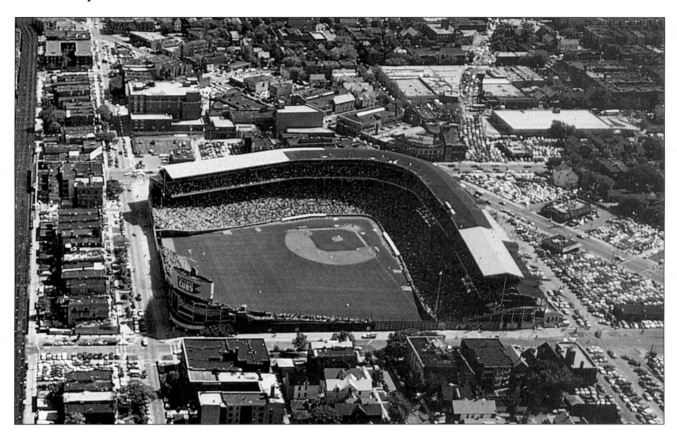

Wrigley Field (Chicago).

of the community, into the city's social and economic fabric. By and large these ballparks were good neighbors, bringing activity, commerce, and enhanced property values to the areas where they were built. As the accompanying photograph of Chicago's Wrigley Field shows, the ballpark, built in 1914, fits comfortably into its North Side neighborhood—so much so that the houses on the far side of North Sheffield Avenue, beyond the right-field fence, have gradually become accepted as virtual extensions of the ballpark itself. Indeed, on the roof of one of the houses across Sheffield Avenue is a large sign reading 495 FEET, indicating its distance from home plate.

Similarly, Fenway Park's 37-foot-high left-field wall is topped by a 23-foot-high screen that has no baseball function at all; its sole purpose is to protect windows in buildings on the far side of Lansdowne Street.

By contrast, today's ballparks—or stadiums, as

they are usually called, because the pastoral image conveyed by "ballparks" hardly fits massive mega-structures—are located not in a populated part of a city or suburb but more likely near a major highway, surrounded by acres of parking space and little else.

The homey intimacy that pervades Fenway Park and Wrigley Field vanishes in huge, circular, multi-purpose structures such as Veterans Stadium (Philadelphia), Busch Memorial Stadium (St. Louis), Fulton County Stadium (Atlanta), Three Rivers Stadium (Pittsburgh), Jack Murphy Stadium (San Diego), and Riverfront Stadium (Cincinnati), all catering to professional football as well as baseball, all built in the sixties and seventies, and, as the photographs of the first three show, all practically indistinguishable from one another.

"When I go up to bat," third baseman Richie Hebner once said, "I can't tell whether I'm in Cincinnati, Philly, Pittsburgh, or St. Louis. They all look alike."

Another feature that has been incorporated into

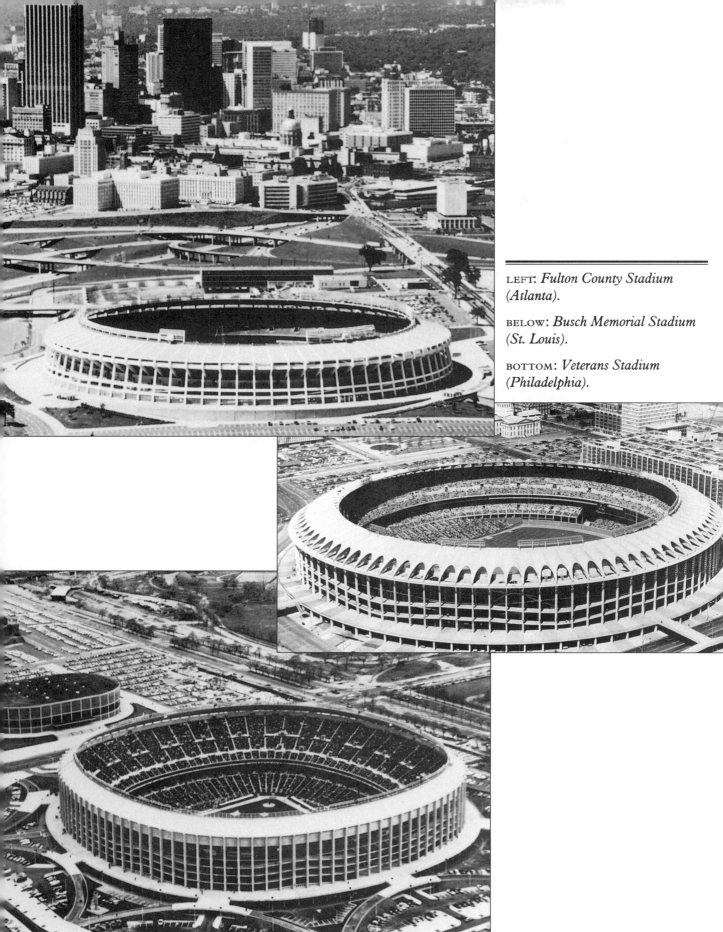

Major League Ballparks with Artificial Turf:

NATIONAL LEAGUE EAST
Busch Memorial Stadium (St. Louis)
Olympic Stadium (Montreal)
Three Rivers Stadium (Pittsburgh)
Veterans Stadium (Philadelphia)

NATIONAL LEAGUE WEST
Astrodome (Houston)
Riverfront Stadium (Cincinnati)

AMERICAN LEAGUE EAST
SkyDome (Toronto)

AMERICAN LEAGUE WEST
Kingdome (Seattle)
Metrodome (Minnesota)
Royals Stadium (Kansas City)

many of today's ballparks is artificial turf in place of real grass. Artificial turf was introduced in 1966 in Houston's Astrodome, the first of the domed stadiums, when it was found that lack of sunlight caused by the dome interfered with the growth of natural grass. As the table indicates, at present ten of twenty-six major league ballparks have plastic carpets, while the remaining sixteen still have real grass. Only half of the ballparks that use artificial turf are domed; the others installed it because of cost savings relative to the more expensive maintenance said to be required by natural grass.

For better or worse, the introduction of artificial turf has changed the nature of the game, putting more emphasis on speed afoot. For example, balls bounce higher and skip along faster on plastic carpet than on real grass, so that infielders and outfielders have to play farther back on artificial turf to prevent batted balls from bouncing over

their heads or skipping past them before they have time to react. Outfielders have to be fast enough to stop ordinary singles and doubles from rolling all the way to the wall for triples.

On the other hand, fielders worry less about bad hops on synthetic surfaces, although bad hops do occur occasionally when the ball hits seams or zippers (which are necessary because the carpet is installed in sections). Cincinnati shortstop Dave Concepcion, for example, devised an ingenious way of using artificial turf to his advantage, a technique that has since become standard practice. On long throws to first base, he perfected the art of deliberately throwing the ball into the turf about ten or fifteen feet in front of the first baseman, letting a long bounce carry it the rest of the way. This procedure isn't recommended on grass, because the bounce isn't as true and the ball doesn't accelerate

when it hits real grass the way it seems to when it hits the slick surface of the artificial turf.

Players, however, complain that plastic carpets tend to shorten their careers. Although the various brands differ somewhat, in general they all consist of nylon fibers about half an inch long stitched into a polyester mat that is laid on a half-inch foam-rubber pad for cushioning. The pad is glued to an asphalt or concrete base. The hard surface, considerably less yielding than natural grass, contributes to knee and ankle injuries and generally puts excessive stress on players' legs. Disenchantment with these and other consequences of artificial turf has led owners of two of the newest ballparks—Comiskey Park in Chicago and Oriole Park at Camden Yards in Baltimore, both built in the nineties—to decide in favor of natural grass despite the purported economies of artificial turf.

The atmosphere inside the ballpark has also changed greatly over time, becoming—like the ballparks themselves—more mass-produced and less diversified. Years ago, the dominant sounds during pregame batting and fielding practice, as well as during the game itself, were the *crack* of the bat hitting the ball, the *thud* of the ball into the well-worn leather glove, the voices of players bantering with or harassing one another, and the cries of vendors mingling with the shouts of fans.

Nowadays, what you hear is loud nonstop recorded music blaring from the loudspeaker system. Normal relaxed conversation during and between innings is about as feasible as at a heavy-metal rock concert or a birthday party for hyperactive five-year-olds. Between the recorded music, the organist, the electronic scoreboard telling fans

when to cheer (CHARGE!), winning numbers flashed on the scoreboard between innings, team mascots (like the San Diego Chicken) cavorting on the field and in the stands, and cartoon characters racing across the Diamond Vision scoreboard screen, today's fans, like it or not, are caught up in the midst of a nonstop multimedia three-ring circus.

Apparently, many general managers believe that *something*—whether music, cartoon high jinks on the scoreboard screen, a team mascot, or a raffle—has to be going on constantly or baseball fans will get bored and go home. Ballpark likes and dislikes are partly a matter of taste and, as is well known, *de gustibus non est disputandum*. There is no arguing about tastes. Lots of people no doubt *enjoy* the disco-like excitement of virtually continuous hyperactivity.

Nevertheless, it is the belief of many baseball fans and former players, and of architects as well, that yesterday's frequently eccentric and always singular ballparks were better places to watch a baseball game than today's cold concrete ovals.

Most of yesterday's ballparks are gone, bulldozed into oblivion. They will never return, but there are indications that they are appreciated more today than has been the case for a long time. They had their faults, no doubt, but they had magic as well, magic that will live for years in the memories of those who were lucky enough to have passed through their turnstiles.

For twenty-two ballparks that no longer exist—ballparks that are lost forever but that once bore clamorous witness to many wondrous and thrilling events—the following pages may convey to you some hint of the spell they once cast.

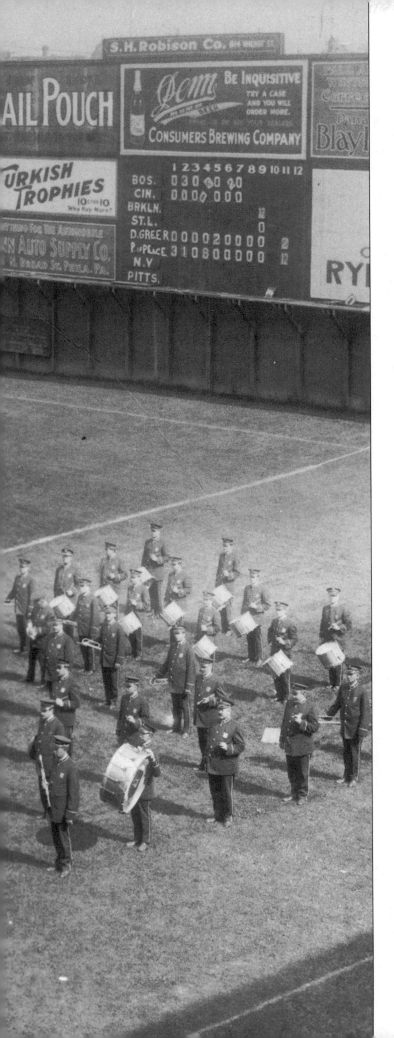

Baker Bowl
PHILADELPHIA

LOCATION: In North Philadelphia, about three miles north of Independence Hall, on the square block bounded by Huntingdon Street, Broad Street, Lehigh Avenue, and North 15th Street. The first-base foul line ran parallel to Huntingdon Street, right field to center field parallel to Broad Street, center field to left field parallel to Lehigh Avenue, while the third-base foul line paralleled 15th Street.

HOME OF: The Philadelphia Phillies from April 30, 1887, to June 30, 1938.

*B*aker Bowl began life as a mighty battleship and ended up half a century later as a leaky garbage scow, barely able to stay afloat. Officially named National League Park, it was commonly called the Huntingdon Street Grounds and gradually came to be known as Baker Bowl after William F. Baker, who owned the Phillies from 1913 to 1930. It is doubtful if its "official" name was ever changed.

When opened in 1887, National League Park was widely praised as a model for its time, said to incorporate the latest techniques in ballpark architecture. However, constructed mostly of wood,

The Philadelphia Police Department's marching band in the Phillies ballpark in 1912. At the foul line, the famous 40-foot-high right-field wall was only 280 feet from home plate.

it suffered a fate common to many ballparks in that era—it caught fire in 1894 and burned to the ground.

A rebuilt structure, inaugurated in 1895, was even more state-of-the-art than the original: a new double-decked grandstand was built of steel, brick, and concrete to prevent future fires, and was the first ballpark in the United States to be built with a cantilever design, which eliminated many obstructing columns.

Patrons were welcomed to the rebuilt park with a notice that stated:

> The same business management which catered only to the respectable and refined classes in the past will continue so to do in the future. Our Park Rules prescribe temperance, order and discipline. They proscribe gambling, betting, profanity, obscenity and disorderly conduct, as well as Sunday ball playing at home or abroad. Our players, proud of their past reputation, prefer to sacrifice both championship and place rather than win either by trickery, rudeness, or other conduct unworthy of their good name or the approval of the ladies and gentlemen whose refining presence honors their contest for supremacy on the ball field.

The covered double-decked grandstand curved around home plate and by 1910 extended all the way down the right-field foul line and halfway down the left-field line. A single uncovered deck continued the rest of the way down the left-field line and then swung across the length of left field to center field, where the clubhouse for both teams was located.

An imposing wall and screen 40 feet high (raised to *sixty* feet starting in 1929) ran from the center-field clubhouse to the right-field foul line, comparable to Fenway Park's familiar 37-foot-high Green Monster in left field. Anything hit off the wall *or* screen remained in play.

Small changes were made in outfield dimensions in the beginning years, but starting in the early twenties distances stabilized: from home plate to the bleachers down the left-field line was a healthy

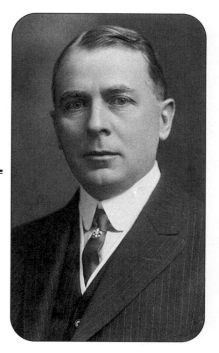

William F. Baker, for whom Baker Bowl was named. A former New York City police commissioner, he owned the Phillies from 1913 until his death in 1930.

341 feet, to dead center field a respectable 408 feet. However, many a ball was rocketed off the right-field wall, because it was only 280 feet from home plate down the right-field foul line, a neighborly 310–320 feet in the right-center-field power alley.

Because of the cozy right-field wall and the inviting right-center power alley, Baker Bowl was often described as "tiny" and frequently laughed at as a "cigar box" or "band box." Indeed, the first game played in the ballpark, on April 30, 1887, gave a preview of what was to come when 29 runs scored as the Phillies clobbered the visiting Giants, 19–10.

While Fenway's Green Monster inspires affection, at least in recent years, for some unknown reason the right-field wall at Baker Bowl seemed to evoke mostly ridicule. "It might be exaggerating to say the outfield wall cast a shadow across the infield," wrote sportswriter Red Smith years after he had covered the Phillies, "but if the right fielder had eaten onions at lunch the second baseman knew it."

Poking fun at Baker Bowl became so common that the batting accomplishments of many fine Philly sluggers were never fully appreciated. It was a hitters' park, all right, but over the years the Phillies also had more than their share of first-rate

batsmen who were quite adept at rattling the fences in any ballpark.

Longtime Philly outfielder Chuck Klein, for instance, batted an extraordinary .359 during his six prime years with the Phillies (1928–33), leading the league in hits twice, in doubles twice, and in home runs four times. But on the day in 1936 when Klein hit four home runs in a game, a feat few have achieved, he did it in Pittsburgh's roomy Forbes Field, not in "tiny" Baker Bowl. Nevertheless, because he played half his games in Baker Bowl, skepticism over the significance of his numbers kept him from election to the Hall of Fame until 1980.

On the other hand, there certainly was no disparaging the sneaky fastball and deceptive sinker of Grover Cleveland Alexander, the best pitcher who ever wore a Philly uniform. Alex was a right-hander who toiled for years in a ballpark designed for the pleasure of left-handed batters. (Regardless of ballpark dimensions, lefty batters are supposed to feast on right-handed pitchers.) Alexander won 31 games in 1915, 33 in 1916, and still another 30 in 1917—with a record 16 shutouts in 1916, an amazing *nine* of which he hurled at Baker Bowl. This was so impressive that, unlike Klein, Alexander made the Hall of Fame among the first dozen players selected.

The year 1930 has always had a special fascination for baseball fans because it demonstrates so

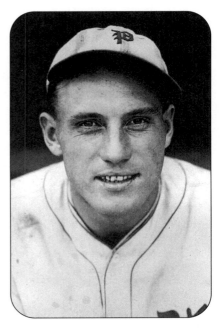

Chuck Klein, longtime Phillies outfielder and four-time National League home-run king.

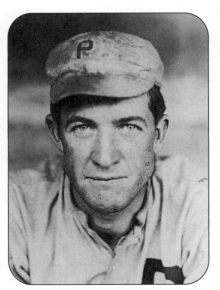

Grover Cleveland Alexander. A 33-game winner for the Phillies in 1916, he won 373 games in the course of his twenty-year career.

clearly the overriding importance of pitching. It also demonstrates what happens when a baseball is made as lively as a souped-up Lamborghini. The Phillies had a *team* batting average of .315 that season, yet finished dead last in the National League standings, buried 40 full games out of first place.

Indeed, batted balls ricocheted off Baker Bowl's right-field wall in 1930 at an unthinkable pace. The Phillies scored 543 runs in the 77 games they played at home (far more than the 1927 or 1961 Yankees ever scored at home), but then proceeded to allow the opposition an astonishing 644 runs—an average of more than 15 runs a game for the two teams taken together. No other big league ballpark, before or since, has ever seen as many spikes dent home plate in the course of a season.

It must have been on just such a typical Baker Bowl day that stocky Hack Wilson, hot and sweating, waited out in right field, hands on knees, eyes downcast, while his manager walked to the pitcher's mound to replace Walter "Boom-Boom" Beck. Line drives had been caroming off the wall all afternoon—after all, Beck wasn't called "Boom-Boom" for nothing—and Wilson was exhausted from chasing the ball.

Unhappy at being removed, Beck angrily heaved the ball toward the outfield with all his might.

Lost Ballparks

Hearing a familiar sound as the ball glanced off one of the tin advertising signs on the right-field wall, the startled Wilson awoke from his reverie, ran after the ricocheting ball as fast as he could, and fired it on a line to second base—a perfect peg to get the runner trying to stretch a single into a double, if only there had been one!

The players' clubhouse, planted solidly in dead center field, was either an eyesore or the perfect finishing touch, depending on your point of view. In either case, it was hard to ignore because it was about 35 feet high and had a dozen large windows facing the playing field. The left-field bleachers extended part of the way in front of the clubhouse, and for a number of years there were several hundred seats on *top* of it as well.

Squatting as it did in straightaway center field, the clubhouse joined the left-field bleachers to the right-field wall, slanting between the two. These connections created crazy angles and alleys, especially on the right-field side where the clubhouse met the wall, making it difficult for outfielders to play caroms of balls bouncing around in that area. The problem was compounded for a number of years by a banked 15-foot-wide warning track (actually a bicycle track) that rimmed the outfield, so that outfielders had to run up an incline to catch some long fly balls. No ball was ever hit *over* the clubhouse, although in 1929 Rogers Hornsby hit a home run *through* it—that is, right through one of its (closed) windows.

Two unusual features of the ballpark deserve special mention: until the mid-twenties, lawnmowers were not needed to trim Baker Bowl's infield or outfield grass. Three sheep grazed on the field between games. Cared for by the groundskeepers, the sheep had their own living quarters under the stands. Just as unusual was a noticeable hump in

It is 1937 and the gasoline cans are on the wet field to dry it. The gasoline will be spread on the field and then lighted. The right-field fence is now 60 feet high because of the screen on top of the wall. ("The Phillies use Lifebuoy," it was said at the time, "but they still stink.")

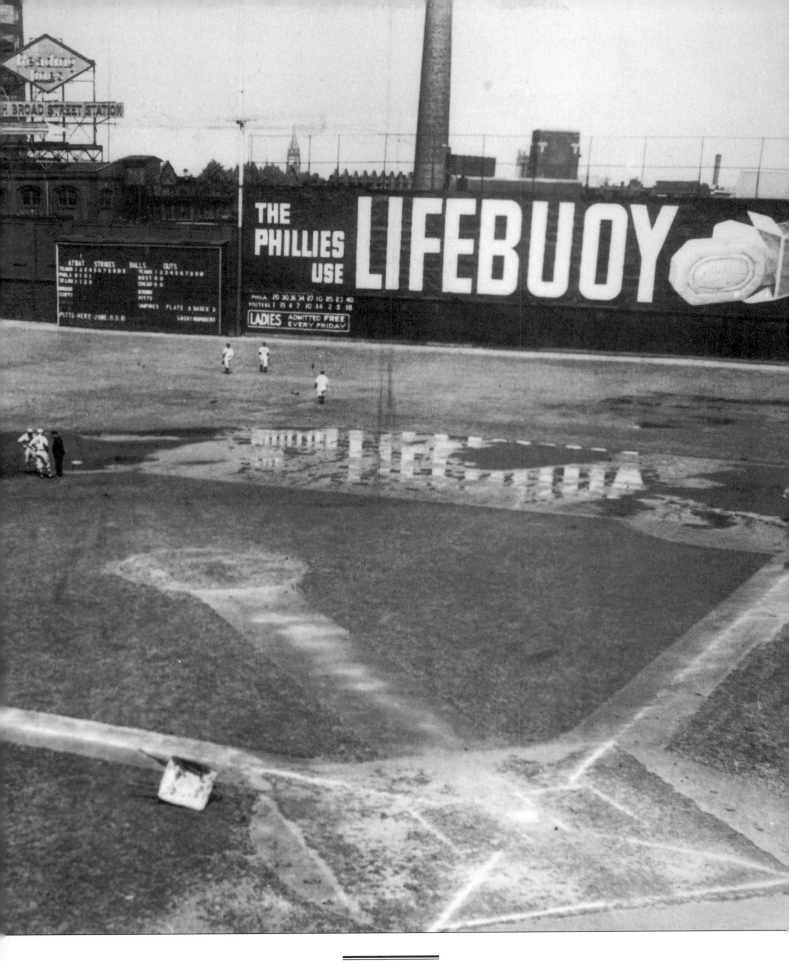

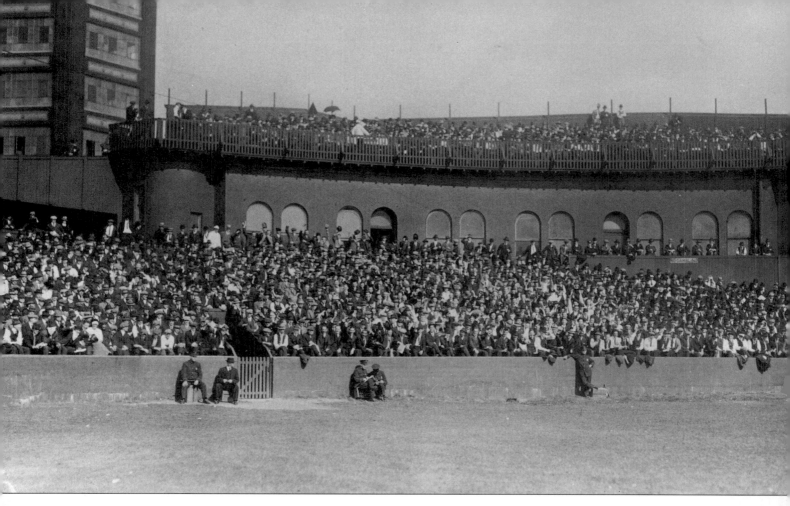

deep center field, where an underground Philadel-
phia and Reading Railroad tunnel ran beneath the
ballpark.

The first, second, and fifth games of the 1915
World Series, between the Phillies and the Boston
Red Sox, were the only World Series games ever
played in Baker Bowl. Phillies owner Bill Baker
committed a penny-wise, pound-foolish blunder in
his Series preparations: he installed additional
bleachers in front of the clubhouse in right-center
field in order to pack in a few more paying cus-
tomers. However, in the fifth game Boston
outfielder Harry Hooper hit two long fly balls that
bounced into the temporary seats and were declared
home runs under the special rules in effect, provid-
ing the winning margin in a 5–4 Red Sox victory
that locked up the Series for Boston.

As the years unfolded, Baker Bowl, built in the
1890s, became increasingly passé. Its seating capac-
ity never exceeded 20,000, whereas competitors
were building ballparks large enough to hold two
and three times that many. Even more important,
the failure of the Phillies to field winning teams in

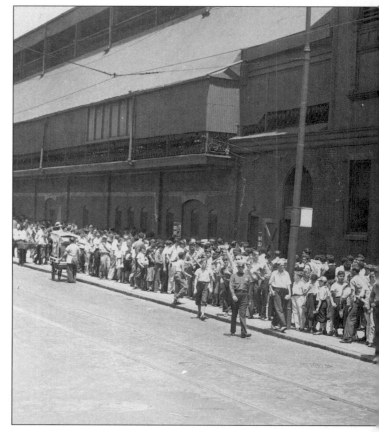

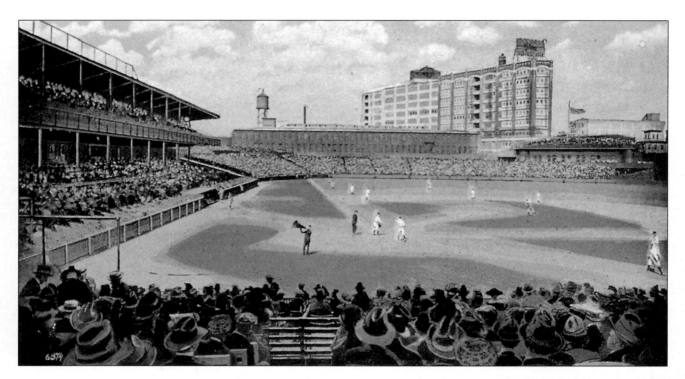

ABOVE: *Baker Bowl.*

OPPOSITE: *A big game at Baker Bowl in 1915. Notice the seats on top of the center-field clubhouse. The tall building at the left is on the other side of Lehigh Avenue.*

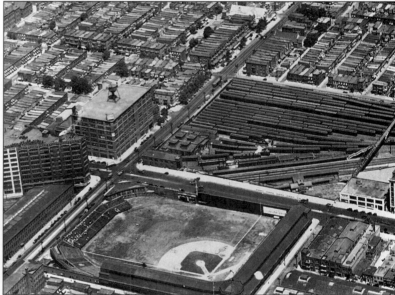

ABOVE: *An aerial view of Baker Bowl and its surrounding neighborhood in 1928.*

LEFT: *A crowd of youngsters (most of them probably with free passes) waiting to get into Baker Bowl in the thirties.*

the twenties and thirties kept attendance so low that there was no money for maintenance and upkeep, much less expansion. Just once in all of the twenties and thirties did the Phillies finish as high as fourth; usually they ended last or close to it. As a result, attendance in the thirties averaged no more than 2,500 a game. Financially, and often artistically as well, rainouts were preferable to opening the gates.

Without proper maintenance, the ballpark started to come apart at the seams. Actually, it had never been as sound as it looked. On August 6, 1903, the third-base stands collapsed during a game, killing 11 people and injuring more than 200. And on May 14, 1927, a section of the upper deck in right field gave way, sending hundreds of fans tumbling on top of those below, causing many serious injuries.

Player amenities also deteriorated over time. Regarding the once-proud clubhouse in center field, a local sportswriter noted: "National League players will be pleased to learn that the visiting dressing room at Baker Bowl is being completely refurbished for next season—brand new nails are being installed on which to hang their clothes."

After the 1938 season was under way, the Phillies finally decided to abandon decaying Baker Bowl in favor of sharing Shibe Park with Connie Mack's A's. The last game in the old ballpark was played against New York on June 30, 1938; only 1,500 hard-core fans watched, many no doubt with mixed emotions, as the Giants trounced the Phillies, 14–1, perhaps in symbolic retribution for the 19–10 beating the Phillies had administered the Giants when the ballpark had first opened, fifty-one years earlier.

Baker Bowl was used for many activities over the next dozen years, including midget auto races. In the forties, the dignified if incongruous players' clubhouse became the Alpine Musical Bar—yodeling and all.

The entire structure was demolished in 1950. The square block bounded by 15th, Huntingdon, Lehigh, and Broad is now part of a commercial area. Anyone walking on the block today will find no evidence suggesting that big league baseball ever flourished there.

April 19, 1938, Opening Day of what will be the Phillies' last season in Baker Bowl. First baseman Dolf Camilli of the visiting Dodgers has just homered.

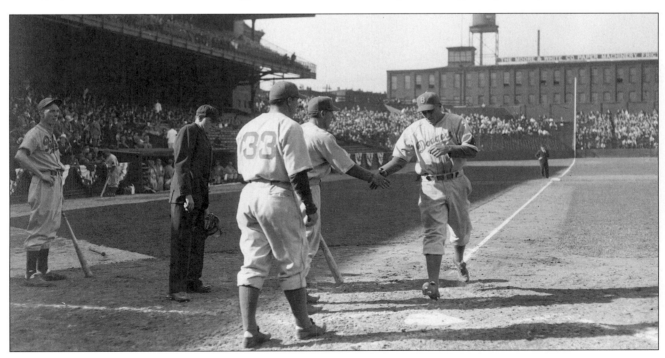

Baker Bowl's
Ten Most Memorable Moments

1. October 8, 1915, first game of the World Series: Playing in the World Series for the first time, the Phillies subdue the Boston Red Sox, 3–1, behind 31-game-winner Grover Cleveland Alexander.

2. October 13, 1915, fifth and deciding game of the World Series: A disappointed standing-room-only crowd watches Boston right fielder Harry Hooper hit two home runs to defeat the Phillies, 5–4, making the Red Sox world champions.

3. October 2, 1916: The Phillies beat the Boston Braves, 2–0, as Grover Cleveland Alexander allows only three hits and pitches his sixteenth shutout of the season (still a record).

4. June 12, 1922: The St. Louis Cardinals get a record-tying 10 hits in a row in the sixth inning as they outslug the Phillies, 14–8.

5. June 1, 1923: The New York Giants score in each of the nine innings—4, 2, 1, 1, 5, 5, 1, 2, 1—as they trounce the Phillies, 22–5.

6. June 6, 1926: Philadelphia first baseman Russ Wrightstone hits a home run, a triple, and two doubles, driving in nine runs, in a 13–11 Philadelphia victory over the Pittsburgh Pirates.

7. July 6, 1929: The Cardinals crush the Phillies, 28–6; St. Louis gets 28 hits and receives nine bases on balls as Jim Bottomley and Chick Hafey both hit grand-slam home runs.

8. October 6, 1929, the last day of the season: Philadelphia outfielder Lefty O'Doul gets six hits in eight times at bat in a doubleheader against the Giants to raise his league-leading batting average to .398 and set a National League record for hits in a season, 254.

9. May 30, 1935: Babe Ruth, now a Boston Brave, grounds out to first base in the first inning of the first game of a Memorial Day doubleheader against the Phillies; the forty-year-old Bambino then takes himself out of the lineup and never plays again.

10. April 19, 1938, Opening Day: In the first inning, Brooklyn outfielder Ernie Koy homers in his first major league time at bat; in the bottom half of the same inning, Philadelphia second baseman Emmett Mueller also homers in *his* first big league time at bat.

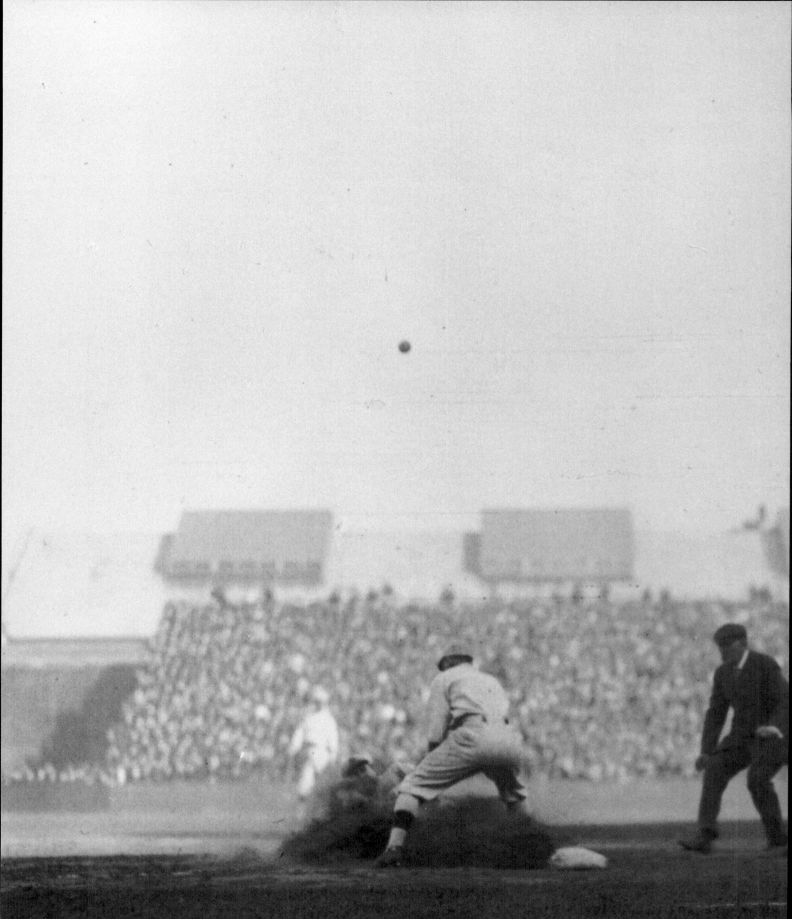

Braves Field

BOSTON

LOCATION: About three miles west of Boston Common, on the site bounded by Commonwealth Avenue, Gaffney Street, the Boston and Albany Railroad tracks, and Babcock Street. The first-base foul line ran parallel to Commonwealth Avenue, right field to center field parallel to Gaffney Street, center field to left field parallel to the railroad tracks (with the Charles River in the background), while the third-base foul line paralleled Babcock Street.

HOME OF: The Boston Braves from August 18, 1915, to September 21, 1952.

*T*he popularity of baseball reached a peak in the first decade of the twentieth century, sparked by the widely publicized exploits of Ty Cobb, Honus Wagner, Christy Mathewson, and Walter Johnson. It is not surprising, then, that the first wave of modern concrete-and-steel ballparks sprang up shortly thereafter, with eleven new ones opening from 1909 through 1915. Specifically, Shibe Park and Forbes Field opened in 1909; Cleveland's League Park and Comiskey Park in 1910; Griffith Stadium in 1911; Crosley Field, Fenway Park, and Tiger Stadium in 1912; Ebbets Field in 1913;

First game of the 1916 World Series. Brooklyn's Zack Wheat is safe at third base on a triple in the fourth inning. The "jury box" is in the background.

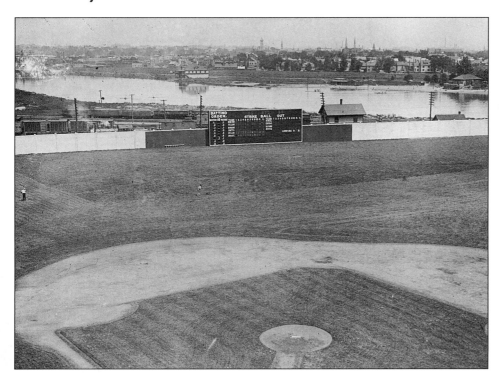

Pristine Braves Field on August 11, 1915, a week before its formal inauguration. The Charles River is in the background.

Wrigley Field in 1914; and finally the last of the group—and the largest—Braves Field in 1915.

Braves owner James Gaffney constructed his new stadium on the site of what had been the Allston Golf Club, a thirteen-acre plot of land between Commonwealth Avenue and the Boston and Albany Railroad tracks, about three miles west of the Boston Common and only a mile from Fenway Park, home of the Boston Red Sox.

Gaffney wanted a ballpark conducive to inside-the-park home runs, his favorite kind of baseball action, and that's just what he designed. The new park was laid out so that the distance from home plate was 402 feet down each foul line and 550 feet to dead center. These wide-open spaces generated plenty of triples and inside-the-park homers, but the corollary was that hardly anyone could muscle the ball out of the park for a real honest-to-goodness Babe Ruth–type home run.

Aside from the playing field's dimensions, the ballpark consisted of four separate parts, which in the aggregate seated 40,000. A covered single-decked grandstand seating 18,000 curved around home plate and extended down the foul lines well past third base and first base.

Two uncovered stands then took over, one continuing down the left-field foul line and the other down the right-field line, each of which held 10,000. They were called pavilions—the left-field pavilion and the right-field pavilion—but they were really just large bleachers, since there was no shade or rain cover and seating consisted of tiered long backless planks.

The main entrance to the ballpark, on Gaffney Street.

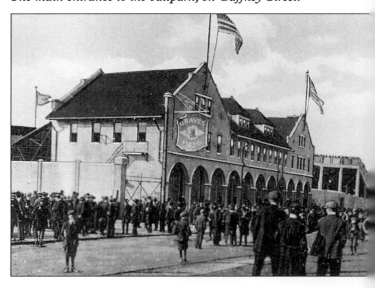

Finally, a small section of bleachers, seating 2,000, was located all by itself in right-field fair territory. It came to be known as the "jury box," the most famous part of the ballpark, reportedly named by a sportswriter who one day noticed that it contained just *twelve* spectators. A neat feature was an arrangement that enabled trolley cars on the Commonwealth Avenue line to bring passengers right *into* the ballpark, or at least into the area enclosed by a 10-foot-high concrete wall that defined Braves Field territory.

The largest ballpark in the country, it was inaugurated on August 18, 1915, with Boston defeating the St. Louis Cardinals, 3–1, before a packed house numbering well over 40,000, including thousands of standees. At the time this was the largest crowd ever to attend a baseball game *anywhere*.

RIGHT: *An aerial view of an overflow crowd at Braves Field circa 1930. Notice the on-the-field seating. (There are no light standards; the first night game at the ballpark would not be played until May 11, 1946.)*

BELOW: *Braves Field under the lights.*

Not only was the much-heralded brand-new ballpark an attraction, but in addition, at that time Boston was one of the nation's most baseball-crazy cities: the Red Sox had won the World Series in 1912 and the "Miracle Braves" had won it in 1914. Both Boston teams were in the thick of their respective pennant races in 1915 and hopes ran high for an all-Boston World Series that October. (It never happened—not that year, not ever.)

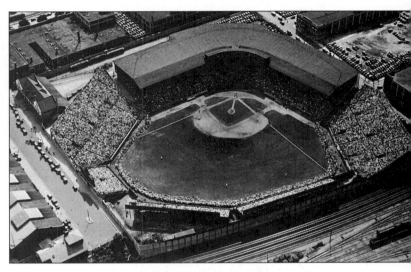

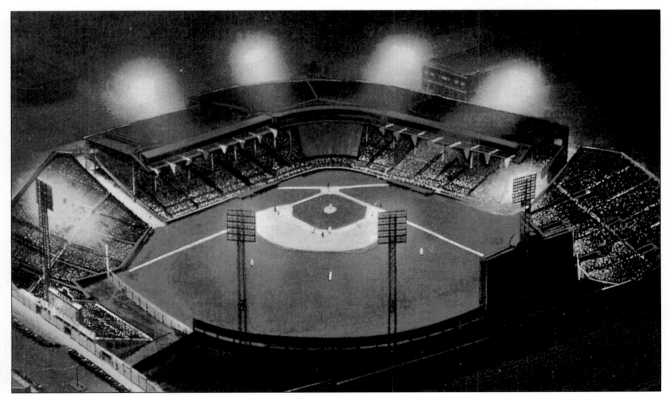

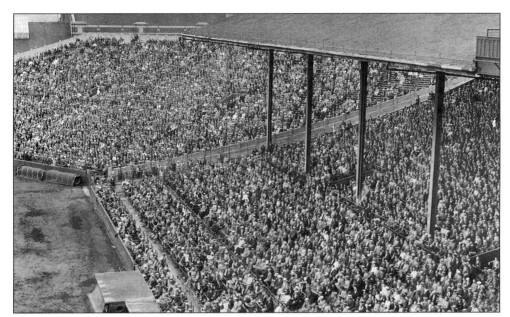

LEFT: *August 21, 1933. Part of a crowd of 35,000 watches Boston win a doubleheader from Pittsburgh at Braves Field.*

OPPOSITE: *Braves favorite Wally Berger (left) and everybody's favorite, Babe Ruth, in 1935. The Babe ended his career that year as a part-time player with Boston.*

The World Series *was* played at Braves Field in 1915—but it wasn't the Boston Braves who were involved, it was the Boston Red Sox. In 1914, when the Braves *were* in the Series, they had arranged to play their home games at Fenway Park, home of the Red Sox, because it had a larger seating capacity than the small ballpark the Braves were using at the time (the South End Grounds). So in 1915 (and 1916, too) the Braves reciprocated by letting the pennant-winning Red Sox use Braves Field as their World Series home park. (So much for concerns in that era about home-field advantage!)

The only other World Series ever played at Braves Field took place in 1948, the Boston Braves versus the Cleveland Indians, which Cleveland won in six games. This was also the closest the city of Boston would ever come to an all-Boston World Series, because the Red Sox *almost* won the American League pennant that year—the regular season ended in a Boston–Cleveland tie, after which the Red Sox lost a winner-take-all one-game playoff to the Indians.

Braves Field succeeded admirably in producing inside-the-park homers. In 1921, for example, 34 out of 38 home runs hit there were of the inside-the-park variety. On April 29, 1922, the visiting New York Giants hit *four* inside-the-park homers in one game.

Unfortunately, the dimensions of the ballpark left Braves fans watching nineteenth-century baseball while fans everywhere else were swept up in the excitement of the "new" game that was taking the country by storm—the lively-ball, swing-for-the-fences kind of game exemplified by the heroics of one George Herman Ruth.

Responding to fan demand, Braves management finally joined the parade and in 1928 pulled in the outfield fences by installing new bleachers in left and center fields. These shrank home-run distances to 320 feet down the left-field line, 330 feet to left-center, 387 feet to center, and 364 feet down the right-field line.

But wait! The new bleachers brought the left-field fence in so far that homers started falling like April raindrops. It was in this setting that third baseman Les Bell, a right-handed batter, came within an eyelash of smacking four home runs in a game: he hit three into the new left-field bleachers, plus a triple that almost made it.

Back to the drawing board. Hard to believe, but starting in 1928 the dimensions of Braves Field were altered almost annually (some claimed almost daily, à la Bill Veeck, who, after the fact, admitted having moved the fences in and out at Cleveland in the dead of night, depending on who the Indians were scheduled to play the next day).

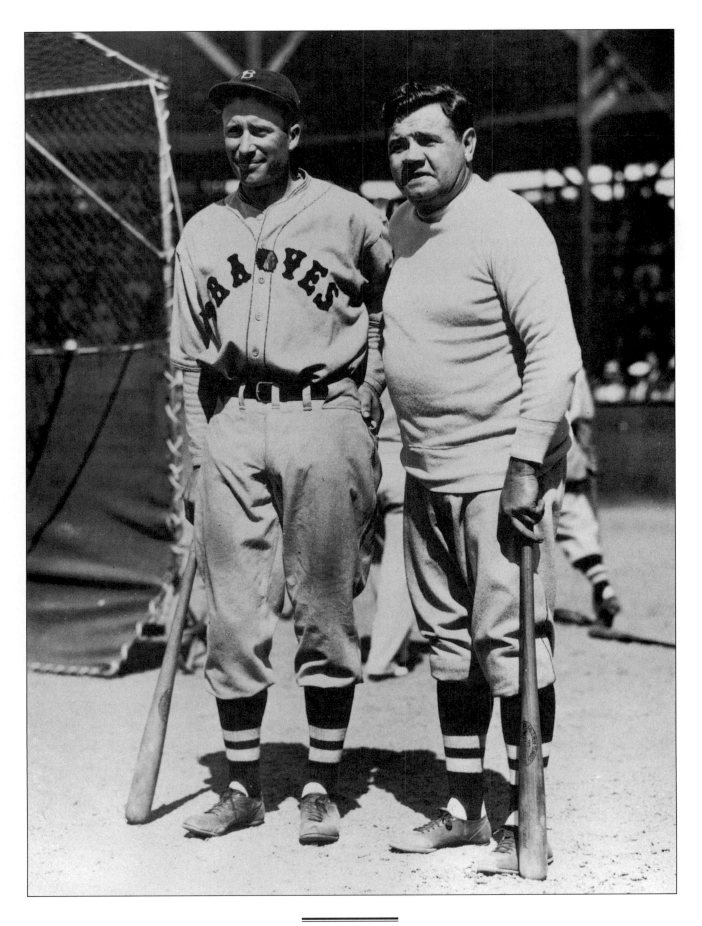

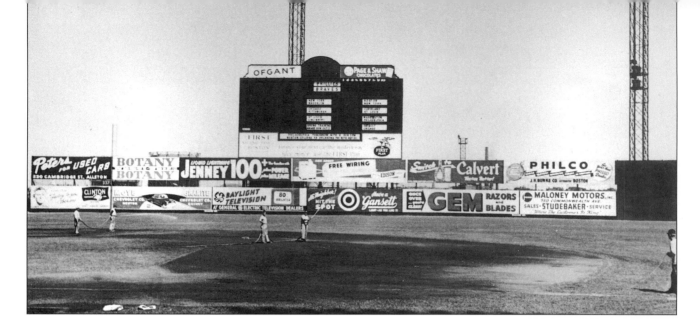

Braves Field's left-field fence in 1949.

The new bleachers in left and center fields were removed . . . an 8-foot-high wood inner fence was put up inside the original 10-foot-high concrete wall . . . the bleachers reappeared . . . and disappeared again . . . the inner fence was moved farther back . . . and then brought closer. . . . Home plate was even moved and the entire right-field foul line shifted 25 feet to the right—which brought part of the right-field pavilion into fair territory, requiring that a chunk of it be blasted out in order to restore a reasonable distance down the right-field line.

By 1950, the park's dimensions had stabilized (more or less): 337 feet from home plate down the left-field foul line, 365 feet in left-center, 390 feet in deepest center, 355 feet in right-center, and 319 feet down the right-field line. The wood inner fence, plastered with advertising signs, extended from the left-field foul line to right-center field; it was 8 feet high from 1928 through 1945, 20 feet high in 1946 and 1947, and 25 feet high thereafter. The right-field wood inner fence was 4 feet high plus a 6-foot screen. The 10-foot-high concrete outer wall remained, although it no longer had any particular function aside from tracing the perimeter of the ballpark.

Regardless of the size of the playing field, the team fared none too well. After the 1914 "Miracle Braves" had come from last place on July 19 to take

Braves Field.

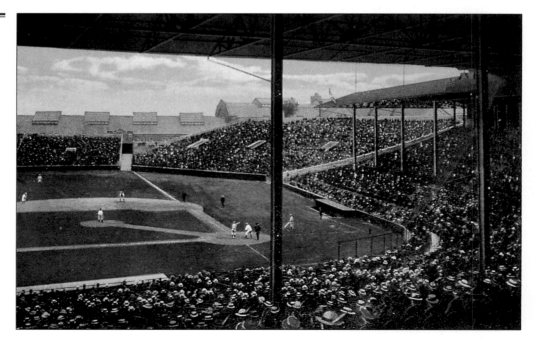

it all, beating the Philadelphia Athletics in the World Series, the team subsequently faded into the second division. In the twenty-nine years from 1917 through 1945, the Braves ended fifth or lower twenty-six times.

The biggest favorite of Braves fans in those years was slugging outfielder Wally Berger, who patrolled center field during most of the thirties. Berger was the starting National League center fielder in the 1933 and 1934 All-Star Games and his 105 home runs in Braves Field are the most anyone ever hit there.

Many people do not realize that Babe Ruth ended his career playing right field to Berger's center field. Released by the Yankees, the Babe signed with Boston in February 1935. The Braves were a sick franchise at the time, in desperate need of help, and Ruth was bamboozled into supplying it. Judge Emil Fuchs, who owned the Braves then, offered Ruth the positions of vice-president, assistant manager, *and* active player. Dangled in front of his nose was the implied promise that in 1936 he could take over the managerial reins from Bill McKechnie, a job the Babe desperately wanted.

Ruth started the season with a flourish—on Opening Day at Braves Field, fat and forty, he singled and homered off the great Carl Hubbell to drive in three runs in a 4–2 Boston victory over the visiting New York Giants.

However, he soon realized that he had made a mistake. He was in no condition to play. "Vice-president" and "assistant manager" turned out to be empty titles, carrying no duties or responsibilities. And it became apparent that there was no real intention of appointing him manager in 1936. So on June 2, 1935, in the clubhouse at Braves Field, the Babe announced his retirement as an active player. Owner Emil Fuchs fired him on the same day. Not that it matters, but just for the record no one knows whether he quit before he got fired or got fired before he quit.

The fortunes of the Braves took a turn for the better in the forties. Old-time Boston fans still remember the two-man pitching staff ("Spahn and Sain and pray for rain") that led Boston to the 1948

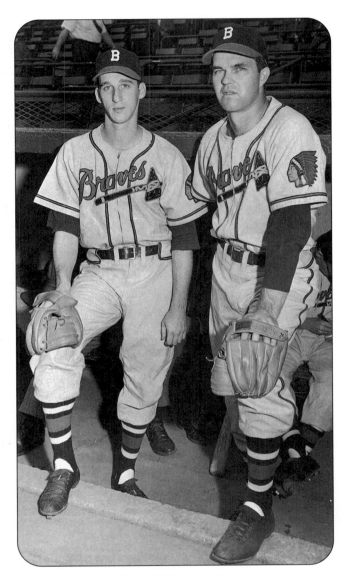

Warren Spahn (left) and Johnny Sain in 1948, the year they pitched the Braves to the National League pennant.

National League pennant, their first in thirty-four years. Attendance hit 1.5 million that year, the highest in Braves history.

But in the fifties the team slumped on the field and attendance declined correspondingly—to only 280,000 in 1952. On September 21, 1952, unaware that the Braves would be gone next year, only 8,822 fans attended what would turn out to be the last major league contest at Braves Field; the Brooklyn Dodgers won the game by a score of 8–2.

No major league franchise had moved since

Braves Field's
Ten Most Memorable Moments

1. October 9, 1916, second game of the World Series: Babe Ruth pitches the Boston Red Sox to a 14-inning, 2–1 victory over the Brooklyn Dodgers. (In 1915 and 1916 the Red Sox play their World Series home games at Braves Field.)

2. May 1, 1920: Joe Oeschger of the Braves and Leon Cadore of the Dodgers both pitch the full 26 innings of a 1–1 tie, still the longest game by innings in major league history.

3. June 2, 1928: Boston third baseman Les Bell hits three home runs and a triple, driving in six runs, but the Braves still lose to Cincinnati, 20–12.

4. October 1, 1933, the last day of the season: Boston outfielder Wally Berger leaves a sickbed to pinch-hit a grand-slam home run in the bottom of the seventh inning, winning the game and giving the Braves a fourth-place finish—the first time in twelve years they have ended a season that high in the standings.

5. April 16, 1935, Opening Day: In his National League debut with the Boston Braves, forty-year-old Babe Ruth singles and homers against the New York Giants—with Carl Hubbell pitching for New York—to lead the Braves to a 4–2 victory.

6. May 13, 1942: Boston's Jim Tobin hits three consecutive home runs while pitching the Braves to a 6–5 win over the Cubs.

7. September 26, 1948: The Braves clinch their first National League pennant since 1914 by beating the New York Giants, 3–2, on third baseman Bob Elliott's three-run homer.

8. October 6, 1948, first game of the World Series: Bob Feller pitches a two-hitter for the Cleveland Indians, but the Boston Braves win, 1–0, behind the four-hit pitching of Johnny Sain (plus an assist from umpire Bill Stewart's controversial "safe" call on an eighth-inning pick-off play at second base).

9. October 11, 1948, sixth and deciding game of the World Series: A capacity crowd of mostly Boston fans unhappily watches the Indians edge the Braves, 4–3, behind the pitching of Bob Lemon and Gene Bearden, to win Cleveland's first world championship since 1920.

10. September 30, 1951, the last day of the season: The New York Giants beat the Braves, 3–2, to tie the Brooklyn Dodgers for the National League pennant and set the stage for a three-game playoff.

1903, but in March 1953, only weeks before the season was due to begin, Braves owner Lou Perini announced that arrangements had been finalized to transfer the team to Wisconsin. Thus, a month later, the Braves showed up a thousand miles to the west, calling themselves the *Milwaukee* Braves. (In 1966, they flew to Georgia and became the *Atlanta* Braves!)

Today Braves Field is the property of nearby Boston University. It is a football field now, called Nickerson Field, home of the Boston University Terriers. Many other university activities also take place there, including commencement ceremonies every May. The old single-decked grandstand, the left-field pavilion, and the jury box have all been demolished. The right-field pavilion, which still stands, is now part of Nickerson Field's seating arrangements.

It is somehow appropriate that Braves Field has evolved into a Boston University athletic facility. Catcher Mickey Cochrane and first baseman Harry Agganis were both star B.U. quarterbacks before they turned to baseball full-time. Unfortunately, Detroit manager Cochrane's playing career was ended by a severe beaning in 1937 that fractured his skull in three places.

Popular and widely admired Red Sox first baseman Harry Agganis was even more ill-starred. Recovering from pneumonia in 1955, he was suddenly stricken by a massive pulmonary embolism and died in midseason at the age of twenty-five. He was a Boston Area native, and all of New England mourned his tragic passing.

Boston University's Nickerson Field. The stands on the far side were once the right-field pavilion of Braves Field.

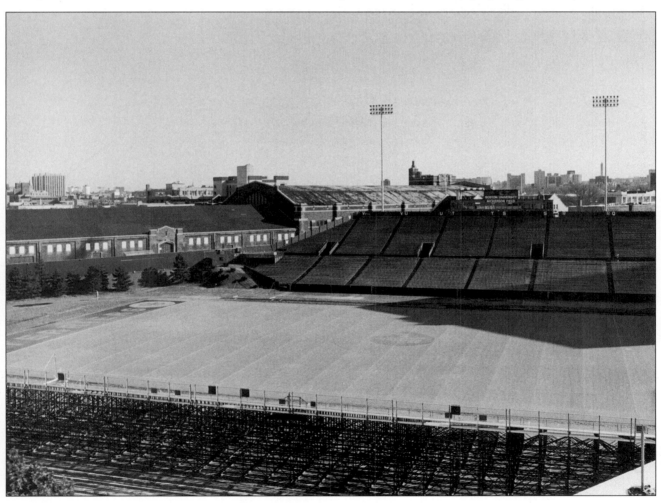

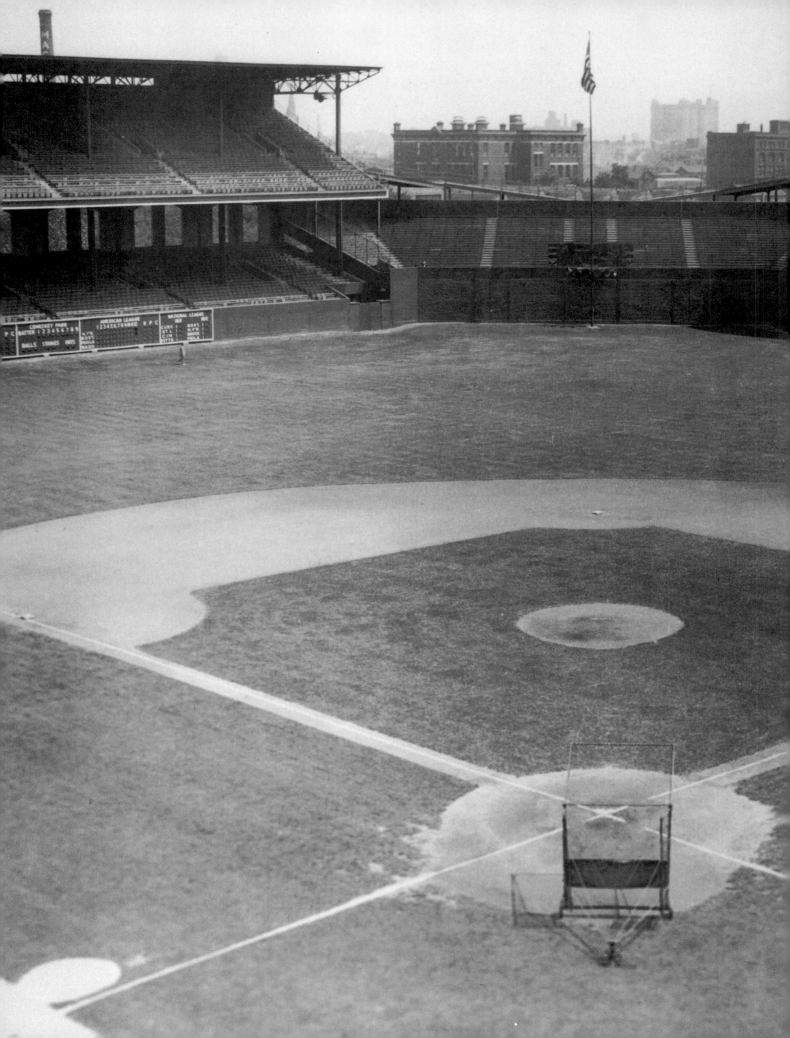

Comiskey Park
CHICAGO

LOCATION: On the South Side of Chicago on the site bounded by West 35th Street, Wentworth Avenue, 34th Place, and South Shields Avenue. The first-base foul line ran parallel to 35th Street, right field to center field parallel to Wentworth Avenue (and the Dan Ryan Expressway), center field to left field parallel to 34th Place, while the third-base foul line paralleled South Shields Avenue.

HOME OF: The Chicago White Sox from July 1, 1910, to September 30, 1990.

Owner Charles A. Comiskey—a light-hitting first baseman player/manager before he shifted to the business end of the game—moved the St. Paul club of the Western League to the South Side of Chicago when the American League started up at the turn of the century. Indeed, Comiskey was one of the principal architects of the new league.

Comiskey Park in the mid-thirties. The big scoreboard has not yet been installed in center field and there are no lights for night baseball. (The first night game at Comiskey Park was played on August 14, 1939.)

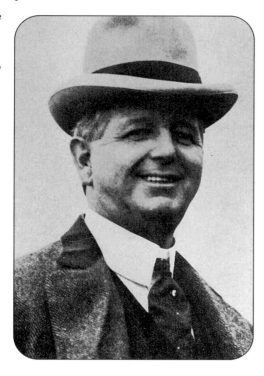

Charles A. Comiskey in the early 1900s. He owned the White Sox from 1901 until his death in 1931.

Comiskey's White Sox won the American League pennant in 1901 and 1906 and finished a highly competitive second or third on four other occasions in that decade. South Side Park, where the team had been playing, was obsolete and seated only 15,000, so Comiskey decided to build a modern concrete-and-steel stadium for his popular ball club.

They built ballparks faster then than they do now. Ground was broken on February 15, 1910, a green cornerstone was laid on March 17 (St. Patrick's Day), and the gates were thrown open for business on July 1. Inaugural festivities were marred when St. Louis took the measure of the White Sox, 2–0.

Actually, they built the park so quickly that the construction crew was somewhat less than painstaking in clearing the site. The plot of land on which the park was built had been a city dump. One day in the thirties, a quarter century after the park had opened, White Sox shortstop Luke Appling was routinely smoothing the dirt around his position with his feet when he felt what he thought was a rock. "I started digging with my spikes," he recalled years later, "and, lo and behold, I uncovered a blue-and-white teakettle. Quite an antique. The ground crew had to fill in the hole before play could continue."

Comiskey Park originally consisted of a covered double-decked grandstand that curved around home plate and extended along the foul lines 30 or so feet beyond first and third base. Two roofed single-decked pavilions, detached from the grandstand, continued down the foul lines. Separate (uncovered) wooden bleachers surrounded the outfielders, except for a fairly wide scoreboard area in center field, where there was no seating. The new ballpark's seating capacity was 32,000, of which 7,000 were 25-cent bleacher seats. With the ballpark located in a working-class area of Chicago, Comiskey priced his product accordingly.

Mr. Comiskey liked symmetry. The playing field at the start was exactly 362 feet from home plate down each foul line and 420 feet to center. He also liked plenty of room for the outfielders to roam, as

OPPOSITE: *Shoeless Joe Jackson, the most famous of the Black Sox.*

BELOW: *Comiskey Park as it looked shortly before it opened in 1910.*

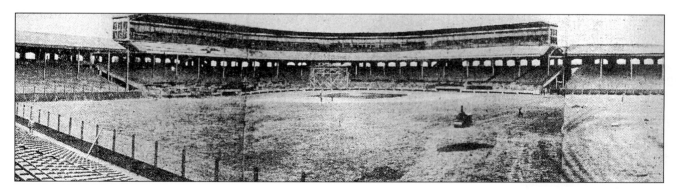

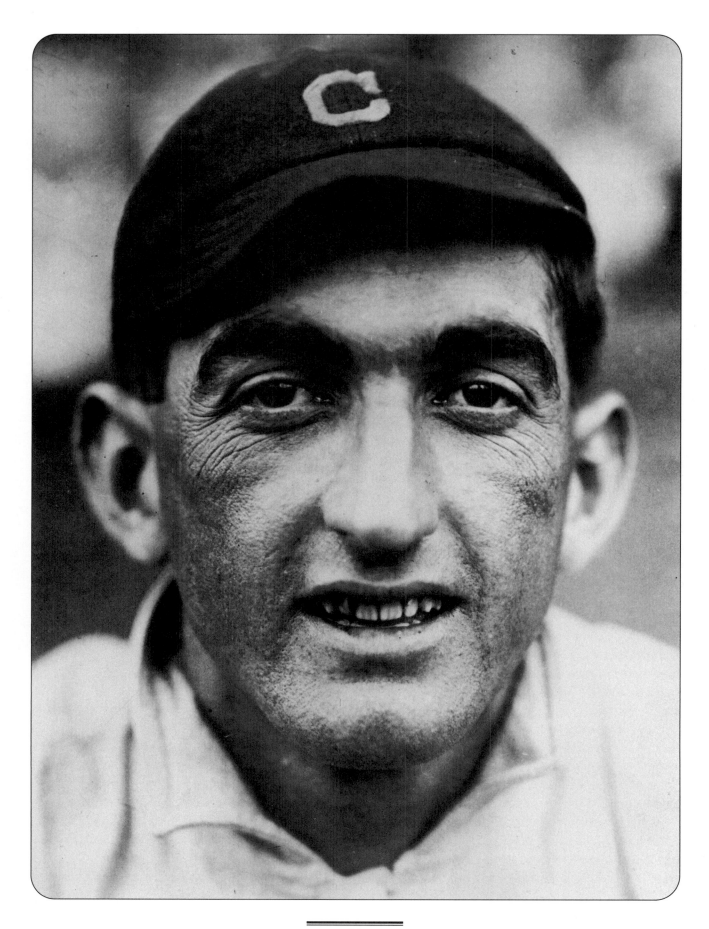

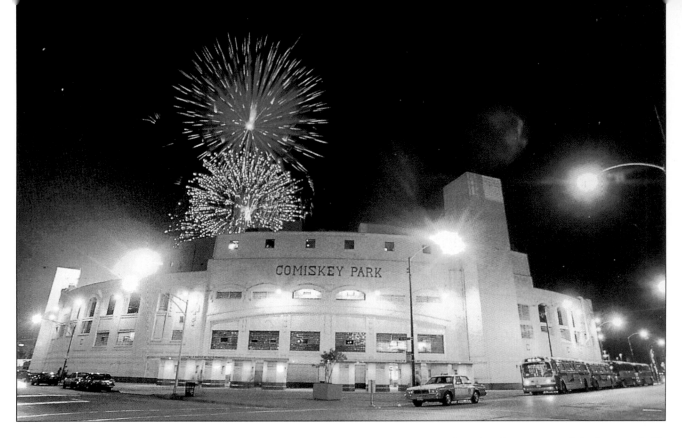

Fireworks over Comiskey Park.

did Ed Walsh, the famous White Sox spitball pitcher, who helped the architects design the ballpark. Outfield fences were 10 feet high in left and right fields, 11 feet high in center.

The ballpark remained essentially unchanged until 1926–27, when major structural alterations undertaken in the off-season increased Comiskey Park's seating capacity to 52,000. In the overhaul, the pavilions, like the grandstand, were double-decked; the wooden left- and right-field bleachers were torn down, replaced with concrete-and-steel stands, and also roofed and double-decked; and the circle was closed by adding a section of uncovered single-decked center-field bleachers. The new outfield distances were 352 feet down the foul lines and 440 feet to center, with 10-foot-high walls. Symmetry had been retained and, with those distances, Comiskey Park was still more a pitcher's than a hitter's ballyard.

Pitchers were also favored by the unusually long distance between home plate and the backstop—98 feet in 1910, reduced to 85 in the mid-thirties, considerably more space for catchers to grab foul pop-ups than the standard 60 or so feet of running room behind home plate in the average big league ballpark. Along with Forbes Field and Shibe Park, Comiskey had the longest distance between home plate and the backstop of any major league park.

When the Sox acquired slugger Al Simmons from the A's in 1933, home plate was moved 14 feet toward the center-field fence—in hopes that he would pop a few more into the stands—but in 1935 "Bucketfoot Al" was sold to Detroit and home plate was moved back to, one is tempted to say, where it belonged. Thereafter, management tinkered with the fences frequently, but until the eighties they invariably returned like homing pigeons to the 352–440–352 distances that had been established in 1927.

For the last five years of Comiskey Park's life, there was an inner fence in center field that decreased the distances to 347–409–347, with 380 feet in the left-center and right-center power alleys. This meant that Comiskey Park no longer favored pitchers over hitters. Part of the center-field bleachers had also been closed off a number of years earlier to make a better background for batters, so in the park's last years seating capacity was reduced to about 44,000.

In all, four World Series were played in Comiskey Park: 1917, 1918, 1919, and 1959. The 1918 Series

was unusual because Comiskey was home park for the Cubs, not the White Sox. Just as the Red Sox had borrowed Braves Field in 1916 and 1917, so the Cubs borrowed the White Sox park in 1918; it didn't help—the Cubs lost the Series to the Boston Red Sox, four games to two.

And 1919 was even more unusual because it has become immortalized as the Black Sox Series, in which eight Chicago players, including Shoeless Joe Jackson, did business with gamblers before the first pitch was thrown. Like the 1920 and 1921 Series, the 1919 Series was a best-five-out-of-nine affair, of which only games three, four, five, and eight were played at Comiskey Park (the others were in Cincinnati).

Of those four, the Reds won games four, five, and eight by scores of 2–0, 5–0, and 10–5. White Sox pitcher Eddie Cicotte made two suspicious errors in game four, center fielder Happy Felsch made a suspicious error in game five, and Lefty Williams gave eight bases on balls and allowed 12 hits and 12 earned runs in 16 innings of pitching.

Comiskey Park also played host to a number of Negro Leagues World Series Games, and from 1933 to 1950 was the scene of the annual Negro Leagues East-West All-Star Games. The East-West game attracted tremendous interest in the black community each year; in 1943, for example, it drew 51,700. Satchel Paige started the game for the West that year and was the winning pitcher.

In addition to baseball, the ballpark was home field for the Chicago Cardinals of the National Football League and was the site of a number of big-time boxing matches. Comiskey Park was where Joe Louis knocked out James J. Braddock to win the heavyweight championship in 1937, where Ezzard Charles defeated Jersey Joe Walcott to win the heavyweight boxing crown in 1949, and where Sonny Liston knocked out Floyd Patterson to take the heavyweight title in 1962.

In baseball, though, the biggest thing to hit

New owners Bill Veeck (left) and Hank Greenberg, just after they bought the White Sox in March of 1959.

Chicago since Charles A. Comiskey was William "Just call me Bill" Veeck, who headed a syndicate that, on March 10, 1959, bought the White Sox from the Comiskey heirs (Charles A. had passed away in 1931).

The marketing-minded Veeck put a picnic area in left field by knocking bricks out of the wall and installing a screen so that picnickers could watch the game as they frolicked. He painted the park white, remodeled the rest rooms, and expanded park security.

In 1960, he also installed the world's first screeching, screaming, no-holds-barred exploding scoreboard. A massive new state-of-the-art scoreboard had been placed on top of the center-field

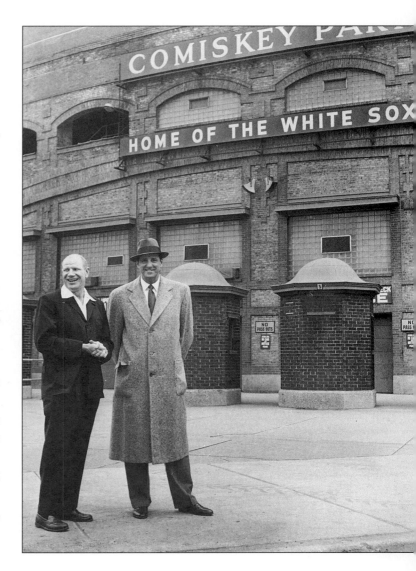

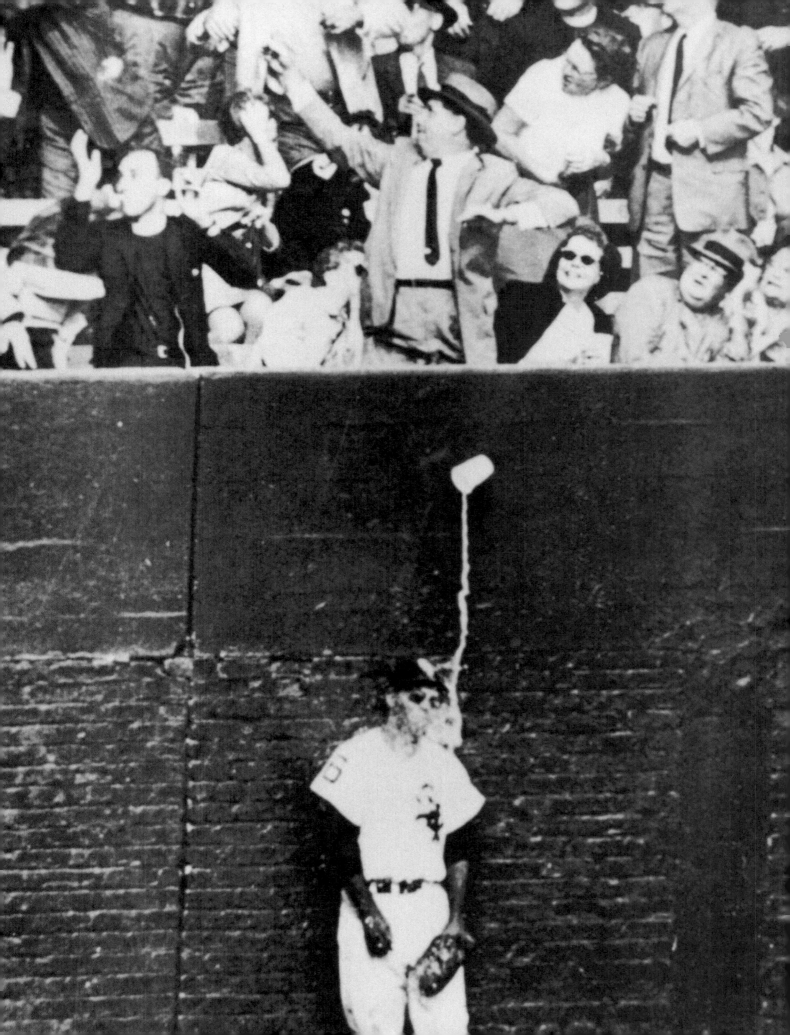

RIGHT: *Scoreboard at Comiskey Park.*

OPPOSITE: *It is the second game of the 1959 World Series and Charlie Neal of the Dodgers has homered into Comiskey Park's seats. A fan, lunging for the ball, has accidentally knocked a beer off the ledge right onto the head of White Sox left fielder Al Smith.*

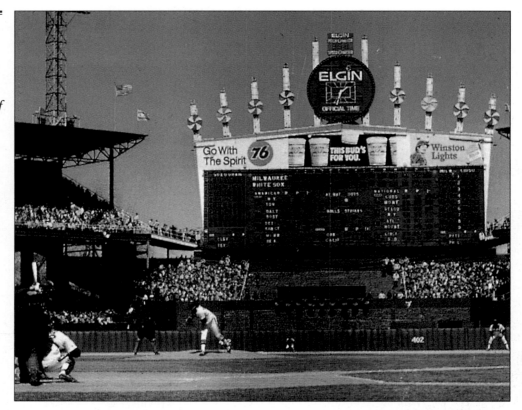

bleachers in 1951. Veeck rewired it, equipped it for sound and fireworks, and on Opening Day 1960 sprang it on an unsuspecting public.

The scoreboard went into action whenever a White Sox player hit a home run. There were foghorns, a cavalry-charge bugle, crashing trains, fire engine sirens, the *William Tell* overture, a chorus whistling "Dixie," flashing strobe lights, and the final coup de grace—a series of firework explosions, each louder and more colorful than the one before. It was the first exploding scoreboard in major league baseball. Imitated often, it has never been surpassed. Chicago outfielder Minnie Minoso set it off twice that Opening Day with two home runs.

Since the scoreboard was triggered only by a White Sox home run, Casey Stengel and the Yankees decided to do their own celebrating on their first 1960 visit to Comiskey Park. Unknown to anyone, the Yankees secreted a supply of sparklers on their bench. Yankee third baseman Clete Boyer did indeed hit one into the stands, and as he circled the bases everyone in the ballpark could see all the

Yankees standing in front of their dugout bravely waving little sparklers.

Bill Veeck had hardly gotten up a good head of steam in Chicago before he fell ill. In June 1961, he sold the White Sox to Arthur C. Allyn, Jr., and went to Maryland's Eastern Shore to regain his health. In December 1975, fully recovered, he reacquired the club and was ready to take up where he'd left off fourteen years earlier.

But things didn't go as well this time around. Veeck made an auspicious beginning in 1976 by bulldozing the artificial turf that had been installed in the infield (only) in 1968. He replaced it with real grass and gave away bunches of the plastic carpet to the fans. But other changes encountered a hostile reception, like newly designed uniforms with shorts instead of the traditional knickers (yes, that's what they are, although the way they are worn today they hardly look like knickers).

Veeck's worst promotion of all took place on July 12, 1979: "Disco Demolition Night" was held in conjunction with a local rock-oriented radio station and was supposed to demonstrate the feelings of

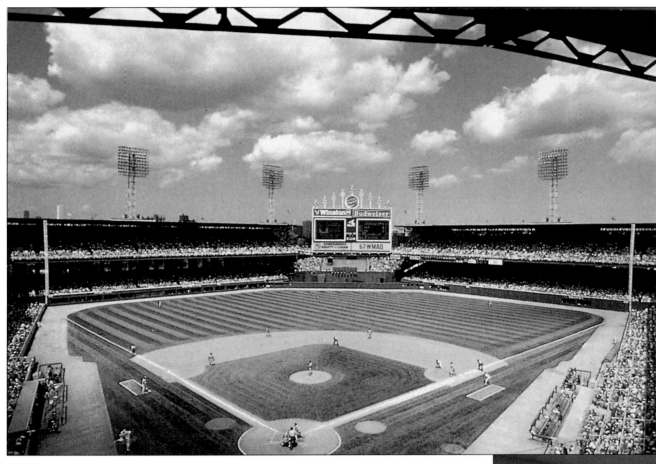

Comiskey Park.

Comiskey Park grounds crew at work in 1990.

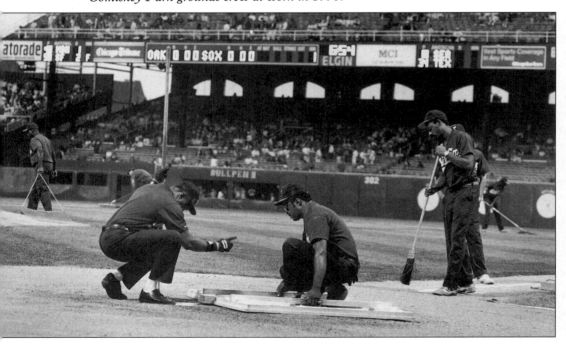

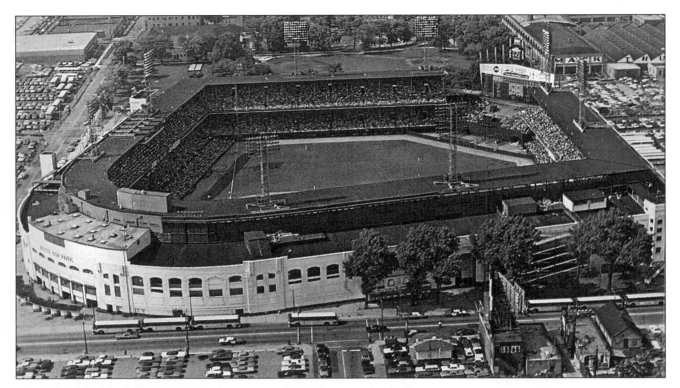

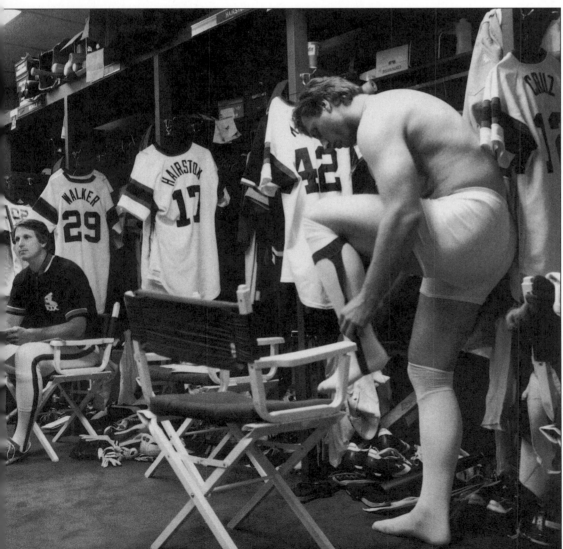

ABOVE: *An aerial view of Comiskey Park in the mid-seventies (it was officially renamed White Sox Park in the early seventies but nobody paid any attention).*

LEFT: *The White Sox locker room in 1986: Greg Walker seated, Ron Kittle at right, Luis Salazar standing.*

rock 'n' roll aficionados about disco music. Admission was 98 cents, bring your own disco record, and between games of a doubleheader all the hated disco records were to be consumed in a huge bonfire. Over 47,000 music lovers showed up, presumably some disco enthusiasts among them, but the festivities turned ugly when thousands of teenagers stormed out of the stands between games and started to wreck the field. Destruction was so widespread that the second game of the doubleheader had to be forfeited to the visiting Detroit Tigers.

Operating on the proverbial shoestring, Veeck found himself unable to compete for players in the era of megabuck free agency that began in 1976. So, in January 1981, he again sold the Sox, this time to wealthy businessmen Jerry Reinsdorf and Eddie Einhorn.

The new owners commissioned a team of engineers to explore the feasibility of renovating the oldest active ballpark in the majors. Receiving a negative report, Reinsdorf and Einhorn threatened to move the team to another city unless the Illinois State Legislature appropriated funds for the construction of a new stadium. New Comiskey Park, built on the other side of 35th Street, directly across from the old one, opened in 1991.

The last game in old Comiskey Park was played on September 30, 1990, before a packed house of 42,849 nostalgic fans. In its eight decades, a grand total of 72,801,381 paying customers had passed through its gates. The score of the last game, just for the record, was 2–1, Chicago over Seattle.

Old Comiskey Park was razed in 1991. Before demolition, the infield dirt—a carefully nurtured mix of sand and clay—was painstakingly moved from the old park to the new one.

The site of the old ballpark now provides parking facilities for the automobiles of people going to new Comiskey Park across the street.

Old Comiskey Park in 1990, its last year, with new Comiskey Park looming in the background.

Comiskey Park's
Ten Most Memorable Moments

1. October 5, 1918, first game of the World Series: Babe Ruth pitches the Boston Red Sox to a 1–0 victory over the Chicago Cubs (who in 1918 are playing their World Series home games at Comiskey Park).

2. October 9, 1919, eighth and deciding game of the World Series: Cincinnati wins the Series by defeating the White Sox, 10–5. (Later it is revealed that eight of the White Sox, hereafter known as the Black Sox, conspired with gamblers to lose the Series.)

3. July 6, 1933: In the All-Star Game, the first ever played, Babe Ruth appropriately hits a home run and a single to lead the American League to a 4–2 victory.

4. April 16, 1940, Opening Day: Cleveland's Bob Feller beats the White Sox, 1–0, with the only Opening Day no-hitter ever pitched in the major leagues.

5. July 5, 1947: Larry Doby becomes the first black player in the American League when he is sent up as a pinch-hitter for Cleveland in a game against the White Sox (and strikes out).

6. August 13, 1948: Forty-two-year-old Satchel Paige, legendary black superstar recently signed to a Cleveland contract, shuts out the White Sox on five hits before a packed house of more than 50,000.

7. July 11, 1950: In the All-Star Game, Ralph Kiner's ninth-inning home run ties the score and Red Schoendienst's fourteenth-inning homer wins it for the National League, 4–3.

8. October 1, 1959, first game of the World Series: Pennant winners for the first time since the scandal-ridden 1919 World Series, the White Sox celebrate with an 11–0 trouncing of the Los Angeles Dodgers (who eventually win the Series, anyway).

9. May 8 and 9, 1984: Chicago and Milwaukee play the longest game in terms of time in major league history (eight hours and six minutes). The game starts on May 8, but isn't completed until the next evening because play has to be suspended after seventeen innings, with the score tied, due to an American League curfew rule. A home run by Harold Baines in the bottom of the twenty-fifth inning finally gives Chicago victory, 7–6.

10. July 1, 1990: New York's Andy Hawkins pitches a no-hitter against the White Sox—but loses the game, 4–0, as the result of bases on balls and errors by his Yankee teammates.

Crosley Field

CINCINNATI

LOCATION: In Cincinnati's West End, at the intersection of Findlay Street and Western Avenue. The first-base foul line ran parallel to Findlay Street, while right and most of center field paralleled Western Avenue (which intersects Findlay at a 45-degree angle from the north); left field was parallel to York Street, and there was no street on the side paralleling the third-base foul line.

HOME OF: The Cincinnati Reds from 1884 to June 24, 1970.

*T*he Cincinnati Reds played baseball at the intersection of Findlay Street and Western Avenue for eighty-six years, from May 1, 1884, to June 24, 1970.

League Park, erected in 1884 on the site of an abandoned brickyard at Findlay and Western, lasted until it burned down in 1900. A new wooden grandstand was built, again known as League Park, although sometimes it was called the Palace of the Fans. Finally, a modern concrete-and-steel ballpark became the Reds' permanent home for six decades; inaugurated on April 11, 1912, as the Reds beat the

The 1937 flood submerged the playing field under 21 feet of water. Pitcher Lee Grissom (left) and John McDonald, the Reds' traveling secretary, rowed right over the left-field fence.

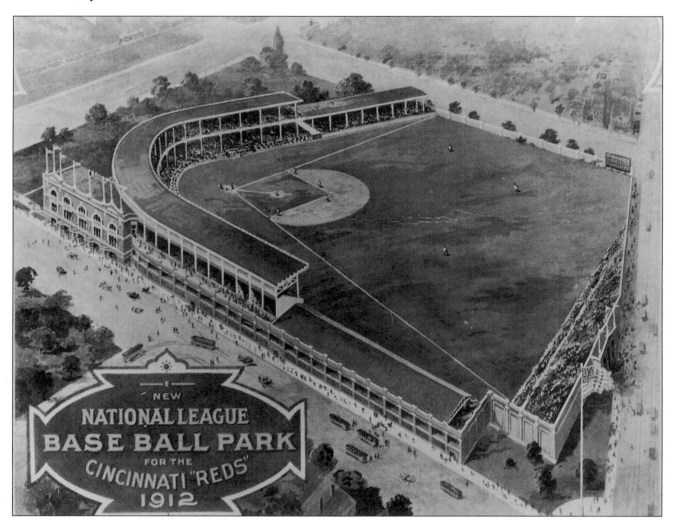

Cubs, 10–6, it was known as Redland Field until 1934, when it became Crosley Field.

Its centerpiece was a covered double-decked grandstand that curved around home plate and extended about 30 feet past first and third base. Covered single-decked pavilions continued down the length of both foul lines. In addition, a separate bleacher section behind right field seated 4,500. There were no seats in fair territory behind center or left field. Total seating capacity was 20,000.

The original outfield dimensions were a generous 360 feet from home plate down the foul lines and 420 feet to center field. The fences in left and center were 14 feet high, and there was a 9-foot-high screen in front of the right-field bleachers. In left field—and to a lesser extent in left-center field—the ground sloped upward in a moderately

Crosley Field—then known as Redland Field—as it looked when it was built in 1912.

sharp 4-foot incline starting 15 feet from the fence, so that although the left-field fence was only 14 feet high, the top of the fence was actually 18 feet above home plate.

The incline was called a "terrace" and remained both a conversation piece and a cause for vituperation for the life of the ballpark. Visiting outfielders were especially bothered by having to run uphill in pursuit of fly balls, especially when backpedaling. On May 28, 1935, near the end of his career, Babe Ruth tripped on the incline while chasing a fly ball, fell on his face, and stormed off the field in disgust. He retired a few days later.

It was inevitable that outfield distances be short-

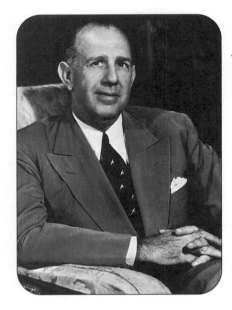

Powel Crosley, Jr., owner of the Reds from 1934 until his death in 1961.

(1946–50 and 1953–57) when a screen installed in front of the right-field bleachers shortened the lengthy 366 feet to a more normal 342 feet. Fence heights remained 14 feet in left and center and 9 feet in right.

An old-fashioned touch that never changed was the location of the home and visiting teams' clubhouses: both were behind the left-field stands. Players had to walk through a public area, usually full of fans, to reach the playing field from the clubhouse and to return to the clubhouse from the playing field.

In 1934, in the Depression, industrialist Powel Crosley, Jr., bought the club for $450,000 and Redland Field was officially named Crosley Field in his honor. Crosley was a well-known manufacturer of refrigerators, radios, and automobiles who was ahead of his time; in the mid-thirties he tried unsuccessfully to market a small compact car, a vehicle not much different from the Volkswagen Beetle that would sweep America a generation later. Otherwise, he was not a man of broad interests; his third wife complained that their social life consisted mostly of baseball and fishing.

As the Reds started to win in the late thirties, attendance at Crosley Field picked up, so in 1939 roofed upper decks were added to the left- and

ened, since the spaciousness of the ballpark was unsuitable for the hit-it-over-the-fence kind of game ushered in by that same Babe Ruth in the twenties. So in the winter of 1926–27 home plate was moved 20 feet toward the outfield, and in the 1937–38 off-season it was moved *another* 20 feet, producing distances of 328 feet down the left-field line, 387 feet to center, and 366 feet—still quite a poke—down the right-field line.

These dimensions remained the same for the life of the ballpark, except for two five-year periods

Aerial view of Crosley Field.

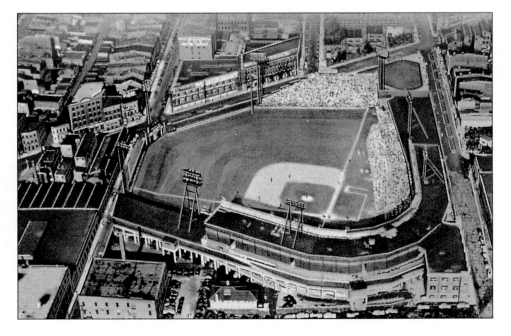

right-field pavilions, giving the park the overall appearance it retained for the remaining three decades of its life. When the Reds abandoned Crosley Field for Riverfront Stadium in 1970, the park had a seating capacity of about 30,000.

Four World Series were played at Crosley: 1919, 1939, 1940, and 1961. The Reds won in 1919 (over Chicago) and 1940 (over Detroit) and lost in 1939 and 1961 to the Yankees. The 1919 victory was, of course, tainted by evidence that the Series was deliberately lost by the Black Sox. The first two games were played at Crosley Field and won by the Reds. Reportedly, the signal that the fix was in was for Chicago's Eddie Cicotte to hit Cincinnati's leadoff batter with a pitch. When Cincinnati second baseman Morrie Rath was indeed hit between

the shoulder blades, the pact was sealed and an additional flood of money was promptly wagered on the Reds.

In 1940, the Reds beat the Detroit Tigers in a hard-fought seven-game Series with poignant emotional overtones. Detroit's colorful Bobo Newsom was the winning pitcher in the first game, but his joy ended suddenly the following morning with the unexpected death of his father, who had come up from South Carolina to see him pitch.

Dedicating the Series to his father, Newsom also won the fifth game, shutting out the Reds with a three-hitter. However, pitching with only one day of rest, Bobo lost the seventh and deciding game at Crosley Field to Paul Derringer, 2–1.

The Reds had their own emotional overhang,

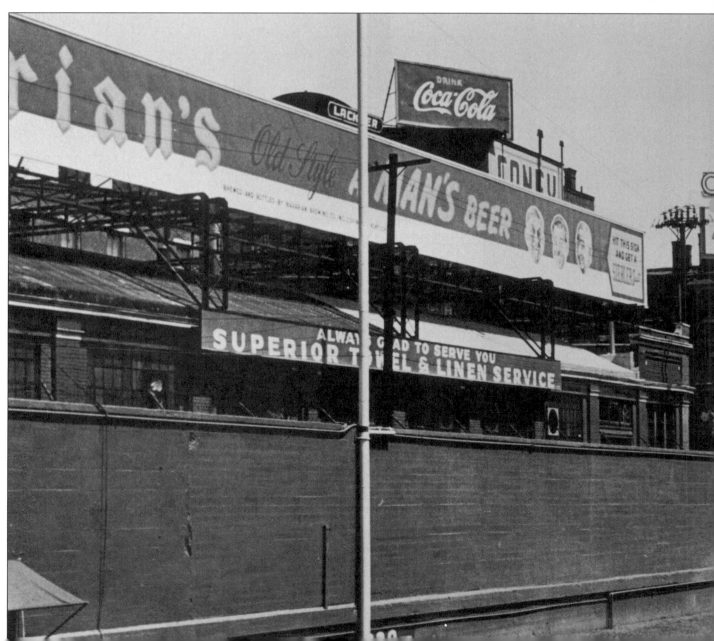

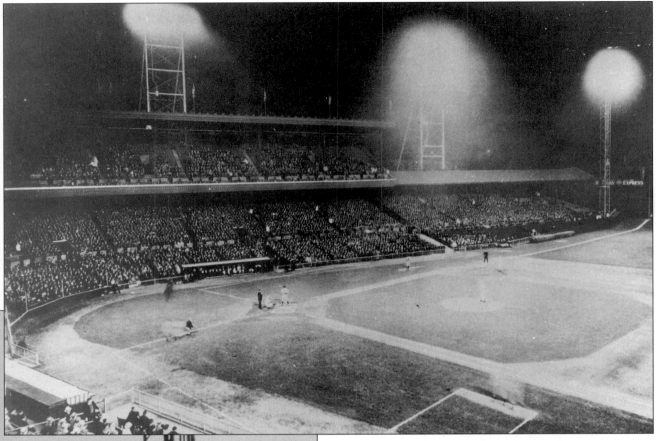

ABOVE: *It is May 24, 1935, and at Crosley Field the first major league night game is being played. (The left-field foul line shows the inclined terrace.)*

LEFT: *Crosley Field's left-field fence and scoreboard in the early fifties. The Superior Towel & Linen Service sign and "Hit This Sign and Get a Siebler Suit" were locally famous.*

stemming from the death of catcher Willard Hershberger, who had committed suicide in his room at the Copley Plaza Hotel in Boston on August 3. Since he left no note, no one can be sure why Hershberger slit his throat with his roommate's razor, but he had been suffering from severe depression for some time. In addition, he apparently held himself responsible for several recent Cincinnati losses, especially one three days earlier in which the Giants had defeated the Reds with a two-out ninth-inning rally.

Larry MacPhail, blustery, abrasive, brilliant, one of baseball's great innovators, became general man-

ager of the Reds in 1934. In an effort to stimulate attendance in the depths of the Depression, he introduced night baseball to the major leagues on May 24, 1935. President Franklin Delano Roosevelt threw a switch in the White House; instantly Crosley Field was as light as day (well, almost), and baseball was forever changed.

Most owners resisted the idea of playing baseball at night, so that MacPhail was initially limited to seven night games a season, one against every other team in the league. Baseball under the stars became immediately popular, of course, so that by 1948 every ballpark in the majors except Wrigley Field had lights, and they would have had them sooner were it not for blackouts and shortages caused by World War II.

The 20,422 who attended the historic first night game in the major leagues never forgot the experience, nor did the 35,000-plus who showed up at Crosley Field a couple of months later, on July 31, for a night game with the St. Louis Cardinals. MacPhail had sold thousands of reserved seats to fans in adjoining states—Indiana, Kentucky, and West Virginia—but when their trains were late, thousands of general admissions customers moved down and occupied the empty seats. When the out-of-staters finally arrived, arguments and near fistfights erupted all over the ballpark. It turned out that MacPhail had sold seats far beyond the seating capacity of Crosley Field. Thousands of fans wound up standing on the field, behind ropes strung along the foul lines and in the outfield. For his part, MacPhail left the ballpark and went home, leaving his secretary in charge.

In the bottom of the eighth inning, amid all the chaos, a local burlesque queen named Kitty Burke dashed up to home plate, grabbed Babe Herman's bat out of his hands, and dared Cardinal pitcher Paul Dean to put one over the plate. After some hesitation he obliged—underhanded—and she swung and hit a grounder that was fielded by Dean, who threw her out at first base.

"It was the first time a woman ever pinch-hit for me," said Babe Herman later.

Subsequently, Kitty Burke got a Cincinnati uni-

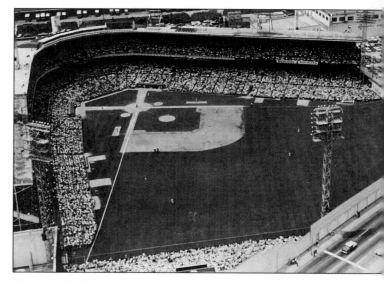

Crosley Field in the sixties.

form from Larry MacPhail. She used it to good advantage in her burlesque act, billing herself as "the only girl who ever batted in the big leagues."

Equally bizarre, in January 1937, the playing field of the ballpark completely disappeared from view when the Mill Creek Flood submerged it under 21 feet of water. Cincinnati pitcher Lee Grissom and John McDonald, the Reds traveling secretary, found a rowboat and proceeded to row right over the left-field fence, presumably in search of the pitcher's mound.

What was the greatest play ever in Crosley Field's fifty-eight-year history? According to Pat Harmon, longtime Cincinnati sportswriter, it occurred in August 1952 when Reds catcher Andy Seminick chased a high pop fly into the third-base dugout: "As Seminick ran, he knew if he went onto the concrete dugout steps running with spikes, he would slip. Five yards before he reached the dugout, he knelt and made a slide. He slid into the dugout. His body went bump-bump, up and down, as he bounced on the dugout steps. The ball fell into his glove while he was bouncing on his back and he caught it."

The growth of Cincinnati more or less bypassed the Findlay and Western neighborhood. One indication of exodus from the area was the razing of the Superior Towel & Linen Service Building in 1960.

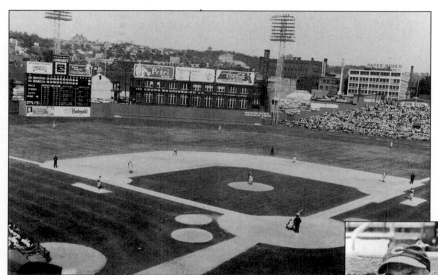

LEFT: *Los Angeles vs. Cincinnati at Crosley Field in the sixties. The new 58-foot-high-by-65-foot-wide scoreboard was installed at the start of the 1957 season. The right-field bleachers were called the Sun Deck.*

BELOW: *Double-No-Hit Johnny Vander Meer (center), with his manager, Bill McKechnie (left), and his catcher, Ernie Lombardi.*

For as long as most people could remember, Superior had been prominently visible behind the left-field fence, across York Street. Siebler Suits, a downtown clothing store, had a locally famous sign—HIT THIS SIGN AND GET A SIEBLER SUIT—on top of the building. Reds outfielder Wally Post reportedly won the most suits over the years, sixteen, while among visiting players the champ was Willie Mays, with seven.

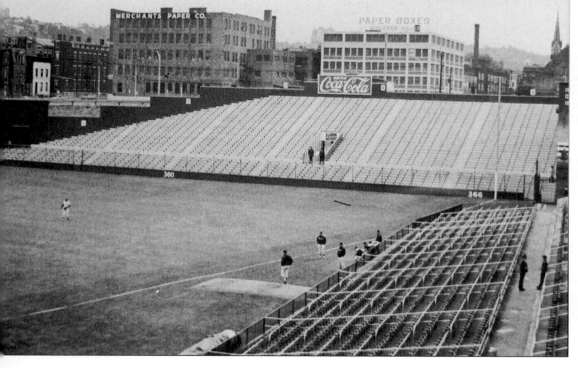

LEFT: *The date is September 28, 1967, and a twi-night doubleheader against Atlanta will start soon. However, so far only two fans have paid their way into the right-field bleachers—they are the speck in the left corner near the light standard and the man standing at the far right. The others are ushers. Total attendance at Crosley Field that night eventually reached 1,399.*

Crosley Field's
Ten Most Memorable Moments

1. May 24, 1935: President Franklin D. Roosevelt throws a switch in the White House that turns on the lights for the first night game in major league history—whereupon the Reds proceed to beat the Phillies 2–1, behind the six-hit pitching of Paul Derringer.

2. May 27, 1937: New York Giants left-hander Carl Hubbell stops the Reds in a rare relief appearance and is credited with the victory, his twenty-fourth straight win over two seasons (still a record).

3. June 11, 1938: Cincinnati's Johnny Vander Meer pitches the first of his two consecutive no-hitters, beating Boston, 3–0.

4. October 8, 1939, fourth and deciding game of the World Series: Stunned by a collision at home plate with Yankee base runner Charlie Keller, Cincinnati catcher Ernie Lombardi lies momentarily dazed as Joe DiMaggio circles the bases in the tenth inning to score the final run of a 7–4 Yankee victory.

5. October 8, 1940, seventh and deciding game of the World Series: Behind pitcher Paul Derringer, the Reds edge the Detroit Tigers, 2–1, to bring Cincinnati its first nontainted world championship. (In 1919, the Black Sox had conspired with gamblers to throw the Series to the Reds.)

6. June 10, 1944: Fifteen-year-old Joe Nuxhall, the youngest player in major league history, pitches two thirds of the ninth inning for the Reds, giving up five runs on five walks, two singles, and a wild pitch; the final score is Cardinals 18, Reds 0.

7. June 22, 1947: Cincinnati's Ewell Blackwell almost duplicates Johnny Vander Meer's feat of pitching two consecutive no-hitters; after no-hitting Boston on June 18, he goes eight and one third no-hit innings against the visiting Brooklyn Dodgers before Brooklyn second baseman Eddie Stanky singles in the ninth inning.

8. August 23, 1961: The San Francisco Giants hit a record five home runs in a *twelve-run* ninth inning to overwhelm the Reds, 14–0.

9. June 14, 1965: Cincinnati's Jim Maloney pitches a no-hitter for 10 innings against the Mets, striking out 18 batters—but loses the game in the eleventh, 1–0, on a home run by Mets outfielder Johnny Lewis (who had previously struck out three times).

10. August 14, 1966: Cincinnati outfielder Art Shamsky hits his fourth consecutive home run in four successive times at bat over two games.

On the night of June 24, 1970, the last major league game was played at venerable Crosley Field: a nostalgic near-capacity crowd of 28,027 saw Johnny Bench and Lee May of the Reds hit consecutive eighth-inning homers to edge Juan Marichal and the San Francisco Giants, 5–4. Crosley Field's home plate was thereupon transported to and duly installed in brand-new, thoroughly modern, publicly financed Riverfront Stadium, located near downtown Cincinnati.

Crosley Field itself was bulldozed in 1972 and an industrial park now occupies the site. But a *life-size* replica proudly stands as a memorial in Blue Ash, Ohio, a suburb fifteen miles northeast of downtown Cincinnati. It has a section of seats and a ticket booth from the old ballpark, outfield dimensions that are the same, including an incline approaching the fence in left and left-center fields, and a huge 58-foot-high-by-65-foot-wide copy of Crosley Field's scoreboard, on which the last game ever played there has been frozen for posterity: the batting orders, umpires, and out-of-town scores are posted just as they were on the night of June 24, 1970. Furthermore, the ballpark is regularly used as a playing field by local high school and amateur teams.

The memorial was dedicated on July 11, 1988, attracting a crowd of some 7,500—including former Reds players Ed Bailey, Gus Bell, Jim Greengrass, Brooks Lawrence, Joe Nuxhall, Johnny Temple, Jim O'Toole, and others who had once attracted large crowds of their own to Findlay Street and Western Avenue. The place evokes strong feelings: "Looking at the old scoreboard and the terrace was a mind-boggling experience," said Johnny Temple, the Cincinnati second baseman in the fifties. "First I got goose pimples, and then I started to cry."

It is June 24, 1970, and Reds captain Pete Rose (No. 14), Giants captain Willie Mays, and the umpires are exchanging lineup cards before the last game that will ever be played at Crosley Field.

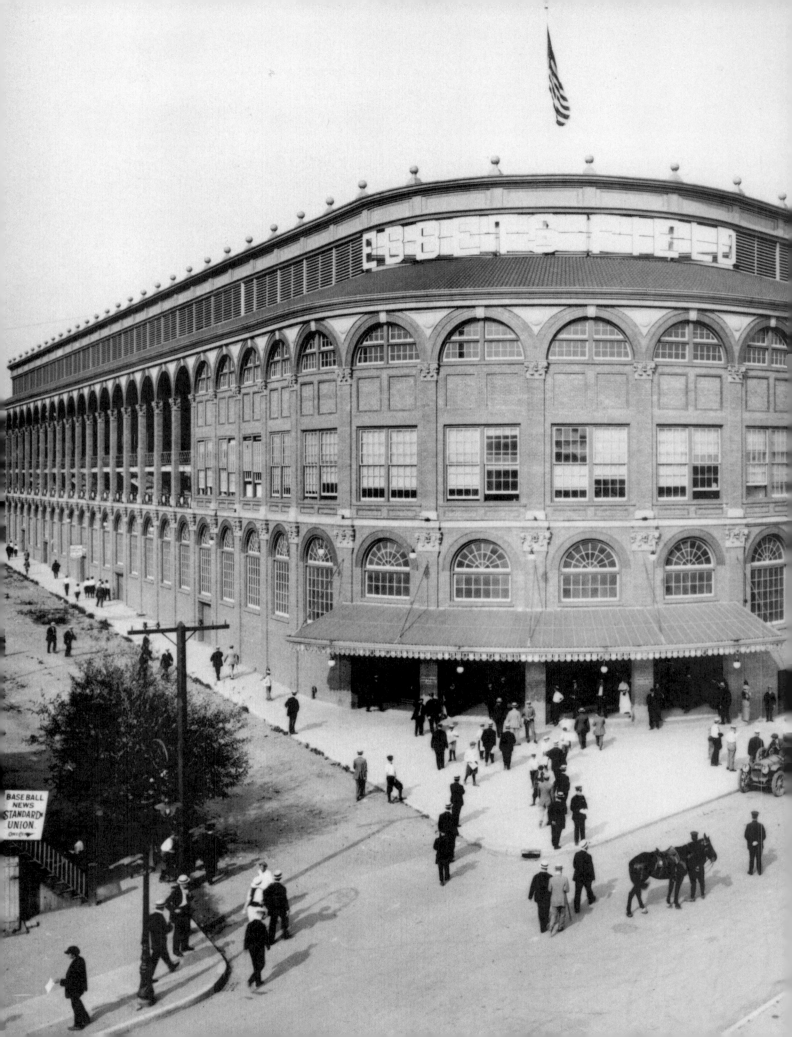

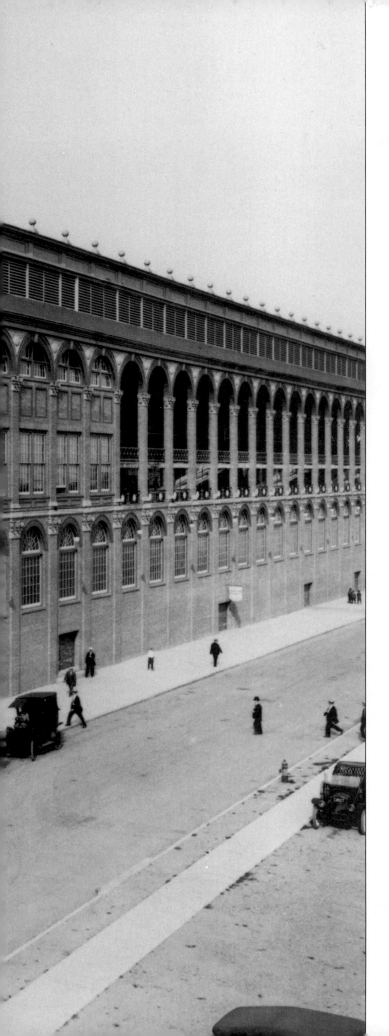

Ebbets Field

BROOKLYN

LOCATION: In the Flatbush section of Brooklyn, on the block bounded by Sullivan Place, Bedford Avenue, Montgomery Street, and McKeever Place. The first-base foul line ran parallel to Sullivan Place, right field to center field parallel to Bedford Avenue, center field to left field parallel to Montgomery Street, while the third-base foul line paralleled McKeever Place.

HOME OF: The Brooklyn Dodgers from April 9, 1913, to September 24, 1957.

*O*f all the ballparks that no longer exist, none has been romanticized more than Ebbets Field. From 1898 to 1912, the Brooklyn Dodgers played at Washington Park, near the Gowanus Canal on Third Street and Fourth Avenue in the Red Hook section of Brooklyn. When Washington Park became cramped, Dodger owner Charlie Ebbets moved a couple of miles west to Flatbush, where he built a new ballpark and, instead of naming it after George Washington, named it after—why not?—himself.

Ebbets Field soon after it opened in 1913. The ornate rotunda inside the main entrance featured a floor of Italian marble decorated with a pattern resembling the circular stitching on a baseball. Hanging from the ceiling was a huge chandelier with twelve arms designed in the shape of baseball bats.

51

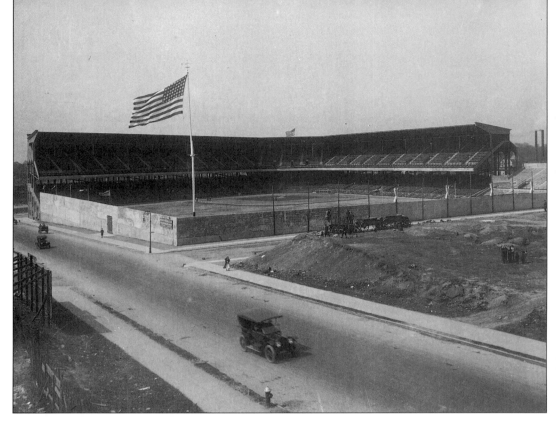

Ebbets Field opened on April 9, 1913, with a seating capacity of 25,000, although cold and windy weather held Inauguration Day attendance to less than half that. The visiting Phillies put a further damper on the party by beating the Dodgers, 1–0, despite some heroics by Brooklyn's twenty-two-year-old center fielder, Casey Stengel.

Forty years later, when showing Mickey Mantle how to play rebounds off the outfield wall at Ebbets Field, Yankee manager Casey Stengel astonished Mantle by referring to his own experiences. Mantle, not yet twenty-one, found it impossible to imagine Stengel playing professional baseball. "He thinks I was born sixty years old," Stengel remarked afterward.

Originally, Ebbets Field had a covered double-decked grandstand that curved around home plate and on the first-base side continued all the way down to the foul pole. However, on the third-base side the grandstand went only 30 or 40 feet past the infield; uncovered single-decked bleacher seats extended the rest of the way to the left-field foul pole. The fences were 9 feet high all around the outfield and there were no seats in fair territory behind any of the outfielders.

Dimensions were a robust 419 feet from home plate down the left-field foul line, a distant 477 feet to dead center, and a convenient 301 feet down the right-field line. It was a pitcher's park, except for left-handed batters.

In the 1920s, some uncovered stands were installed in fair territory in left field, bringing in the left- and center-field fences, but the ballpark did not assume its final shape until the winter of 1931–32. At that time, the covered double-decked grandstand was extended from third base down to the left-field corner and from there over to center

Charles H. Ebbets in the 1890s. He owned the Dodgers from 1898 until his death in 1925.

field. All of Ebbets Field was thereby completely roofed and double-decked except for right and right-center fields, and the seating capacity was expanded to the neighborhood of 32,000.

Further tinkering with the fences continued throughout the thirties and early forties, eventually stabilizing at 348 feet from home plate down the left-field foul line, 389 feet to dead center, and 297 feet from home plate down the right-field line. It was only about 360–370 feet to the seats in the power alley in left-center, about 315 feet to the wall in the power alley in right-center. What had started out as a pitcher's park was thus transformed into just the opposite; Brooklyn slugger Duke Snider is said to have broken down and wept when the Dodgers left Ebbets Field.

The concrete wall in left field was 10 feet high; in right field, backing up against Bedford Avenue, it was 19 feet tall with a 19-foot-high screen above that. In Fenway Park, balls driven into the screen are home runs, but in Baker Bowl and Ebbets Field, balls hitting the screen remained in play. Strangely, the concrete right-field wall was concave to the playing field—that is, the bottom half of the wall slanted away from the field and then at mid-point it straightened and became vertical. The wall was, therefore, bent at the middle.

The crooked wall baffled visiting outfielders,

who often chased every which way after caroming baseballs. Dodger outfielders did better. Right fielders Dixie Walker in the forties and Carl Furillo in the fifties became wizards at playing the wall; they racked up assists year after year, throwing out unsuspecting base runners at second base (and occasionally even at first base).

The Dodgers have been one of baseball's most successful franchises since 1940, but in the twenties and thirties they were sometimes known as the "three men on third" team! According to folklore, a taxicab was cruising past Ebbets Field and the cabdriver yelled up at a spectator, "How's the game going?"

"The Dodgers have three men on base!" the fan shouted back.

"Ah," said the driver, "which base?"

The story was inspired by a game played at Ebbets Field on August 15, 1926. The Braves were the visiting team and in the bottom of the seventh Brooklyn loaded the bases with the score tied and one out. The Brooklyn catcher was on third,

Brooklyn's Dazzy Vance pitching to Cubs outfielder Kiki Cuyler at Ebbets Field in 1930. The big right-field scoreboard was not put up until two years later.

Babe Herman—Brooklyn's Babe.
He hit .393 for the Dodgers in 1930.

pitcher Dazzy Vance was on second, and infielder Chick Fewster was on first.

Up to the plate came Babe Herman, who promptly walloped a long drive to right. It was hard to say if the ball would be caught or would hit the wall. In fact, it did hit the wall, and the man on third scored easily. But Vance held up so long on second, waiting to see if the ball would be caught, that he could only make it halfway to home—so at the last second he decided to play it safe and tried to return to third. Alas, he was caught in a rundown along the way. Just as Chick Fewster, who had kept on going

through it all, made it to third, Vance slid back into the base from the home-plate side.

As for Babe Herman—well, many years later he told a friend about that play. Clearly, it was as fresh in his mind as if it had just happened: "I saw the ball hit the wall as I was on my way to first base and from the way it bounced I figured I could make it to second. I slid into second safely with a double, but as I'm lying there I see that a rundown is taking place between third and home. Naturally, I figure it is Chick Fewster in the rundown, who'd been on first, so I get up and sprint for third like

I'm supposed to. That way we'll have a man on third base, even if Fewster is tagged out.

"But when I get to third, Fewster is *already* there, which surprises me. And here comes Vance into third from the other side. That *really* surprises me, 'cause I thought he'd scored long ago. After all, he was on second and even if you're slow as a turtle you should be able to score from second on a double.

"Anyway, there we are, all three of us on third base at one and the same time. The Boston third baseman, Eddie Taylor, doesn't know what to do, so he tags all of us. Vance was declared safe and Fewster and I were both out. If there was any justice, Vance would have been the one declared out, because he's the one caused the traffic jam in the first place. But down through history, for some strange reason, it's all been blamed on me."

Three men on third! With the passage of time, the scene took on a life of its own and people started believing that Babe Herman had tripled into a triple play. But he couldn't have done that, because there was one out to begin with. Trying to set the record straight, reporter John Lardner summed it up by writing: "Babe Herman never tripled into a triple play, but he did double into a double play, which is the next best thing."

Three innovations were introduced to the world at Ebbets Field, two of which became historical milestones that changed the game of baseball and, to some extent, the world forever. The innovation that had no effect at all was an experiment with yellow baseballs in a game between the Dodgers and the Cardinals on August 2, 1938. Yellow was supposed to be easier to see than white, but the players weren't impressed and the fans didn't like it, so the idea was dropped.

The first historical milestone was major league baseball's television debut, which took place at Ebbets Field on August 26, 1939. With Dodger radio broadcaster Red Barber at the microphone, NBC telecast the first game of a Saturday afternoon doubleheader, Cincinnati vs. Brooklyn. According

Main entrance to Ebbets Field.

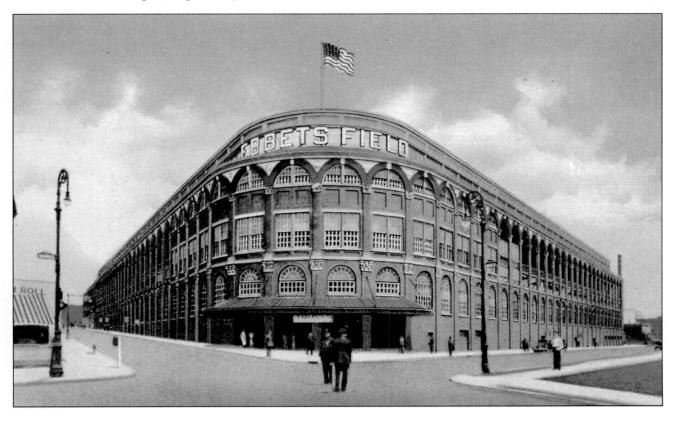

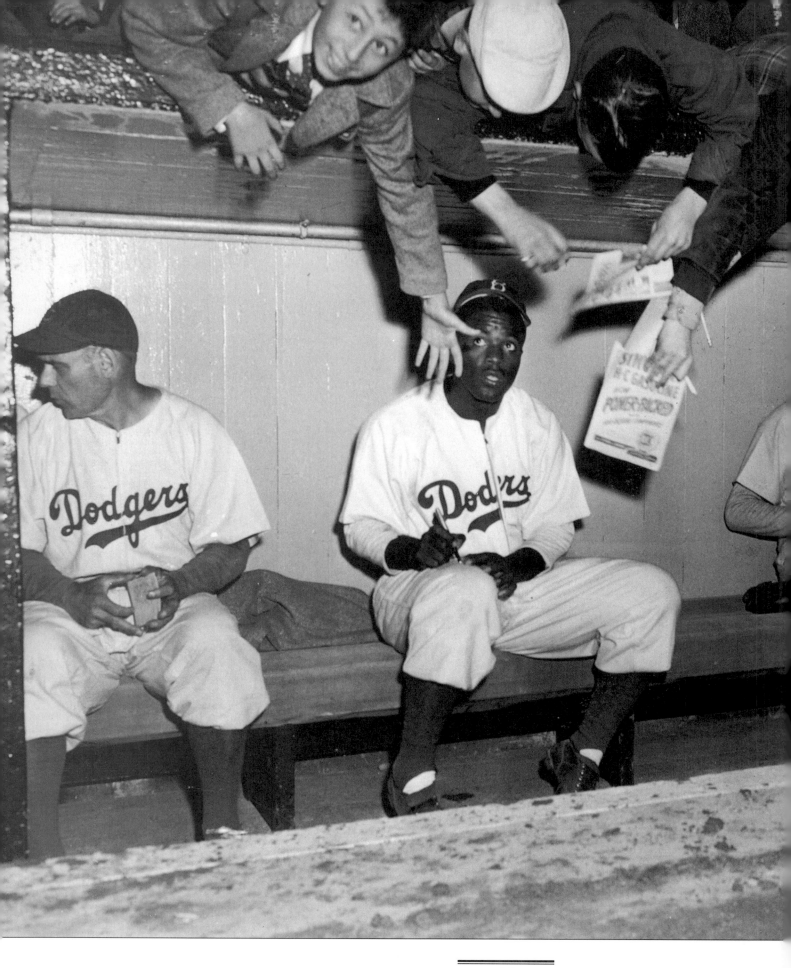

to *The New York Times*, "television set owners as far away as 50 miles viewed the action and heard the roar of the crowd."

The second historical milestone—the breaking of the color line that had shamed organized baseball since the 1880s—will always be identified with Ebbets Field and with Branch Rickey, president and general manager of the Brooklyn Dodgers in the forties. For millions of Americans, baseball's most thrilling moment occurred not when Bobby Thomson or Bill Mazeroski hit their magical home runs but at 2 P.M. on Tuesday, April 15, 1947, when Jackie Robinson trotted out to his position as first baseman for the Brooklyn Dodgers. Thus ended apartheid in major league baseball.

After 1940, the Dodgers were clowns no more. During the forty-five years they called Ebbets Field home, the Dodgers won nine National League pennants—in 1916, 1920, 1941, 1947, 1949, 1952, 1953, 1955, and 1956—but only one World Series (1955). Much of the romance of Ebbets Field revolves around such dramatic events as Mickey Owen's dropped third strike in the 1941 World Series, or Cookie Lavagetto's pinch-hit double in the 1947 Series.

Above all, though, the ballpark's history reflects the love affair between the Dodgers and their fans. Part of the story was the crowd, like bleacherite Hilda Chester, with her ever-present cowbell, and the not-too-musical roaming Dodgers Sym-phony Band, consisting of a trombone, a trumpet, cymbals, a snare drum, and a bass drum. And part was the intimacy fostered by the ballpark itself: "If you were in a box seat at Ebbets Field," said broadcaster Red Barber, "you were so close you were practically an infielder."

Most of Brooklyn took the Dodgers to their hearts and, as a result, an ethnically diverse, racially mixed community found a shared interest through which everyone could be on an equal footing. When the Dodgers moved to Los Angeles,

Jackie Robinson on the Dodgers bench in the 1947 season. Coach Ray Blades is on the left, pitcher Ralph Branca on the right.

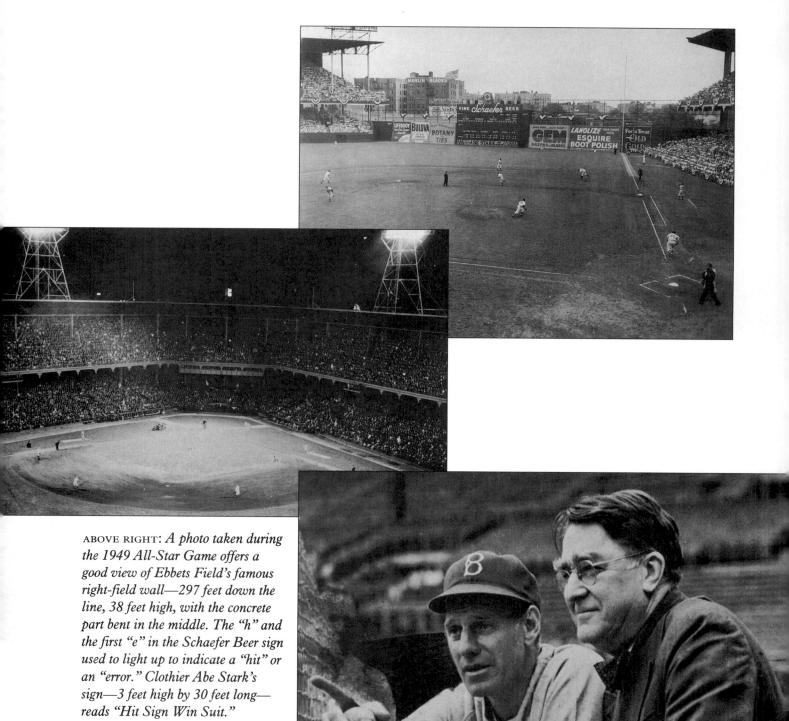

ABOVE RIGHT: *A photo taken during the 1949 All-Star Game offers a good view of Ebbets Field's famous right-field wall—297 feet down the line, 38 feet high, with the concrete part bent in the middle. The "h" and the first "e" in the Schaefer Beer sign used to light up to indicate a "hit" or an "error." Clothier Abe Stark's sign—3 feet high by 30 feet long— reads "Hit Sign Win Suit."*

ABOVE: *It is June 15, 1938, the first night game at Ebbets Field, and Johnny Vander Meer is pitching his second consecutive no-hitter.*

RIGHT: *Brooklyn manager Leo Durocher (left) and Dodgers president Branch Rickey conferring early in 1947.*

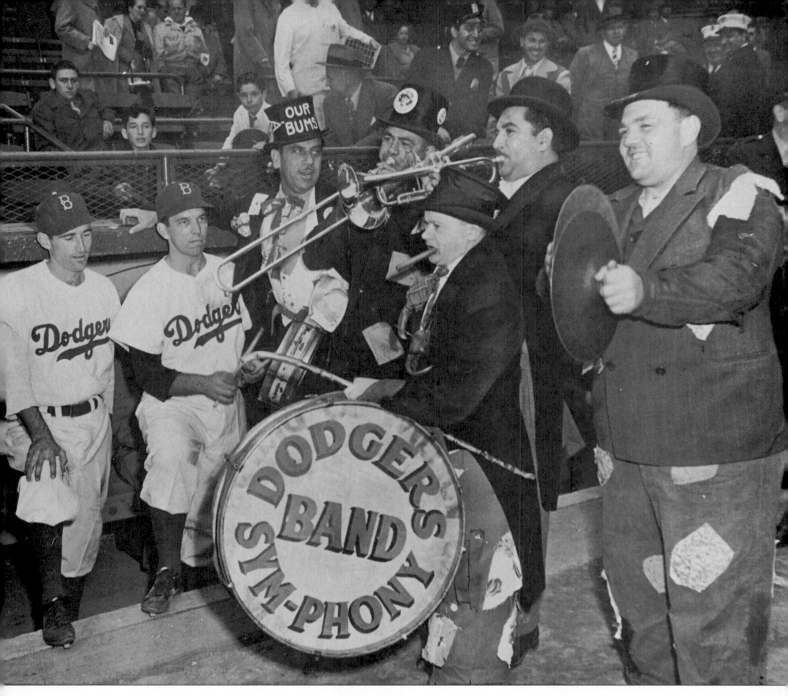

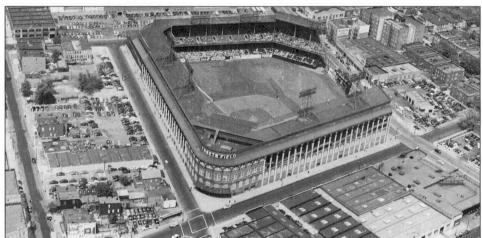

Lost Ballparks

Brooklyn lost a common bond that had restrained a tendency to split into ethnic and racial enclaves.

Why did the Dodgers leave Brooklyn? It wasn't for lack of attendance, the reason that drove the Braves out of Boston, the Giants out of New York, the A's out of Philadelphia. The Dodgers drew over a million customers in 1957, their last season in Ebbets Field.

The Dodgers were profitable in Brooklyn, but moved because profits promised to be even greater in Los Angeles. The commissioner of baseball at the time, Ford C. Frick, did not interfere. For the good of baseball and definitely for the good of Brooklyn, he should have. Los Angeles deserved major league baseball, but whether L.A. should have obtained it at the expense of Brooklyn is another matter altogether.

The Brooklyn Dodgers played at Ebbets Field for the last time on September 24, 1957, defeating the Pittsburgh Pirates, 2–0, before only 6,702 spectators. The imminent departure of the team was already well known.

Ebbets Field was razed in 1960. When demolition was about to begin—on a wintry day in February—Lucy Monroe sang the National Anthem, as she had at the start of many Dodgers ball games. A number of ex–Brooklyn players were also present for the pre-demolition ceremonies.

The high-rise Ebbets Field Apartments now occupy the site. Nearby is the Jackie Robinson Intermediate School.

It is 1957, the Dodgers' last year in Brooklyn. Ebbets Field attracted over a million customers in 1957, but you could hardly tell it from this picture.

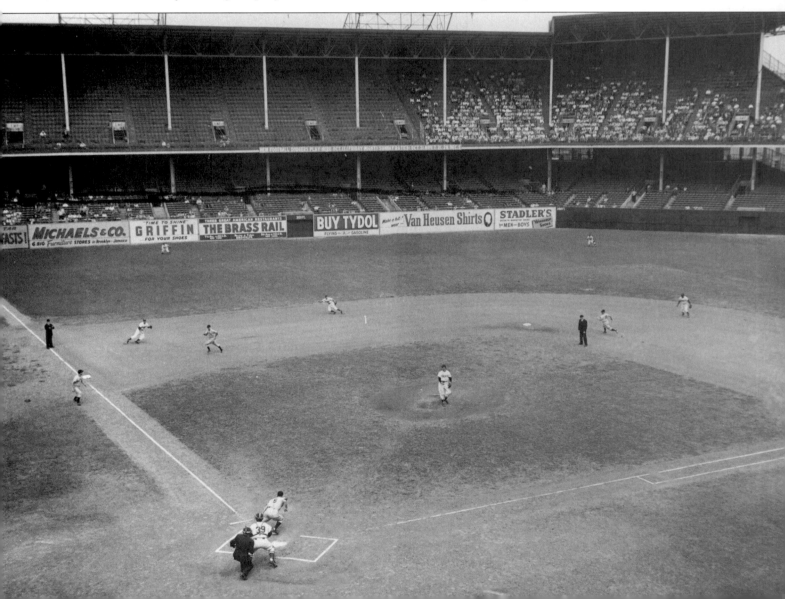

Ebbets Field's
Ten Most Memorable Moments

1. September 16, 1924: St. Louis first baseman Jim Bottomley hits a grand-slam home run, a two-run homer, a double, and three singles in six times at bat, driving in a record *twelve* runs, as the Cardinals trounce the Brooklyn Dodgers, 17–3.

2. September 21, 1934: The Cardinals win a double-Dean double-shutout doubleheader over the Dodgers, as Dizzy Dean pitches a three-hitter, followed by brother Paul's no-hitter.

3. June 15, 1938: On the occasion of the first night game at Ebbets Field, Cincinnati's Johnny Vander Meer pitches his second consecutive no-hitter, beating the Dodgers, 6–0.

4. October 5, 1941, fourth game of the World Series: Brooklyn catcher Mickey Owen drops the third strike of what would have been the last out of a Dodger victory over the Yankees; given a second chance, the Yankees win the game (and go on to win the Series).

5. April 15, 1947, Opening Day: Jackie Robinson becomes the first black player in the major leagues in the twentieth century when he starts the season as first baseman for the Brooklyn Dodgers.

6. October 3, 1947, fourth game of the World Series: Yankee pitcher Bill Bevens is pitching a no-hitter against the Dodgers with two men out in the ninth inning—when Dodger pinch-hitter Cookie Lavagetto suddenly doubles in two runs to break up the no-hitter and win the game for Brooklyn.

7. August 31, 1950: Brooklyn first baseman Gil Hodges hits four home runs and a single, driving in nine runs, in a 19–3 Brooklyn victory over the Boston Braves.

8. October 1, 1950, the last day of the season: Philadelphia's Robin Roberts pitches a five-hitter and outfielder Dick Sisler hits a dramatic tenth-inning three-run homer to beat the Dodgers, 4–1, and win the National League pennant for the Phillies, their first since 1915.

9. October 7, 1952, seventh and deciding game of the World Series: In the seventh inning, with the bases loaded, Yankee second baseman Billy Martin makes a last-second knee-high catch of a short infield fly ball hit by Jackie Robinson, saving the game and the Series for the Yankees.

10. July 31, 1954: Milwaukee first baseman Joe Adcock hits four home runs and a double, driving in seven runs, in a 15–7 Milwaukee triumph over the Dodgers.

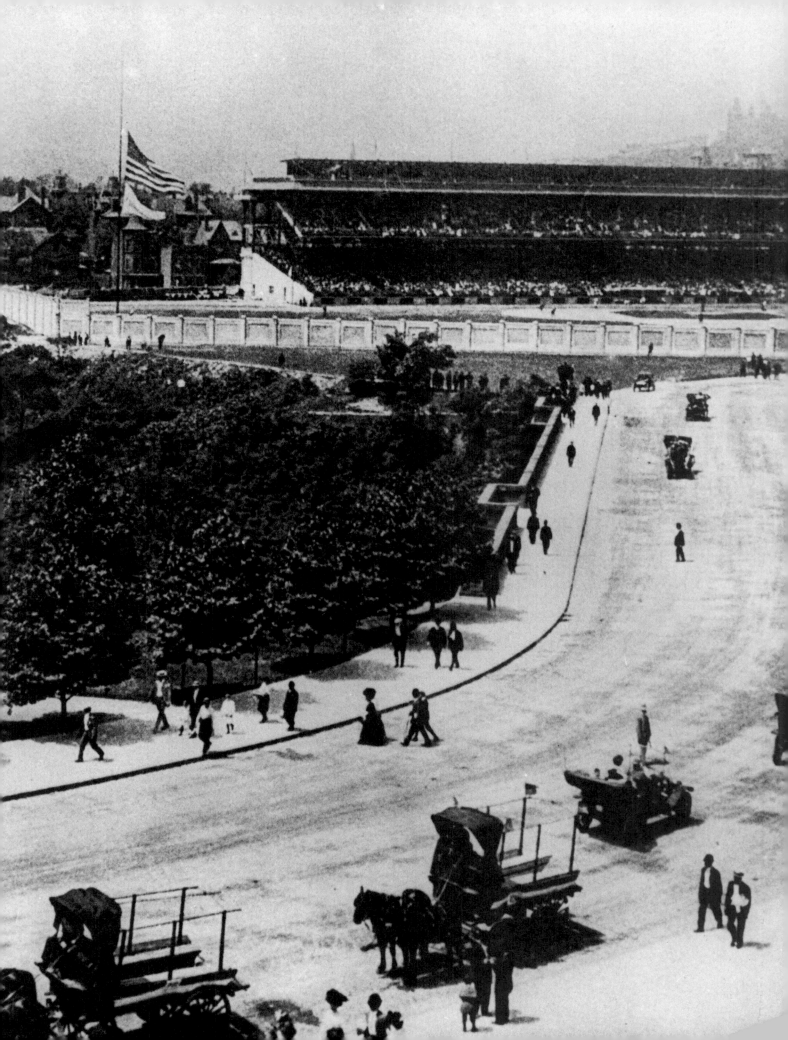

Forbes Field

PITTSBURGH

LOCATION: In the Oakland section of Pittsburgh, near Schenley Park, at the intersection of Boquet and Sennott streets. The first-base foul line ran parallel to Boquet Street, while from the right-field corner partway to center field paralleled Joncaire Street; the rest of the outfield bordered on Schenley Park, with the third-base foul line parallel to Sennott Street.

HOME OF: The Pittsburgh Pirates from June 30, 1909, to June 28, 1970.

*W*hen owner Barney Dreyfuss decided in 1908 to build a modern ballpark for his Pirates, he chose an upscale site on the outskirts of the city three miles east of downtown Pittsburgh. He acquired a seven-acre parcel of land that was part of Schenley Farms (later to become Schenley Park) and started to level the ground in January of 1909. Construction of the grandstand began in March and the ballpark was ready four months later.

Dreyfuss named his imposing all-concrete-and-steel playground Forbes Field, after General John Forbes (1710–59). Forbes was a British general in the French and Indian War who captured Fort Duquesne from the French in 1758 and renamed it Fort Pitt (hence Pittsburgh).

Forbes Field as it looked on Opening Day—
June 30, 1909.

This is the famous 1909 Honus Wagner baseball card that in 1991 sold for $451,000 at Sotheby's in New York.

Originally, Forbes Field consisted of a roofed double-decked grandstand that curved around home plate and extended 25 to 30 feet past first and third bases. On top of the grandstand roof was a mini third deck, consisting of a covered row of box seats that stretched from one end of the grandstand roof to the other. The roof boxes were apparently the 1909 equivalent of today's luxury sky boxes.

A separate section of bleacher seats continued down the rest of the left-field foul line. There were no permanent seats down the rest of the right-field foul line or in fair outfield territory. When the park was sold out, however, temporary bleachers were often erected (and/or roped-off standees allowed) along the right-field line and behind the outfielders.

Seating capacity was 25,000—19,500 seats for ordinary folks in the two main levels of the grandstand, 2,000 for the upper crust in the field boxes and roof boxes, and 3,500 for the hoi polloi in the left-field bleachers. In 1909, box seats, either field-level or on the roof, cost $1.25; a reserved grandstand seat $1.00; general admission grandstand 75 cents; and a left-field bleacher seat 50 cents.

These prices sound cheap, but they weren't. In 1992, the overall consumer price level is seventeen times higher than it was in 1909. On average, to buy the goods and services in 1992 that one dollar could buy in 1909 requires the outlay of *seventeen* dollars. Thus, in terms of dollars with 1992 purchasing power, box seats in 1909 cost the equivalent of $21.25, reserved grandstand $17.00, general admission grandstand $12.75, and left-field bleacher seats $8.50. Hoi polloi, indeed!

For Inauguration Day, June 30, 1909, the 25,000 capacity of the ballpark was exceeded by more than 5,000, because of temporary bleachers and standees. Unhappily for most of the spectators, the Chicago Cubs beat the Pirates, 3–2.

The original outfield distances were 360 feet from home plate down the left-field line, 462 feet to center field, and a mighty 376 feet down the right-field foul line. While it was difficult to hit a ball over the fences, the generous dimensions encouraged triples and inside-the-park homers. It is no accident that the season record for triples was set by a Pirate—36 by Chief Wilson in 1912—a record that still stands.

At first, the backstop was so far behind home plate, 110 feet as compared with the typical 60 feet, that some people—such as sportscaster/historian Art Rust, Jr.—claimed that at Forbes Field the catcher was practically a fourth outfielder. Over the years, the distance from home to the backstop was decreased somewhat, to 84 feet in 1938 and finally

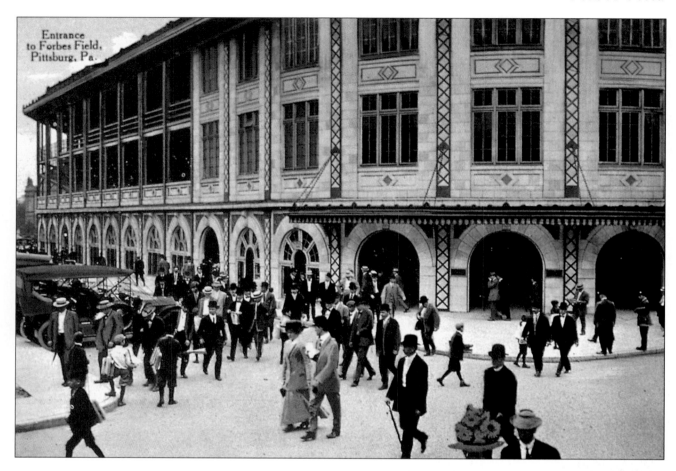

ABOVE: *Main entrance to Forbes Field.*

RIGHT: *It is June 4, 1940, the first night game at Forbes Field.*

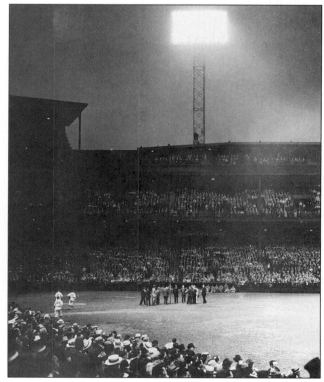

to 75 feet in 1959, but it still competed with Comiskey and Shibe Parks for the biggest home-plate-to-backstop distance in the majors. (Strangely, a no-hitter was never pitched in the history of Forbes Field.)

In the ensuing sixty-one years, only two major changes were made in the ballpark. The first occurred in 1925, when the roofed double-decked grandstand was extended down to the right-field corner and over a couple of hundred feet into fair territory. This reduced the distance down the right-field foul line from 376 to 300 feet. To avoid cheap home runs, a 28-foot-high screen was installed in front of the lower-right-field seats from the foul line over to the 375-foot marker.

The second change took place in 1938. With the Pirates expected to win the pennant, a covered third deck was built atop the second deck in the area behind home plate. The idea was to make room for the many reporters from around the country who would descend on Forbes Field to cover the upcoming World Series.

It never happened. A homer in the gloaming by Cubs manager Gabby Hartnett snatched the flag out of Pittsburgh's grasp in the waning days of the 1938 season. The third deck—known as the Crow's Nest—lived on for the life of the ballpark.

No additional structural alterations of any importance were ever made, so the basic shape of the stands was fixed by 1938—double-decked grandstands from fair territory in right field over past the right-field foul line and then up to and around home plate and down the left-field line a modest distance past third base; bleachers down

the rest of the left-field foul line; roof boxes; and a third deck behind the home plate area only. Post-1938 seating capacity was 35,000. There was no seating behind the 12-foot-high outfield wall in center and left fields, which after 1945 was an ivy-covered red-brick wall in keeping with the bucolic Schenley Park background.

Before the start of the 1947 season, the Pirates acquired right-handed power-hitter Hank Greenberg. To help him a bit (Hank was thirty-six by then), the bullpens were moved from the sidelines to a newly constructed fenced-in area in front of the left-field wall. "Greenberg Gardens," as it was

RIGHT: *Ralph Kiner. On average, Kiner hit a homer every 14.1 times at bat, a frequency exceeded only by Babe Ruth, who homered on average once every 11.8 times at bat.*

BELOW: *Greenberg Gardens—later known as Kiner's Korner. In place from 1947 through 1953, it shortened Forbes Field's left-field home-run distance by 30 feet.*

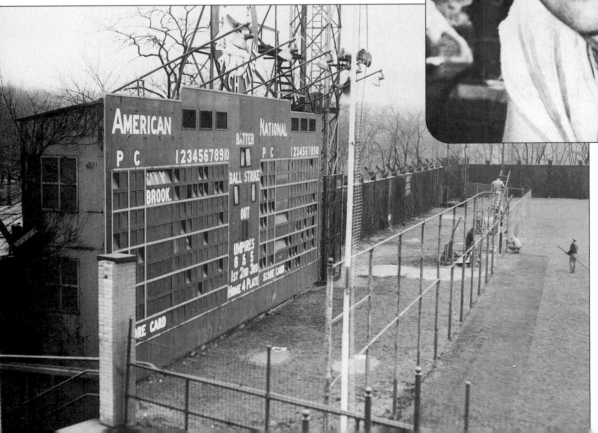

called, decreased the distance from home plate to the left-field foul pole from 365 feet to 335 feet.

Greenberg Gardens didn't help Hank too much—he managed only 25 home runs that year and then retired—but it didn't hurt a twenty-four-year-old California beach boy who was just learning the ropes. Greenberg showed the youngster how to be selective at bat, how to choose which pitches to swing at, and Pittsburgh outfielder Ralph Kiner responded with 51 home runs in 1947, and 54 in 1949. Thus, Greenberg Gardens continued to bloom, except its name became Kiner's Korner. After Ralph was traded to the Cubs in 1953, the bullpens returned to the sidelines and the left-field distance returned to 365 feet.

Thereafter, the dimensions of Forbes Field remained 365 feet from home plate down the left-field line, 457 feet to center, and 300 feet down the right-field line. It was about 405 feet in the left-center and right-center power alleys.

What is the most dramatic moment in the entire history of baseball? Many would say Bobby Thomson's 1951 home run, and some would say Babe Ruth's 1932 called shot homer, or Roger Maris's sixty-first home run in 1961. But near the top of anyone's list has to be Bill Mazeroski's bottom-of-the-ninth-inning home run, a stroke of lightning that ended the seventh game of the 1960 World Series.

With the score tied, the Pittsburgh second baseman hit Ralph Terry's second pitch over the ivy-covered left-field wall of Forbes Field at the 406-foot marker. It is still the only time a World Series ended with the punctuation of a home run.

Almost as dramatic for an earlier generation, but virtually forgotten now, was Kiki Cuyler's two-run tie-breaking double off Walter Johnson that won the 1925 World Series for the Pirates. Goose Goslin, who was in the outfield for the Washington Senators on that rainy October day in 1925, is one person who didn't forget it.

"It was ridiculous," Goslin recalled years later. "The seventh game of the 1925 World Series was played in a terrific rainstorm. I'm not kidding, it

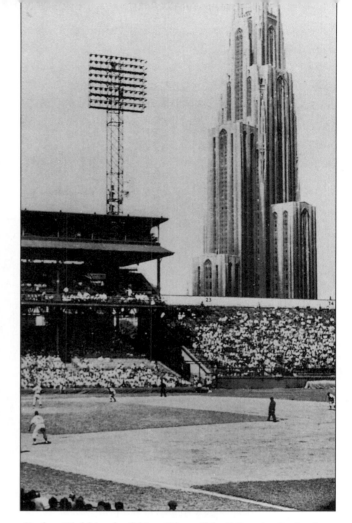

Forbes Field in the fifties. The tall building in the background is the Cathedral of Learning on the University of Pittsburgh campus.

was pouring like mad from the third inning on, and by the seventh inning the fog in Forbes Field was so thick I could just about make out what was going on in the infield from out there in the outfield. In the bottom of the eighth, Cuyler hit a ball down the right-field line that they called fair, and that won the game for Pittsburgh. It wasn't fair at all. It was foul by two feet. I know it was foul because the ball hit in the mud and *stuck* there. The umpires couldn't see it. It was too dark and foggy."

It was also in Forbes Field that Babe Ruth had his last hurrah. On May 25, 1935, forty years old, sick and grumpy, playing out the string with the Boston Braves, the Bambino came to bat with a man on base in the first inning and drove a pitch into the right-field seats. When he came up again, the starting Pittsburgh pitcher had been replaced by Guy Bush. Again there was a man on and again

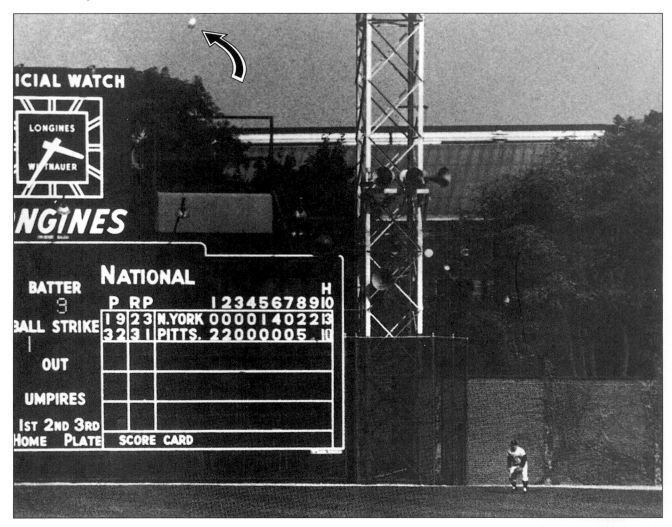

ICIAL WATCH

LONGINES

WITTNAUER

NGINES

BATTER	NATIONAL													
9	P	RP		1	2	3	4	5	6	7	8	9	10	H

BALL STRIKE 19 23 N.YORK 0 0 0 0 1 4 0 2 2 13
3 2 3 1 PITTS. 2 2 0 0 0 0 0 5 10

OUT

UMPIRES

1st 2nd 3rd
HOME PLATE SCORE CARD

Ruth hammered the ball into the right-field stands. The third time up he singled another run across the plate. He came up for the fourth time in the seventh inning, with Bush still pitching, and this time lofted one high over the right-field roof. The Associated Press reported that it was the longest drive ever hit at Forbes Field, the first ever to go completely over the roof (built in 1925).

Almost four decades later, pitcher Guy Bush remembered that moment: "I don't recall the first home run he hit off me that day. But I'll never forget the second one. He got hold of that ball and hit it clear out of the ballpark. It was the longest cock-eyed ball I ever saw in my life. That poor fellow, he'd gotten to where he could hardly hobble along. When he rounded third base, I looked over there at him and he kind of looked at me. I tipped my cap,

It is the ninth inning of the seventh game of the 1960 World Series and Pittsburgh's Bill Mazeroski has just connected with Ralph Terry's fastball. Yankee left fielder Yogi Berra has his eye on the ball—it is above and to the right of the clock—but it cleared the fence to bring victory to the Pirates.

sort of to say, 'I've seen everything now, Babe.' He looked at me and kind of saluted and smiled. We got in that gesture of good friendship. And that's the last home run he ever hit."

Many people think that Ruth hit three home runs in his last major league game, that after circling the bases, "he went into the dugout, through the tunnel, to the clubhouse, and called it a career." But it isn't so. Maybe that's what he *should* have done, but he didn't. He hung on for another week,

hoping that maybe the old magic was back. Finding it wasn't, he played his last game on May 30 and *then*, on June 2, announced his retirement in Boston.

Although still serviceable, Forbes Field began to show signs of age in the fifties and sixties. In addition, the nearby University of Pittsburgh needed room for expansion. The site was consequently sold to the university and the Pirates moved to Three Rivers Stadium.

On June 28, 1970, a packed house of 40,918 said goodbye to Forbes Field with a Pittsburgh double-header victory over the Chicago Cubs. The ballpark was razed the following year.

Home plate from Forbes Field is now on display under Lucite, in the exact spot where it used to be, now in the lobby of the University of Pittsburgh's Forbes Quadrangle building. Sections of the outfield wall have also been preserved by the university, complete with ivy, and a long row of red bricks embedded in a campus sidewalk traces where

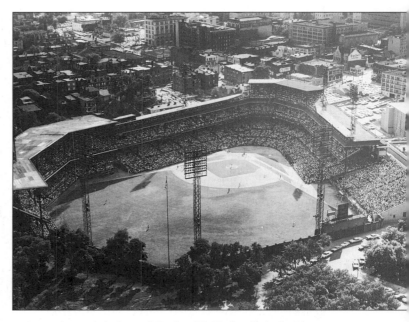

ABOVE: *An aerial view of Forbes Field shortly before it was demolished.*

BELOW: *Forbes Field at night.*

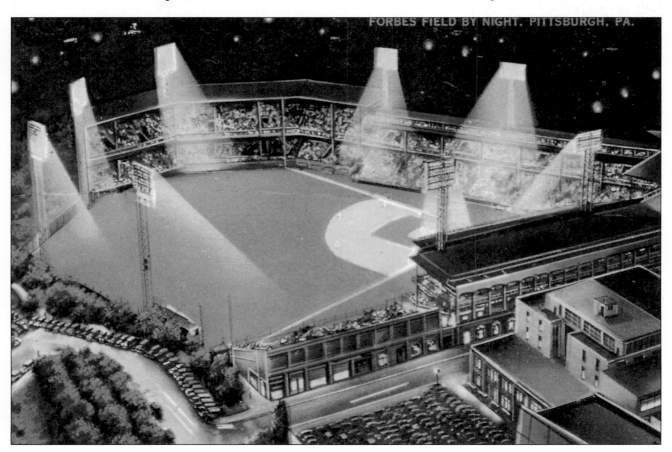

Forbes Field's
Ten Most Memorable Moments

1. October 8, 1909, first game of the World Series: In the first World Series game ever played at Forbes Field, Pittsburgh rookie pitcher Babe Adams allows Detroit only six hits as the Pirates win, 4–1.

2. July 17, 1914: Rube Marquard of the Giants beats Babe Adams of the Pirates, 3–1, in a 21-inning game, with both pitchers going the distance.

3. October 2, 1920: The last major league tripleheader is played as Cincinnati beats Pittsburgh in the first two games but loses the third to the Pirates.

4. October 15, 1925, seventh and deciding game of the World Series: Pittsburgh outfielder Kiki Cuyler's two-run tie-breaking eighth-inning double in semi-darkness wins the game, 9–7, and the Series for the Pirates.

5. August 26, 1926: Pittsburgh outfielder Paul Waner collects six hits in as many trips to the plate, including two doubles and a triple, using six different bats in the process.

6. October 5, 1927, first game of the World Series: The Yankees put on such an awesome display of home-run power in pregame batting practice that Pittsburgh's confidence apparently erodes even before the first pitch is thrown. Once the game begins, Babe Ruth gets three hits and Lou Gehrig drives in two runs as the Yankees win the first of four straight over the Pirates.

7. May 25, 1935: Babe Ruth, winding up his career with the Boston Braves, hits three home runs and a single and drives in six runs; the third homer, number 714, the last of his career, is the first ever to clear Forbes Field's right-field roof.

8. July 10, 1936: Philadelphia outfielder Chuck Klein hits four home runs, driving in six runs, as the Phillies outscore the Pirates in ten innings, 9–6.

9. May 28, 1956: First baseman Dale Long of the Pirates hits his eighth home run in eight consecutive games to help Pittsburgh subdue the Brooklyn Dodgers, 3–2.

10. October 13, 1960, seventh and deciding game of the World Series: In the last World Series game ever played at Forbes Field, Pittsburgh second baseman Bill Mazeroski homers in the bottom of the ninth against the New York Yankees to give the Pirates a dramatic 10–9 victory and the world championship.

much of the rest of the outfield wall used to stand.

At the appropriate place is a plaque on which is inscribed:

This marks the spot where Bill Mazeroski's home run ball cleared the left center field wall of Forbes Field on October 13, 1960, thereby winning the world series championship for the Pittsburgh Pirates. The historical hit came in the ninth inning of the seventh game to beat the New York Yankees by a score of 10–9.

Part of the Forbes Field outfield wall and its home plate have been preserved on the University of Pittsburgh campus.

BELOW: *Forbes Field in 1971.*

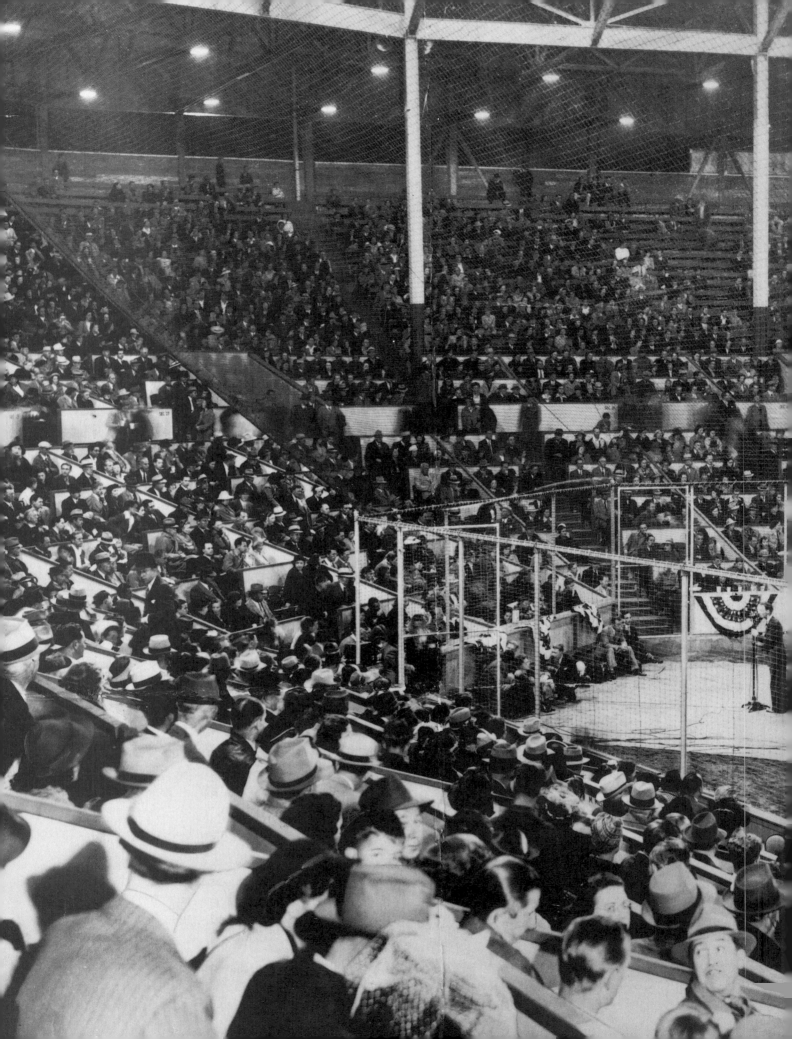

Gilmore Field
HOLLYWOOD

LOCATION: 7700 Beverly Boulevard, near the Farmer's Market, about three miles from Hollywood and Vine as the crow flies. The first-base foul line ran parallel to Fairfax Avenue, right field to center field parallel to Third Street, center field to left field faced Gardner Street, while the third-base foul line paralleled Beverly Boulevard.

HOME OF: The Hollywood Stars in the Pacific Coast League from May 2, 1939, to September 5, 1957.

*B*efore air travel became common, in the late forties, the most Western big league outpost was St. Louis. Given travel limitations, there was no practical way for West Coast cities to have teams in the big leagues. For coast fans, the best baseball available—and it was almost as good as in the majors—was played in the AAA-rated Pacific Coast League (PCL), one of three top-ranked minor leagues in the country (the other two were the International League along the Eastern Seaboard and the American Association in the Midwest).

The Hollywood Stars, of the PCL, were not only

Ceremonies on May 1, 1939, dedicating brand-new Gilmore Field.

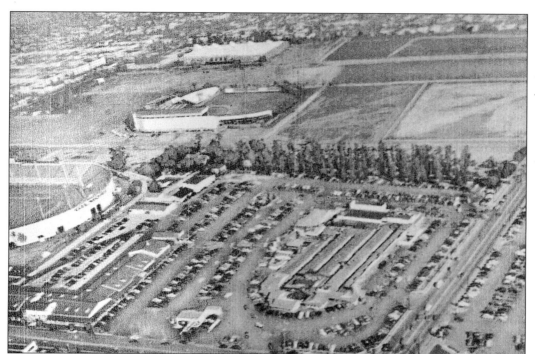

The famous Hollywood Farmers Market in the foreground, in the early forties, with part of Gilmore Stadium on the left, Gilmore Field above, and the Pan-Pacific Auditorium in the background.

good, they were also one of the great fun teams of all time. No ballpark provided a more festive environment than Gilmore Field during its short, happy life.

The Hollywood Stars were born in 1915, disguised as the Salt Lake City Bees of the Pacific Coast League. The team was then owned by Bill Lane, who had made a small fortune prospecting for gold in the Yukon Territory at the turn of the century. In 1926, disappointed with attendance at Salt Lake City, Lane moved the franchise from Utah to Hollywood. Without a ballpark of its own, the team played at Wrigley Field, home of the already popular Los Angeles Angels. Wrigley Field wasn't even close to Hollywood—it was in south-central Los Angeles, about eight or nine miles from Hollywood and Vine.

In competition with the established Angels, and without a real home stadium, Bill Lane's Hollywood Stars lost money, so that in January 1936 he transferred the franchise again, this time to San Diego. As the San Diego Padres, they finally prospered for three decades, until the major leagues annexed the territory in 1969.

The 1936 transfer of the franchise to San Diego left Hollywood without a team in the PCL, which opened the way for the second coming of the Stars. San Francisco had two PCL teams, the Seals and the Missions, and Bay City fans clearly favored the Seals. In 1938, therefore, the Mission club moved to Los Angeles and became the reincarnated Hollywood Stars, with the understanding that they would play at Wrigley Field for only one year while they built their own ballpark. The club was sold to a Hollywood group headed by Robert H. Cobb, who also owned the famous Brown Derby restaurants in Hollywood and Beverly Hills.

By 1939, the new home park was ready, on Beverly Boulevard near the intersection of Beverly and Fairfax. For the first time the Hollywood Stars had their own home and it was even in Hollywood. It was named Gilmore Field, after Earl Gilmore, an oil tycoon who owned the site and whose construction company built the ballpark. A couple of hundred yards to the west was Gilmore Stadium, an oval arena built several years earlier and used for football games and midget auto racing.

Gilmore Field consisted of a single-decked "fireproof" wooden grandstand that curved around home plate and stretched from foul pole to foul pole. The

main part of the grandstand was roofed—that is, the section around home plate and two thirds of the way down both foul lines. The main part of the grandstand also rose higher than the narrower open bleachers that stretched the rest of the way down the foul lines: the grandstand had about 30 graduated tiers of seats from field level to the top, the narrower bleachers only about 15 tiers. There were no seats in fair outfield territory, which was surrounded by a 12-foot-high fence and a background of trees.

Although it was 1939 and many big league parks had yet to install lights for night baseball, Gilmore Field had a state-of-the-art lighting system. Seating capacity was 11,000—of which 9,500 was grandstand and 1,500 bleachers.

The park's dimensions were a symmetrical 335 feet from home plate down both foul lines and 407 feet in dead center. The left-center and right-center power alleys were both about 385 feet from home

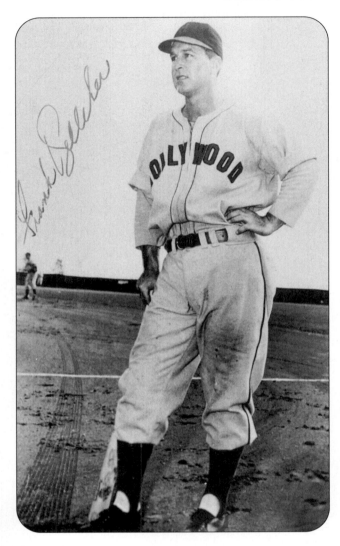

RIGHT: *Outfielder Frank Kelleher. The most popular of all the Stars, Kelleher hit 40 home runs and batted in 135 runs for Hollywood in 1950.*

BELOW: *Bob Cobb, patron saint and guiding light of the Stars, at his Brown Derby restaurant in Hollywood.*

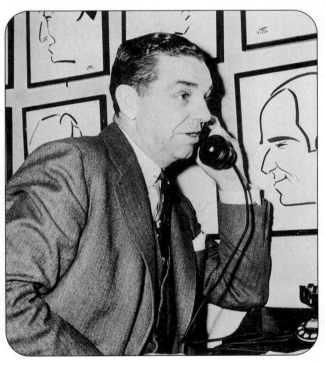

plate to the outfield fences. All respectable distances, so on the surface a park perhaps favoring pitchers.

However, the playing field was extraordinarily close to the spectators—only 34 feet from home plate to the backstop as compared with the typical 60 feet in the average major league ballpark. This gave Gilmore an intimate feeling, imparting some substance to the slogan "Friendly Gilmore Field," as it was usually referred to in radio commercials and newspaper advertisements. From first and third base to the nearby grandstand was only 24 feet, close enough for fans to count the beads of perspiration on the infielders' foreheads.

The grandstand was close enough to encourage foul pop-ups to drop into the stands and escape fielders' eager gloves, thereby making a hitter's park

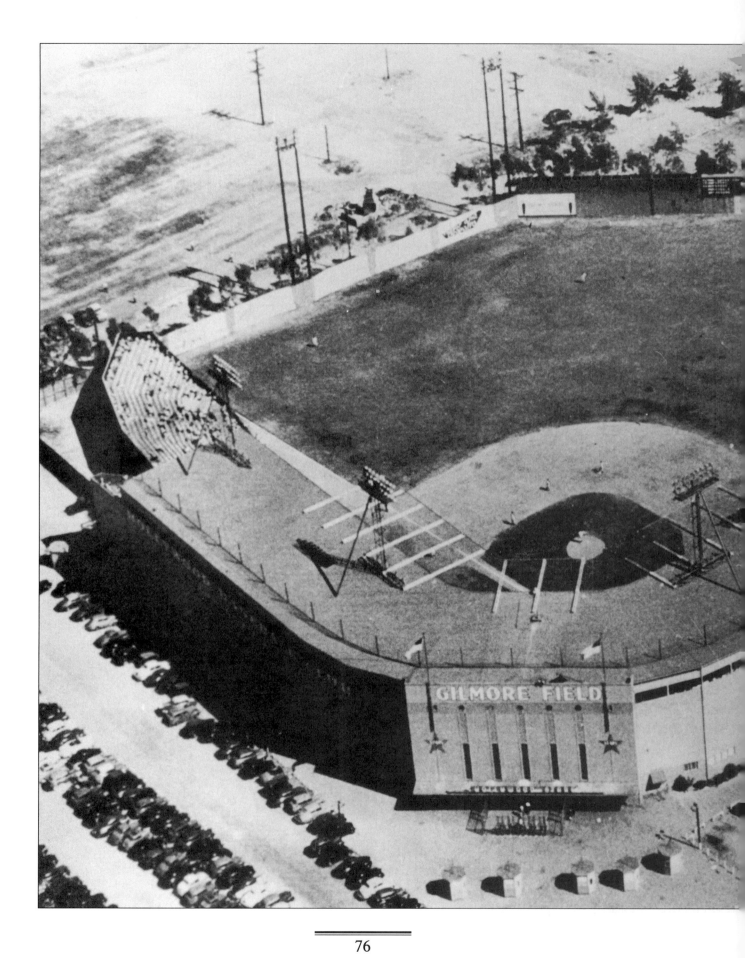

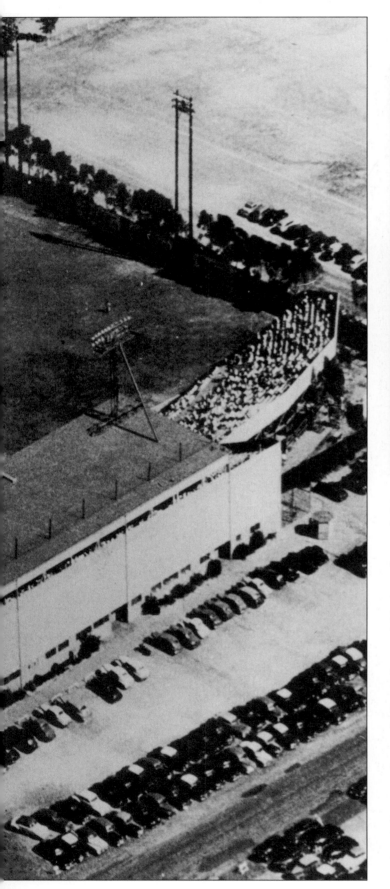

Bobby Bragan managed the Stars in 1953, '54, and '55, winning the Pacific Coast League pennant in 1953.

LEFT: *A closer aerial view of Gilmore Field, mid-forties.*

out of what appeared at first glance to be a pitcher's park. Batters got second and third chances after what elsewhere would have been foul pop-fly outs.

Gilmore Field was inaugurated on May 2, 1939, as a standing-room-only crowd saw the Stars lose to the Seattle Rainiers, 8–5. Owner Bob Cobb had sold shares of the club to many Hollywood stars (with a small *s*), a number of whom showed up to make the inauguration of Gilmore Field more like a movie premiere than a ballpark opening. Among the owners were Gracie Allen, Gene Autry, George Burns, Gary Cooper, Bing Crosby, William Frawley, Cecil B. De Mille, Gail Patrick (Mrs. Cobb), William Powell, George Raft, Barbara Stanwyck, and Robert Taylor.

Movie stars attended games frequently, attracting

ordinary people who hoped to catch a glimpse of film royalty. People went there both to see and be seen. A special room under the stands, where refreshments were served, made it convenient for actors and actresses to socialize with each other before and after games, or even during them should they want to. From 1939 to 1957, Gilmore Field was one of the "in" places to go in Hollywood. Probably more beautiful women watched baseball games at Gilmore than anywhere else—either major or minor league.

On the field, the team had difficulties through the war years but were consistent winners starting in the late forties. The Stars won PCL pennants in 1949 and 1952 under manager Fred Haney and in 1953 under Bobby Bragan. Babe Herman, in the twilight of his career, played for the Stars from 1939 to 1944. Other fan favorites were Carlos Bernier, Johnny Lindell, Dale Long, Bill Mazeroski, Irv Noren, Gus Zernial, and above all—probably the most popular Hollywood player ever—homer-hitting outfielder Frankie Kelleher. Frankie never made it in the majors, mainly because he was the property of the Yankees for many years and couldn't dislodge DiMaggio, Keller, or Henrich, but Hollywood fans loved him.

In 1950, sixteen years before the Chicago White Sox tried the same thing, the Stars appeared on the field with their uniform pants changed from knickers to shorts plus knee-length hose. In a short while, though, the idea went the same way as the White Sox experiment.

When the Brooklyn Dodgers decided to move to Los Angeles, the days of the Hollywood Stars had to come to an end. Few want to watch minor league baseball when they can see big leaguers. The last game at Gilmore Field was a victory over the San Francisco Seals, 6–0, on September 5, 1957. A good-natured crowd of 6,354 was present, only 348 less than would be at Ebbets Field's last game a couple of weeks later.

Before the game, Jayne Mansfield, Miss Hollywood Stars of 1955, presented president Bob Cobb with a new car, and the fans chimed in with a noisy standing ovation. "These years with the Stars have been the best years of my life," Cobb said, trying to hold back the tears.

Cobb sold the franchise late in 1957 to a group representing Salt Lake City, which is where the team had come from thirty-one years earlier.

Gilmore Field was razed in 1958. Much of the site is now occupied by a parking lot that belongs to CBS's Television City. If you look long enough, you might locate some of the trees that used to be behind the outfield fence, a number of which are said to still stand, now watching Jaguars and Porsches instead of line drives and lazy fly balls.

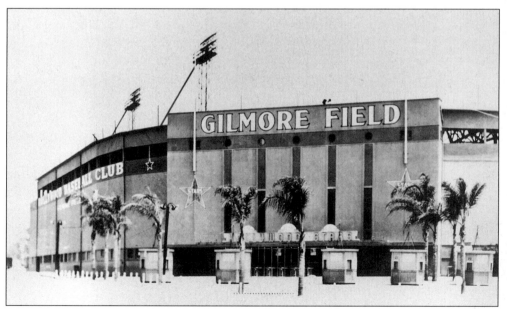

OPPOSITE: *Actress Jayne Mansfield was a hit as Miss Hollywood Stars of 1955.*

LEFT: *Gilmore Field's main entrance.*

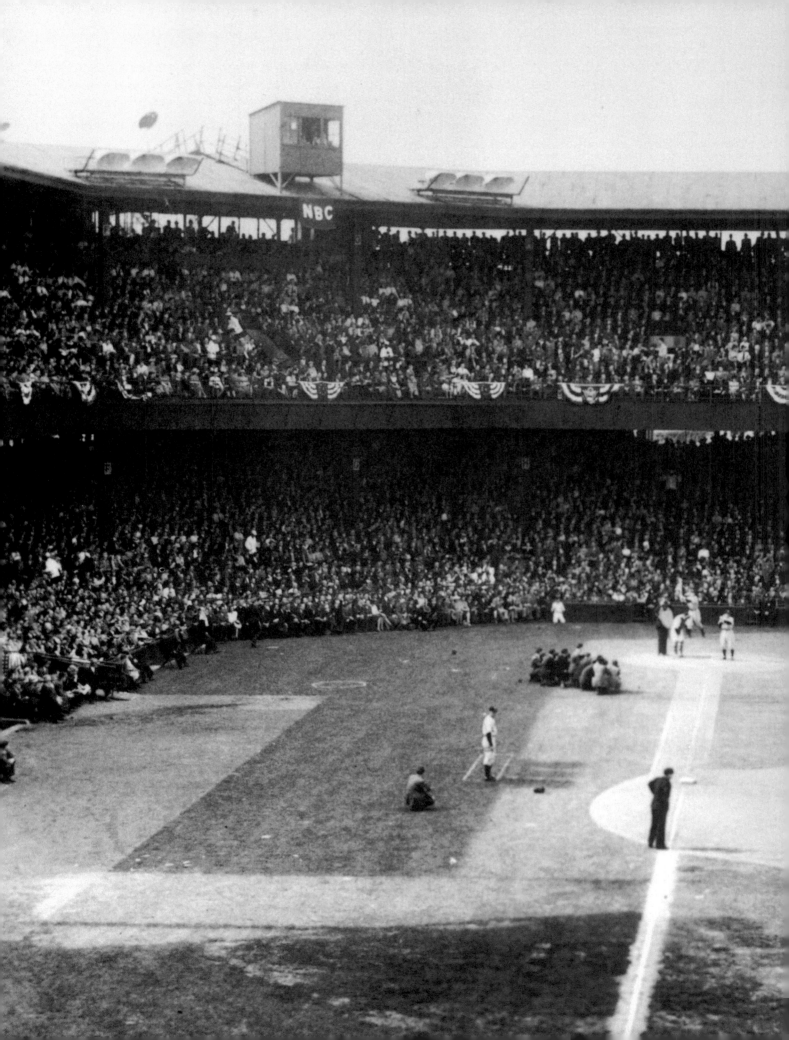

Griffith Stadium

WASHINGTON, D.C.

LOCATION: In Northwest Washington, about two miles north of the White House, on the site bounded by Georgia Avenue, U Street, Fifth Street, and W Street NW. The first-base foul line ran parallel to Georgia Avenue, right field to center field parallel to U Street, center field to left field parallel to Fifth Street, while the third-base foul line paralleled W Street.

HOME OF: The Washington Senators from 1892 through 1899 and from April 22, 1903, to September 21, 1961.

*T*he Washington Senators were charter members of the American League in 1901. Formerly, the Senators had played in the National League from 1886 through 1889 and from 1892 through 1899.

From April 16, 1892, to October 14, 1899, the *National* League Washington Senators played their home games at 6,500-seat National Park, near the intersection of Florida Avenue and Seventh Street NW, the eventual site of Griffith Stadium. But the league eliminated four cities in 1900, Washington

Opening Day at Griffith Stadium in 1942. Notice how close the photographers are to the batter's box.

among them, leaving the nation's capital out in the cold with respect to big league baseball.

This was rectified in 1901, when the newly organized American League took in Washington as a founding member. In 1901 and 1902, the fledgling *American* League Washington Senators used a park at 14th Street and Bladensburg Road NE for their home games. However, in 1903 they moved back to National Park, enlarged it to seat 10,000, renamed it American League Park, and inaugurated it for a second time on April 22, 1903, with a 3–1 victory over the New York Highlanders (later known as the Yankees).

When the Senators were in spring training in 1911, American League Park—or just League Park, as it was often called, or National Park, the most common name of all—burned to the ground. Remarkably, in three weeks enough of it was rebuilt, this time with steel and concrete, to start the season on time: on April 12, 1911, the Senators played Opening Day as scheduled and even emerged with an 8–5 victory over the Boston Red Sox.

The rebuilt League (or National) Park became Griffith Stadium in 1920, renamed in honor of Clark Griffith, who had been field manager of the Senators and a minority stockholder before becoming owner and president (as well as manager) in 1920. Earlier, Griffith had been a pitcher in the major leagues, good enough to win 240 games against only 141 losses. Griffith stopped managing the Senators after 1920 but remained their president and guiding light until his death in 1955.

Griffith Stadium was always a difficult park in which to hit home runs. The original (1911) dimensions were 407 feet from home plate down the left-field line, 421 feet to center field, and 320 feet down the right-field line. (The marker next to the right-field foul line always said 328 FEET, but later measurement showed the actual distance to be 320 feet.) A 30-foot-high concrete wall dominated right field, and balls hitting it were in play—the left-field wall in Fenway Park, the famous Green Monster, is 5 feet closer and 7 feet higher.

Changes were minor through most of the life of the ballpark: in the early fifties it was 405 feet to

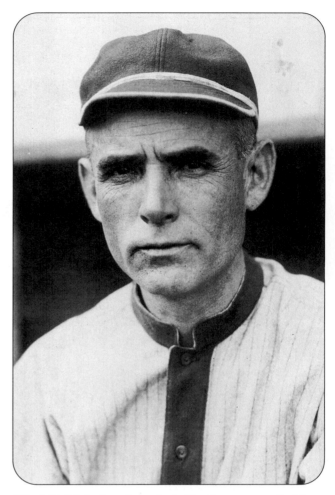

Clark Griffith, for whom the ballpark was named. After many years as a successful pitcher, he managed the Senators from 1912 to 1920 and was their principal owner from 1920 until his death in 1955.

left, 421 to center, and 320 to right. The listed height of the right-field wall, which had always been 30 feet, was changed to 31 feet in the early fifties; most likely, the wall didn't grow by a foot but had actually been 31 feet high all along. Seating capacity was only about 29,000.

The building of Griffith Stadium proceeded gradually after the 1911 fire. At first, the park had a double-decked roofed grandstand that swept around home plate down to slightly past the infield, followed on each side by single-decked covered stands that continued to the foul poles. There was no seating behind the right fielder, just the wall, but a long expanse of open bleachers

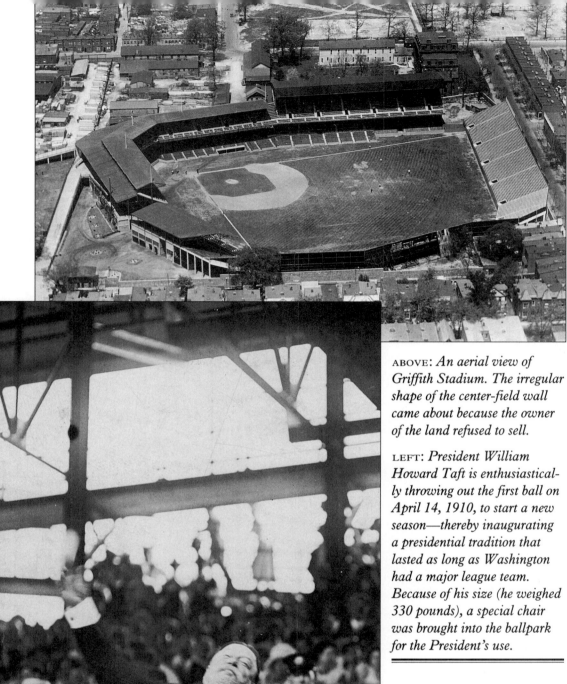

ABOVE: *An aerial view of Griffith Stadium. The irregular shape of the center-field wall came about because the owner of the land refused to sell.*

LEFT: *President William Howard Taft is enthusiastically throwing out the first ball on April 14, 1910, to start a new season—thereby inaugurating a presidential tradition that lasted as long as Washington had a major league team. Because of his size (he weighed 330 pounds), a special chair was brought into the ballpark for the President's use.*

stretched from left-field foul territory all the way over to mid–center field behind a concrete barrier 4 or 5 feet high.

In 1920, the park was completed when the single-decked stands from the infield to the foul poles were double-decked. On both sides, first and third base, the new second-deck roof was a good 15 feet higher than the roof over the home-plate grandstand. This looked strange but was unavoidable, since the infield-to-foul-pole stands had been

ABOVE: *Josh Gibson, famed catcher for the Homestead Grays who was known as the Babe Ruth of the Negro Leagues.*

RIGHT: *Walter Johnson, winner of 416 games, tops in the twentieth century, and all of them for the Washington Senators.*

Action at Griffith Stadium.

graded more steeply than the home-plate stands when both were originally constructed.

One ceremony that was unique to the city of Washington was the throwing out of the first ball on Opening Day by the President of the United States. President William Howard Taft started the tradition on April 14, 1910, at National Park. A former Cincinnati sandlot catcher, the 330-pound Republican twenty-seventh President of the United States saw Walter Johnson pitch a one-hitter that afternoon and defeat the A's, 3–0.

Johnson was also the player who caught the President's ceremonial first pitch. The following day Walter had a messenger bring the ball to the White House with a request for a presidential signature. President Taft obliged with the following inscription:

> To Walter Johnson, with the hope that he may continue to be as formidable as in yesterday's game.
>
> William H. Taft.

Thereafter, the Presidential Box was always located next to the first-base dugout on the side of the dugout near home plate. The last President to throw out a ceremonial Opening Day first ball at Griffith Stadium was President John F. Kennedy on April 10, 1961.

Walter Johnson was the greatest player ever to don a Washington uniform. He pitched for no other major league team over his remarkable twenty-one-year career (1907–27), during which he won 416 games, the most by any pitcher in the twentieth century. (The legendary Cy Young won over 500 games, but he won most of them before 1900.) Johnson is also the all-time leader in shutouts, with 110. For many years he was the all-time strikeout king as well, but Nolan Ryan has made that title his own, probably forever. However, Johnson's 3,508 lifetime strikeouts did last as a record for fifty-five years.

Johnson pitched his first big league game on August 2, 1907, against the visiting Detroit Tigers. Sam Crawford was Detroit's center fielder that day and years later he recalled the occasion: "Big Joe Cantillon was managing Washington at the time. He was a nice guy, Joe was, always kidding. Before the game, Joe came over to our bench and said, 'Well, boys, I've got a great big apple-knocker I'm going to pitch against you guys today. Better watch out, he's plenty fast. He's got a swift.'

"He told us that, you know. And here comes Walter, just a string of a kid, nineteen years old, tall, lanky. Didn't even have a curve. Just that fastball. Did you ever see those pitching machines they have? That's what Walter always reminded me of,

one of those compressed-air pitching machines. They gear them up so that the ball comes in there just like a bullet. It comes in so fast that when it goes by it *swooshes*. You hardly see the ball at all. But you *hear* it. *Swoosh*, and it smacks into the catcher's mitt. Well, that was the kind of ball Walter Johnson pitched. He had such an easy motion it looked like he was just playing catch. That's what threw you off. He threw so nice and easy—and then *swoosh*, and it was by you."

Only three World Series were played at Griffith Stadium—1924, 1925, and 1933. The Senators won the 1924 Series, against the Giants, lost to Pittsburgh in 1925, and then lost to the Giants in 1933. The 1924 Washington–New York World Series is still considered one of the all-time greats, on a par with Cincinnati-Boston in 1975, the Mets and the Red Sox in 1986, and perhaps a handful of other never-to-be-forgotten fall classics.

In the bottom of the eighth inning of the seventh game, Washington player/manager Bucky Harris grounded to third, but the ball hit a pebble and bounced over Giants third baseman Freddie Lindstrom's head to allow two runs to cross the plate and tie the score. Walter Johnson, who had never won a World Series game, came into the game in relief in the ninth inning. In the bottom of the twelfth it happened again: first, Hank Gowdy, the Giants catcher, tripped over his own mask trying to catch an easy foul pop-up, and then another grounder hit a pebble and bounced over Giants third baseman Lindstrom's head, this time allowing the winning run to score.

"That mask up and *bit* Gowdy," Clark Griffith said. "He was going to catch that pop foul and it *grabbed* him away from it. Had to be that God was on our side that day, else how did those pebbles get in front of Lindstrom not once but *twice*?"

In addition to the Washington Senators, Griffith Stadium was also home to the Homestead Grays in the Negro National League in the thirties and forties. Actually, the Grays had two home parks: Forbes Field in Pittsburgh and Griffith Stadium. They would play in Forbes Field as the Pittsburgh Homestead Grays when the Pirates were on the road and in Griffith Stadium as the Washington Homestead Grays when the Senators were away.

Catcher Josh Gibson—known in those days as "the black Babe Ruth"—was the Grays' star attraction during the thirties and early forties. Clark Griffith is reported to have said that Gibson hit more home runs in a year into Griffith Stadium's distant left-field seats than did the whole American League. Indeed, Griffith often talked about signing black players for the Senators, but he never did anything about it. By the time Branch Rickey did do something about it, signing Jackie Robinson, Gibson was dead. He died of a stroke in 1947 at the age of thirty-five, only eighty-five days before Robinson walked onto a major league baseball diamond wearing a Brooklyn Dodgers uniform.

Boxing and football were other frequent Griffith Stadium attractions. It was there in 1941 that Buddy Baer knocked heavyweight champion Joe Louis out of the ring in the first round of their title bout before Louis knocked out Baer in the sixth round. The National Football League's Washington Redskins played their home games at Griffith Stadium for many years. On the day the Japanese bombed Pearl Harbor—Sunday, December 7, 1941, a few minutes before 1 P.M., Eastern Standard Time—announcements were piped over the public address system at a Redskins game urging generals and admirals to report for duty on the double.

After Clark Griffith died and his nephew and adopted son, Calvin, took over the presidency of the Senators in 1956, a 6-foot-high screen was placed well in front of the left-field stands, shortening the distance for right-handed Washington power-hitters Harmon Killebrew, Jim Lemon, and Roy Sievers. Thus, for a few years in the late fifties, outfield distances were 350 feet to left, 408 to center, and 320 to right, dimensions that are not repre-

OPPOSITE: *It is July 5, 1924, and Babe Ruth, recklessly chasing a fly ball that drifted into foul territory, has knocked himself out by running smack into the concrete abutment in front of Griffith Stadium's right-field stands. Trainer Doc Woods (wearing a Yankees cap) is trying to revive him.*

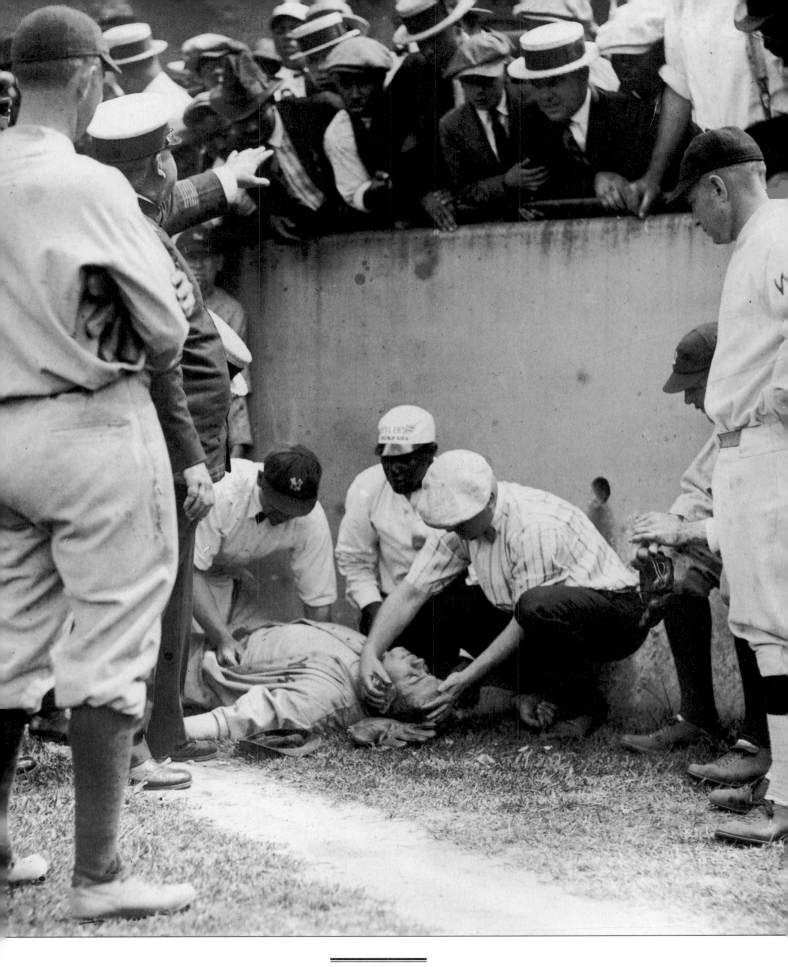

sentative of Griffith Stadium during most of its lifetime. The screen never helped much, anyway: without the screen the Senators ended last in 1955; with the screen they also ended last in three of the next four years.

Although Clark Griffith had been committed to Washington, son Calvin wasn't, so after the 1960 season the original Washington Senators packed their bags and moved to Minnesota, where they became the Minnesota Twins. The last game for the original Senators at Griffith Stadium was played on October 2, 1960, as the Baltimore Orioles beat them, 2–1.

The ballpark was granted a one-year reprieve,

however, when the American League placed an expansion team in Washington in 1961. The expansion Senators played one season in Griffith Stadium and closed down the fifty-year-old ballpark on September 21, 1961, as less than 1,500 spectators watched the Minnesota Twins (the *old* Senators) beat the *new* Senators, 6–3. The following year the new Senators moved to brand-new D.C. Stadium— and a few years later to Texas as the Texas Rangers.

After three years in limbo, Griffith Stadium was demolished in 1965. There is no indication of any sort—not even a marker—that it ever existed. Howard University Hospital now occupies the site.

LEFT: *Griffith Stadium's right-field wall—31 feet high and 320 feet from home plate down the foul line.*

BELOW: *It is September 7, 1954, and the A's are playing the Senators at Griffith Stadium before an officially reported total of only 460 spectators.*

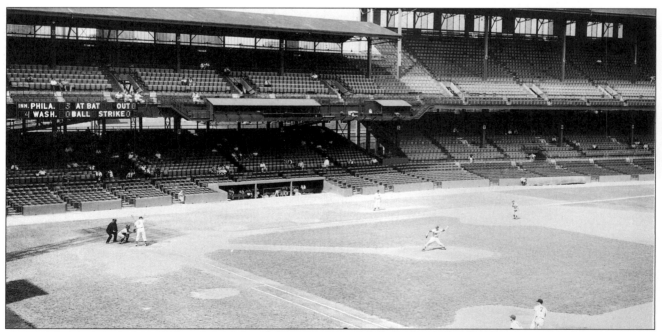

Griffith Stadium's
Ten Most Memorable Moments

1. April 15, 1910: Walter Johnson, pitching his first Opening Day game for Washington, allows but one hit as he defeats Philadelphia, 3–0.

2. September 29, 1913: Walter Johnson of the Senators beats the Philadelphia Athletics, 1–0, for his thirty-sixth win of the season (against seven losses) and his eleventh shutout.

3. October 10, 1924, seventh and deciding game of the World Series: In the bottom of the twelfth inning, a potential double-play ground ball hits a pebble and bounces over Giants third baseman Freddie Lindstrom's head, giving the Washington Senators the game, 4–3, and their first (and only) world championship.

4. October 10, 1925, third game of the World Series: Washington outfielder Sam Rice tumbles into the stands making a circus catch of a ball hit by Pittsburgh catcher Earl Smith; the call of "out" by umpire Cy Rigler is hotly disputed—but fifty years later, after Rice's death, a letter found among his effects attests that he did indeed catch the ball.

5. April 13, 1926: Walter Johnson, pitching his fourteenth (and last) Opening Day game for Washington, defeats Eddie Rommel and the Athletics in 15 innings, 1–0, with both pitchers going the distance.

6. October 7, 1933, fifth and deciding game of the World Series: New York Giants outfielder Mel Ott homers in the tenth inning to beat the Senators, 4–3, and make the Giants world champions for the fourth time.

7. July 7, 1937: In the All-Star Game, Yankee first baseman Lou Gehrig doubles, homers, and drives in four runs in an 8–3 American League triumph over the National League.

8. July 7, 1937: In the same All-Star Game, a line drive from the bat of Earl Averill hits pitcher Dizzy Dean on the foot, breaking his toe; as the season progresses, Dean tries to pitch before the toe is fully healed and thereby injures his arm, impairing his effectiveness and ultimately ending his career prematurely.

9. July 15, 1952: Detroit first baseman Walt Dropo gets seven straight hits in seven times at bat in a doubleheader against Washington; the day before, he hit safely five times in a row, giving him a record 12 consecutive base hits.

10. April 17, 1953: Yankee outfielder Mickey Mantle, batting right-handed, hits a home run off Washington left-hander Chuck Stobbs that goes clear over the left-field wall and lands a guesstimated 565 feet from home plate.

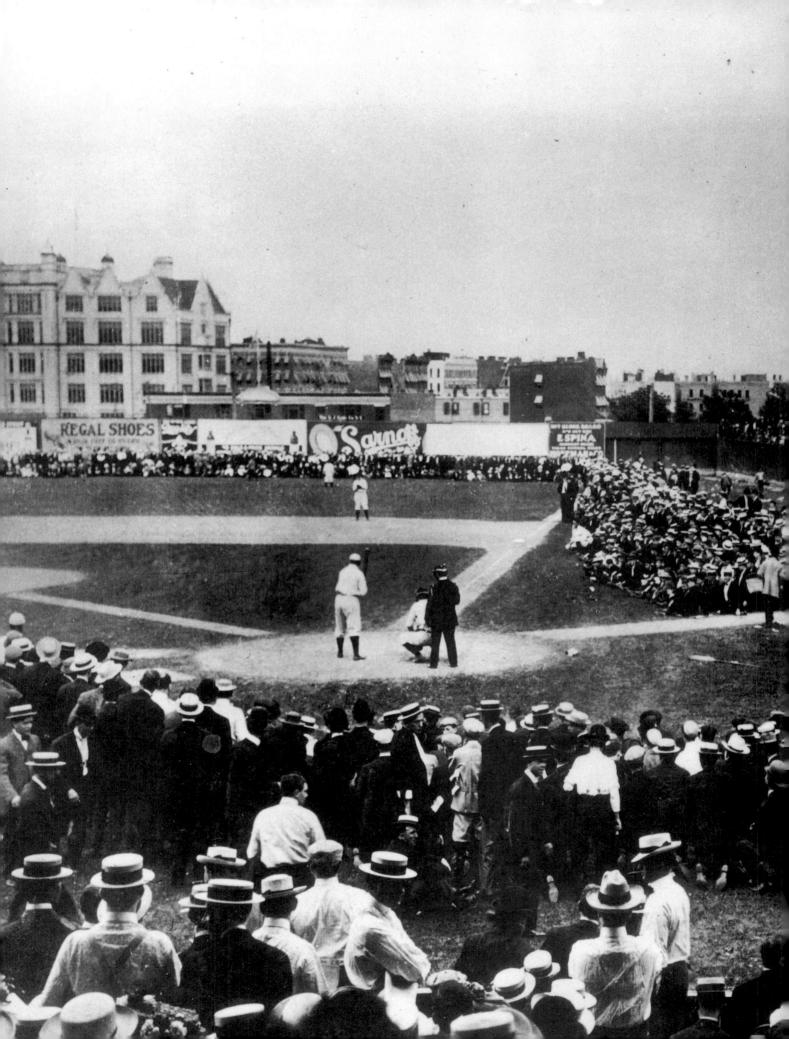

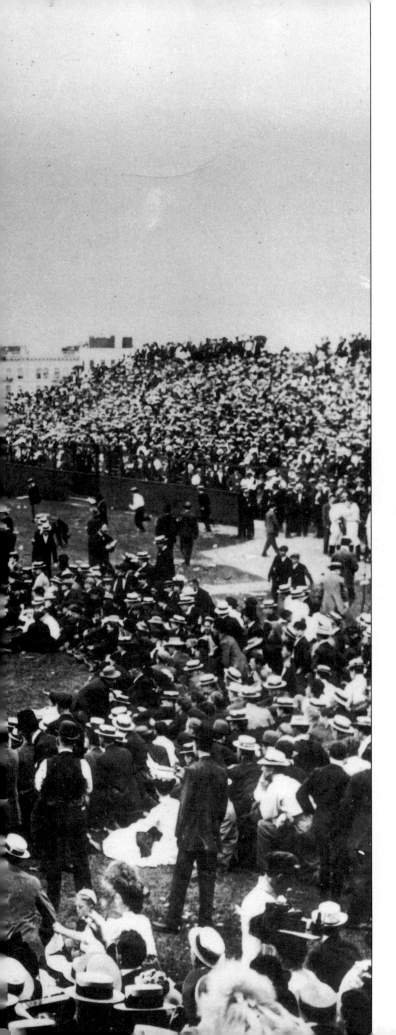

Hilltop Park

NEW YORK

LOCATION: In the Washington Heights section of Manhattan, on the west side of Broadway between West 165th and West 168th streets. The first-base foul line ran parallel to 165th Street, right field to center field parallel to Broadway, center field to left field parallel to (and backed up against) 168th Street, while the third-base foul line paralleled Fort Washington Avenue.

HOME OF: The New York Highlanders (later the Yankees) from April 30, 1903, to October 5, 1912.

New York made its entrance into the still-new American League in 1903, when Frank Farrell and Bill Devery acquired the Baltimore American League franchise for $18,000 and moved the team to New York. Farrell was an ex-bartender and saloon-keeper turned racing stable owner and gambling house proprietor, and Devery a former New York City police official turned real estate wheeler-dealer. Both men had extensive political connections, which were crucial in getting a foothold in New York, since the rival team, the Giants, was politically influential and not eager to welcome a competitor.

The Highlanders in action against the Philadelphia Athletics at Hilltop Park on July 4, 1907.

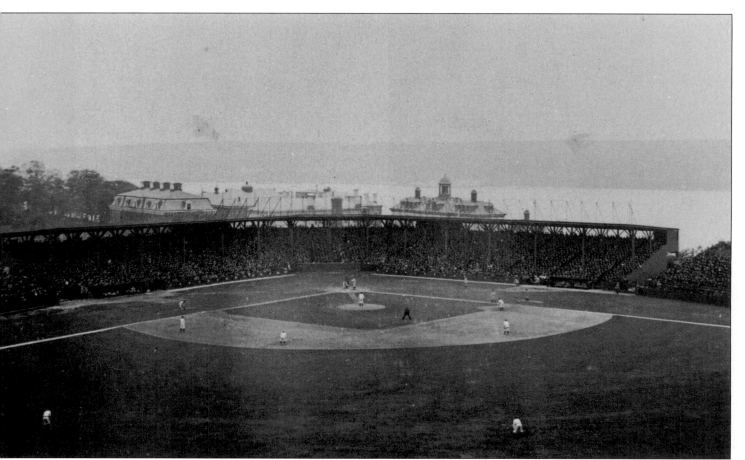

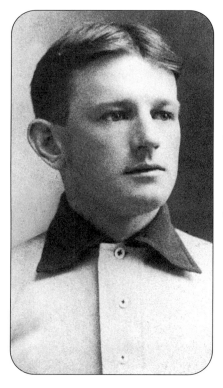

ABOVE: *Hilltop Park, with the Hudson River in the background.*

LEFT: *High-landers pitcher Jack Chesbro, whose 41 wins in 1904 are still a twentieth-century record.*

Known at first as the Highlanders, then as the Yankees, the team played its home games at newly constructed Hilltop Park in the Washington Heights section of Manhattan. Hilltop Park—also called American League Park or simply League Park or Highlander Park—was built in only six weeks once the transfer of the Baltimore franchise to New York became official.

Hilltop had a roofed single-decked wooden grand-stand that curved around home plate and extended a few feet past first base and third base. Open single-decked bleachers then took over at both ends of the covered grandstand and continued down the foul lines to the outfield fences. In 1911, a roof was also put over the stands down the left-field foul line. There were no permanent seats between the foul poles in fair outfield territory until 1912, when cen-ter-field bleachers were erected for the ballpark's final year. A fence about 15 to 20 feet high and cov-ered with advertising signs surrounded the outfield.

Because Hilltop Park was used only in the dead-ball era, its outfield distances were appropriately humongous: 365 feet from home plate down the left-field line, 542 feet to center, and 400 feet down the right-field line. Although no records exist to prove it one way or another, it is doubtful that anyone ever muscled a fair ball over one of its outfield fences.

The seating capacity of the ballpark was said to be 16,000. Since it was on the highest ground in Manhattan, seats in the top row of the stands behind home plate and along the third-base line offered a great scenic view of the Hudson River and the New Jersey Palisades (provided spectators turned their backs on the ball game).

Actually, the listed seating capacity didn't mean too much because standing was permitted on the field and fans were allowed to bring their own seats and sit in the outfield or even between the foul lines and the stands. Attendance occasionally exceeded

One of the entrances to Hilltop Park. The stands visible are located along the right-field foul line and the street is Broadway in the first decade of the twentieth century.

20,000 and on at least one occasion approached 30,000.

Over 16,000 spectators saw the ballpark dedicated on April 30, 1903, as the Highlanders celebrated the occasion by beating the Washington Senators, 6–2. Just to prove that George M. Cohan knew precisely what he was doing when he sang "You're a Grand Old Flag" and "Yankee Doodle Dandy" on every conceivable occasion, each spectator passing through the turnstiles that day was given a small American flag. Before the game, with every player waving a miniature American flag, and the crowd doing the same, the two teams marched across the field led by the 69th Regiment Band playing a medley of patriotic tunes including "Yankee Doodle" and "The Star-Spangled Banner" (not yet the official National Anthem).

The Highlanders' first manager was Clark Griffith, later to become patriarch of the Washington Senators; he both managed and pitched for the Highlanders from 1903 through 1908. Their first *star* pitcher, though, was Happy Jack Chesbro, whose 41 victories in 1904 are still a twentieth-century record. He got win number 41 on October 7

of that year, but only three days later experienced one of those calamities that only people like Fred Snodgrass, Ralph Branca, and Bill Buckner can fully appreciate.

The Red Sox and Highlanders were scheduled to play a doubleheader at Hilltop Park on October 10, 1904. It was the last day of the season, and the American League pennant was on the line: the Highlanders had to win both games of the doubleheader to take the pennant, while the Red Sox could do it with just one victory. Close to 30,000 fans squeezed into the little ballpark for what would be the largest crowd in Hilltop's ten-year history.

In the top half of the ninth inning of the first game of the twin bill, with the score tied, 2–2, Boston got a man on third base with two outs. Chesbro got ahead of the batter, no balls and two strikes, but completely lost control of the next pitch, a spitball (then a legal pitch), and it sailed over the catcher's head, bringing in the go-ahead run. The Highlanders failed to score in the bottom of the ninth, so that was that.

Most of the crowd, sorely disappointed, left after the first game. The Highlanders won the nightcap, 1–0, but it was too late. Chesbro's record was 41 wins against 12 losses that year; he completed 48 of

51 starts and led the league in innings pitched, wins, and winning percentage. Nevertheless, the year ended on a sour note because after all is said and done it was Happy Jack's wild pitch that lost the 1904 pennant.

Walter Johnson started pitching for the Washington Senators in 1907. A year later, in 1908, he came to national prominence by shutting out the Highlanders—by now generally called the Yankees—three times in four days, all at Hilltop Park. In the three games, Johnson gave up a combined total of

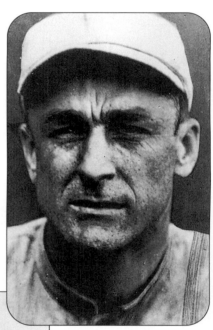

RIGHT: *Branch Rickey. He was a catcher for the Highlanders in 1907.*

BELOW: *The Chicago White Sox vs. the Highlanders at Hilltop Park in 1909.*

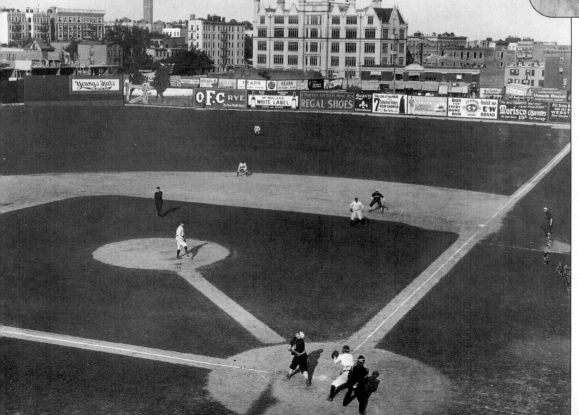

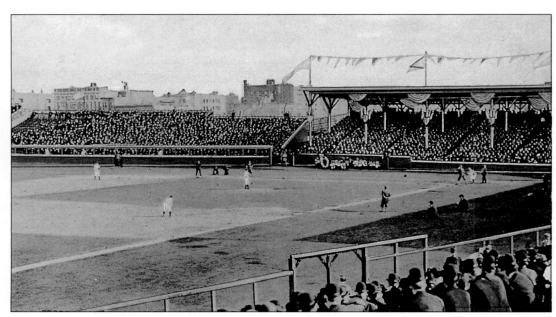

Hilltop Park.

only twelve hits, walked one, and struck out twelve.

On Friday, September 4, Johnson shut out the Highlanders with six hits as the Senators won, 3–0. On Saturday, the score was 6–0 and the Highlanders got only four hits. There was no game the next day because Sunday baseball was then illegal in New York. On Monday, however, Johnson took the mound again—almost on a dare—and this time allowed the New Yorkers just two hits, winning by a score of 4–0.

The animosity that marked the Highlanders' invasion of the Giants' turf in 1903 evaporated with time, so that the two teams engaged in a postseason City Series in 1910, the first such postseason Yankees–Giants exhibition series in New York baseball history. In New York, the 1910 City Series attracted at least as much attention as the World Series being played at the same time between the Philadelphia Athletics and the Chicago Cubs. The games alternated between the Polo Grounds and Hilltop Park, with the Giants winning the city championship, four games to two. (They had another City Series in 1914, and the Giants won that one, too.)

On April 14, 1911, just after the season began, the Polo Grounds was severely damaged by fire, leaving the Giants temporarily homeless. The Yankees offered to share Hilltop Park while the Polo Grounds was being rebuilt, so that from April 15 until the Polo Grounds reopened on June 28 the Giants and Yankees both played their home games at Hilltop. A couple of years later, when the Yankees' lease on Hilltop Park expired, the Giants repaid the hospitality by inviting the Yankees to share the Polo Grounds, an arrangement that lasted until April 18, 1923, when Yankee Stadium opened its gates for the first time.

The Yankees and Giants also cooperated on April 21, 1912, in a benefit game for the survivors of the *Titanic*, the ocean liner that on its maiden voyage hit an iceberg and sank in the North Atlantic with the loss of over 1,500 lives. The *Titanic*, the fastest ship afloat at the time, was thought to be unsinkable and was carrying many notables among her more than 2,200 passengers. For whatever it is worth, the Giants won the benefit exhibition game, 11–2.

Less than a month later, on May 15, as he was returning from center field to his team's dugout on the third-base side of the infield to start the fourth inning, Ty Cobb of the visiting Detroit Tigers vaulted over the railing into the third-base stands at Hilltop Park and attacked a heckling fan, giving him a severe beating.

The spectator's name was Claude Lueker and it turned out that he had no hands: he formerly worked in the press room of a local newspaper and

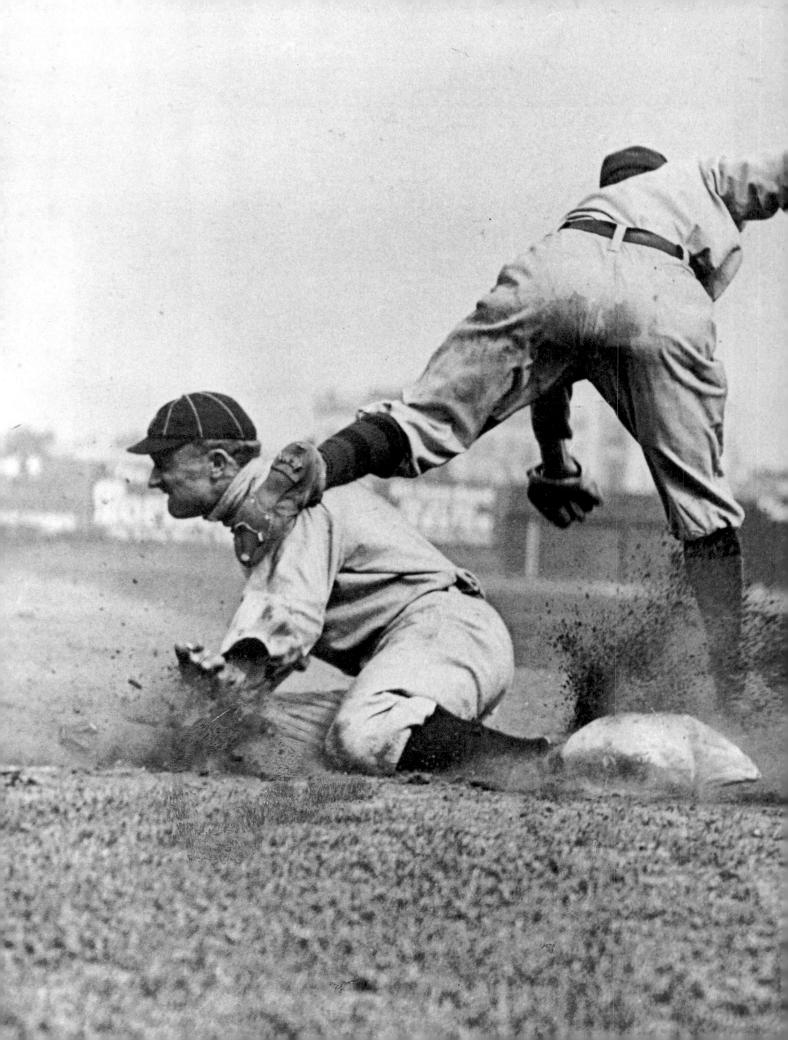

One of the most famous baseball pictures ever snapped: in 1909, photographer Charles Conlon caught Ty Cobb of the Detroit Tigers sliding into third baseman Jimmy Austin at Hilltop Park.

had lost one hand and most of the other in a printing press accident a year earlier. Whether Cobb was aware of the fact that he was hitting a handicapped person is not clear.

The following is a typical newspaper account of the incident:

> Tyrus was followed [into the stands] by the entire Detroit squad, but no one interfered until Cobb had handed the fan a good thrashing. Some of [Yankee] President Farrell's private graycoats finally broke up the scrap. The beaten fan requested the park police to arrest Cobb, but they refused and he was led out of the stands.
>
> When Cobb returned to the bench his face was distorted with anger. He was immediately put out of the game by Umpire O'Loughlin. After the incident Hugh Jennings, the Detroit manager, went over to the press stand and explained that the fan had called Ty Cobb "a half-nigger." Jennings said no Southerner would stand for such an insult. "I heard the remark," said Jennings, "but I knew it would be useless to restrain Ty, as he would have got his tormenter sooner or later. When Ty's Southern blood is aroused he is a bad man to handle."

The next day American League president Ban Johnson suspended Cobb indefinitely. In protest, the entire Detroit team went on strike, refusing to take the field for a scheduled game against the Athletics in Philadelphia. To avoid a forfeit and a fine, Detroit management recruited amateurs, who put on Detroit uniforms, only to be clobbered by the Athletics, 24–2.

The players' strike ended after one day when the league threatened permanent suspension for the strikers and Cobb asked his teammates to call it off. The league office fined each striking player $100; Cobb himself was suspended for ten days and fined $50. There is no record of further civil or criminal legal action.

The 1912 season was the last for the Yankees at Hilltop Park, which by now was woefully out of date. The last game played there was on October 5, when the Yankees defeated the Washington Senators, 8–6. For the next ten years, the Yankees called

Hilltop Park's
Ten Most Memorable Moments

1. April 30, 1903, Opening Day: In the first home game in New York American League history, a capacity crowd of 16,000 sees the Highlanders beat Washington, 6–2, behind the pitching of Jack Chesbro.

2. October 7, 1904: New York pitcher Jack Chesbro beats Boston 3–2, to win his forty-first game of the season, still a twentieth-century record.

3. October 10, 1904: The Red Sox clinch the American League pennant when Jack Chesbro unleashes a wild pitch in the ninth inning that allows the winning Boston run to score from third base.

4. September 1, 1906: The Highlanders beat Washington in a doubleheader, 5–4 and 5–3, their third doubleheader win over the Senators in three days.

5. June 28, 1907: Yankee catcher Branch Rickey allows 13 Washington stolen bases in a 16–5 Washington romp over New York.

6. June 30, 1908: Forty-one-year-old Cy Young pitches his third career no-hitter as Boston beats the Yankees, 8–0.

7. September 7, 1908: Washington's Walter Johnson pitches his third consecutive shutout against New York in four days.

8. August 30, 1910: New York's Tom Hughes pitches a no-hitter against Cleveland for nine innings—but then gives up a hit in the tenth and loses the game in the eleventh, 5–0.

9. September 20, 1911: The Yankees commit 12 errors in a doubleheader—7 in the first game and 5 in the second—but still manage to gain a split with Cleveland, losing the first game, 12–9, but winning the second, 5–4.

10. May 15, 1912: An angry Ty Cobb of the visiting Detroit Tigers jumps into the stands and assaults a heckling fan (for which he will be suspended).

the Polo Grounds home, along with the Giants.

In 1915, Farrell and Devery sold the club for $460,000 to Colonel Jacob Ruppert, a millionaire brewery owner, and Colonel Tillinghast L'Hommedieu Huston, a wealthy soldier-engineer. Colonel Ruppert had also served four consecutive terms, 1899 through 1906, as a Democratic congressman from New York City; he bought out Huston in 1923 and remained sole owner until his death in 1939.

As for Farrell and Devery, selling for $460,000 what they had acquired for $18,000 twelve years earlier netted them a neat return of 31 percent *per annum* on their investment.

Eventually, of course, the Yankees went on to become the most famous and most successful franchise in sports history, winner of twenty-two world championships between 1922 and 1982.

Hilltop Park, however, has been long forgotten. The ballpark was demolished in 1914 and since the 1920s Columbia-Presbyterian Medical Center has occupied the site where Hilltop Park once stood. There is no marker or memorial of any sort.

ABOVE: *The Washington Senators vs. the Highlanders on Memorial Day, 1910. This is the only known photo of Hilltop Park's left field and the stands down the left-field line. A packed house numbering 21,000 saw the Highlanders beat the Senators twice that day; notice the crowd along the foul line and around the outfield.*

RIGHT: *Ty Cobb batting at Hilltop Park in 1912.*

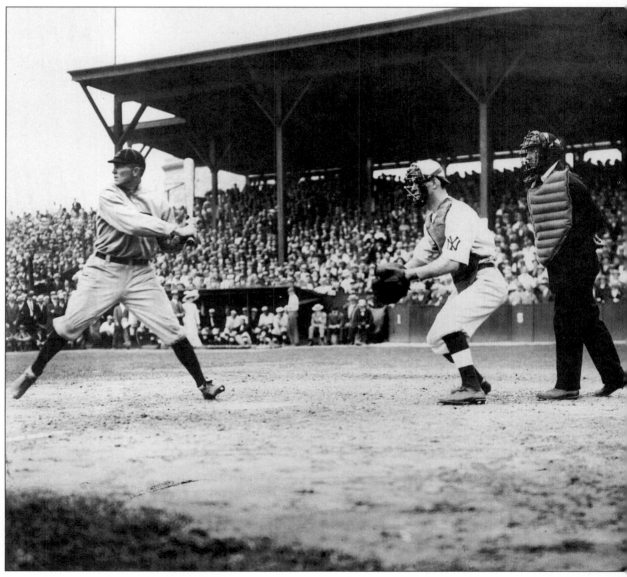

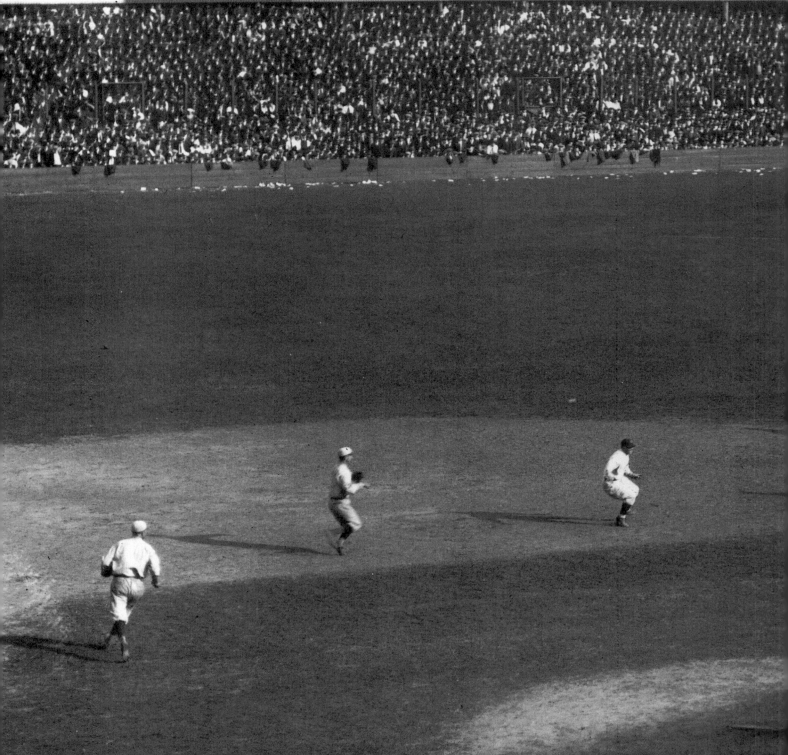

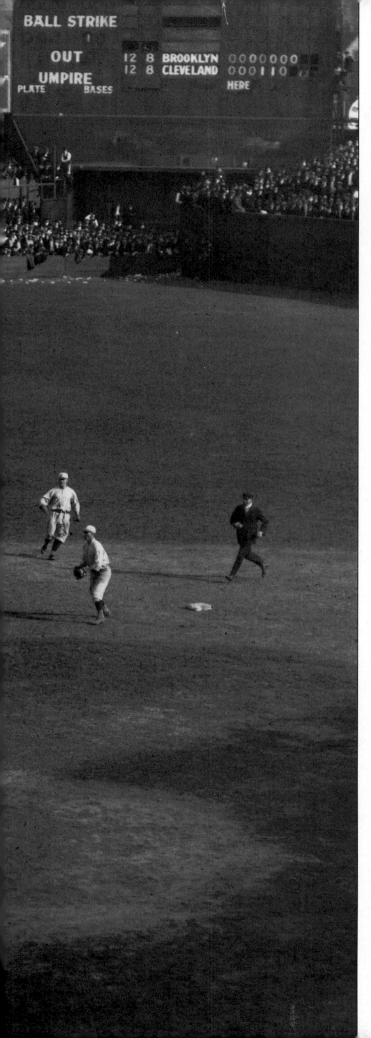

League Park

CLEVELAND

LOCATION: About three miles east of City Hall, at the intersection of East 66th Street and Lexington Avenue. The first-base foul line ran parallel to East 66th Street, right field to center field parallel to Lexington Avenue, center field to left field parallel to East 70th Street, while the third-base foul line paralleled Linwood Avenue.

HOME OF: The Cleveland Indians (formerly called the Spiders, Blues, Broncos, and Naps) from May 1, 1891, to September 21, 1946.

*J*ust as the Cincinnati Reds played baseball continuously at Findlay and Western from 1884 to 1970, so the Cleveland club played continuously at East 66th and Lexington from 1891 through 1946. Cleveland was in the National League from 1879 through 1884 and from 1889 through 1899, switching to the infant American League in 1900.

With Cy Young pitching and 9,000 fans watching, Cleveland inaugurated League Park on May 1, 1891, by beating Cincinnati, 12–3. The team's pre-

Cleveland catcher Steve O'Neill is caught in a rundown in the seventh inning of the seventh game of the 1920 World Series. Many of the left-center-field seats and all of those on the right-field side of the scoreboard are temporary, installed for the World Series.

101

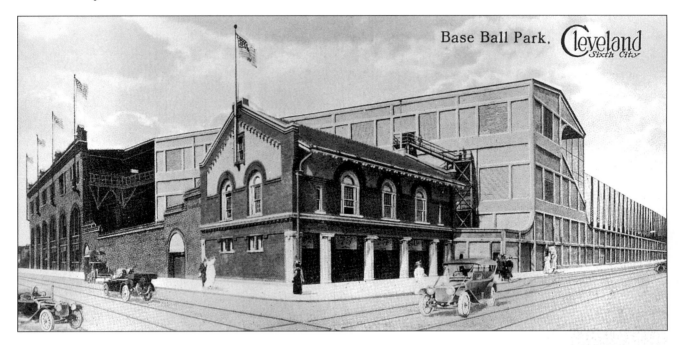

Base Ball Park. Cleveland
Sixth City

vious home, about a mile to the west at East 37th and Payne, had been destroyed by lightning the year before. When club owner/streetcar owner Frank DeHaas Robinson found a spot to rebuild, at East 66th and Lexington, it turned out to be right where the most convenient means of transportation to and from the ballpark would be via (surprise!) his very own trolley-car lines.

Before the start of the 1910 season, League Park was completely modernized, the wooden grandstand replaced by steel and concrete and double-decked. When it opened on April 21, with Detroit shutting out Cleveland, 5–0, the ballpark looked much as it would for the next thirty-six years.

Wes Ferrell, winner of 20 or more games six times, was one of Cleveland's all-time great pitchers. In the summer of 1927, then a nineteen-year-old sandlot ballplayer, he was asked to go to Cleveland for a tryout. Many years later, he talked to writer Donald Honig and his description of how he felt when he initially saw League Park has become a classic.

"So here I go to Cleveland, still a little old country boy with a drawl thick as molasses. When I got off the train I asked somebody how to get out to League Park. They put me on a streetcar, and I told the conductor where I wanted to get off. It was

ABOVE: *League Park, at the corner of 66th and Lexington, shortly after the ballpark opened in 1910.*

OPPOSITE: *Tris Speaker, one of the greatest of all center fielders and player-manager of the Indians from 1919 through 1926.*

quite a long ride, and finally he looked around at me and said, 'This is it.'

"I get off the streetcar, and I'm looking for a ballpark. Now the only ballparks I'd ever seen were back home and what those were were playing fields with little wooden fences around them. So I'm looking around, and I don't see a ballpark. Some kids were playing in the street, and I asked them where League Park was. They pointed and said, 'That's it.' Well, I turned around and looked up, and there's this great stone structure. Biggest thing I ever saw in my life. They called this a ballpark? I couldn't believe it. Then I heard a little noise in the back of my mind: *major leagues*. The sound of those two words was like instant education.

"So I took a tighter hold on my suitcase and walked through the gates of that thing, staring up and around at everything like I was walking through a palace. I went past all those great stone pillars and got up onto a concrete runway and looked way

down and there at the end was a beautiful green ball field and guys playing ball on it. There was a game going on. And all of a sudden the notion of baseball got as big as all get-out in my mind. Seeing it being played down there in that setting was just beautiful."

The stadium was double-decked and roofed all the way from the right-field foul pole around home plate and past third base down to within 15 or 20 feet of the left-field foul pole. Uncovered single-decked stands continued the remaining distance to the left-field foul line and turned into left-field fair territory for about 40 feet behind a 5-foot-high concrete wall.

Attached to the single-deck stands in left field was a narrow bleacher section that ran as far as the left-field side of the center-field scoreboard. In front of the bleachers was a 10-foot-high barrier: a 7-foot-high wire screen on top of a 3-foot-high concrete base.

Original outfield distances were 375 feet from home plate to the left-field foul pole, 460 feet to center, and only 290 feet down the right-field line. Starting in 1920, the center-field distance was reduced from 460 to 420 feet. Permanent seating capacity for the park never exceeded 22,000.

There was no seating in right field. Instead, just 290 feet down the line from home plate and extending all the way over to the center-field scoreboard was a 40-foot-high fence consisting of a 20-foot-high screen on top of an equally high concrete wall. Balls hitting the screen stayed in play. Balls hit-ting the wall might rebound any which way, especially if they hit one of the protruding steel beams. Shades of Baker Bowl and Ebbets Field!

At most urban ballparks—as contrasted with suburban ones surrounded by parking lots and little else—a daily battle of wits has been fought since the dawn of time between ballpark employees, who want everyone to pay to get in, and neighborhood kids, who want to see the game for free. Balls hit *over* the right-field screen onto Lexington Avenue could be turned in for free admission to the ballpark. Needless to say, every summer afternoon when the Indians were home, lots of baseball-happy kids could be seen hanging out on Lexington Avenue even before batting practice was scheduled to start.

According to League Park historian Peter Jedick, "Kids laid on their stomachs by the crack beneath the exit gate in the outfield wall, hollering

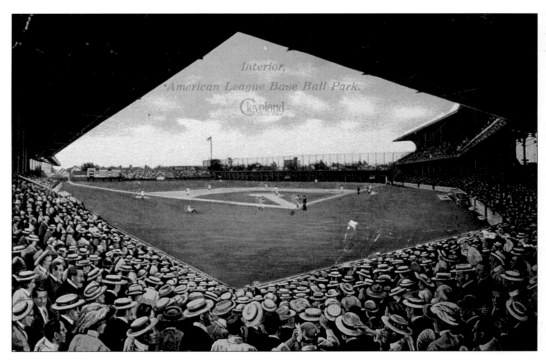

Infield grandstand at League Park.

at the outfielders during batting practice to throw a few more over. They often obliged."

Some lucky kids gained entrance by turning turnstiles. When the ticket taker tore a customer's ticket in half to return the raincheck portion, the youngster would turn the turnstile for the entering customer's convenience. Most ticket takers would close down in the third or fourth inning, at which time the turnstile turner was free to go watch the game. The only problem with turning turnstiles was that there were only about half a dozen such opportunities daily. Every day, right before the gates opened, the ticket takers would choose their helpers from a mob of shouting, hand-waving kids, most of whom were jumping up and down to get noticed. No longshoremen's shape-up was ever more intense.

Selling concessions was a good way to get to see the ball game, but child labor laws limited such jobs to kids sixteen and older (or big kids who at least *looked* sixteen or older). Some of those left out would invariably climb the fire escape at Dunham School across the street, even though it offered only a partial view of the field. Better sight lines were available from the roof of the Andrews Storage Company, but that was a more dangerous climb.

In 1916, the name of the park was changed to Dunn Field in honor of Sunny Jim Dunn, a railroad contractor who bought the Indians that year for $500,000. However, the name promptly reverted to League Park when the Dunn family sold the club (for $1 million) in 1927.

Without question, the most celebrated single play in the history of the ballpark was the unassisted triple play executed by Cleveland second baseman Bill Wambsganss in the fifth game of the 1920 World Series, the only World Series ever played at League Park. Unassisted triple plays are even rarer than perfect games. There have been about a dozen or so perfect games pitched in the big leagues but only half that many unassisted triple plays, and like Don Larsen's perfect game in the 1956 World Series, only *one* unassisted triple play has ever occurred in a World Series game. That one took place on October 10, 1920, in League Park.

Bill Wambsganss, who in 1920 executed the only unassisted triple play in World Series history.

Bill Wambsganss was often called w'b's ss, 2b in the box scores and WAMBY in the headlines, because Wambsganss took up too much space. He even called *himself* "Wamby" in the phone book. Born in Cleveland, Wamby was the son of a Lutheran minister who expected his son to follow in his footsteps. But the younger Wambsganss was too shy to speak from the pulpit, so he wound up playing second base for the Indians instead.

Long after it happened, he recalled how he did it: "Pete Kilduff, the first man up for Brooklyn, singled, and so did Otto Miller, so there were run-

ners on first and second and none out. The next batter smacked a rising line drive toward center field, a little over to my right—that is, to my second-base side. I made an instinctive running leap for the ball, and just managed to jump high enough to catch it in my glove for the first out.

"The impetus of my run and leap carried me toward second base and as I continued in that direction I saw Pete Kilduff still running toward third. He thought it was a sure hit, see, and was on his way to score. There I was with the ball in my glove, and him with his back to me, so I just kept on going and touched second base for the second out.

"As I touched the base, I looked to my left and there was Otto Miller, from first base, just standing there, with his mouth open, no more than a few feet away from me. 'Where did you get that ball?' he asked me. I said, 'Well, I've got it and you're going to be out number three,' and took a step or two over and tagged him lightly on the right arm. Then I started running in to the dugout.

"It took place so suddenly that most of the fans—and the players, too, for that matter—didn't know what had happened. They had to stop and

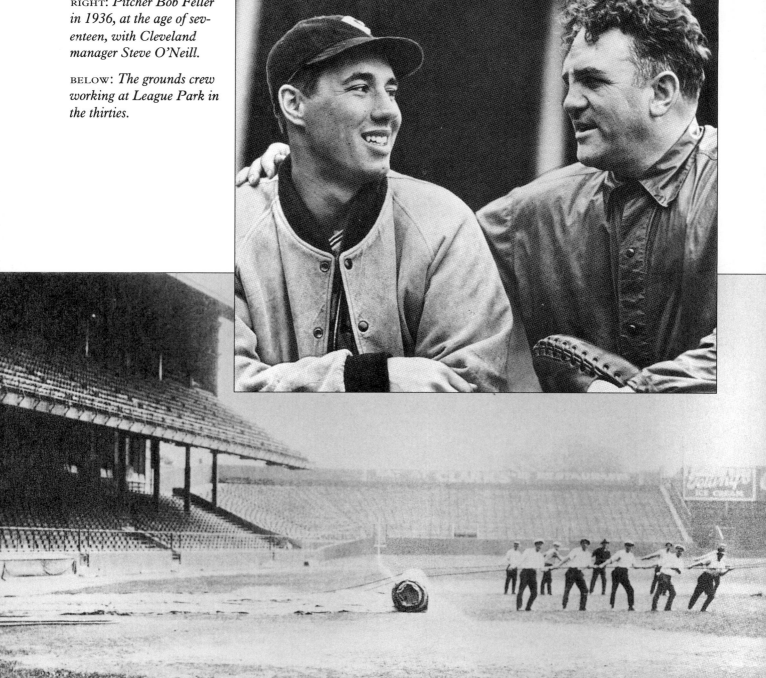

RIGHT: *Pitcher Bob Feller in 1936, at the age of seventeen, with Cleveland manager Steve O'Neill.*

BELOW: *The grounds crew working at League Park in the thirties.*

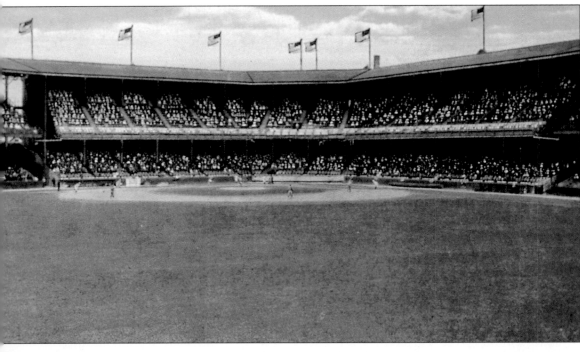

LEFT: *Panoramic view of League Park.*

BELOW: *A standing-room-only crowd packed into League Park's outfield for a game against the visiting Washington Senators in the twenties.*

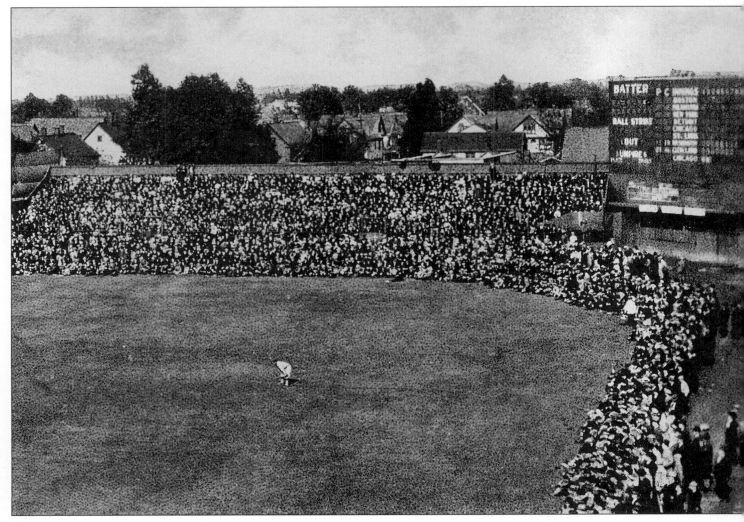

figure out just how many were out. So there was dead silence. Then, as I approached the dugout, it began to dawn on everybody what they had just seen, and the cheering started and got louder and louder. By the time I got to the bench it was bedlam, people screaming, my teammates pounding me on the back."

After city-financed Municipal Stadium was built on the shores of Lake Erie in the early thirties, League Park was no longer the sole home field of the Cleveland Indians. From 1934 through 1946, League Park was used only for weekday and Saturday day games. Huge Municipal Stadium had almost four times the seating capacity of little League Park, so the Indians played their Sunday and holiday games at the Stadium, as well as all their night games after 1939, because League Park never did get lights.

Bill Veeck became principal owner and president of the Indians in the middle of the 1946 season. The next year *all* Indians' home games were played at Municipal Stadium and League Park was abandoned. The last major league game at the thirty-six-year-old ballpark was played on September 21, 1946, a 5–3 Detroit victory over Cleveland that was witnessed by a sparse crowd of 2,772.

The ballpark was bought by the city and demolished in 1951. The site is now a playground and public park, named League Park, with a few remembrances of the ballpark still in place for old times' sake. "Today," says Cleveland historian Peter Jedick, "any kid can go out to League Park and hit a few baseballs where Ruth, Cobb, Speaker, and Josh Gibson once roamed. But they can't turn one in to watch them play."

An aerial view of League Park in the thirties. (The ballpark never did get lights.)

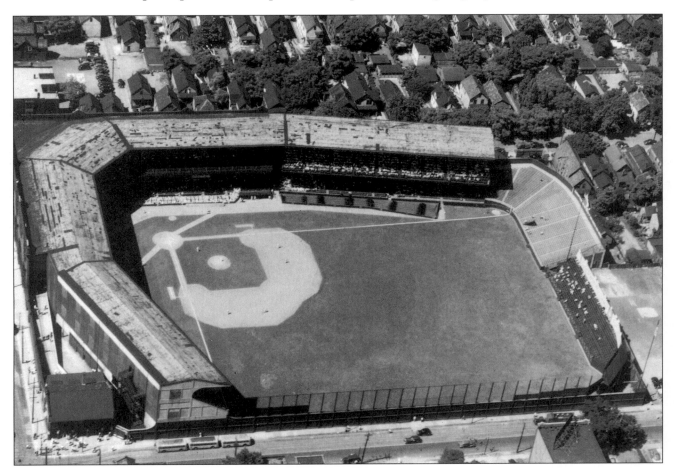

League Park's
Ten Most Memorable Moments

1. October 2, 1908: In a crucial game for the American League pennant, Chicago's Ed Walsh pitches a four-hitter against Cleveland and strikes out 15—but loses, 1–0, to Addie Joss, who pitches a perfect game.

2. July 24, 1911: A team of American League All-Stars plays the Cleveland Indians in a benefit game for the widow of the late Addie Joss, who died on April 14 of tubercular meningitis at the age of thirty-one.

3. July 19, 1915: Washington beats Cleveland, 11–4, stealing a record eight bases in the first inning against Cleveland catcher Steve O'Neill.

4. October 10, 1920, fifth game of the World Series: In the first inning, Cleveland outfielder Elmer Smith hits the first-ever World Series grand-slam home run.

5. October 10, 1920: In the fifth inning of the same World Series game, Cleveland second baseman Bill Wambsganss executes the only unassisted triple play in World Series history.

6. October 12, 1920, seventh and deciding game of the World Series: Cleveland's Stanley Coveleski wins his third complete game of the Series as the Indians beat Brooklyn, 3–0, to become world champions for the first time.

7. July 10, 1932: Philadelphia defeats Cleveland, 18–17, in a wild 18-inning game in which Cleveland's John Burnett gets a record nine hits, including two doubles, while Philadelphia's Jimmie Foxx connects for two singles, a double, and three home runs.

8. July 6, 1936: Bob Feller, a seventeen-year-old unknown, pitches three innings of an exhibition game between Cleveland and St. Louis and creates a sensation by striking out eight Cardinals.

9. September 13, 1936: Cleveland's Bob Feller, still only seventeen years old but no longer an unknown, beats Philadelphia, 5–2, allowing only two hits and striking out 17 batters for a new American League strikeout record.

10. July 16, 1941: New York's Joe DiMaggio gets three hits—a double and two singles—to stretch his consecutive-game hitting streak to 56 games (where it will end).

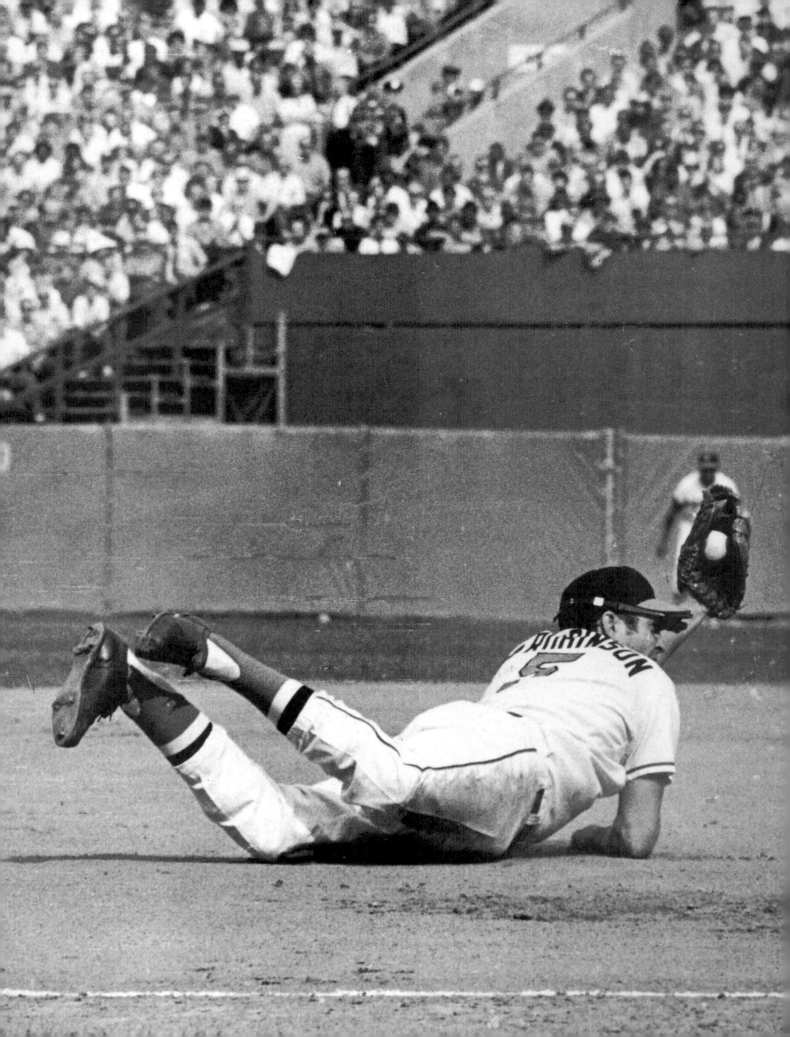

Memorial Stadium

BALTIMORE

LOCATION: About three miles northeast of downtown, a mile east of Johns Hopkins University, on the north side of 33rd Street. Home plate was along 33rd Street, midway between Ednor Road and Ellerslie Avenue: the first-base foul line went from home plate toward Ednor Road, the third-base foul line from home plate toward Ellerslie Avenue, and center field paralleled 36th Street.

HOME OF: The International League Baltimore Orioles from 1950 through 1953 and the American League Baltimore Orioles from April 15, 1954, to October 6, 1991.

*O*nce upon a time, back in the Gay Nineties, the Baltimore Orioles had been a powerhouse in the *National* League. Led by "Hit 'em where they ain't" Wee Willie Keeler and fiery John J. McGraw, one five feet four inches tall and the other a towering five foot seven, Baltimore won National League pennants in 1894, 1895, and 1896, and finished a strong second in 1897 and 1898.

Brooks Robinson makes a diving catch of a Johnny Bench line drive in the third game of the 1970 World Series.

However, an interleague financial war erupted at the turn of the century—the newly organized American League vs. the established National League—and in 1901 the Baltimore club joined the upstart American League. Only two years later, though, the Baltimore franchise was sold and transferred to New York. There the team was renamed the Highlanders and subsequently, as the Yankees, between 1920 and 1980 became the most successful franchise in sports history.

After 1902, it would be half a century before Baltimore was once again in the major leagues. Finally, in 1954 the hapless St. Louis Browns of the American League moved to Baltimore, changed their name from Browns to Orioles, and before long Brooks and Frank Robinson began emulating Keeler and McGraw.

Memorial Stadium, a multipurpose stadium seating 30,000 in an oval-shaped uncovered single deck, was constructed with public funds in 1949–50. It was designed mainly for professional football, for the Baltimore Colts, but also for the Baltimore Orioles of the International League, in hopes that the majors might be tempted. Late in 1953, big league baseball was indeed assured for Baltimore, and soon thereafter the city gave the practically new stadium a thorough overhaul, just for good measure.

In particular, on top of the existing single deck a second deck was built behind home plate and extending down to both foul poles, along with a mezzanine (a narrow mini deck below the new second deck). The new upper deck was left uncovered when built and remained that way for the life of the ballpark.

The lower deck *was* covered, of course, by the new upper deck, except that the upper deck ended near the foul poles, while the lower deck curved around into right-center field and left-center field, thereby creating uncovered outfield bleachers.

OPPOSITE: *A packed house at Memorial Stadium for the 1958 All-Star Game.*

BELOW: *Main entrance to Memorial Stadium.*

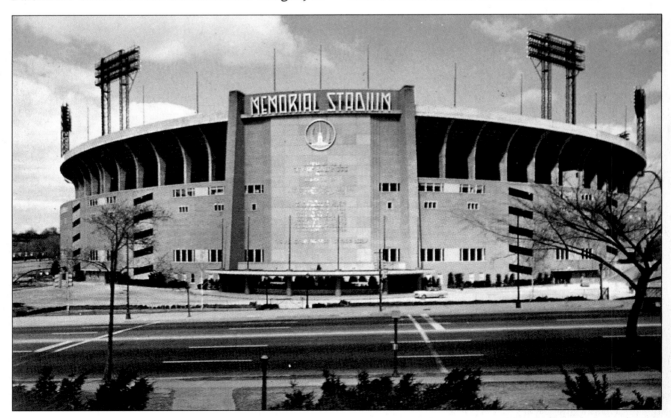

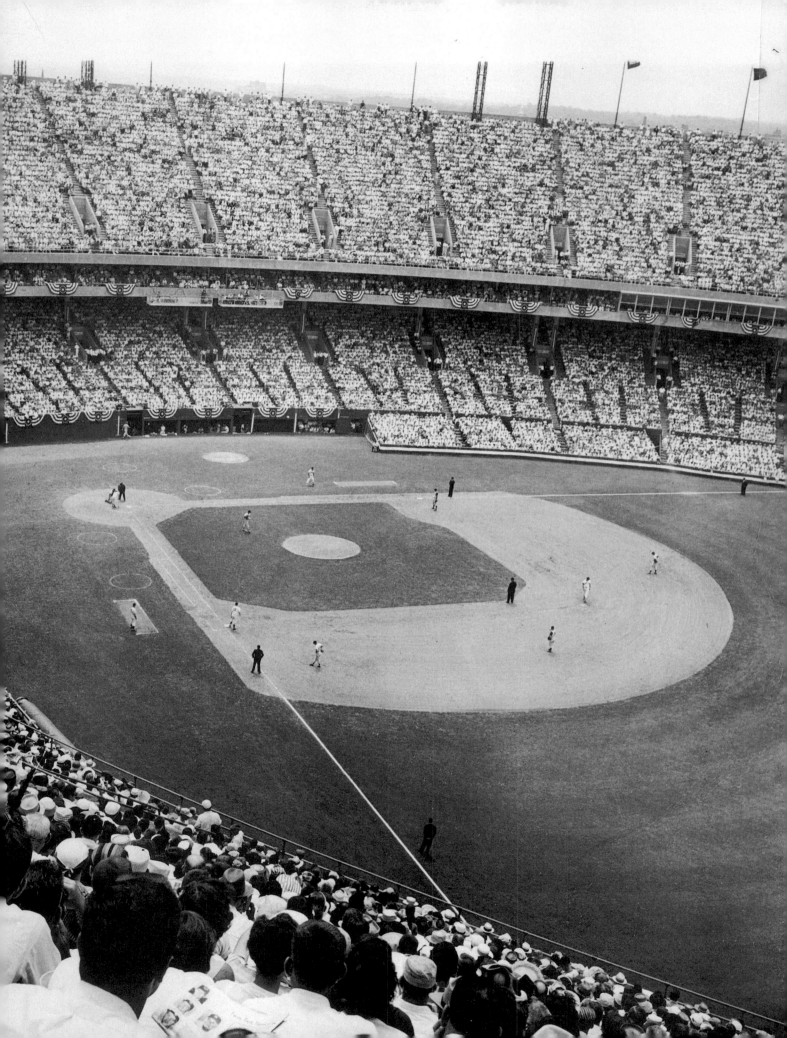

These additions increased seating capacity to 48,000 (over the years, additional box seats were squeezed in here and there for a final total of 54,000).

After a few years, seats were removed from center field; in their place, a scoreboard and an attractive clump of trees filled in the background between the right- and left-field bleachers.

Originally, outfield dimensions were 309 feet from home plate down both foul lines and 450 feet to dead center. Although 309 feet down the foul

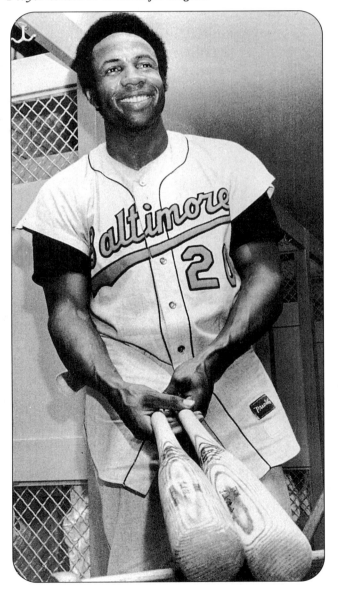

Frank Robinson, the only player to win Most Valuable Player honors in both major leagues.

lines seems short, Memorial Stadium was no hitter's heaven: the distance increased rapidly past the foul poles, so that the power alleys were a healthy 360–370 feet in both left and right fields. Along the left-field foul line, by the way, in foul territory, of course, was groundskeeper Pat Santarone's flourishing vegetable patch—tomatoes, basil, and peppers.

The distance down the foul lines remained unchanged at 309 feet for the life of the ballpark, but center field was reduced from 450 to 410 feet in 1958, when an inner fence was installed which curved around the outfield from left-center to right-center in front of the trees. The bleacher walls were 14 feet high from the foul poles to the inner outfield fence in left-center and right-center, with the inner fence exactly half that height. The fence was shifted slightly in the mid-seventies, reducing the center-field distance from 410 to 405 feet.

The section of 33rd Street in front of the ballpark was called Babe Ruth Plaza, in honor of Baltimore's most famous native son. The greatest baseball player of all time was born on the Baltimore waterfront and raised in St. Mary's Industrial School for Boys on Wilkens Avenue, four miles southwest of downtown.

During the thirty-eight years the Orioles called Memorial Stadium home, the team won six American League pennants and three World Series. The pennants were won in 1966, 1969, 1970, 1971, 1979, and 1983, and the World Series were won in 1966, 1970, and 1983. (In addition, the team won American League East division titles in 1973 and 1974, but lost those pennant playoffs to Oakland.

During that thirty-eight-year time span, many outstanding players wore Baltimore uniforms: Mark Belanger, Paul Blair, Don Buford, Dave McNally, Eddie Murray, Jim Palmer, Boog Powell, Cal Ripken, Ken Singleton, and Gus Triandos, among others. But the three dominant players/personalities of the era were third baseman Brooks Robinson, outfielder Frank Robinson, and manager Earl Weaver.

Brooks Robinson was born and raised in Little Rock, Arkansas, the son of a fireman. He wanted to be a big league third baseman from the time he was

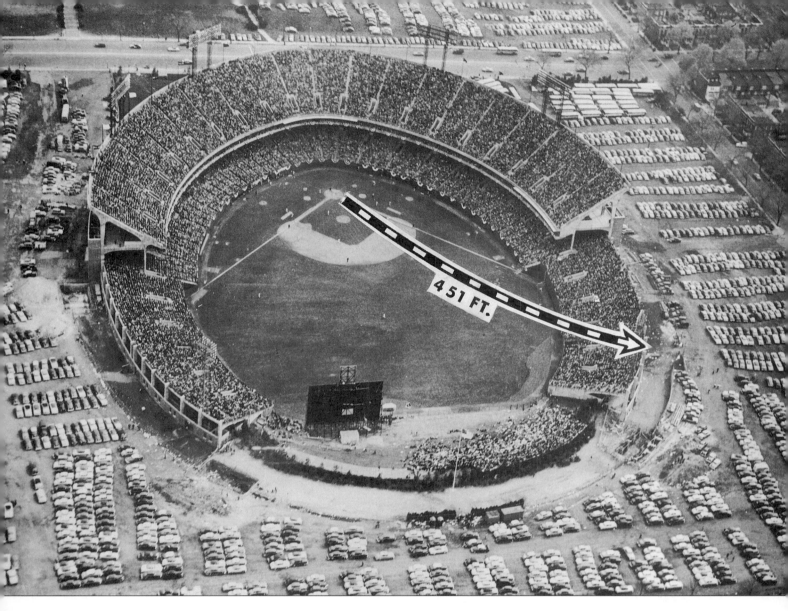

451 FT.

in the ninth grade. As indicated by his sixteen Golden Glove Awards between 1960 and 1975, all with the Baltimore Orioles, what he did become was perhaps the best all-around third baseman who ever lived. His only competitors for that honor are Pete Rose, Mike Schmidt, and Pie Traynor.

Going to his left, backhanding shots down the line, and, most spectacularly of all, coming in for bunts and slow rollers and throwing runners out with a swooping pickup and toss, Brooks Robinson set the modern standard for how third base should be played. He was Baltimore's third baseman for twenty years, from 1957 through 1976.

Brooks Robinson reached his peak in the 1970 World Series, when the Orioles beat the Cincinnati Reds in five games, with a Series performance that ranks among the greatest ever by an individual. In the first game, he hit a game-winning home run in

An aerial view of Memorial Stadium. The dashed line marks the path of a home run hit over the left-field bleachers by Frank Robinson on May 8, 1966. Subsequently, trees replaced seats in the area behind center field.

the seventh inning and robbed Lee May of a double with a spectacular backhand catch. In the second game, he drove in the tying run and again robbed Lee May of a sure double, turning it into a double play. Third game: two doubles, two runs driven in, and Johnny Bench robbed of a hit with a diving catch. Fourth game: four hits, including a home run. Fifth game: an impossible diving catch on another Johnny Bench line drive and a single, giving him a .429 Series batting average.

Frank Robinson is the only man ever to win the Most Valuable Player Award in both leagues—in the National League in 1961 and in the American

League in 1966. He joined the Cincinnati Reds in 1956 at the age of twenty-one, and promptly hit 38 home runs. In 1961, his MVP year with the Reds, Frank batted .323, hit 37 homers, and drove in 124 runs. The next year he hit for a higher average, hit more home runs, and drove in more runs, but Maury Wills was voted MVP (he stole 104 bases, breaking Ty Cobb's record of 96 that had been set forty-seven years earlier).

On December 9, 1965, Cincinnati general manager Bill DeWitt traded Robinson to Baltimore for pitchers Jack Baldschun and Milt Pappas and outfielder Dick Simpson, surely one of the worst trades ever made. DeWitt defended the deal by asserting that Robinson's future was behind him, that he wasn't merely thirty years of age but "an old thirty."

Robbie made him eat those words with another MVP year in 1966, this time for Baltimore—a .316 batting average, 122 runs batted in, and 49 home runs, league-leading figures in all three categories,

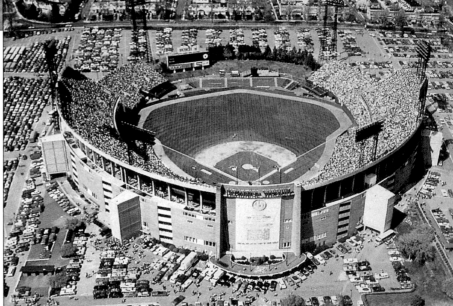

ABOVE, LEFT: *Pitchers Jim Palmer (left) and Mike Flanagan in the Baltimore dugout in 1979.*

ABOVE: *Aerial view of Memorial Stadium.*

LEFT: *Time schedule for the evening's festivities, posted in the Baltimore locker room.*

LEFT: *A beneath-the-stands batting cage at Memorial Stadium. Infielder Donnie Hill practices under the watchful eye of Bob Watson, Oakland A's batting coach.*

BELOW: *Baltimore shortstop Cal Ripken getting his ankle taped and talking with Orioles coach Elrod Hendricks in the trainer's room in Memorial Stadium in 1986.*

a feat only one player (Carl Yastrzemski) has achieved since. Frank's 586 lifetime home runs are surpassed only by Hank Aaron (755), Babe Ruth (714), and Willie Mays (660).

While still an active player, Frank Robinson became the first black manager hired in the major leagues when he was appointed player/manager of the Cleveland Indians in 1974. Then, as happens to all managers, in 1977 he became the first black manager to be *fired*.

Robinson later managed the San Francisco Giants and the Baltimore Orioles. In 1989, as Baltimore manager, he was voted American League Manager of the Year, an award that went well on his mantel between his two MVP trophies.

Earl Weaver managed at Memorial Stadium for seventeen years in all, fifteen in succession from 1968 through 1982. Generally acknowledged as one of the best managers ever, he was also one of the most unorthodox.

Weaver's Laws of Managing are not as famous as Satchel Paige's Rules for Staying Young, but among baseball people some of them are more controversial, especially:

1. Your most precious possessions on offense are your 27 outs.
2. If you play for one run, that's all you'll get.
3. The easiest way around the bases is with one swing of the bat.
4. It's easier to find four good starting pitchers than five.

The upshot of Weaver's Laws is that sacrifice bunts are rarely used because outs are too precious to give away. It is better to sit back and wait for the big inning, the three-run home run. "Dr. Longball," according to Earl, "is a manager's best friend."

And a four-man pitching rotation, with three

Memorial Stadium's
Ten Most Memorable Moments

1. April 15, 1954, Opening Day: Returning to the American League after a 51-year absence, the Baltimore Orioles celebrate by beating the Chicago White Sox, 3–1, before a capacity crowd of 46,354 paid admissions.

2. June 10, 1959: Cleveland outfielder Rocky Colavito hits four consecutive home runs against the Orioles as the Indians win, 11–8.

3. September 12, 1962: Washington pitcher Tom Cheney strikes out a record 21 batters in a 16-inning game, beating the Orioles, 2–1.

4. October 5, 1966, first game of the World Series: The Orioles beat the Los Angeles Dodgers, 5–2, on home runs by Frank and Brooks Robinson and six and two-thirds innings of one-hit relief pitching by Moe Drabowski, who strikes out 11, including a record six in a row.

5. October 9, 1966, fourth and deciding game of the World Series: Dave McNally's four-hit pitching and Frank Robinson's home run beat the Dodgers, 1–0, giving Baltimore its first world championship in the twentieth century.

6. October 13, 1970, third game of the World Series: Baltimore defeats the Cincinnati Reds, 9–3, on a grand-slam home run by pitcher Dave McNally and a host of fielding gems by third baseman Brooks Robinson.

7. October 3, 1979, first game of the American League Championship Series: Pinch-hitter John Lowenstein's home run in the bottom of the tenth gives Baltimore a dramatic victory over the California Angels.

8. October 3, 1982, the last day of the season: Milwaukee snatches the American League East flag from Baltimore by defeating the Orioles, 10–2; nevertheless, a capacity crowd gives retiring Baltimore manager Earl Weaver an emotional twenty-minute postgame standing ovation, featuring numerous curtain calls.

9. October 12, 1983, second game of the World Series: The Orioles top the Phillies, 4–1, behind the three-hit pitching of Mike Boddicker and the clutch hitting of John Lowenstein and Rick Dempsey.

10. May 2, 1988: Despite the Orioles' dismal record of 23 losses and only one win, a crowd of over 50,000 shows up at Memorial Stadium to welcome the team home from a road trip—and Baltimore responds by beating the Texas Rangers, 9–4.

days of rest between starts, is preferred over a five-man rotation, with four days between starts. In the twenties and thirties, four starters was standard, but now a five-man rotation is more common. "Over the years," says Earl, "I've gone with a four-man rotation more often than any other manager. This gives the pitchers chances for more wins. It means more starts for each pitcher. I look at it this way: if you have four pitchers who are winning for you and you can get them to the mound more often, it means more wins for the team. The starts you give to your fifth-best starter are taken away from the four who are better than him."

Most managers disagree emphatically with Weaver's methods. The sacrifice bunt and the hit-and-run are standard plays in the managerial arsenal. And five-man pitching rotations are the norm. But for Earl Weaver, his methods worked. During the fifteen years from 1968 through 1982 he finished first, second, or third all but twice.

The last game of the 1982 season was widely billed as Earl Weaver's swan song. Long before, he had announced that this would be his last year as manager. As fate would have it, on the last day of the season Milwaukee and Baltimore were tied for first place in the American League East and scheduled to meet each other in Memorial Stadium.

Baltimore lost the game, 10–2, and with it the pennant, but even in defeat 51,642 Baltimore fans gave Earl Weaver an all-out emotional farewell. It lasted a full twenty minutes, and was both a thank-you to the team and a farewell to its manager.

Unfortunately, Earl spoiled his own curtain calls by coming back in 1985 and 1986, but then he retired again, this time for good.

There was really no need to abandon Memorial Stadium in 1991 and move to a new ballpark. "It was an aesthetically beautiful stadium—I loved it," said former Orioles outfielder John Lowenstein. And it was structurally sound. But when noted trial lawyer Edward Bennett Williams purchased the Baltimore franchise in 1979, he did so with the understanding that the city would eventually build him a new ballpark, one more accessible to Washington, with better parking facilities, and with more luxury box seats.

Having just lost the National Football League Colts to Indianapolis in 1984, the city of Baltimore and the state of Maryland were in no position to gamble. If the price of keeping the Orioles in Baltimore was the building of a new stadium, the public authorities were prepared to sacrifice Memorial Stadium to that end—which is exactly what they did. Brand-new Oriole Park at Camden Yards in downtown Baltimore was ready for the start of the 1992 season. The last major league game at Memorial Stadium was played on October 6, 1991; a sellout crowd of 50,700 saw the Orioles lose to the Detroit Tigers, 7–1.

Earl Weaver in his office in Memorial Stadium two hours before game time, 1986.

119

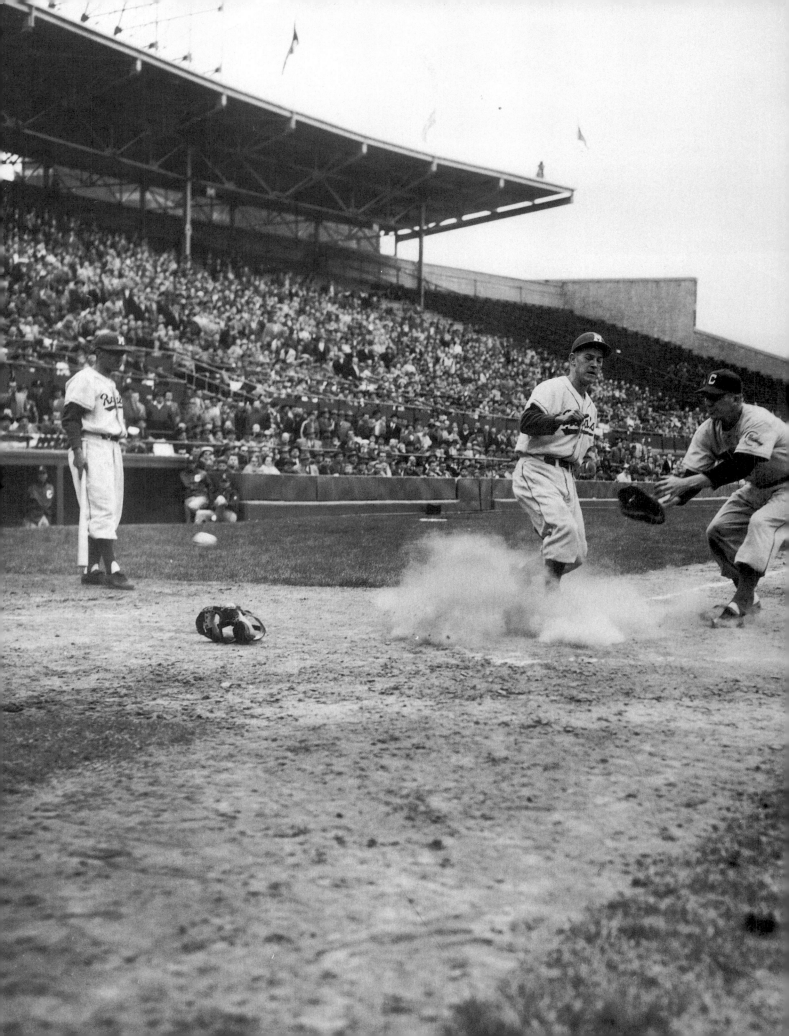

Montreal Stadium AND Jarry Park Stadium

MONTREAL

LOCATION: 1. Montreal Stadium (also known as Delorimier Downs)—three and a half kilometers (2.1 miles) from downtown, on the square block bounded by Ontario, Parthenais, Lariviere, and Delorimier streets. The first-base foul line ran parallel to Ontario Street, right field to center field parallel to Parthenais Street, center field to left field parallel to Lariviere Street, while the third-base foul line paralleled Delorimier Street.

2. Jarry Park Stadium—about seven kilometers (4.2 miles) from downtown, tucked into a corner of Jarry Park, a public recreation area. The first-base foul line ran parallel to Rue Faillon, right field to center field parallel to Boulevard St. Laurent (and a public swimming pool), center field to left field

An action scene at Delorimier Downs in 1958.

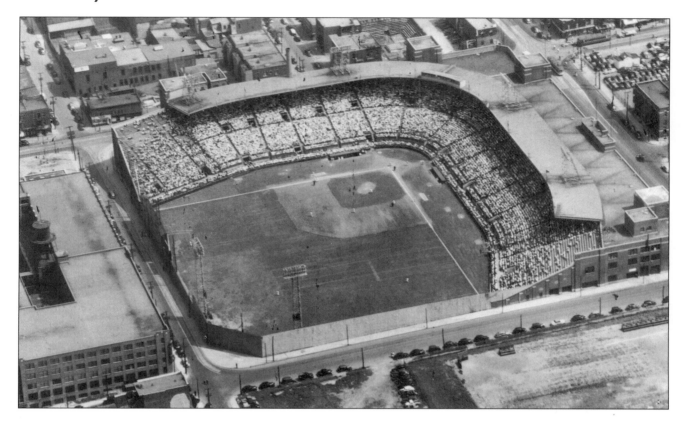

An aerial view of Delorimier Downs circa 1950.

parallel to Rue Jarry, while the third-base foul line paralleled the Canadian Pacific Railroad tracks.

H O M E O F : Montreal Stadium was the home of the Montreal *Royals* in the International League from May 5, 1928, through September 7, 1960. Jarry Park Stadium was the home of the Montreal *Expos* in the National League from April 14, 1969, to September 26, 1976.

*a*lthough baseball is called America's National Pastime, it also has deep roots embedded firmly in Canadian soil. Montreal had a team in the International League briefly in 1890 and from 1897 to 1917, and in the Eastern Canada League in the early twenties. After a ten-year absence, Montreal returned to the International League in 1928, replacing Syracuse.

A brand-new concrete-and-steel ballpark—officially named Montreal Stadium, but commonly known as Delorimier Downs—was built not far from downtown, at the intersection of Ontario and Delorimier streets. The new ballpark was inaugurated on May 5, 1928, when a packed house of 22,000, including Commissioner of Baseball Kenesaw Mountain Landis, saw the Montreal Royals beat the Reading (Pennsylvania) team, 7–4.

Montreal Stadium was a single-decked ballpark seating 20,000. Its single-decked grandstand swept around the infield and extended down both foul lines all the way to the fences, with a half-roof that ended on both wings about 80 feet before the foul poles. Thus the last 80 feet down each foul line consisted of uncovered bleacher seats. There was no seating behind the outfielders, except for the occasional accommodation of overflow crowds.

The distance from home plate to the left-field foul pole was 340 feet, to center field 440 feet, and down the right-field foul line only 293 feet. The outfield fences were 20 feet high in left field and 25 feet high in right, where there was a large scoreboard, plus a 20-foot-high right-field screen. However, the right-field screen was erected only to

protect the windows in the Grover Knit-to-Fit Mills building on the other side of Parthenais Street; any batted ball hitting the screen was a home run, as at Fenway Park.

Although they won the International League pennant in 1935, the Royals' fortunes were rather erratic until the Brooklyn Dodgers bought the franchise in 1939 and made Montreal their main farm club. The Dodgers themselves were on their way up—they won the National League pennant in 1941 for the first time since 1920—and they carried Montreal to the top along with them.

After World War II ended in 1945, Brooklyn won six pennants in the next dozen years and Montreal did the same! Among the many Dodgers-to-be who learned their trade at Delorimier Downs were pitchers Ralph Branca, Don Drysdale, and Don Newcombe; catchers Roy Campanella and John Roseboro; infielders Jim Gilliam and Rocky Nelson; and outfielders Carl Furillo and Duke Snider. First baseman Rocky Nelson was a particular favorite of Montreal fans—he remains the only player in International League history to win the league's Most Valuable Player Award three times.

From a historical point of view, the most important single event in the chronicles of the Montreal Royals was the 1946 debut of Jackie Robinson—the man who broke baseball's color line.

Robinson actually signed his first organized-baseball contract on October 23, 1945, and the place where he signed it was in the executive offices of the Royals in Montreal Stadium. Technically, his 1946 contract was with Montreal, not Brooklyn, although of course the Royals were a Brooklyn farm club.

Montreal always opened on the road because of cold weather at home, so that the 1946 inaugural for the Royals was in Jersey City's Roosevelt Stadium on April 18. Playing second base, Robinson made a dramatic debut with a home run and three singles. He went on to spark the Royals to the International League pennant, while also leading the league with a .349 batting average.

In the ensuing Junior World Series, Montreal defeated Louisville, the American Association's pennant winner, four games to two. A packed house at Delorimier Downs saw Montreal beat Louisville, 2–0, in the sixth and deciding game. At the last put-out excited fans hoisted Jackie Robinson onto their shoulders and marched him around the field to enthusiastic cheers.

When Robinson left the ballpark, jubilant fans mobbed him and chased him down the street. Sportswriter Sam Martin wrote: "It was probably the only time in history that a black man ran from a white mob with love instead of lynching on its mind."

Montreal Stadium and the Montreal Royals lived and died together. Television undermined the minor leagues and Montreal was a glaring example: attendance shrank to only 130,000 in 1960, the small-

Jackie Robinson broke into organized baseball with Montreal in 1946.

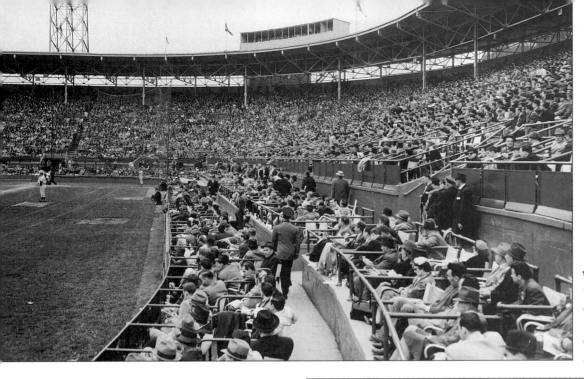

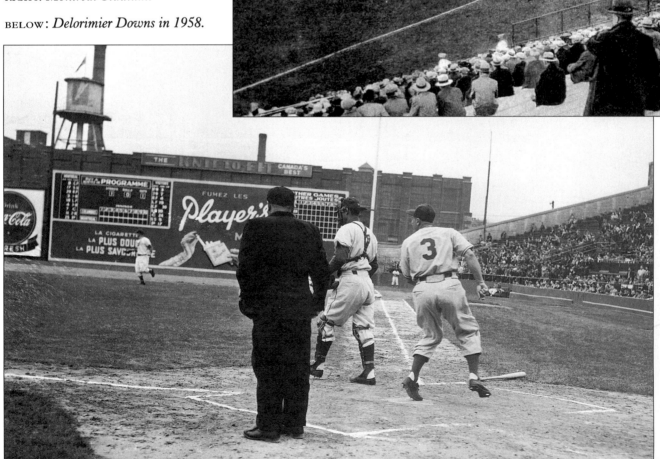

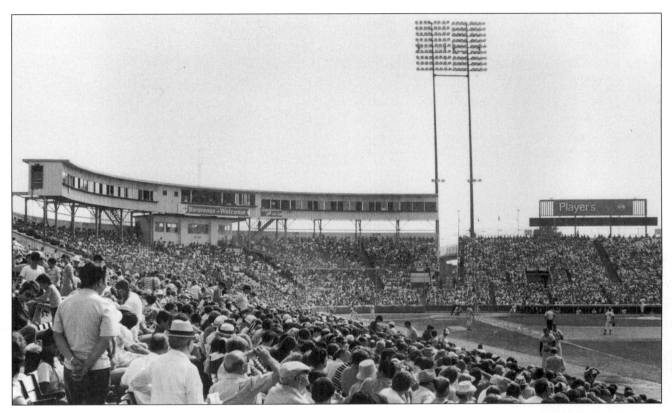

est since the Royals were resurrected in 1928 and only about 20 percent of what they had drawn annually a decade earlier.

The parent Dodgers, since 1957 no longer on the East Coast themselves, decided to sell the ballpark, turn in the franchise to the league, and shift their top minor league affiliation to Spokane in the Pacific Coast League. Thus, for all intents and purposes, the lives of the Royals and of Delorimier Downs, both thirty-three years of age, came to a common end on September 7, 1960, as the Royals lost to Buffalo, 7–4, before only 1,016 spectators.

The ballpark was demolished in 1971. A French high school and adjoining athletic field now occupy the site.

Montreal did not reenter organized baseball until the National League granted local businessmen an expansion franchise in 1968, with the proviso that they find a suitable place to play, pending the eventual construction of a promised domed stadium.

The best they could do was Jarry Park Stadium, a small (3,000-seat) municipally owned ballpark located in a corner of Jarry Park. The city promised to overhaul the ballpark in time for the 1969 season and by Opening Day, to everyone's surprise, Jarry Park Stadium was actually ready: it was nothing fancy, but now could seat 28,500 and serve more or less adequately until the domed stadium could be built.

A crowd of 29,184 packed the park on April 14, 1969, for the first home game of the new Montreal Expos and indeed for the first major league baseball game ever played in Canada. The partisan audience was rewarded with a Montreal victory over the St. Louis Cardinals, 8–7.

Jarry Park Stadium was a single-decked ballpark with completely uncovered stands that circled around the infield and continued all the way down both foul lines. An outfield bleacher section began at the left-field foul pole and extended into left-center field. There was no seating in right field or in center field past the left-field bleachers.

Outfield distances were 340 feet from home plate down each foul line and 417 feet to center (420 feet in 1974 and later). An 8-foot-high wire fence bordered the entire outfield, creating power-alley dis-

tances of 370 feet to both left- and right-center. A large scoreboard stood behind the fence in right field.

Although the Expos had difficulty winning during the eight years they played at Jarry, the fans did have some particular favorites—especially outfielders Rusty Staub and Ken Singleton, second baseman Ron Hunt, and pitcher Claude Raymond.

OPPOSITE: *The grandstand around the infield at Jarry Park.*

BELOW: *An aerial view of Jarry Park. Home runs sometimes reached the public swimming pool beyond the right-field fence.*

Right-hander Raymond won only eight games for the Expos, but as a local French-Canadian he had the special distinction of having once played sandlot games in the *original* Jarry Park.

Jarry had always been considered a stopgap, so it was no surprise when the last big league games were played there on September 26, 1976: the Phillies beat the Expos twice in a doubleheader, 4–1 and 2–1, before a crowd of 14,166. In 1977, five years behind schedule, the Expos moved not to the promised domed stadium but to Olympic Stadium, which had been built for the 1976 Olympics and was not domed until 1987.

Jarry Park Stadium is still standing, used regularly for social and civic events, for professional tennis, and for other large outdoor gatherings.

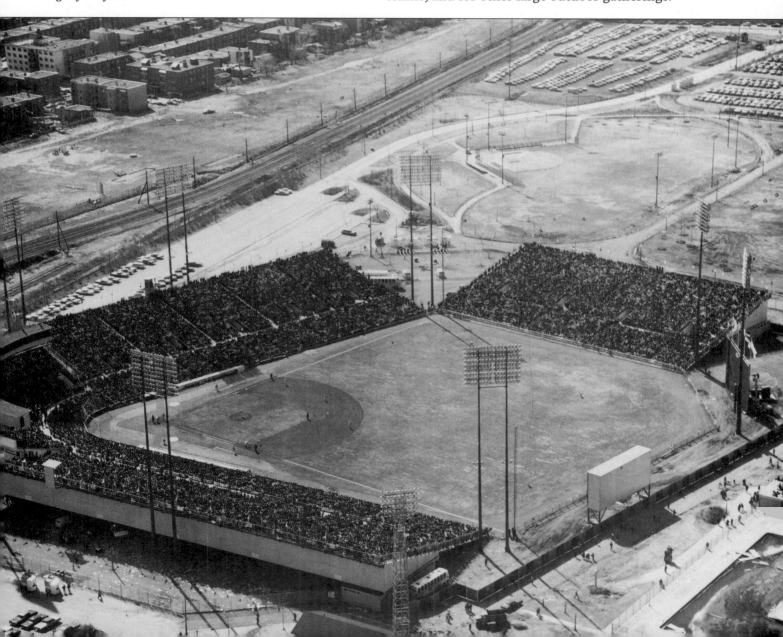

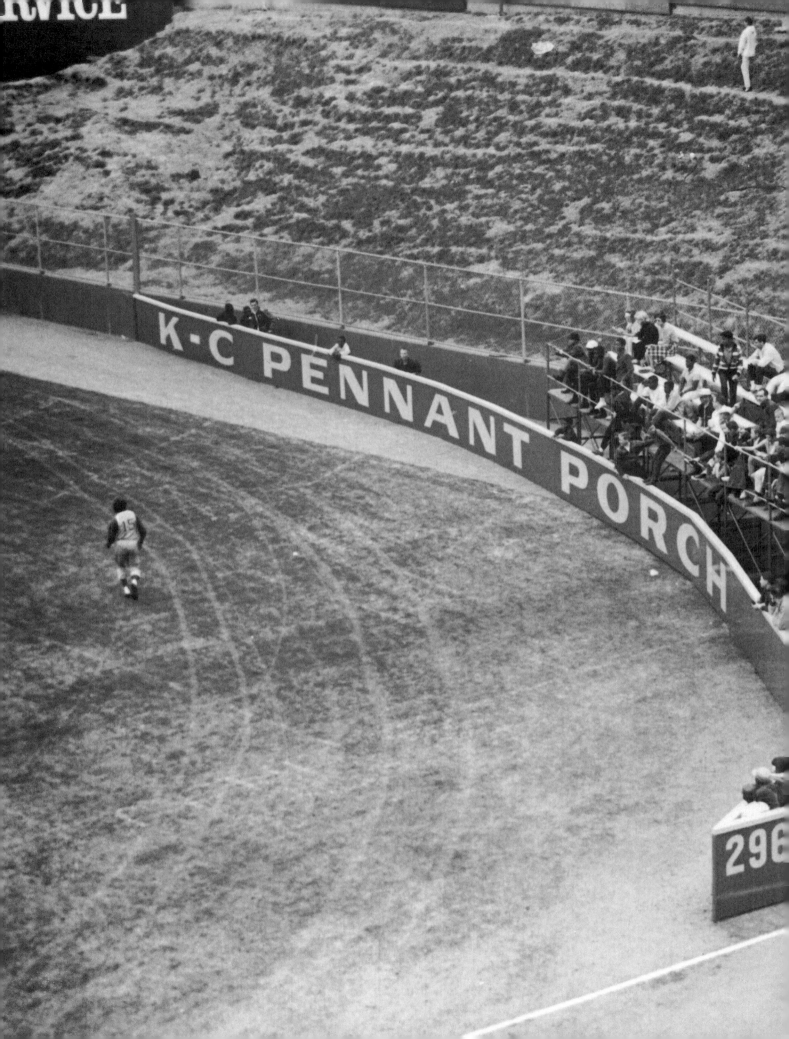

Municipal Stadium

KANSAS CITY

LOCATION: A mile and a half southeast of downtown, at the intersection of 22nd Street and Brooklyn Avenue. The first-base foul line ran parallel to 22nd Street, right field to center field parallel to Brooklyn Avenue, center field to left field parallel to 21st Street, while the third-base foul line paralleled Euclid Avenue.

HOME OF: The Kansas City *Blues* in the American Association from 1923 through 1954; the Kansas City *Athletics* in the American League from April 12, 1955, to September 27, 1967; and the Kansas City *Royals* in the American League from April 8, 1969, through October 4, 1972. (There was no Kansas City team in organized baseball in 1968.)

Kansas City began calling its ballpark Municipal Stadium only in 1955. Before that, it had many names: Muehlebach Field from 1923, when it was inaugurated, to 1937; Ruppert Stadium from 1938 to 1942; and Blues Stadium from 1943 to 1954. As Municipal Stadium, it lasted from 1955 through 1972, after which the Kansas City Royals left the

Charlie Finley's short-lived 1964 "Pennant Porch."

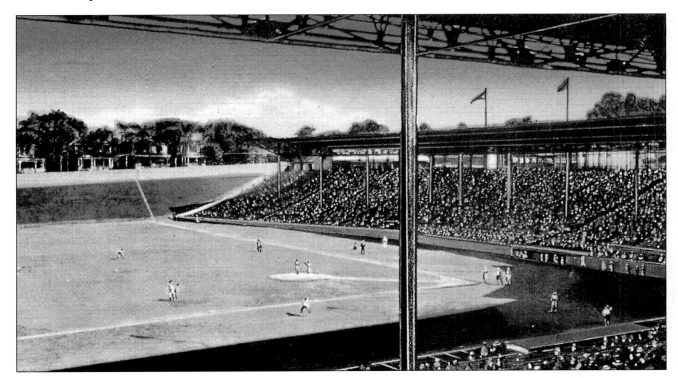

The infield at Muehlebach Field, later Municipal Stadium.

fifty-year-old ballpark and moved to the suburbs—to brand-new publicly financed Royals Stadium, along Interstate 70 on the outskirts of town.

Whatever its name, the ballpark at 22nd Street and Brooklyn Avenue hosted minor league baseball (the Kansas City Blues) for well over half its lifetime, thirty-two years out of fifty. It was also home for a number of years to the famed Kansas City Monarchs of the Negro Leagues. Indeed, in many ways the Blues and Monarchs were more interesting to watch than their less successful big league successors, the A's (for thirteen years) and the Royals (for four).

The Kansas City Blues joined the American Association in 1902, when the league was first formed. The Blues had little success until they were bought by brewer George Muehlebach in the early twenties. In the spring of 1923, soon after acquiring the club, Muehlebach spent $400,000 building a 17,000-seat, roofed, single-decked ballpark that was to bear his name for fifteen years. The site, at 22nd Street and Brooklyn Avenue, had previously been an ash heap and frog pond.

It was a large ballpark, more appropriate for the dead-ball era that was ending than for the homer-hitting era that was just beginning: its dimensions were 350 feet from home plate down both the left- and right-field foul lines and 450 feet to dead center field.

The Blues won the American Association pennant in 1923, the first year in their new ballpark, and in 1929 as well. Both times, they also won the Junior World Series, beating the International League's Baltimore Orioles in 1923 and the Rochester Red Wings in 1929. The hero of Kansas City in the twenties was slugging first baseman Bunny Brief (real name Antonio Bordetzki), who frequently led the league in home runs and in runs-batted-in, despite playing in what was generally considered a pitcher's park. (However, the prevailing wind usually blew toward left field and Brief was a right-handed pull hitter.)

In the summer of 1937, the New York Yankees acquired the Kansas City American Association franchise for their farm system, and the ballpark was renamed Ruppert Stadium, in honor of Yankee owner Colonel Jacob Ruppert. However, Colonel

Ruppert died in 1939, so shortly thereafter the name was changed again, this time to Blues Stadium.

The wealth of talent supplied by the Yankees enabled the Blues to win pennant after pennant while they were a Yankee farm club (from 1937 through 1954). Hank Bauer, Bob Cerv, Jerry Coleman, Jerry Priddy, and Phil Rizzuto are only a few of the future big leaguers who learned to master their trade at Kansas City. In 1940, five-foot-six-inch Rizzuto hit .347 for the pennant-winning Blues and was honored as Minor League Player of the Year by *The Sporting News*. He also won a local poll as the most popular Kansas City player.

All this time, the Kansas City Monarchs were also playing their home games at 22nd Street and Brooklyn Avenue. The Monarchs were one of the nation's leading Negro teams from their formation in 1920 until their demise in 1955, the unfortunate but inevitable result of integration in baseball. It was from the Monarchs that Jackie Robinson made his historic leap into organized baseball. Some other Monarchs who starred for many years in the majors were Ernie Banks, Elston Howard, and Satchel Paige, who made Kansas City his home.

When Muehlebach Field first opened its gates, seating was segregated when the Blues played, but the WHITE and COLORED signs came down for Monarchs games. Johnny Kling, the former Cubs catcher, owned the Blues for several years in the mid-thirties and he refused to segregate seating in

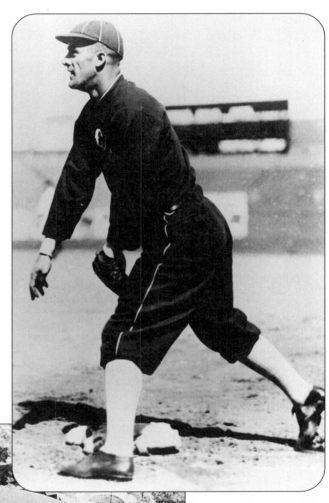

ABOVE: *Bunny Brief, Kansas City Blues first baseman. He led the American Association in both home runs and RBIs four times between 1920 and 1925.*

LEFT: *Blues Stadium in the forties.*

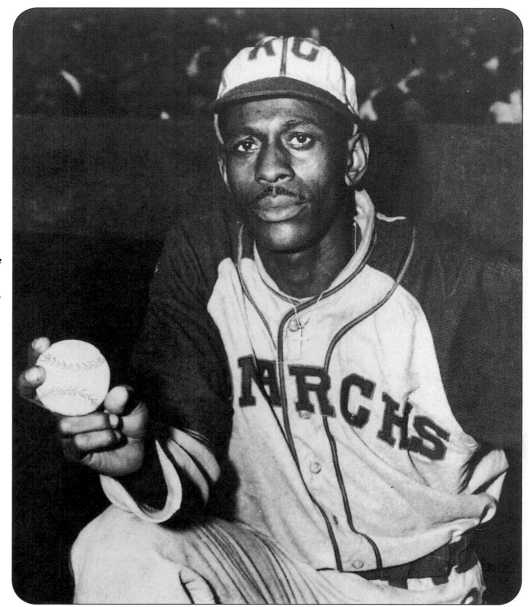

*Satchel Paige of the
Kansas City Monarchs.*

the ballpark regardless of who was playing. How-ever, when the Yankees acquired the club in 1937, segregation was reinstituted for Blues games, a decision that caused considerable bitterness in the black community.

The move of the Boston Braves to Milwaukee in 1953 and of the St. Louis Browns to Baltimore in 1954 whetted the appetite of Kansas Citians, black and white, for a major league team of their own. Until then, they didn't have much hope for major league status, since there hadn't been a big league franchise shift since 1903. They made it in Novem-ber of 1954, however, when Chicago businessman Arnold M. Johnson bought the Philadelphia Ath-letics from Connie Mack and his two sons, Roy and Earle, and received permission from the American League to move the franchise to Kansas City.

In the few months between November 1954 and Opening Day, April 12, 1955, the ballpark was com-pletely rebuilt, financed with the proceeds of a bond issue that had been approved by the voters the previous August. A roofed second deck was built to double-deck the ballpark, which expanded seating capacity from 17,000 to 31,000. (Subsequent

alterations increased seating to the neighborhood of 35,000.)

The enlarged ballpark's double-decked stands swept around home plate most of the way to the foul pole on the right-field side of the playing area, and to a short distance past third base on the left-field side. Uncovered single-decked bleachers then continued the remaining distance to the left-field foul pole.

There were no permanent stands in fair outfield territory, although temporary bleachers were occasionally erected behind the right-field fence. The outfield fence curved around in a semicircle from foul pole to foul pole. The height of the fence varied almost from year to year, but typically it was between 12 and 14 feet high. The big scoreboard, placed in right-center field, had formerly been the scoreboard in Boston's Braves Field.

Outfield distances at first were 312 feet from home plate to the left-field foul pole, 450 feet to dead center, and 347 feet down the right-field line. In the first year or two, these were adjusted, lengthening the distance to the left-field fence and bringing center in substantially: to 330 feet down the left-field line, 421 feet to center, and 353 down the right-field line.

Phil Rizzuto, age twenty-two. He was voted the Kansas City Blues' most popular player in 1939.

The A's never finished higher than sixth during the six years that Arnold Johnson or his widow owned the club. At the age of fifty-four, Johnson died suddenly while at spring training prior to the start of the 1960 season. Subsequently, flamboyant multimillionaire insurance broker Charles O. Finley bought the club in December 1960. The A's did even worse for him, at least during the seven additional years they remained in Kansas City. Even though Charlie O's team didn't win many ball games, there was always something interesting (and usually controversial) happening at 22nd and Brooklyn.

ABOVE: *Versatile Bert Campaneris, one of the stars of the Kansas City A's.*

RIGHT: *Aerial view of Municipal Stadium.*

For instance, in 1964 Finley decided that the reason the A's didn't do as well as the perennial pennant-winning Yankees was that the Yankees had an advantage: namely, the distance from home plate down the right-field line at Yankee Stadium was only 296 feet, whereas at Municipal Stadium it was a lengthy 338 feet (he had already reduced it from 353). Thus, the Yankees hit lots of home runs in New York that would be just long outs if hit by the A's in Kansas City.

The solution, Finley reasoned, was to match Yankee Stadium's 296 feet to the right-field stands. He therefore erected a 44-inch-high fence (the same height as the right-field fence at Yankee Stadium) that curved from right-center field to the foul line 296 feet from home plate, thereby mimicking Yankee Stadium's right-field dimensions.

The "Pennant Porch," as Finley called it, lasted for only two preseason exhibition games. Commissioner of Baseball Ford Frick and league president Joe Cronin ordered it removed on the grounds that it violated a rule specifying that all ballparks built after 1958 must have at least 325 feet down the foul lines and 400 feet to the center-field fence, and that no park could be remodeled to reduce distances below those figures. Finley responded by building a "One-Half Pennant Porch," with 325 feet down the

RIGHT: *Charles O. Finley astride Charlie O, the team mascot.*

BELOW: *It is Opening Day, 1955, and Blues Stadium has been double-decked and transformed into major league Municipal Stadium.*

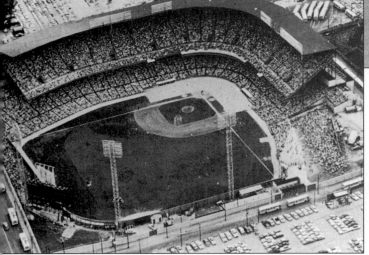

right-field line, which he kept through the 1964 and 1965 seasons.

An animal lover at heart, Finley put a picnic area and a small children's zoo in foul territory down the left-field line, featuring pheasants, monkeys, and rabbits. Sheep also grazed along the right-field embankment between the outfield fence and the outer concrete wall that backed up against Brooklyn Avenue, keeping down landscaping costs. And above all there was the A's mascot, "Charlie O," a Missouri mule that, for better or worse, often traveled with the team.

After numerous arguments with the municipal authorities (who were his landlords, since he leased the ballpark from the city), Finley departed in a huff for Oakland after the 1967 season and took his ballclub with him. This left Municipal Stadium empty in 1968 and Kansas City without a team in organized baseball. Missouri's representatives in Washington got so upset and the political ramifications were so explosive that baseball's top brass rushed to fill the void: in 1969, the American League returned to Kansas City in the form of an expansion team—named the Royals in a fan contest. The new team was owned by Ewing Kauffman, president of Marion Laboratories, a large pharmaceutical company.

For the last four years of its life, under the new Kauffman regime, the outfield dimensions of Municipal Stadium stabilized at 369 feet down the left-field line, 421 feet to center, and 338 feet down the right-field line.

The A's and Royals didn't set any houses afire during their seventeen years at Municipal Stadium,

but even so, they had some exciting moments. On September 8, 1965, for example, versatile shortstop Bert Campaneris became the first player in modern times to play all nine positions in one game, when he did so in a game against California at Municipal Stadium. Campaneris had to leave the game in the ninth inning after a collision at home plate, when, as the catcher, he blocked the plate against a base runner trying to score. Kansas City lost, 5–3, in thirteen innings.

In this game, Campaneris pitched strictly right-handed, his normal way of throwing. Three years earlier, in a Florida State League game, he had pitched two innings in relief throwing right-handed to right-handed batters and left-handed to left-handed batters! On August 13, 1962, pitching for Daytona Beach against Fort Lauderdale, the slim nineteen-year-old Cuban had struck out four, walked two, and allowed one hit and one run in two innings of ambidextrous pitching. "Now I've seen everything," said an awestruck scout who was watching the game.

Other special favorites of Kansas City fans between 1955 and 1972 included Bob Cerv, Bud Daley, Joe DeMaestri, Ken Harrelson, Catfish Hunter, Amos Otis, Lou Piniella, Vic Power, Suitcase Harry Simpson, and Gus Zernial.

On October 4, 1972, a small crowd of 7,329 saw the Royals defeat the Texas Rangers, 4–0, in the last big league game ever played at Municipal Stadium. The Royals thereupon left the old ballpark in favor of the Harry S. Truman Sports Complex on the edge of town, featuring side-by-side his-and-hers artificial-turf state-of-the-art stadiums for the Royals and the Kansas City Chiefs of the National Football League (who had also used Municipal Stadium).

Muehlebach–Ruppert–Blues–Municipal Stadium was razed by the city in 1976. The site on which it stood for half a century is now partly a community garden and partly a vacant lot.

Municipal Stadium in 1976.

Municipal Stadium's
Ten Most Memorable Moments

1. August 9, 1930: In a Negro League game, the Homestead Grays beat the Kansas City Monarchs in twelve innings, 1–0, with Smokey Joe Williams of the Grays striking out 27 Monarchs and allowing but one hit, while losing pitcher Chet Brewer of the Monarchs strikes out 19 and allows only four hits.

2. October 8, 1938: The Kansas City Blues of the American Association defeat the Newark Bears of the International League, 8–4, in the seventh and deciding game of the Junior World Series. (Kansas City and Newark are both farm teams of the New York Yankees.)

3. April 12, 1955, Opening Day: Transplanted from Philadelphia, the A's play their first game in the American League as the *Kansas City* A's, and beat the Detroit Tigers, 6–2.

4. July 13, 1963: In his *eighth* attempt, forty-three-year-old Early Wynn finally wins his 300th (and last) game, as Cleveland subdues Kansas City, 7–4.

5. May 2, 1964: Tony Oliva, Bob Allison, Jimmie Hall, and Harmon Killebrew of the Minnesota Twins hit consecutive home runs in the eleventh inning to outscore Kansas City, 7–3.

6. September 8, 1965: Kansas City shortstop Bert Campaneris becomes the first player in modern times to play all nine positions in one game as Kansas City loses to the California Angels, 5–3.

7. September 25, 1965: Fifty-nine-year-old Satchel Paige, appearing by special invitation, pitches three scoreless innings against the Red Sox, allowing only one hit and striking out one.

8. September 22, 1966: The Baltimore Orioles defeat the A's, 6–1, behind Jim Palmer's five-hitter, to clinch the American League pennant—the first major league flag won by a Baltimore team in seventy years.

9. September 27, 1967: The Kansas City A's play their last home game in Municipal Stadium—beating the White Sox, 4–0, behind the pitching of Catfish Hunter—before moving on to California, where they will reappear in 1968 as the *Oakland* A's.

10. April 8, 1969, Opening Day: The Kansas City *Royals*, a brand-new expansion franchise, play their first game in the American League, upsetting Minnesota in twelve innings, 4–3.

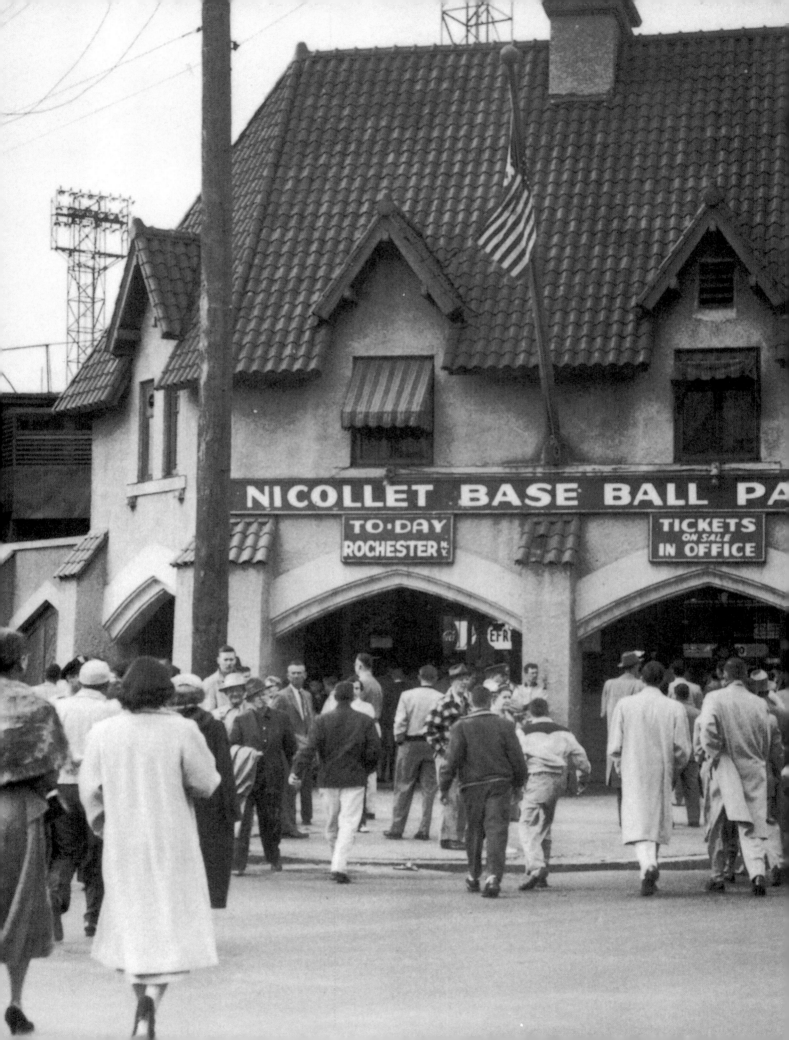

Nicollet Park

AND

Metropolitan Stadium

MINNEAPOLIS

LOCATION: 1. Nicollet Park—two miles south of downtown Minneapolis at the intersection of West 31st Street and Nicollet Avenue. The first-base foul line ran parallel to 31st Street, right field to center field parallel to Nicollet Avenue, center field to left field parallel to Lake Street, while the third-base foul line paralleled Blaisdell Avenue. 2. Metropolitan Stadium—in Bloomington, a suburb fifteen miles south of downtown Minneapolis, near the Minneapolis–St. Paul International Airport. The first-base foul line ran parallel to Cedar Avenue, right field to center field parallel to East 83rd Street (renamed Killebrew Drive), center field to left field parallel to 24th Avenue South, while the third-base foul line paralleled East 79th Street.

It is September 28, 1955, and the last game ever to be played at Nicollet will begin shortly.

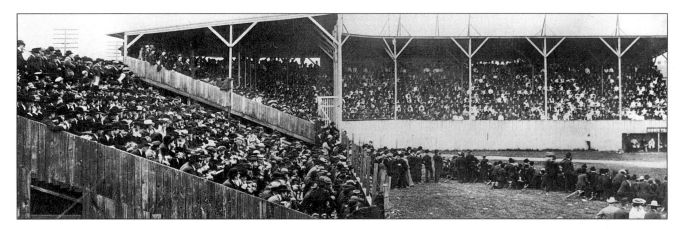

HOME OF: 1. Nicollet Park was the home of the *Minneapolis Millers*—in the Western League from 1896 through 1899, in the American League in 1900, and in the American Association from 1902 through 1955. 2. Metropolitan Stadium was the home of the *Minneapolis Millers* in the American Association from 1956 through 1960, and of the *Minnesota Twins* in the American League from April 21, 1961, to September 30, 1981.

ABOVE: *Opening Day, 1903, in Nicollet Park.*

BELOW: *First baseman Joe Hauser. He hit 69 home runs and drove in 182 runs for the Minneapolis Millers in 1933.*

*L*ong before Calvin Griffith moved his Washington Senators from Griffith Stadium to Minnesota in 1961, the Minneapolis Millers and the St. Paul Saints of the American Association had provided decades of exciting baseball for residents of the Twin Cities. Nicollet Park was built in 1896—inaugurated on June 19 of that year—when the Millers were in the Western League. A few years later, in 1902, Minneapolis and St. Paul both became charter members of the new American Association, a league they remained in until major league baseball dispossessed them in 1961.

Nicollet, by the way, is pronounced "Nick-let," like "Chiclet," with the accent on the first syllable and the "et" as in "bet," even though the name comes from nineteenth-century French astronomer-explorer Joseph Nicollet, who presumably pronounced it to rhyme with "Chevrolet." The ballpark was a single-decked stadium, with seats curving around home plate and extending down the length of both foul lines. There was no seating in fair outfield territory. In the beginning, only the area in

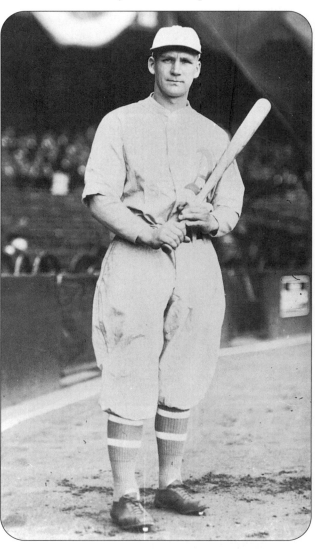

the neighborhood of home plate was roofed, but over time the roof was extended virtually the full length of both foul lines—all the way down the right-field foul line probably in 1912, when the park was renovated, and most of the way down the left-field foul line sometime after 1925.

The park's dimensions were largely determined by the city streets defining the block where it was located: it was 334 feet from home plate down the left-field line, with a 12-foot-high left-field fence, and 432 feet to center, both generous distances. Right field, however, was a mere 279 feet down the foul line.

The right-field power alley was a very reachable 330 feet. The inviting right-field fence was 25 feet high before 1935, 30 feet high thereafter. One aspect of the park that favored pitchers was the distance from home plate to the backstop: 88 feet, as compared with a normal 60 feet or so.

Seating capacity began at 4,000 in 1896 and increased over the years to a maximum of 8,500. When more wanted to get in, they sat on the field, in foul territory, or against the outfield fences.

Minneapolis was generally a successful team in the American Association. The Millers never finished last and won nine pennants—1910, 1911, 1912, 1915, 1932, 1934, 1935, 1950, and 1955. Joe Cantillon was the manager for the first four pennants, Donie Bush for the next three, Tommy Heath in 1950, and Bill Rigney in 1955.

It was at Nicollet Park that General Mills first used the advertising slogan "Breakfast of Champions" for Wheaties, putting the words on a billboard on the outfield fence in 1933, right after the Millers had won a pennant the preceding year. (Wheaties were introduced in 1924 in Minneapolis, which is still the home office of General Mills.)

The biggest star in the history of the Millers was first baseman Joe Hauser. "Unser Choe" (a German immigrant expression meaning "Our Joe") is the only man in baseball history to hit more than 60 home runs *twice*: he hit 63 for Baltimore in the International League in 1930 and 69 for Minneapolis in 1933 (50 of which he hit at Nicollet). In the latter year, Hauser hit numbers 68 and 69 on what was supposed to be the next-to-last day of the season, but lost his chance to hit number 70 when rain canceled what was scheduled to be the last game.

Hard-hitting outfielders Babe Barna, Spencer Harris, and Ab Wright were also great favorites in Minneapolis. Wright was a right-handed batter, so Nicollet's dimensions handicapped him. But on July 4, 1940, he cracked four home runs and a triple at Nicollet against the archrival St. Paul Saints.

Nineteen-year-old Ted Williams spent his third and last minor league season—1938—hitting the

Babe Ruth playing first base in an exhibition game at Nicollet in the mid-twenties.

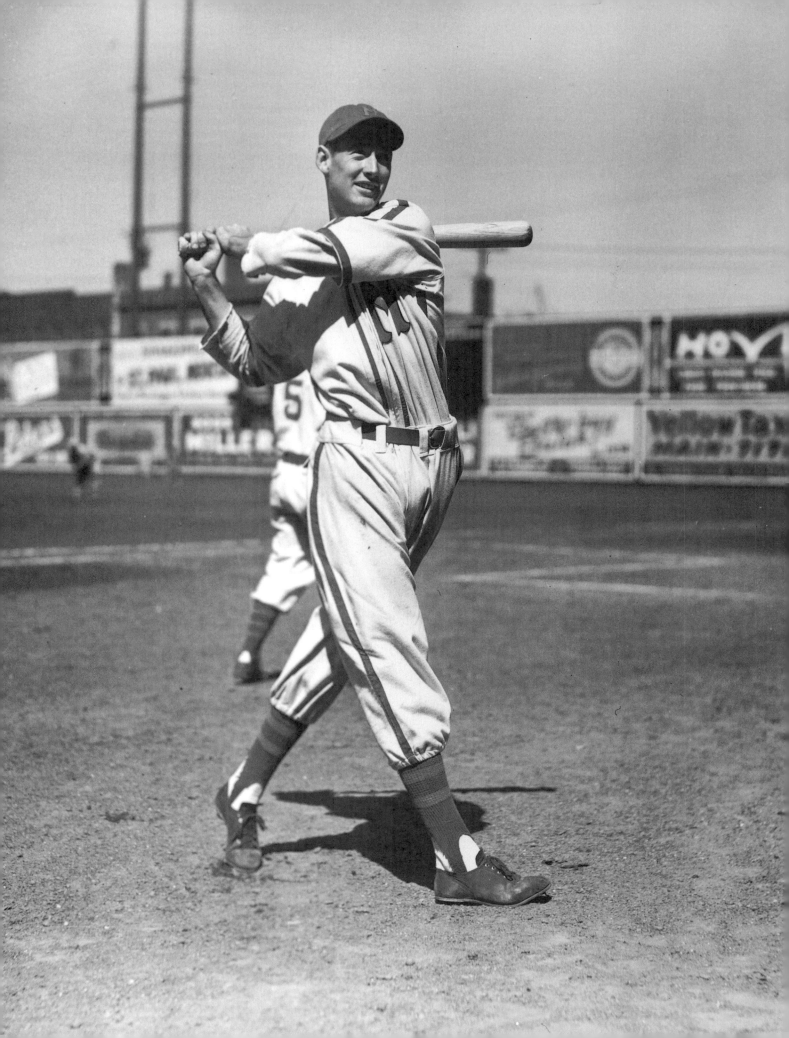

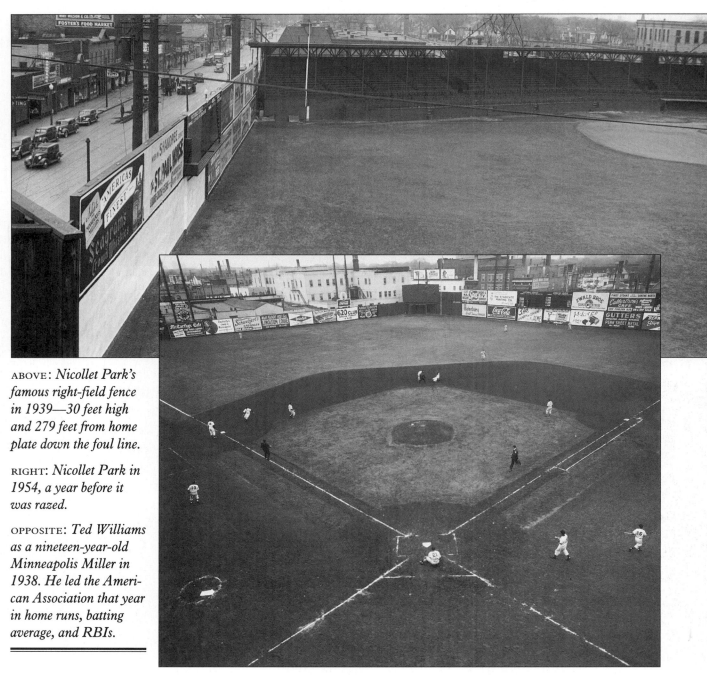

ABOVE: *Nicollet Park's famous right-field fence in 1939—30 feet high and 279 feet from home plate down the foul line.*

RIGHT: *Nicollet Park in 1954, a year before it was razed.*

OPPOSITE: *Ted Williams as a nineteen-year-old Minneapolis Miller in 1938. He led the American Association that year in home runs, batting average, and RBIs.*

ball over Nicollet's friendly right-field wall. Williams led the American Association that year in batting average, home runs, runs batted in, and runs scored. It is said that Williams's cocky attitude and self-centered behavior so annoyed manager Donie Bush that Bush told owner Mike Kelley, "Either that kid goes or I go." The predictable response: "We're going to miss you, Donie."

The story is reminiscent of an incident that took place in Boston a decade later. Williams was well known for refusing to wear a necktie. When it was announced that ex–Yankee manager Joe McCarthy would become the new manager of the Red Sox, the players eagerly looked forward to a confrontation between McCarthy and Williams, since McCarthy was known to insist that his players always wear jackets and ties in public.

On his first morning on the job, however, man-

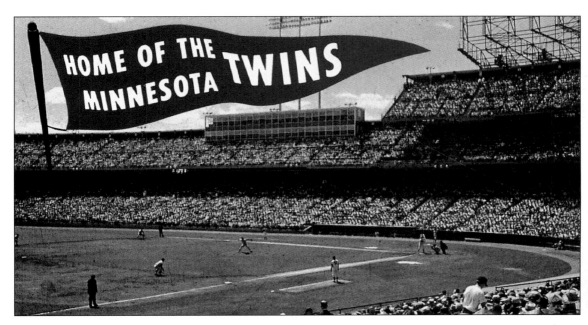

Metropolitan Stadium.

Willie Mays as a nineteen-year-old Minneapolis Miller in 1951. He was called up to the Giants after hitting .477 in 35 games.

ager McCarthy showed up in the hotel dining room wearing a colored sports shirt. "Any manager who can't get along with a .400 hitter," he said, "has to be out of his mind."

The highlights of every Minneapolis–St. Paul season were the traditional holiday doubleheaders between the Millers and the Saints—a morning game in one city and a seven-mile streetcar ride across the Mississippi River for an afternoon game in the other. If fans of both teams happened to be on the same streetcar, trouble was almost inevitable. (The Saints played their home games in

St. Paul's Lexington Park—at University Avenue and Lexington Parkway—which was razed in 1956 to make room for a shopping center.)

Eventually, Nicollet fell victim to the ravages of time and poor maintenance. "Even in the twenties," said catcher Hugh McMullen, "the fences were held up only by the paint on them."

On September 28, 1955, a sellout crowd packed the house for the last game ever played at Nicollet Park. They saw the Millers beat the Rochester Red Wings of the International League, 9–4, to win the Junior World Series (between the champions of the American Association and the International League). Only weeks later, wrecking crews began the demolition process.

A memorial plaque has been placed near the entrance of the Norwest Bank building, which now occupies the site. It reads:

For 60 years—1896 through 1955—Nicollet Park, located in this block, rang with the cheers of Minneapolis Miller baseball fans. Spectators came from all across the upper midwest to watch the best baseball in the region. On one occasion it was reported that the entire town of Buhl, Minnesota—530 people—motored down to the city to watch the Millers play. The park drew its largest crowd ever on April 29, 1946, when 15,761 people watched a doubleheader between the Millers and the St. Paul Saints. The seating capacity of the park was 8,500. The Saints won both games. Many of baseball's big names played and

LEFT: *Harmon Killebrew hitting his 534th career home run at Metropolitan Stadium in 1972. In all, he hit 573 homers (one for every 14.2 times at bat).*

BELOW: *Rod Carew. He won seven batting titles while with Minnesota from 1967 through 1978.*

managed at Nicollet Park, some for the Millers and some as visitors. Among them were Ted Williams, Hobe Ferris, Perry Werden, Mike and Joe Cantillon, Joe Hauser, Gene Mauch, Hoyt Wilhelm, Rube Waddell, Rosy Ryan, Bill Rigney, Herb Score, Al Worthington, Donie Bush, Mike Kelley, Spencer Harris, Ray Dandridge, and Willie Mays.

On April 22, 1956, the Millers opened the American Association season at new Metropolitan Stadium in suburban Bloomington, equidistant from downtown Minneapolis and St. Paul. They played there for five years before the Washington Senators took over the ballpark and the territory, bringing major league baseball to the Upper Midwest for the first time.

The first American League game in Minnesota was played at Metropolitan Stadium on April 21, 1961, with the expansion Washington Senators defeating the Minnesota Twins (the "old" Washington Senators), 5–3.

Metropolitan Stadium was built on 164 acres in the middle of a cornfield. The stadium looked like the product of a spoiled child's Erector set. It had a crazy-quilt combination of triple-decked, double-decked, and single-decked stands, with no roofs over any of them. The stands behind home plate and the infield were triple-decked; those down the right-field foul line to the foul pole, and from the left-field foul line to center field, were double-decked; while the stands down the left-field foul

line to the foul pole, and standing alone in right field, had only a single deck. Initial seating capacity of 40,000 was gradually expanded to 46,000.

At first, outfield dimensions were 330 feet from home plate down both foul lines and 412 feet to dead center. But at these distances baseballs flew out of Metropolitan Stadium like golf balls at a practice range. The New York Yankees hold the all-time record for home runs in a season—240—set in 1961, when Roger Maris hit 61 and Mickey Mantle hit 54. But it is the Twins who hold the all-time record for home runs in *two* consecutive seasons—446—which was set in 1963 and 1964 shortly after they started in Metropolitan Stadium.

Harmon Killebrew, Bob Allison, Earl Battey, and Jimmie Hall accounted for a good share of these four-baggers. All except Jimmie Hall were right-handed batters, leading to the suspicion that the left-field fence was perhaps a bit too close.

In 1965, the left-field fence was moved back to

Nicollet Park's and Metropolitan Stadium's Ten Most Memorable Moments

1. September 9, 1933: Minneapolis first baseman Joe Hauser hits home runs numbers 68 and 69, to set a single-season home run record for the high minor leagues that has never been matched.

2. July 4, 1940: Minneapolis Millers outfielder Ab Wright hits four home runs and a triple in a 17–5 rout of the St. Paul Saints; Wright's first homer is a monster that clears the center-field wall between the flagpole and the scoreboard.

3. September 28, 1955: In the last game ever played at Nicollet Park, the Minneapolis Millers (American Association) defeat the Rochester Red Wings (International League), 9–4, in the seventh and deciding game of the Junior World Series—for Minneapolis's first-ever Junior World Series Championship.

4. April 21, 1961, Opening Day: The Minnesota Twins, transplanted from Washington, inaugurate major league baseball in Minnesota, with the final score Washington Senators (a new expansion team) 5, Minnesota Twins 3—or "new" Senators 5, "old" Senators 3.

5. May 9, 1961: Baltimore first baseman Jim Gentile hits two grand-slam home runs—in consecutive innings—in a Baltimore victory over Minnesota, 13–5.

6. July 18, 1962: Minnesota's Harmon Killebrew and Bob Allison *both* hit grand-slam home runs in an *eleven-run* first inning of an eventual 14–3 win over Cleveland.

7. July 23, 1964: Kansas City shortstop Bert Campaneris hits two home runs in his first major league game, one of which is on the first pitch in his first time at bat. (Over the next nineteen years, Campaneris will come to bat 8,682 more times but manage only 77 more homers, about one for every 110 at bats.)

8. October 7, 1965, second game of the World Series: Minnesota's Jim Kaat outpitches L.A.'s Sandy Koufax, 5–1, assisted by a sensational one-handed diving catch by left fielder Bob Allison in the fifth inning.

9. October 14, 1965, seventh and deciding game of the World Series: This time, Koufax's three-hitter and 10 strikeouts beat Minnesota's Kaat, 2–0, winning the world championship for Los Angeles.

10. June 9, 1966: The Twins set an American League record by hitting five home runs in the seventh inning, beating Kansas City, 9–4.

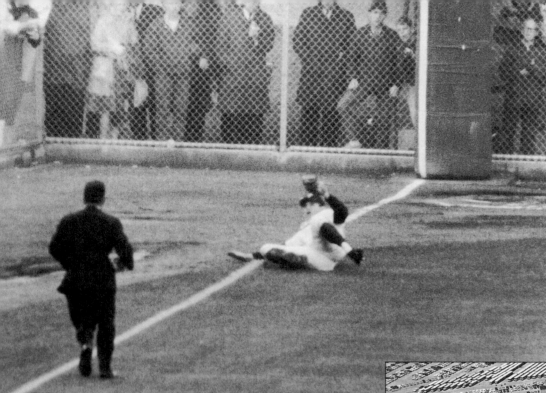

LEFT: *Twins outfielder Bob Allison making his celebrated catch in the second game of the 1965 World Series. (The fence is 344 feet from home plate along the left-field foul line.)*

BELOW: *Metropolitan Stadium in the late sixties.*

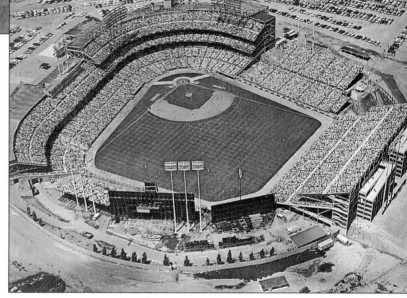

344 feet and, after a little tinkering, outfield distances settled in the late sixties at 346 feet from home plate down the left-field line, 425 feet to center, and 330 feet down the right-field line. For the last five years of the ballpark's life, from 1977 through 1981, the fences were brought in slightly in left and especially in center to 343–402–330. Fences were 12 feet high in left field, 8 feet high in center and right.

The Twins won one American League pennant at Metropolitan Stadium—in 1965—the first for a Griffith-owned club since the Washington Senators in 1933. They also won two divisional championships—in 1969 and 1970—only to lose the playoffs to Baltimore both times.

In the one World Series played at Metropolitan Stadium, the Twins lost in seven games to the Los Angeles Dodgers and the premier pitcher of the era, Sandy Koufax.

After twenty-one years at Metropolitan Stadium, the Twins played their last game there on September 30, 1981, losing to Kansas City, 5–2, before a relatively small crowd, numbering only 15,900.

Six months later, the Twins opened the 1982 baseball season in the Hubert Horatio Humphrey Metrodome, a new indoor temperature-controlled artificial-turf multipurpose domed arena built with public funds near downtown Minneapolis. The Twins left Metropolitan Stadium for the Metrodome (nicknamed the Homer Dome) mainly because the National Football League's Minnesota Vikings, joint tenants at Metropolitan Stadium, wanted an arena with larger seating capacity and threatened to leave town if they didn't get it. To keep the Vikings in Minnesota, the Metropolitan Sports Facilities Commission, a public authority, built the multipurpose Metrodome.

Metropolitan Stadium was demolished in 1985. The site is now occupied by a "megamall"—a huge amusement park and retail store complex.

Offermann Stadium

BUFFALO

LOCATION: On the near east side, about two miles from downtown, on Michigan Avenue at East Ferry Street. The first-base foul line ran parallel to Michigan Avenue, right field to center field parallel to Woodlawn Avenue, center field to left field parallel to Masten Avenue, while the third-base foul line paralleled Ferry Street.

HOME OF: The Buffalo Bisons in the International League from April 30, 1924, to September 17, 1960.

From 1886 through 1970, except for 1899 and 1900, Buffalo was in the International League, one of the three top minor leagues in organized baseball (along with the American Association and the Pacific Coast League).

And just as baseball was played in Cincinnati at the intersection of Findlay and Western for eighty-six consecutive years, so it was played in Buffalo at the intersection of Michigan and Ferry for seventy-two consecutive years, from 1889 through 1960.

A close-up of the non-electric Offermann Stadium center-field scoreboard in 1957. Men working inside the scoreboard's narrow confines changed the numbers by hand.

Olympic Park, erected at Michigan and Ferry in 1889, lasted for thirty-five years. After the 1923 season, the wooden ballpark was replaced by a modern concrete-and-steel structure that was called Bison Stadium for a dozen years and then renamed Offermann Stadium after the death in 1935 of club president Frank J. Offermann.

Offermann (Bison) Stadium had a seating capacity of 14,000 in a single-decked grandstand that was almost entirely roofed. From the home plate area, the grandstand roof stretched past first base all the way down the length of the right-field foul line to the outfield fence. On the third-base side, the roof extended three fourths of the way down the left-field foul line, with an uncovered bleacher section (of 3,100 seats) continuing the remaining distance to the foul pole.

There was no seating in fair outfield territory except for neighbors who ignored the box office and enjoyed games from their rooftops and second-story windows along Masten Avenue (beyond the left-field fence) and along Woodlawn Avenue (beyond the right-field fence). Noted Buffalo historian Joseph Overfield tells of one Woodlawn Avenue resident whose attachment to baseball, which he had watched free for many years, continued to the very end, when a long home run off the bat of Buzz Arlett of the International League Baltimore Orioles crashed through the front window of his house and came to rest among the mourners gathered around his casket.

From home plate to the fence down the left-field foul line was 321 feet, to center field 400 feet, and down the right-field line only 297 feet. The power alleys were 345 feet in left-center and 365 feet in right-center.

For the first decade, fences were 12 feet high all around, except for a huge 50-foot-wide scoreboard just to the right of dead center field that soared 30 feet above the fence. Advertising signs atop the

Ollie Carnegie in 1933. He became a favorite of Buffalo fans, with well over a hundred runs batted in year after year.

150

scoreboard rose another 18 feet to a total height of 60 feet.

Between the 1933 and 1934 seasons, management raised the left-field fence (only) by 20 feet, to a height of 32 feet, in order to block the view from Masten Avenue rooftops.

Just as Crosley Field was the location of the first major league night game, in 1935, so Offermann Stadium—it was still Bison Stadium then—was the site of the first night game in the high minor leagues. On July 3, 1930, five years before it came to the majors, night baseball was introduced to the International League; Depression or not, a curious crowd of over 12,000 paid to see the visiting Montreal Royals defeat the Bisons, 5–4, under the lights.

Offermann was a hitter's park from the start, partly because of the friendly right-field wall that helped left-handed pull hitters, partly because of the prevailing winds that helped right-handed power hitters, and partly because of the short distance between home plate and the backstop—only 33 feet—that helped *all* hitters. Batters were given another chance on foul pop-ups that catchers would probably have caught for outs in other ballparks.

As though to seal Offermann's reputation as a hitter's park, Newark outfielder Bob Seeds had one of the great two-day hitting sprees of all time there on May 6 and 7, 1938. A right-handed batter, thirty-one years old, on the downside of his career, Seeds got nine hits in ten times at bat, including seven home runs, and batted in 17 runs. He hit four of his home runs on May 6 and three more the following day.

RIGHT: *Frank J. Offermann was principal owner of the Bisons from 1920 until his death in 1935. After he died, Bison Stadium was renamed in his honor.*

BELOW: *Offermann Stadium.*

Two other red-letter days stand out from the point of view of batting prowess in Offermann Stadium. On Memorial Day in 1932, the Buffalo Bisons overwhelmed Toronto in a doubleheader by scores of 18–1 and 26–2 (the second game lasted only seven innings!). And sixteen years later, on June 20, 1948, the Bisons trounced Syracuse in a Sunday doubleheader, 28–11 and 16–12 (the second game again limited to seven innings). In those four games, a total of 114 runs were scored, 88 of them by the Buffalo team!

After World War I, Buffalo won only four International League pennants—in 1927 with Bill Clymer as manager, in 1936 under Ray Schalk, in 1949 under Paul Richards, and in 1959 with Kerby Farrell as skipper. The Bisons, representing the International League, never did succeed in winning a Junior World Series; they lost to the team representing the American Association every time they made it that far.

The two most popular players in the history of the Bisons were outfielder Ollie Carnegie and first baseman Luke Easter. Five feet, seven inches tall and 175 pounds, Carnegie worked for the Pennsylvania Railroad until he lost his job in the Great Depression. He didn't start to play professional baseball until 1931, when he was thirty-two years old. Nevertheless, he was Buffalo's regular left fielder from 1932 through 1941: in those ten years, he walloped 254 home runs and drove in over a thousand runs, twice leading the International League in both home runs and runs batted in. In 1938, when he was thirty-nine years old, Ollie Carnegie batted .330, hit 45 home runs, and drove in 136 runs. A right-handed batter, he never got a chance to show what he could do in the big leagues.

BELOW: *Jesse Hill of the visiting Newark Bears is hitting into a double play on July 14, 1932. Notice the empty bleacher seats, while fans are packed on rooftops overlooking the left-field fence.*

RIGHT: *The left-field fence has now been raised 20 feet, eliminating the rooftop audience.*

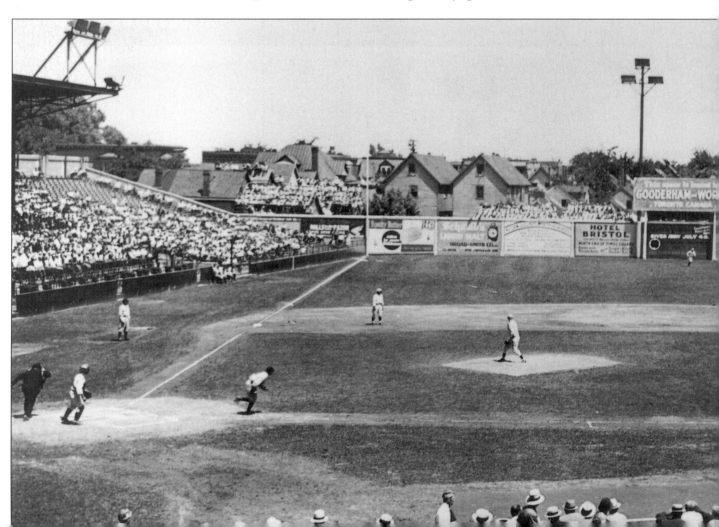

Major league scouts who were attracted by his bat were frightened away by his age.

Luscious Luke Easter—"Luscious" was his real name, not a nickname—a mammoth six-foot-four-inch 240-pound left-handed power hitter, had risen to fame with the Cleveland Indians in the early fifties on the wings of his prodigious home runs. In fact, Luke *still* holds the record for hitting the longest home run at Cleveland's Municipal Stadium, a 477-foot upper-deck blast, on June 23, 1950. Easter came to the Bisons in 1956, Buffalo's first black player since second baseman Frank Grant in 1888.

Easter was already forty-one years old when he arrived in Buffalo. But that didn't stop him from leading the International League in runs batted in

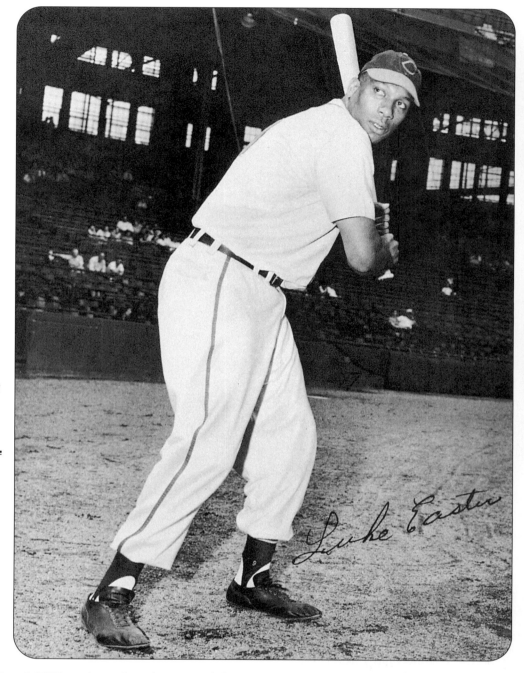

Luke Easter in 1952, when he hit 31 home runs for the Cleveland Indians. In his three-plus years with Buffalo he hit 114 homers and drove in 353 runs.

and home runs in 1956 and 1957, and coming close to the leaders in both categories in 1958. He also became an immediate folk hero in Buffalo, as he had previously been in Cleveland, due as much to his charismatic personality as to his long-distance batting feats.

On July 14, 1957, Luscious Luke did something no one else had ever done—he hit a ball so high and so far that it sailed *over* the center-field scoreboard, 400 feet away. Including the advertising signs atop it, the scoreboard was 60 feet high! On August 15

of the same year, he almost repeated the feat—this time the ball cleared the 42-foot-high scoreboard but hit one of the advertising signs on top of it.

Twenty-two years later, in 1979, Easter, employed as a guard in Euclid, Ohio, was accosted by two men who demanded the $40,000 payroll he was carrying. When he refused, one of the robbers shot and killed him.

The Bisons abandoned Offermann Stadium after the 1960 season when the city, wanting the site for a school, instituted condemnation proceedings

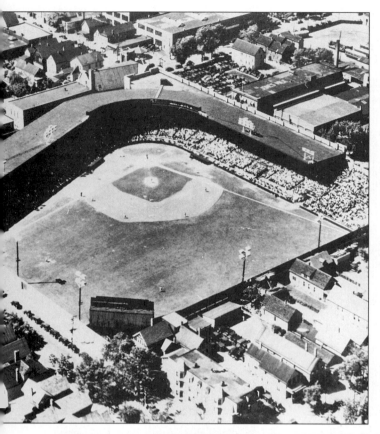

under the right of eminent domain. Only 2,020 fans attended the last game played at the old ballpark, on September 17, 1960; Toronto beat Buffalo on that occasion, 5–3, to win the International League playoffs.

With Offermann no longer available, starting in 1961 the Bisons played ten blocks away at the War Memorial Stadium, which had its own moment of glory in 1983 when it was used as the locale for the movie adaptation of Bernard Malamud's novel *The Natural*, starring Robert Redford. The Bisons moved again in 1988, this time to a new ballpark in downtown Buffalo, Pilot Field, that is capable of enlargement to major league status.

Offermann Stadium was demolished shortly after the 1960 season; the site on which it stood for thirty-seven years is now occupied by a junior high school.

LEFT: *Bison (Offermann) Stadium in 1933.*

BELOW: *A packed house on April 27, 1960, the last Opening Day at Offermann Stadium.*

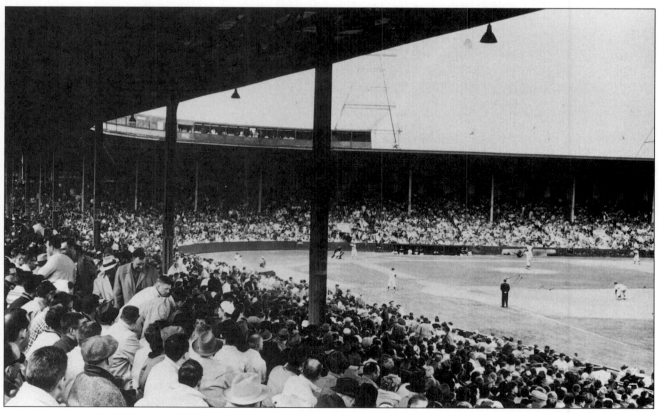

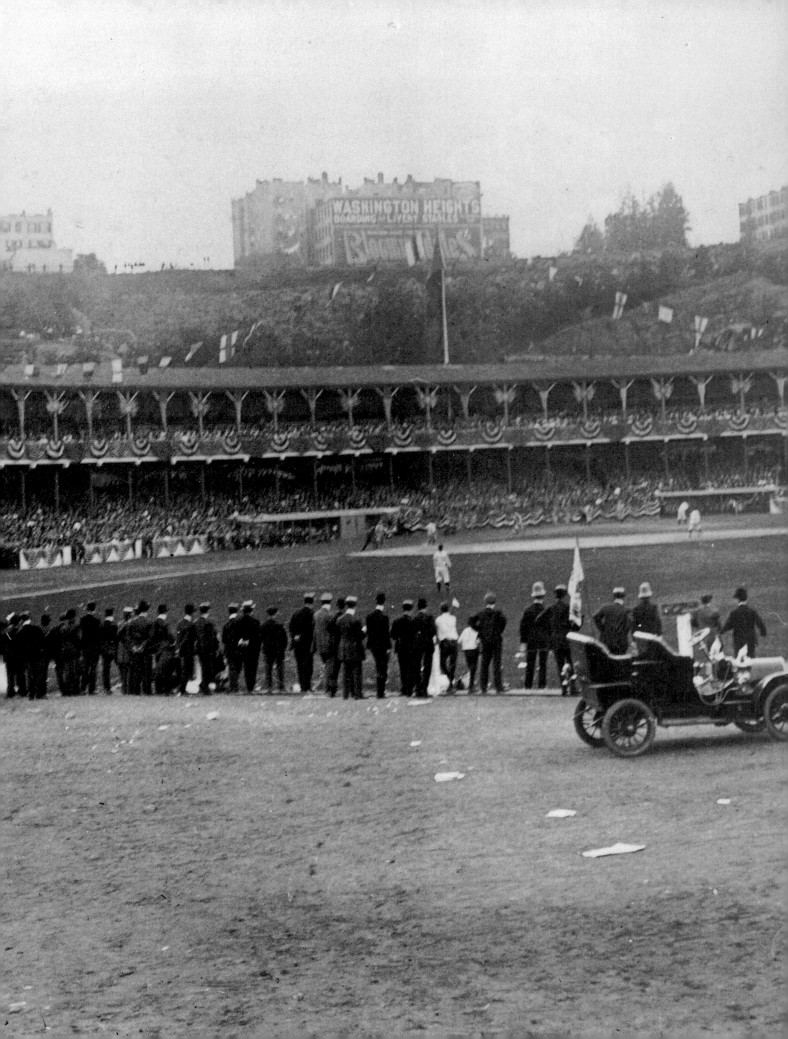

Polo Grounds

NEW YORK

LOCATION: In the north Harlem section of Manhattan, on the west side of Eighth Avenue between 157th and 159th streets. Home plate was directly beneath the Speedway (now the Harlem River Drive) and Coogan's Bluff; the first-base foul line went from home plate toward 157th Street, and the third-base foul line from home plate toward 159th Street, while center field paralleled Eighth Avenue (with the Harlem River in the background).

HOME OF: The New York *Giants* from April 22, 1891, to September 29, 1957; the New York *Yankees* from April 17, 1913, to October 8, 1922; and the New York *Mets* from April 13, 1962, to September 18, 1963.

Next to Yankee Stadium, the Polo Grounds is the most storied ballpark in baseball history. Manager John McGraw brought home ten pennant winners in the strangely shaped stadium; Christy Mathewson, Carl Hubbell, Mel Ott, and Willie Mays became living legends there; and from 1908—when Fred Merkle forgot to touch second base—to 1951—when Bobby Thomson put the

The Polo Grounds in the mid-1890s.

157

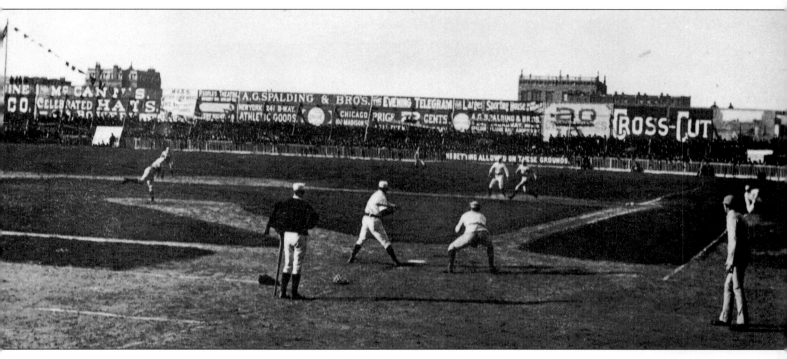

ABOVE: *Boston vs. New York in 1886 at the* original *Polo Grounds, located at 110th Street and Fifth Avenue. Notice where the umpire (there was only one) used to stand.*

RIGHT: *John J. McGraw, manager of the New York Giants from 1902 to 1932.*

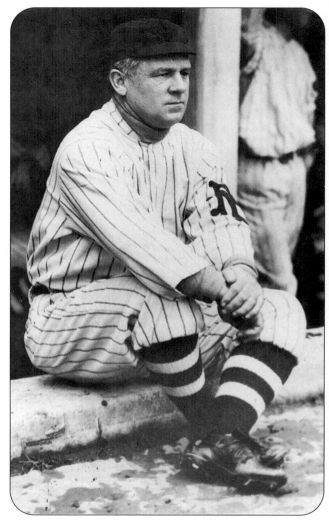

finishing touch on the miracle of Coogan's Bluff— the Polo Grounds was the scene of one unbelievable event after another.

Indeed, polo was once played at the Polo Grounds. But that was long ago, in the 1870s, when it was played in a field adjoining the northeast corner of Central Park—from 110th to 112th streets, west of Fifth Avenue. In 1883, New York Giants owner John B. Day, a wealthy manufacturer, built a baseball park there that, naturally enough, became known as the Polo Grounds.

In 1889, the top brass at City Hall unceremoniously kicked the Giants out of their home when they decided that the city absolutely must have a traffic circle at Fifth Avenue and 110th Street. As the new site for a ballpark, John B. Day chose to lease the southern half of Coogan's Hollow, a grassy meadow under Coogan's Bluff. Both hollow and bluff were named after New York landowner James J. Coogan.

During much of 1889 and 1890, Day's National

League Giants played in the southern half of Coogan's Hollow, in a ballpark erected between 155th and 157th streets. Next door, in the northern half, between 157th and 159th streets, the upstart Players League built their own ballpark.

When the Players League collapsed after the 1890 season, John B. Day acquired the larger Players League ballpark and moved the Giants a few hundred feet north. On April 22, 1891, the Giants played the first National League game at their new home, losing to Boston, 4–3. Since the team used to play at the 110th Street Polo Grounds, their new park took the same name, although polo was never in fact played at the Coogan's Hollow site.

Both the new Polo Grounds, made mostly of wood, and its eventual concrete-and-steel successor were tucked under Coogan's Bluff, with home plate

RIGHT: *Christy Mathewson, winner of 372 games for the New York Giants between 1901 and 1916.*

BELOW: *The view from Coogan's Bluff, where a crowd was usually gathered, in 1908.*

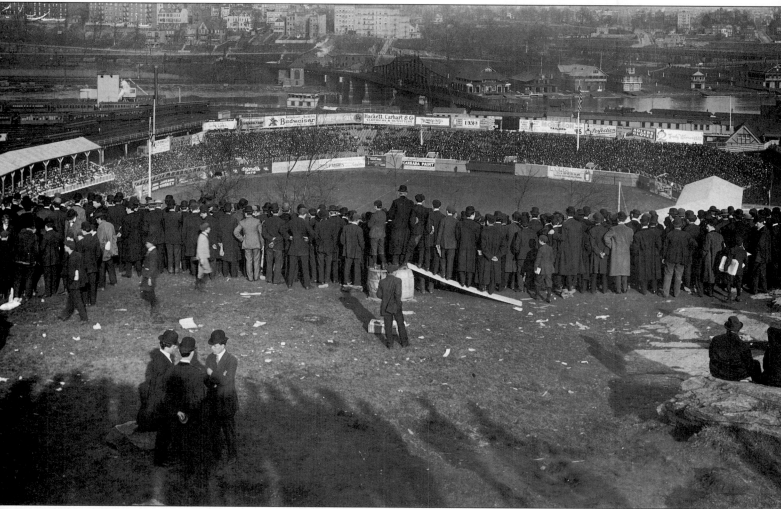

on the meadow almost directly under the cliff and an elongated field the length of two football fields stretching toward Eighth Avenue and the Harlem River. Stairs from the top of the bluff led down to grandstand ticket booths, so that it was the only major league ballpark where the most convenient way to get to upper-deck grandstand seats was by walking *down* rather than up.

In the 1890s, the wooden ballpark beneath Coogan's Bluff consisted of a roofed double-decked grandstand that curved around home plate and went about 20 feet past first base and third base; uncovered bleacher seats then took over and stretched most of the way down both foul lines. The grandstand upper-deck roof was supported by prominent Y-shaped posts spaced approximately 15 feet apart. The gentry could watch from their horse-and-carriages parked behind a rope in deep center field, some 500 feet from home plate. Not counting the horses, the ballpark held 16,000.

By 1905, when the Giants played in their first World Series, the Polo Grounds had been enlarged to seat about 23,000, mainly by the addition of uncovered single-decked bleachers in the outfield. The bleachers now curved around the entire outfield to form an elongated semicircle. The double-decked grandstand around the infield was still identified by its prominent Y-shaped upper-deck support posts.

Specs Toporcer, who was born in 1899 and spent a number of years as a big league infielder in the twenties, recalled seeing games at the Polo Grounds long ago: "When I was ten years old, I started making frequent afternoon excursions to the Polo Grounds," he reminisced. "This meant a five-mile walk each way. Dad was able to give me a weekly allowance of only one cent—yes, one cent—so I didn't have enough money for streetcars or subways, and of course I couldn't pay my way into the ballpark.

"Fortunately, I was able to see my heroes from a perch on Coogan's Bluff, a hill situated behind the home plate area of the grandstand. An open space below the roof of the stadium made it possible for me, and for others crowded together on the rocky hill,

to peek at part of what was happening on the field."

Early in the morning of April 14, 1911, while it was still dark, a raging fire of unknown origin consumed most of the wooden ballpark. The grandstand and left-field bleachers burned to the ground. Only part of the right- and center-field bleachers remained standing, about 10,000 seats in all.

The Yankees invited the Giants to share Hilltop Park while the Polo Grounds was being rebuilt. Astonishingly, the hospitality was needed for only eleven weeks, because by June 28 the ballpark was once again open for business. Most of it was still to be constructed, but by that date 16,000 seats were ready (including the 10,000 that had survived the fire).

By October 14, when the Giants opened the 1911 World Series against the Philadelphia Athletics, 34,000 seats were available in a brand-new concrete-and-steel structure; an imposing double-decked roofed grandstand reached almost to the foul pole in left field and past the foul pole 30 or 40 feet into fair territory in right field, with 15,000

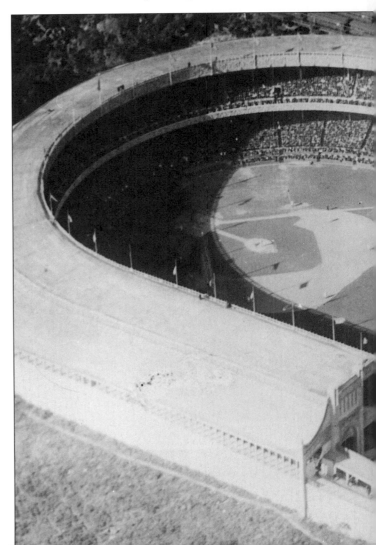

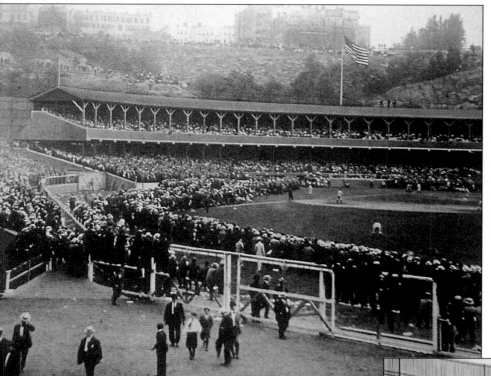

LEFT: *Packed stands at the Polo Grounds.*

BELOW: *George Gibson, Pittsburgh catcher, taking batting practice at the Polo Grounds in 1909. The gadget on top of the stadium prevented foul balls from leaving the ballpark.*

BELOW, LEFT: *A rare aerial view of the Polo Grounds in 1921, before both wings of the double-decked roofed grandstand were extended to replace most of the open bleacher seats.*

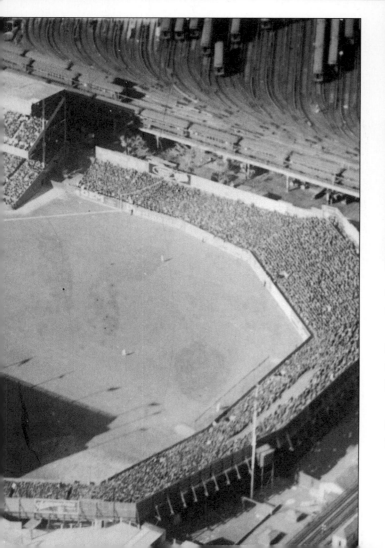

uncovered bleacher seats surrounding the rest of the outfield.

The rebuilt structure was officially named Brush Stadium after John T. Brush, who then owned the Giants, but the name never stuck; Polo Grounds it had been and Polo Grounds it would remain.

After leaving Hilltop Park at the end of the 1912 season, the Yankees shared the Polo Grounds with the Giants for ten years, until Yankee Stadium

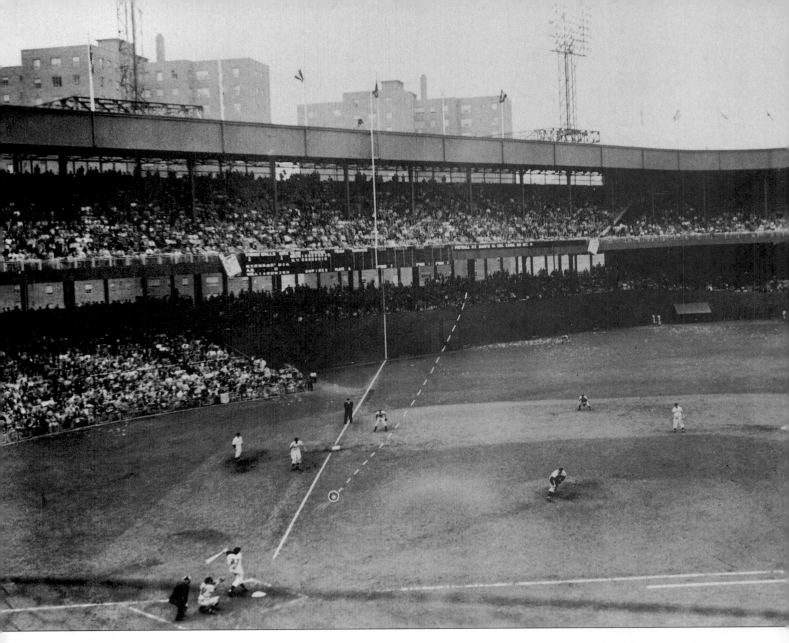

opened on April 18, 1923. Because both the Yankees and the Giants used the Polo Grounds as their home park from 1913 through 1922, the *entire* World Series of 1921 and 1922 took place there. John McGraw's Giants beat Miller Huggins's Yankees both times.

In the 1922–23 off-season, both wings of the double-decked roofed grandstand were extended deep into the outfield, replacing most of the bleacher seats. This gave the stadium the final form that many still remember—a double-decked roofed grandstand completely encircling the playing field, except for a small uncovered single-decked bleacher section in center field that was divided in half by a building containing the players' clubhouses and administrative offices.

One thing that wasn't changed by the 1911 fire, or by any later additions, was the elongated bathtub-like shape of the ballpark. Whether made of wood or of steel and concrete, the Polo Grounds had the same odd basic configuration. The distance from home plate down the foul line to the left-field wall was only 279 feet, down the foul line to the right-field wall only 257 feet. These measurements were virtually the same as in the original wooden park.

The center-field distance was shortened from that of the 1890s, but not by much: from 1923 on, it was 460 feet from home plate to the front of the bleachers, where the bleachers flanked the runway to the clubhouse building, and 483 feet all the way to the clubhouse itself. A few feet in front of the clubhouse, in fair territory and in play, was a 5-foot-

high memorial to Captain Eddie Grant, Harvard graduate and former Giant infielder, the first major league ballplayer killed in World War I.

At the left-field foul pole, the concrete wall was 17 feet high, gradually rising to 18 feet in left center and then sloping down to 12 feet where the left-field grandstand met the center-field bleachers. In right field, the wall was 11 feet high at the foul pole, gradually rising to 12 feet where the right-field grandstand met the center-field bleachers.

OPPOSITE: *It is October 3, 1951, and Bobby Thomson has just hit "the shot heard 'round the world," to win the pennant for the Giants.*

RIGHT: *Aerial view of Yankee Stadium (foreground) and the Polo Grounds, with the Harlem River in between and the Hudson River in the background.*

BELOW: *It is September 29, 1957, and Dusty Rhodes of the Giants is being thrown out at first base for the final out of the Giants' last game at the Polo Grounds. (The Eddie Grant monument is clearly visible in front of the 483-foot sign posted on the clubhouse building in deep center field.)*

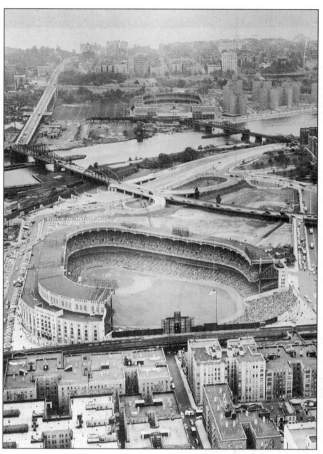

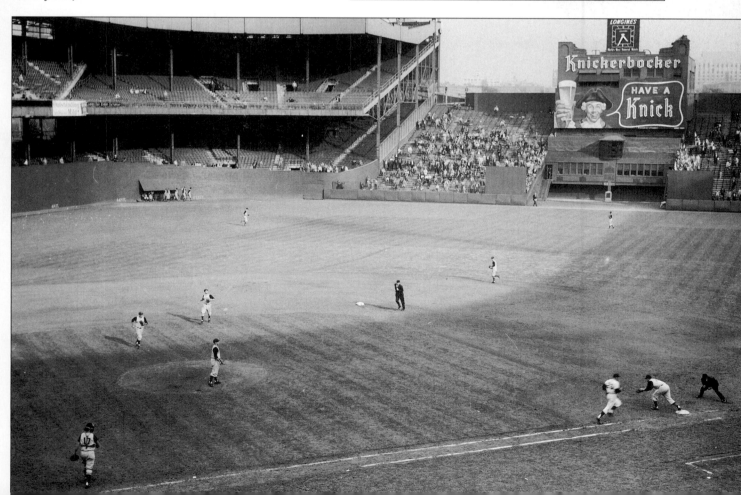

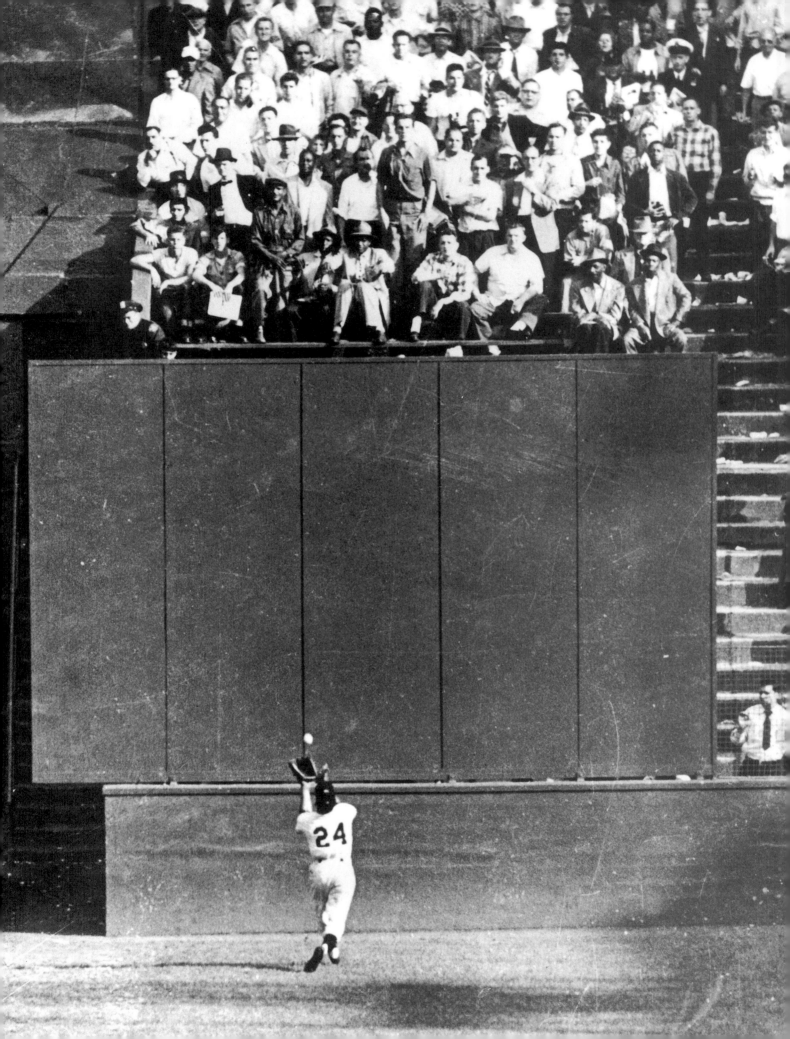

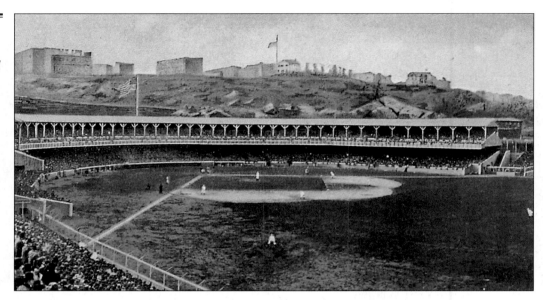

OPPOSITE: *Willie Mays making his famous catch of a ball hit by Cleveland's Vic Wertz in the first game of the 1954 World Series.*

RIGHT: *The Polo Grounds' grandstand.*

The bleacher seats were behind 4-foot-high concrete walls topped by a 4-foot-high wire screen. Two dark-green canvas batters' backdrops, to enable batters to see the ball more clearly, were placed atop the low concrete bleacher walls 460 feet from home plate; each 20 feet wide and 17 feet high, they guarded each side of the runway leading to the clubhouse like the impassive lions in front of the main building of the New York Public Library on Fifth Avenue.

Seating capacity for baseball reached 55,000, of which about 4,500 were the center-field bleacher seats. However, the largest crowd in the history of the Polo Grounds was for *boxing*, not baseball. On September 14, 1923, more than 82,000 paying customers saw what many still consider the greatest heavyweight title fight of all time. Champion Jack Dempsey, knocked out of the ring in the first round by Argentine challenger Luis Angel Firpo, climbed back—actually, he was shoved back by reporters at ringside—and knocked out the "Wild Bull of the Pampas" in fifty-seven seconds of the second round.

In left field (but not in right), there was an unusual upper-deck overhang: beginning in foul territory and extending well toward the bleachers in fair territory, the upper deck jutted out into the playing field farther than the lower deck by a full 23 feet. Many a left fielder waiting for a lazy fly ball to drop into his glove watched helplessly as the ball

fell into the upper deck overhang, or glanced off the facing, for a home run.

Although the recorded distances to the foul poles were 279 feet to left and 257 feet to right, those were ground-level measurements. With respect to the *upper* deck, the home-run distance was actually

BELOW: *Casey Stengel, manager of the New York Mets during their two years at the Polo Grounds (1962 and 1963). He is on the stairs leading to the clubhouse in center field. (Traditionally, the home team's clubhouse was on the right-field side, the visiting team's on the left-field side.)*

a foot *shorter* to left than to right—taking a 34-foot upward trajectory into account, it was 258 feet from home plate down the line to the upper-deck overhang in left and 259 feet to the upper deck in right.

While batters who could pull the ball down the foul lines—such as Johnny Mize, Mel Ott, and Dusty Rhodes—loved the Polo Grounds, hitters who typically drove the ball to the conventional power alleys in left- and right-center hated it. Given the bathtub-like shape of the park, home-run distances increased rapidly from the foul lines toward center field; the power alley in left-center was a solid 380–390 feet and the same in right-center. Many a 400-foot-plus drive that would have been a homer just about anywhere else was caught by outfielders roaming the vast reaches of center field at the Polo Grounds. The most famous example is Willie Mays's dramatic catch of Vic Wertz's 445-foot drive in the first game of the 1954 World Series.

Pennant winners in 1951 and 1954, the Giants nevertheless abandoned the Polo Grounds after the 1957 season to follow the Dodgers to California. On September 29, 1957, before 11,606 spectators, the Giants played their last game under Coogan's Bluff, losing to the Pittsburgh Pirates, 9–1.

A revival began in 1962, when Casey Stengel's expansion Mets brought National League baseball back to New York after a four-year interruption. The Mets called the Polo Grounds home for two years while they awaited completion of Shea Stadium, in the borough of Queens. Finally, though, on September 18, 1963, before a "crowd" of only 1,752, the Mets and the Phillies played the last game in the historic ballpark, with the Mets on the short end of a 5–1 score.

The Polo Grounds was razed in 1964 with the same wrecking ball that had previously demolished Ebbets Field. The site is now occupied by the Polo Grounds Towers, a high-rise public-housing complex.

The view from Coogan's Bluff in September of 1964. The clubhouse building in center field is about all that's left.

Polo Grounds'
Ten Most Memorable Moments

1. October 14, 1905, fifth and deciding game of the World Series: New York Giants pitcher Christy Mathewson defeats Philadelphia's Chief Bender, 2–0, to win the Series for the Giants; it is Matty's third shutout in six days.

2. September 23, 1908: Fred Merkle of the Giants, a base runner on first base, forgets to touch second when the man at bat apparently singles home the winning run in the bottom of the ninth inning; after much confusion, Merkle is called "out" and a game the Giants thought they had won from the Cubs is declared a tie. (Two weeks later, the New York Giants and Chicago Cubs will end the season in another tie, this one for first place.)

3. October 8, 1908: The Cubs win the National League pennant when Mordecai "Three Finger" Brown beats Mathewson, 4–2, in a playoff stemming from the game in which Merkle failed to touch second.

4. July 3, 1912: Giants pitcher Rube Marquard beats Brooklyn, 2–1, for his nineteenth straight win in one season, still a record.

5. August 16, 1920: Cleveland shortstop Ray Chapman is killed when hit by a pitch thrown by Yankee pitcher Carl Mays.

6. July 2, 1933: Carl Hubbell of the Giants beats Tex Carleton of the Cardinals, 1–0, in an 18-inning game, with Hubbell going the entire distance. In the second game of the doubleheader, Roy Parmelee beats Dizzy Dean of the Cardinals, also 1–0.

7. July 10, 1934: In the All-Star Game, Carl Hubbell of the National League achieves lasting fame by striking out in succession Babe Ruth, Lou Gehrig, Jimmie Foxx, Al Simmons, and Joe Cronin.

8. October 3, 1951: In the bottom of the ninth inning of the third and deciding game of a three-game playoff for the National League pennant, Giants third baseman Bobby Thomson hits "the shot heard 'round the world." With one out and the Giants behind, 4–2, Thomson's three-run homer into the lower left-field stands beats Brooklyn, 5–4, and wins the pennant for New York.

9. September 29, 1954, first game of the World Series: In the eighth inning, with the score tied and two runners on base, Willie Mays of the New York Giants makes the most celebrated catch in World Series history. Mays races to deep center field and, with his back to home plate, makes an over-the-shoulder catch of a 445-foot drive off the bat of Cleveland's Vic Wertz; in one fluid motion, he whirls around and throws the ball back to the infield so that instead of two men scoring, none does.

10. April 13, 1962, Opening Day: On a snowy Friday the 13th, National League baseball returns to New York as manager Casey Stengel's New York Mets lose to the Pittsburgh Pirates, 4–3.

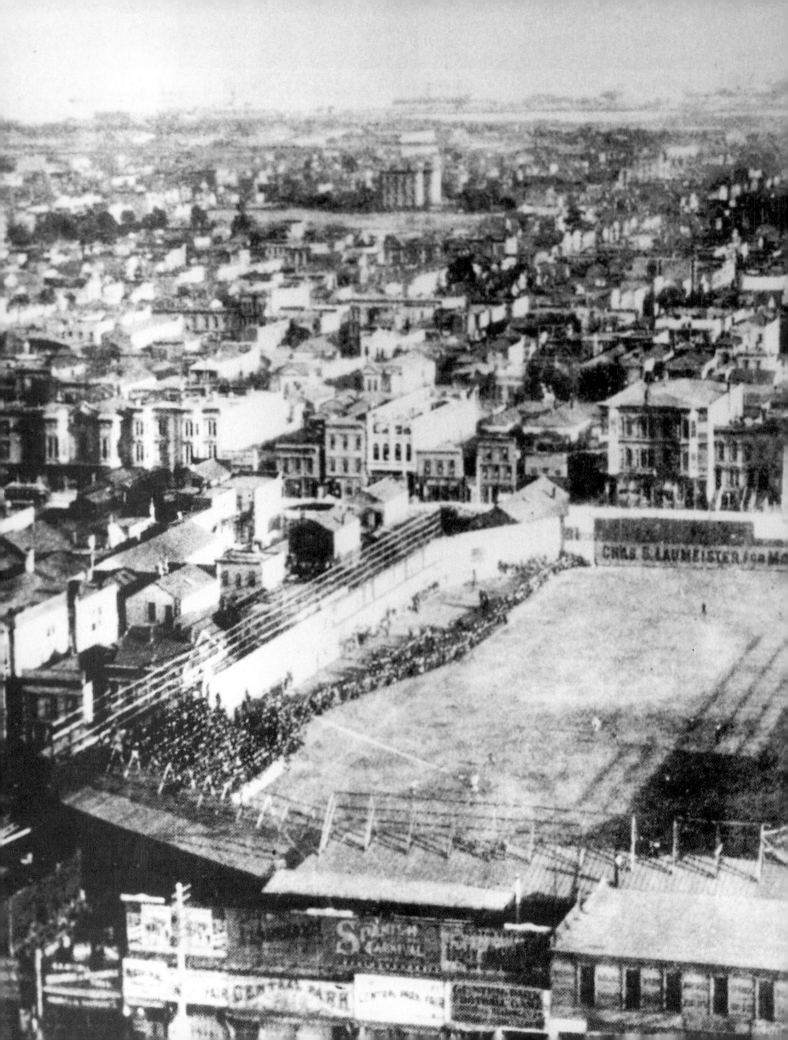

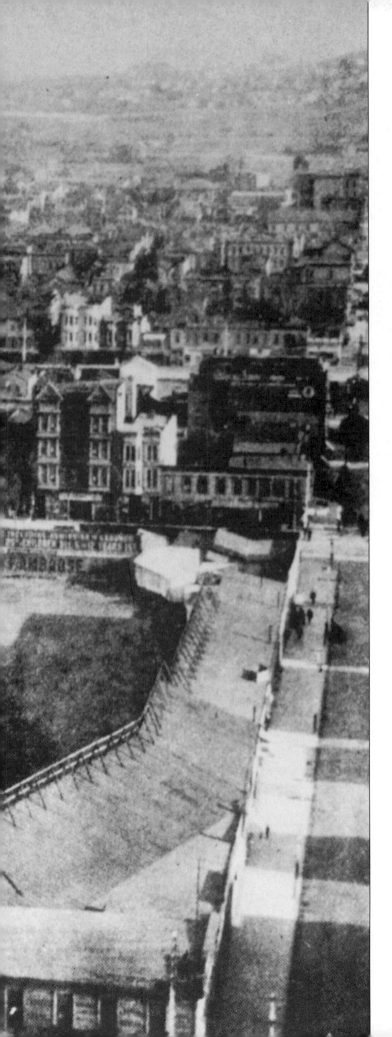

Seals Stadium

SAN FRANCISCO

LOCATION: On the northeastern edge of the Mission District, at 16th and Bryant streets. The first-base foul line ran parallel to Bryant Street, right field to center field parallel to 16th Street (and Franklin Square), center field to left field parallel to Potrero Avenue, while the third-base foul line paralleled Alameda Street.

HOME OF: The San Francisco *Seals* in the Pacific Coast League from 1931 through 1957; the San Francisco *Missions* in the Pacific Coast League from 1931 through 1937; and the San Francisco *Giants* in the National League from April 15, 1958, to September 20, 1959.

*T*he San Francisco Bay Area was a hotbed of baseball activity long before the major leagues arrived in 1958. Joe DiMaggio was a product of the area's sandlots, as were hundreds of other celebrated big leaguers, including Frank Chance, Tony Lazzeri, Ernie Lombardi, and Lefty O'Doul.

When the Pacific Coast League originated in 1903, the San Francisco Seals played in Recreation Park, at 8th and Harrison, which was destroyed in

Recreation Park, San Francisco, in 1896.

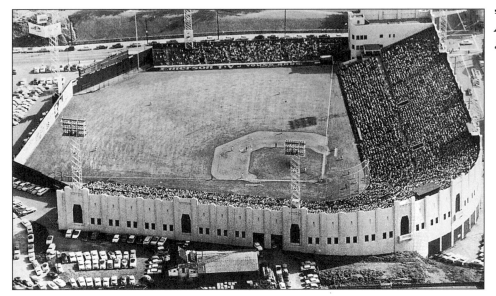

An overview of Seals Stadium.

the famous San Francisco earthquake and fire of 1906. That quake, estimated at 8.3 on the Richter Scale, was sixteen times more powerful than the 7.1 earthquake that erupted during the 1989 World Series. (In the exponential Richter Scale, each whole number represents a force ten times greater than the preceding one.)

"New" Recreation Park opened in 1907 in the Mission District, at 15th and Valencia, a couple of blocks from Mission Dolores, the eighteenth-century Franciscan mission that gives the area its name. Seating 15,000, the wooden ballpark had a right-field fence only 235 feet from home plate; however, its 70-foot height (a 20-foot-high fence and a 50-foot-high wire screen above it) turned most would-be homers into singles or doubles.

It was while their home was Recreation Park, in 1928, that the Seals had probably the hardest-hitting outfield ever assembled: Smead Jolley (who hit .404 that year), Roy Johnson (.360), and Earl Averill (.354).

Starting in 1926, the Seals shared Recreation Park with another Coast League team—the Missions, transplanted from Vernon, a suburb of Los Angeles. In the late twenties and early thirties, the Missions boasted two of the greatest minor league sluggers of all time: outfielder Ike Boone, who hit .380 for the Missions in 1926 and .407 in 1928; and outfielder Ox Eckhardt, who hit .414 in 1933 and .399 in 1935.

In 1931, the Seals and Missions moved a mile east to concrete-and-steel Seals Stadium. Inaugurated on April 7, 1931, with an 8–0 San Francisco win over Portland, Seals Stadium had *three* clubhouses—one for the Seals, one for the Missions, and one for the visiting team. All three were needed for only a few years, though, because in 1938 the Missions, always number two in the hearts of San Franciscans, moved four hundred miles south and became the Hollywood Stars.

Seals Stadium was a single-decked ballpark without a roof over either grandstand or bleachers. The single-decked stands curved around home plate and extended most of the way down both foul lines. A bleacher section consisting of about fifteen tiered rows of long, backless planks was located in right field—at ground level, it began 15 or so feet on the fair side of the right-field foul line and stretched almost as far as the large center-field scoreboard.

The seating capacity of Seals Stadium was originally 18,500. Through 1957, there was no seating in left field: a 20-foot-high fence stretched from the left-field foul pole to the center-field scoreboard. When the Giants arrived in 1958, they added 5,000 seats by installing bleachers in left field.

For most of its life, the ballpark's dimensions were 365 feet from home plate down the left-field foul line; anywhere between 404 and 424 feet from home plate to dead center field, depending on how

RIGHT: *Dominic (left) and Joe DiMaggio both began their careers with the Seals in the thirties. In 1933, Joe hit safely in 61 consecutive games, a forerunner of his 56 straight with the Yankees in 1941.*

BELOW: *Popular Lefty O'Doul managed the San Francisco Seals from 1935 through 1951.*

far in front of the center-field scoreboard a high wire fence was placed; and 350 feet from home plate to the start of the right-field bleachers (about 15 feet in from the foul line).

In 1959, the ballpark's last year, outfield distances were 361 feet down the left-field line, 400 feet to center, and 350 feet to the right-field bleachers. Home runs had to clear a 15-foot-high screen in left field and a 16-foot-high screen in right. The center-field scoreboard was 31 feet high.

Because of the considerable distances to the fences, Seals Stadium was predominantly a pitcher's park. However, right-handed batters were frequently assisted (and left-handed batters hampered) by strong prevailing winds—often 15 or 20 miles per hour—that blew from right to left field.

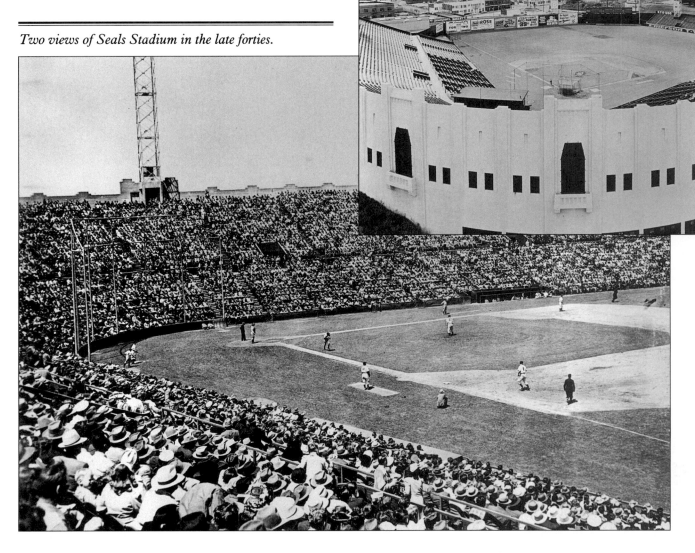

Two views of Seals Stadium in the late forties.

San Francisco's jet streams inspired controversy long before Candlestick Park brought them to national attention. Left-hander Johnny Antonelli won 16 games for the Giants in 1958 and 19 in 1959, the two years the Giants played their home games at Seals Stadium, but he still complained bitterly about the wind "blowing pop-ups over the wall."

The *San Francisco Examiner*, its civic pride wounded, rebuked Antonelli for criticizing "our lifegiving summer breeze, the sweet wind that sweeps San Francisco clean each morning, the tangy wind that puts a joyous spring in every step and soothes every fevered brow..."

It was at Seals Stadium that eighteen-year-old Joe DiMaggio's minor league hitting streak of 61 consecutive games came to an end. On July 26, 1933, Oakland right-hander Ed Walsh, son of the great White Sox hurler, blanked the sensational young Seals outfielder in five times at bat. Eight years later, of course, as a Yankee, DiMaggio would hit in 56 straight games.

In 1935, DiMaggio hit .398 for the Seals, but he didn't lead the league because Ox Eckhardt hit .399 for the Missions (in the same home ballpark). Lefty O'Doul managed the Seals that year. "It's the players who make the manager, not the other way

around," said O'Doul. "In 1935, I had Joe DiMaggio in right field and we won the pennant. Sold him to the Yankees over the winter, and the next year we finished next to last."

Frank "Lefty" O'Doul, in fact, became the walking, talking embodiment of baseball in the city of San Francisco. A native, born and bred, he began his career in 1917 as a pitcher but later switched to the outfield and twice led the National League in hitting. At one time as popular and well known in San Francisco as Joe DiMaggio, the city's other hero, the charismatic O'Doul managed the Seals for seventeen years, from 1935 through 1951, winning pennants in 1935 and 1946.

The last Pacific Coast League game at Seals Stadium was a 14–7 San Francisco loss to Sacramento on September 15, 1957. A happy crowd of 15,484 was on hand to bid the Seals farewell—happy because the big league New York Giants would be moving in next year.

Major league baseball made its debut on the West Coast on April 15, 1958, before a packed house of 23,448 at Seals Stadium, with the San Francisco Giants trouncing the equally brand-new Los Angeles Dodgers, 8–0. The Giants used Seals Stadium for two years while Candlestick Park was

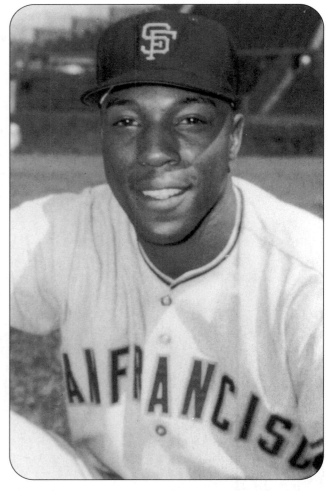

ABOVE: *Willie McCovey. The popular first baseman hit a career total of 521 home runs.*

LEFT: *When the Giants played their home games in Seals Stadium, in 1958 and 1959, capacity was expanded by installing bleachers in left field.*

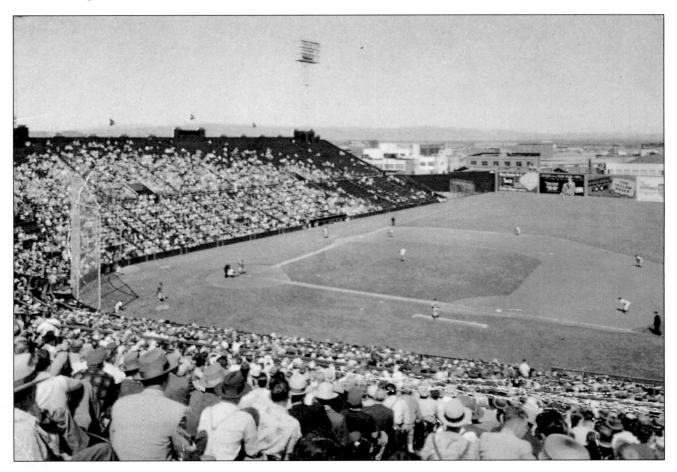

under construction. In that period, they drew 2.7 million customers, more than double their attendance the two previous years at the Polo Grounds in New York!

The Giants had Willie Mays with them when they arrived, and he inspired respect and admiration from San Franciscans. But they reserved their true love and affection for another Willie—first baseman Willie McCovey, who was called up from Phoenix in July 1959. In his first game in the majors, which was played in Seals Stadium, McCovey got four hits, two of them triples. Since he began his illustrious major league career in San Francisco, the modest and likable McCovey was always treated by the locals as a home-grown product, whereas Mays, increasingly aloof with the passage of time, was viewed as an East Coast import.

McCovey liked Seals Stadium: his first Sunday in the majors he walloped a tape-measure shot over the right-field bleachers into Franklin Square on

Seals Stadium.

the other side of 16th Street. Too bad he only played a few months there before moving to Candlestick.

On September 20, 1959, the last game was played at the twenty-nine-year-old ballpark; a crowd of 22,923 saw the Giants close the stadium for good with an 8–2 loss to the Dodgers. Demolition began a few weeks later. In 1960, the seats and light towers were transported to Tacoma and installed in that city's new Cheney Stadium.

The Seals Stadium site is now occupied by the San Francisco Autocenter, headquarters for a number of new-car dealerships, and a Safeway supermarket.

Except for a nearby tavern named The Double Play, there is no indication that a ballpark ever existed in the neighborhood of 16th and Bryant.

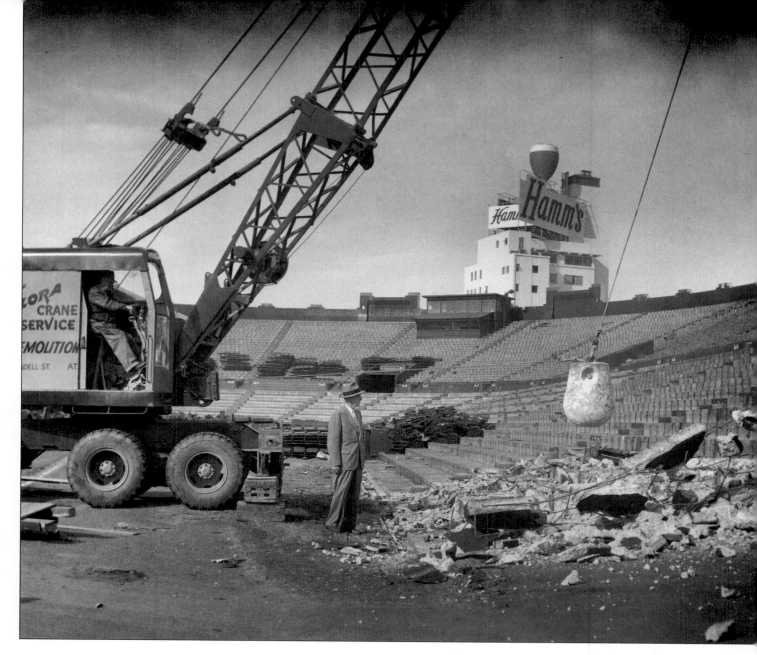

ABOVE: *It is November 1959 and consulting engineer H. J. Brunnier watches the demolition of Seals Stadium, which he designed in 1930.*

RIGHT: *This 1991 view is from Franklin Square looking across 16th Street. The right-field bleachers have been replaced by the San Francisco Autocenter.*

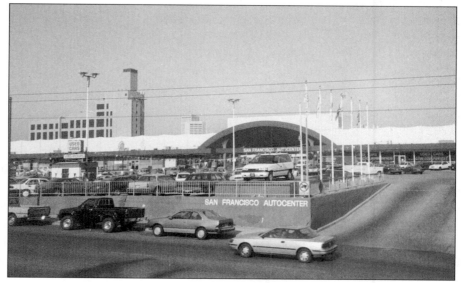

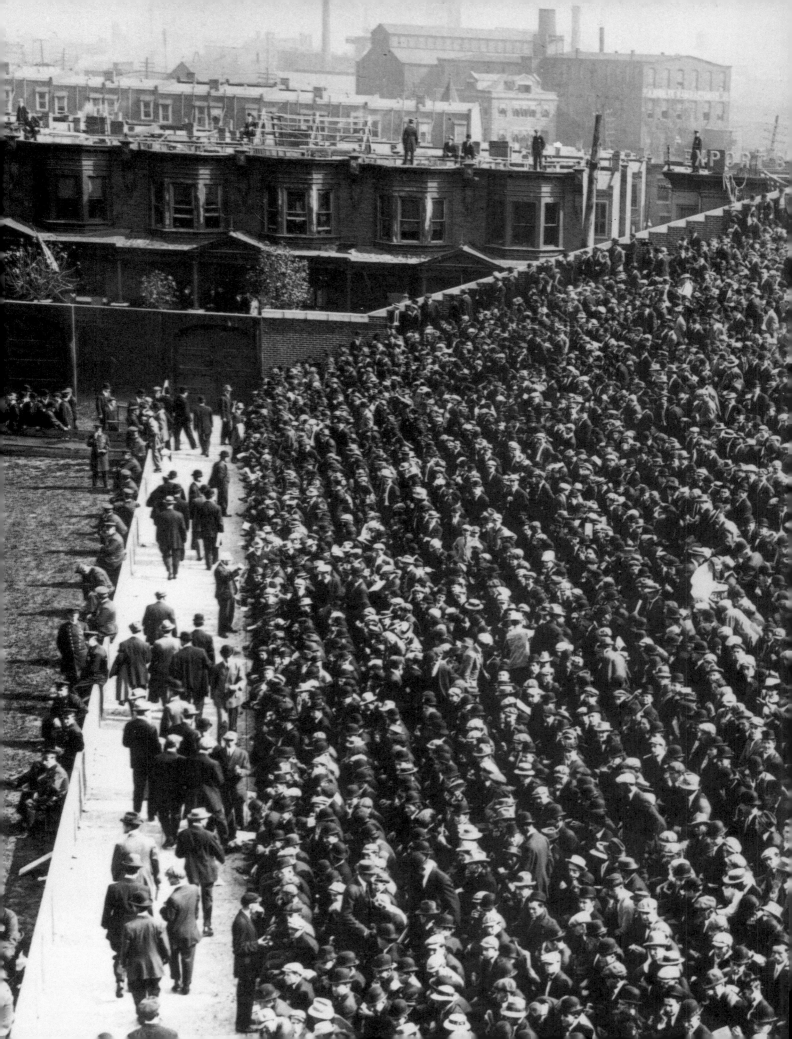

Shibe Park

PHILADELPHIA

LOCATION: In North Philadelphia, about three and a half miles from Independence Hall, on the square block bounded by Lehigh Avenue, North 20th Street, Somerset Street, and North 21st Street. The first-base foul line ran parallel to Lehigh Avenue, right field to center field ran parallel to 20th Street, center field to left field was parallel to Somerset Street, while the third-base foul line paralleled 21st Street.

HOME OF: The Philadelphia *Athletics* from April 12, 1909, to September 19, 1954; and of the Philadelphia *Phillies* from July 4, 1938, to October 1, 1970.

The Philadelphia Athletics joined the American League in 1901, the second year of the league's existence but its first as a major league. Principal owner of the new Philadelphia franchise was Benjamin F. Shibe, who had been and continued to be a partner in A. J. Reach & Company, manufacturers of baseball equipment. Ben Shibe owned 50 percent of the Athletics and was in charge of business matters, while Cornelius McGillicuddy—a former catcher better known as Connie Mack—owned 25 percent and managed the club on the field. (In 1913, Mack would acquire the remaining 25 per-

Packed bleachers along Shibe Park's right-field foul line in 1911.

177

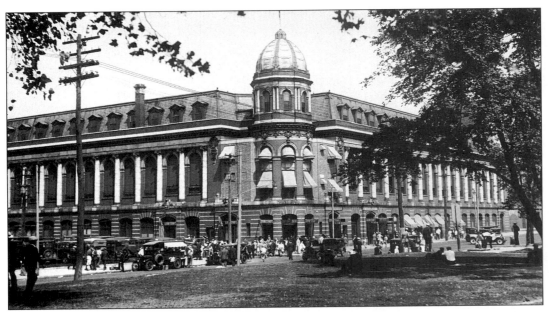

Shibe Park, at the corner of Lehigh and 21st Street, in the twenties.

cent of the shares and become an equal partner with Shibe.)

For the first eight years of their existence, the Athletics played at Columbia Park, a wooden single-decked structure located three miles northwest of Independence Hall on the site bounded by Columbia Avenue and Oxford Street between 29th and 30th streets. Home plate was at 30th and Oxford streets, with the first-base foul line parallel to Oxford Street, and right field to center field parallel to 29th Street. A roofed single-decked grandstand formed a semicircle from first to third, with open bleachers down both foul lines. There were no dugouts for the players, who sat on benches along the sidelines, more or less the way football teams do today. Seating capacity was about 12,000.

The first and third games of the 1905 World Series were played at Columbia Park—both of which were won by the New York Giants behind the shutout pitching of Christy Mathewson. Despite the park's 12,000 seating capacity, paid attendance for the first Series game was 17,955!

The popular Athletics outgrew Columbia Park in short order. Needing larger quarters, in 1909 they moved a mile and a half northeast to brand-new Shibe Park, erected only a short stroll from Baker Bowl. Shibe Park—named after principal owner Ben Shibe—was the first baseball stadium

built completely of concrete and steel. The rebuilt Baker Bowl, inaugurated in 1895, had a concrete-and-steel grandstand but wooden bleachers. And while Pittsburgh's new Forbes Field was also built completely of concrete and steel, it didn't host its first game until eleven weeks after Shibe Park's inaugural.

The new Philadelphia stadium, hailed as the crown jewel of ballparks, opened its gates for the first time on April 12, 1909, with the Athletics taking the measure of the Red Sox, 8–1. Seating capacity was listed as 20,000, but in keeping with Philadelphia tradition, paid attendance on Opening Day was 30,162! Additional fans crowded onto rooftops on the other side of 20th Street, beyond the right-field fence, because there wasn't room to shoehorn a single additional customer within the confines of the ballpark.

When it first opened, Shibe Park had a roofed double-decked grandstand that curved around the infield from first base to third base, followed by uncovered single-decked bleachers that continued the rest of the way down both foul lines. There were no seats in fair territory behind the out-fielders. The original dimensions of the ballpark were 378 feet from home plate down the left-field line, 515 feet to center, and 340 feet down the right-field line.

In addition, the original distance from home plate to the backstop was a lengthy 90 feet. For most of its life, Shibe Park retained an abnormally long distance from home plate to the backstop, putting it in the same league with Comiskey Park and Forbes Field, both of which had the reputation of favoring pitchers over hitters.

Alterations were made in 1913 and 1925 that brought the ballpark to roughly its final form. In 1913, the single-decked bleachers that extended down both foul lines were covered and new, uncovered bleachers were constructed in left field, from the left-field corner to mid–center field.

The 1925 alterations were even more substantial, giving the stadium the basic appearance that would identify it for the rest of its days: all single-decked stands were double-decked and covered, so that the ballpark now consisted of a roofed double-decked grandstand enclosing the entire playing field except for right field.

In right field, a 12-foot-high concrete wall backed up the right fielder; the wall started from the right-field corner and ran parallel to 20th Street until it encountered the double-decked left-field stands in mid–center field (at the corner of 20th and Somerset). The left-field fence was also 12 feet high—4 feet of wire screen atop 8 feet of concrete at the base of the lower-deck stands.

After the renovations of 1925, the park's dimensions shrank to 334 feet from home plate down the left-field line, 468 feet to center field, and 331 feet down the right-field line.

RIGHT: *Benjamin F. Shibe (center), who gave the ballpark its name, with Ed McKeever, Dodgers vice president (left), and Garry Herrmann, president of the Cincinnati Reds. Along with Connie Mack, Ben Shibe owned the A's from 1901 until his death in 1921.*

BELOW: *The Philadelphia Athletics in their Shibe Park dugout waiting for the start of the second game of the 1913 World Series.*

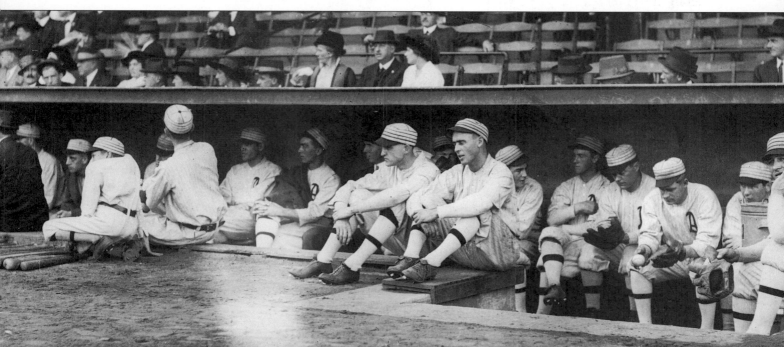

Finally, in 1929, a small mezzanine was constructed between the two decks in the main grandstand, from first around home plate to third, and a press box was built under the roof of the second deck. This brought the park's seating capacity up to the neighborhood of 33,000, where it remained.

Connie Mack's A's won seven pennants and five World Series while domiciled at Shibe Park. His 1910–14 team, winner of four pennants and three World Series, featured such immortals as infielders Home Run Baker and Eddie Collins and pitchers Chief Bender and Eddie Plank. And his 1929–31 team was, if anything, even better, with Mickey Cochrane, Jimmie Foxx, Lefty Grove, and Al Simmons.

Attendance dropped sharply in the 1930s, during the years of the Great Depression, especially after Connie sold off most of the stars of his great pennant-winning teams of 1929, 1930, and 1931 because he couldn't afford to pay their salaries. Attendance at Shibe Park plummeted from 840,000 in 1929 to 230,000 in 1935.

It was then that management decided to do something about the nonpaying customers who enjoyed games from upper-story windows and rooftops on the other side of 20th Street (beyond the right-field fence). In 1935, a 22-foot-high barrier of corrugated sheet iron was erected on top of the existing 12-foot-high concrete wall; this raised the total height of the right-field fence to 34 feet, completely blocking the view from 20th Street rooftops.

Known locally as the "spite fence," the barrier stirred as much amusement as resentment. A 2-foot-deep wooden frame used to support the fence

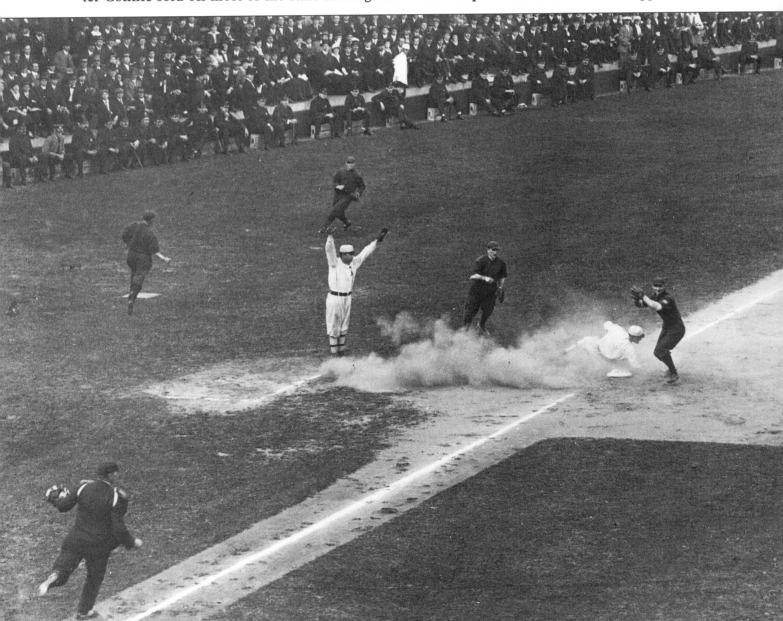

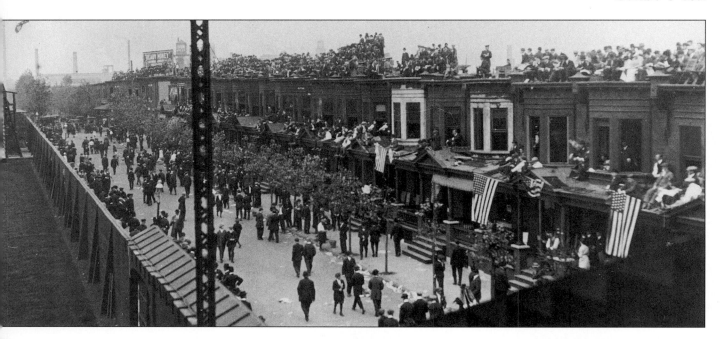

ABOVE: *Fans used to watch the A's from rooftops across 20th Street, on the other side of the right-field wall.*

RIGHT: *The "spite fence" erected atop the right-field wall in 1935 put an end to rooftop freeloaders.*

OPPOSITE: *A's right fielder Eddie Murphy has just been tagged out by Boston third baseman Charlie Deal at Shibe Park in the first game of the 1914 World Series. Notice the small army of policemen sitting in front of the stands.*

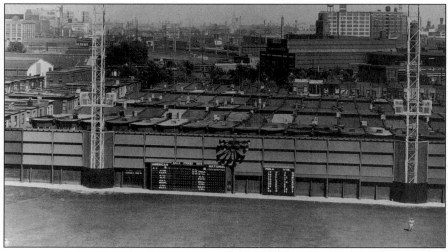

reduced the distance down the right-field line from 331 feet to 329 feet (although the field marker continued to say "331" until 1956).

Upon the death of Benjamin F. Shibe in 1921, his sons Thomas and John took over business management of the club. They were painstaking in their attention to detail, especially John, and there was no better-maintained ballpark anywhere. Souvenir programs in the twenties boasted that

Shibe Park is watched with the same zeal that a good captain watches a battleship. Winter as well as summer, it is inspected regularly and kept painted and up-to-date. During the playing season, not a break or a crack in a chair is tolerated. Vigilant inspectors spot it at once and it is replaced before the next game is played. No ballpark is kept cleaner. After every game, a force of workmen remove every vestige of grime and there is never any danger of milady's filmy summer frock being soiled by an unclean chair.

Hall of Famer Hank Greenberg recalled his experiences at Shibe Park in the thirties: "I always got out to the ballpark early for extra batting practice and often for some extra fielding practice. I did it not only at home in Detroit but also on the road.

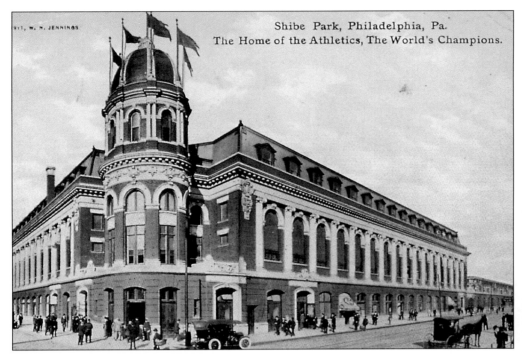

Shibe Park, Philadelphia, Pa.
The Home of the Athletics, The World's Champions.

LEFT: *Main entrance to Shibe Park.*

BELOW: *Connie Mack managed the A's for fifty years—from 1901 through 1950. Here he is exchanging an auto-graphed baseball for a flower. Slugger Jimmie Foxx is obviously intrigued.*

BELOW, LEFT: *Lefty Grove, one of baseball's greatest lefthanders. In 1931 his record for the A's was 31 wins and 4 losses.*

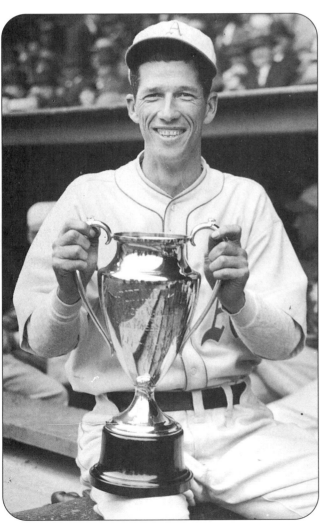

"For a short while I had a problem in Shibe Park in Philadelphia. After about half an hour of batting practice one day, the groundskeeper came over and said we had to leave. As usual, I had a whole crew with me—a pitcher and several guys to shag balls in the outfield. We were getting our gear together, preparing to leave, when an elderly gentleman none of us had noticed, sitting about twenty rows up in the grandstand, called to me.

"I went up to see what he wanted and he said, 'I very much admire what you are doing, young man. You tell that groundskeeper to assist you in every way possible. Tell him that those are John Shibe's

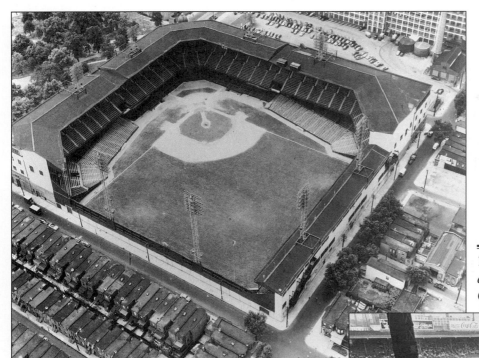

Two views of Shibe Park in the early sixties (by then it was called Connie Mack Stadium).

instructions. And if he doesn't like it, send him right up here to see me.' Needless to say, I never had any more trouble in Shibe Park."

In 1938, the Phillies abandoned decaying Baker Bowl and joined the Athletics in Shibe Park. The National League club made its Shibe Park entrance on the Fourth of July, 1938, splitting a double-header with the Boston Braves before 12,000 spectators, quite a few more than the 1,500 who had watched the Phillies in their final Baker Bowl game a few days earlier.

The Phillies had one unforgettable year at Shibe Park—1950, the year of the Whiz Kids, when they won the pennant with the likes of pitchers Jim Konstanty and Robin Roberts, catcher Andy Seminick, and outfielders Richie Ashburn, Dick Sisler, and Del Ennis. It was their first National League pennant since 1915 and they wouldn't win another for thirty years.

Unfortunately, the Phillies, managed by Eddie Sawyer, met Casey Stengel's Yankees in the 1950 World Series and got blown away in four straight.

When the Athletics moved to Kansas City in 1955, the Phillies took sole possession of Shibe Park—actually of Connie Mack Stadium, which it

had been renamed prior to the 1953 season. Connie had retired in 1950, at eighty-seven years of age, after fifty years as manager of the A's. Soon thereafter, Connie and his sons—now sole owners—sold the club to Arnold M. Johnson and watched it fly away to Missouri. The last A's game at their long-time home was a 4–2 loss to the Yankees on September 19, 1954, before an audience of only 1,715.

The Phillies, now in charge, decided to store the batting cage in center field, so in 1955 they made a little storage area in deep center with two gates 8 feet high, thereby reducing the center-field distance from 468 feet to 447 feet. (In 1968, the center-

Shibe Park's
Ten Most Memorable Moments

1. May 18, 1912: The Detroit Tigers refuse to play a scheduled game because Ty Cobb has been suspended for going into the stands and assaulting a fan; to avoid a forfeit and fine, Detroit management recruits amateur players, who put on Detroit uniforms and are clobbered by the A's, 24–2.

2. June 15, 1925: Trailing Cleveland, 15–3, after six and a half innings and 15–4 after seven and a half, the Philadelphia A's score 13 runs in the eighth inning to win, 17–15. (A 12-run deficit is still the most runs a team has ever overcome to win a game.)

3. October 12, 1929, fourth game of the World Series: Losing to the Chicago Cubs, 8–0, after six and a half innings, the A's score 10 runs in the bottom half of the seventh to win, 10–8. (An eight-run deficit is the most runs a team has ever overcome to win a World Series game.)

4. October 14, 1929, fifth and deciding game of the World Series: With the A's down by two runs in the bottom of the ninth, outfielder Mule Haas hits a two-run homer to tie the score, and before the inning is over, the A's get another run to win the game and the Series.

5. June 3, 1932: Yankees first baseman Lou Gehrig hits four consecutive home runs, driving in six runs, as the Yankees trounce the A's, 20–13.

6. May 24, 1936: Yankees second baseman Tony Lazzeri hits two grand-slam home runs, a solo homer, and a triple, driving in an American League record 11 runs in a 25–2 rout of the A's.

7. July 4, 1939: In an Independence Day doubleheader, the Red Sox and A's celebrate the Fourth with a record 54 runs and 65 hits as the Red Sox win both games, 17–7 and 18–12; Boston third baseman Jim Tabor drives in 11 runs in the doubleheader with a single, a double, and four home runs, two of which are grand slams.

8. September 28, 1941, the last day of the season: Boston's Ted Williams gets six hits in eight times at bat against the A's to raise his league-leading batting average to .406 (making him the last of the .400 hitters).

9. July 18, 1948: White Sox outfielder Pat Seerey hits four home runs and drives in seven runs in an extra-inning game against the A's; the game is won by Chicago, 12–11, when Seerey hits his fourth homer in the eleventh inning.

10. September 30, 1951, the last day of the season: Brooklyn's Jackie Robinson makes a sensational catch in the twelfth inning and hits a dramatic home run in the fourteenth to beat the Phillies, 9–8, tying the New York Giants for the National League pennant and setting the stage for a three-game playoff.

field distance was decreased even further, to 410 feet.)

In 1956, the Phillies also replaced the old Shibe Park scoreboard in right-center field with a mammoth scoreboard that had formerly been used at Yankee Stadium. This had the effect of raising the height of the right-center field fence to 50 feet for the approximately 60-foot length of the scoreboard, with the fence dropping to the old 34-foot height on either side of it. Batted balls hitting the scoreboard were still in play, as were balls hitting a 10-foot-high BALLANTINE BEER sign on top of it; however, a ball hitting the Longines clock above *that* (the top of which was 75 feet above the playing field) was ruled a home run.

Inaugurated in 1909, the ballpark began to show its age in the late 1950s. There was hardly any parking in the area, the place needed substantial upkeep, and the neighborhood had gone downhill. A new municipally financed stadium was built in order in keep both the Phillies and the football Eagles in Philadelphia.

The final major league game was played at Connie Mack Stadium on October 1, 1970: a near-capacity crowd of 31,822 bade a boisterous farewell to the sixty-two-year-old landmark as the Phillies beat the Expos, 2–1, with Tim McCarver crossing home plate with the winning run in the bottom of the tenth inning—the last run ever scored in the historic stadium.

The ballpark was badly damaged by fire in 1971 and totally demolished in 1976. The square block on which it stood is now an unmarked, mostly vacant lot occupied partly by the Deliverance Evangelistic Church.

Connie Mack Stadium in 1974. Infielder Tony Taylor, who played for the Phillies from 1960 to 1976, stands near second base.

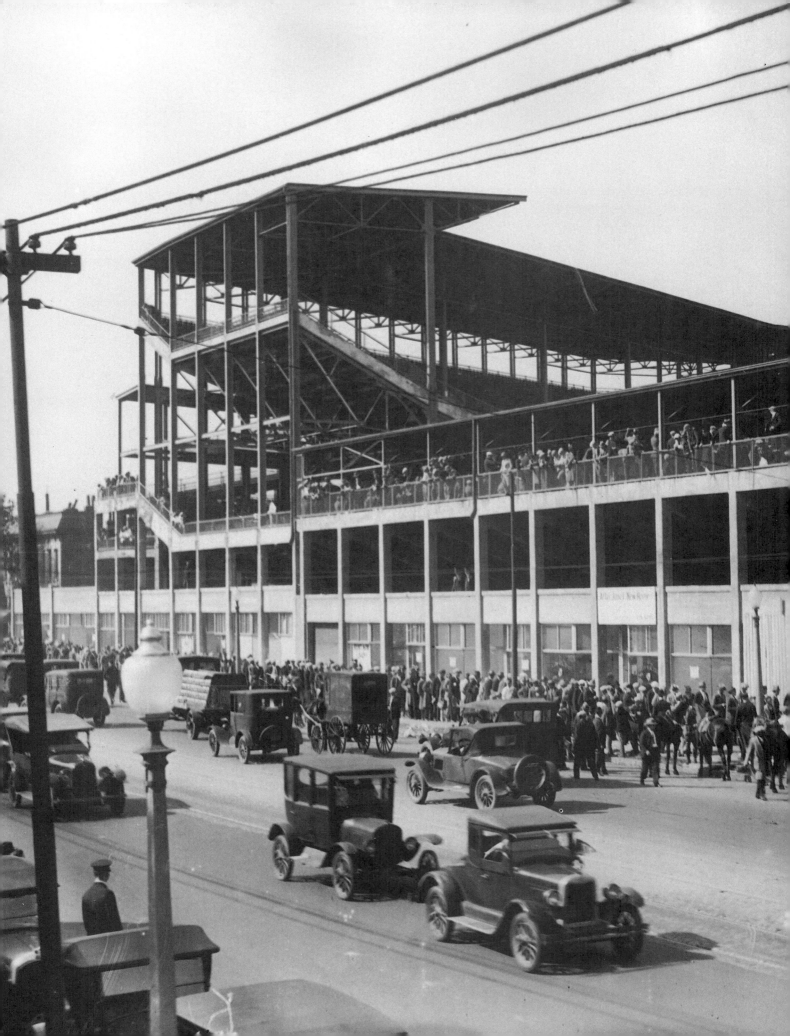

Sportsman's Park

ST. LOUIS

LOCATION: In northwest St. Louis, near Fairground Park, on the block bounded by Dodier Street, Grand Boulevard, Sullivan Avenue, and Spring Avenue. The first-base foul line ran parallel to Dodier Street, right field to center field parallel to Grand Boulevard, center field to left field parallel to Sullivan Avenue, while the third-base foul line paralleled Spring Avenue.

HOME OF: The St. Louis *Browns* from April 23, 1902, to September 27, 1953; and of the St. Louis *Cardinals* from July 1, 1920, to May 8, 1966.

Sportsman's Park had the distinction of being home field for two major league teams for longer than any other stadium. The Polo Grounds was home for the Yankees and Giants for ten years and Shibe Park was home to the A's and Phillies for sixteen years. But the Browns and Cardinals both used Sportsman's Park for thirty-three years—from mid-1920 until the Browns moved to Baltimore after the 1953 season.

It is October 5, 1926, and fans are entering Sportsman's Park at the pavilion entrance on Grand Boulevard to attend the third game of the World Series.

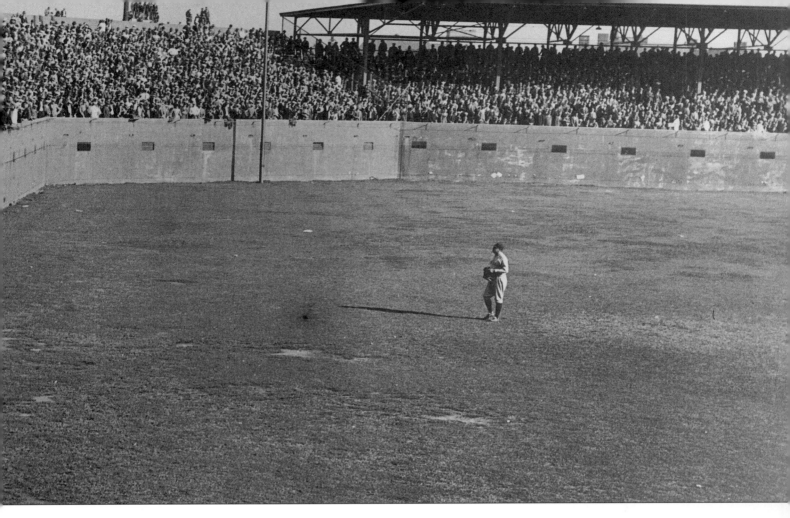

The Browns joined the American League in 1902, in the league's third year of operation and its second with major league status. At that time, Sportsman's Park was a completely single-decked stadium with a covered grandstand from first base to third, an uncovered pavilion down the right-field line, and bleachers stretching down the left-field line and over into fair territory behind the left fielder. Home plate was located in the northwest part of the block, at the corner of Sullivan and Spring avenues. A crowd of 8,000 saw the Browns defeat Cleveland, 5–2, in their home inaugural on April 23, 1902.

After the 1908 season, the park was completely reconstructed by then-owner Robert Lee Hedges. He shifted home plate to the southwest part of the block, at the corner of Spring Avenue and Dodier Street, and constructed a new covered double-decked concrete-and-steel grandstand behind home plate from first base to third. The old covered single-decked grandstand, which used to be behind home plate, with some modifications now became a pavilion down the left-field line. The old bleachers remained, except, with the field rotated, they now bordered the *entire* outfield. A few years later, a new single-decked uncovered pavilion was also erected down the right-field line.

The seating capacity of the new stadium was 18,000. The distance from home plate was 353 feet down the left-field line, 430 feet to the center-field fence, and 320 feet down the right-field line.

The Browns were not a notably successful franchise, either at the gate or on the field. They drew only 150,000 in 1915, just 120,000 in 1918. In 1935, attendance was 80,922, the lowest for a major league club in the twentieth century! (With 77 home games, that meant an average of 1,051 paid admissions a game.)

In the early years, the Cardinals didn't do any better. They played a few blocks north of Sportsman's Park—at Robison Field, located at Natural Bridge and Vandeventer avenues, where Beaumont High School now stands—but Cardinals owner

188

Sam Breadon had to sell his ballpark to pay his bills. In mid-1920, the threadbare Cardinals moved into Sportsman's Park as tenants of the Browns.

The year before, the Browns had outdrawn the Cardinals by more than two to one, and they continued to outdraw the National Leaguers in five of the first six years the two teams shared the stadium.

Confident he could fill additional seats, Browns owner Phil Ball—who owned the American League franchise from 1916 until his death in 1933—undertook a massive expansion of the stadium after the 1925 season. He double-decked and covered both pavilions that went from the infield down to the foul poles, replaced the old wooden bleachers with concrete, and put a roof over the single-decked right-field bleacher section, thereby converting it into the 3,300-seat right-field "pavilion," the best-known section of the park. This increased total seating capacity to 34,000 and gave Sportsman's Park the shape it would have for the next forty years.

Although outfield dimensions fluctuated from time to time, for most of the rest of the ballpark's life the distance was 351 feet from home plate down the left-field line, 422 feet to dead center (426, if measured slightly to the left of dead center), and 310 feet down the right-field line.

The fences were 11½ feet high except for a 33-foot-high screen installed in front of the right-field pavilion. The screen stretched from the foul pole three fifths of the way toward center field. Balls hitting it remained in play. (From home plate to the *unscreened* section of the right-field pavilion was about 370 feet.) The Browns put up the screen in July 1929, the day after Detroit had hit eight homers in four games. It was taken down only once thereafter, for the 1955 season, and more home runs were hit at Sportsman's Park that year than in any other year of its existence. It was not only restored in 1956 but *raised* 4 feet, to a height of 37 feet.

Unfortunately for Browns owner Phil Ball, the 1925–26 expansion of his ballpark primarily bene-

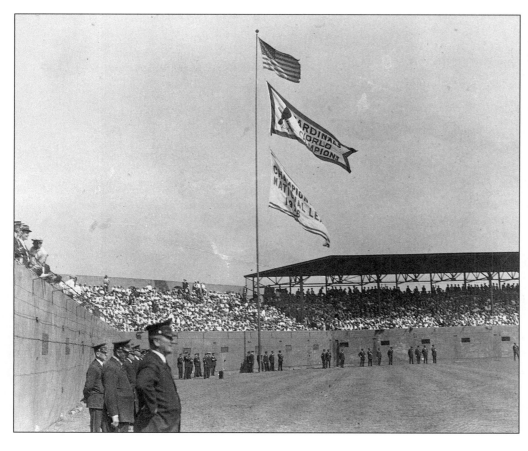

Sportsman's Park in 1927. The Cardinals' 1926 World Championship pennant flies in the breeze.

fited his tenants. In 1926, the Cardinals won their first National League pennant and outdrew the Browns by the outlandish margin of 670,000 to 280,000. In the next twenty years, the Cardinals won eight more pennants and five more World Series. With such drawing cards as Dizzy and Paul Dean, Joe Medwick, and Stan Musial, the National Leaguers completely took over the town. In 1935, the year the Browns drew 81,000, the Cardinals attracted 506,000.

Sportsman's Park was the last major league stadium to abolish segregated seating. The following Associated Press dispatch, dated May 4, 1944, is reprinted in its entirety:

> The St. Louis major league baseball teams, the Cardinals and Browns, have discontinued their old policy of restricting Negroes to the bleachers and pavilion at Sportsman's Park. Negroes may now purchase seats in the grandstand.

The year 1944 was also the *only* pennant-winning

LEFT: *Groundskeepers prepare Sportsman's Park for a game in 1939.*

BELOW: *The Dean brothers, Paul (left) and Dizzy. In 1934, Paul won 19 games and Dizzy 30 for the Cardinals.*

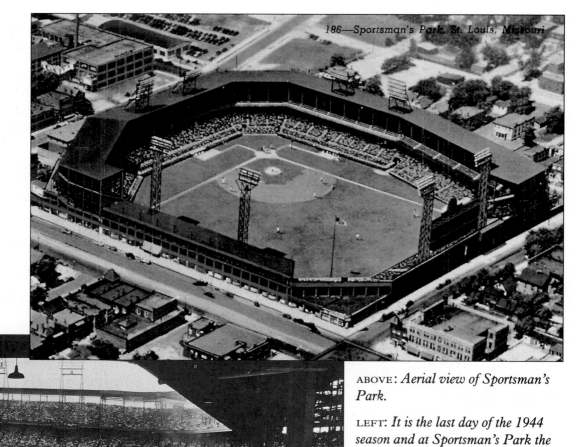

186—Sportsman's Park, St. Louis, Missouri

ABOVE: *Aerial view of Sportsman's Park.*

LEFT: *It is the last day of the 1944 season and at Sportsman's Park the St. Louis Browns are winning the American League pennant for the first (and only) time.*

year in the history of the Browns. The Browns won the pennant on the last day of the season. However, the Cardinals won the only all–St. Louis World Series ever played, four games to two.

On July 5, 1951, colorful Bill Veeck bought the Browns, but despite fanfare and publicity he could never make the team profitable. In April 1953, needing cash, he sold Sportsman's Park to August A. Busch, Jr., president of the Cardinals and of the Anheuser-Busch Brewery.

The Browns thereby became tenants of the Cardinals, a startling reversal of roles in only a thirty-year time span!

Gussie Busch promptly renamed the place Busch Stadium and refurbished it, reducing seating capacity to 30,500 in the process. He removed advertising signs on the fences and on the big scoreboard behind the left-field bleachers, replacing them with only one ad, for Budweiser beer, plus an eagle atop the scoreboard that flapped its wings after every Cardinal home run.

Two days after the 1953 season ended, with attendance below 300,000 for the fourth year out of five, Veeck sold the Browns to a group of Baltimore businessmen. The Browns played their last game on September 27, 1953: only 3,174 fans paid their

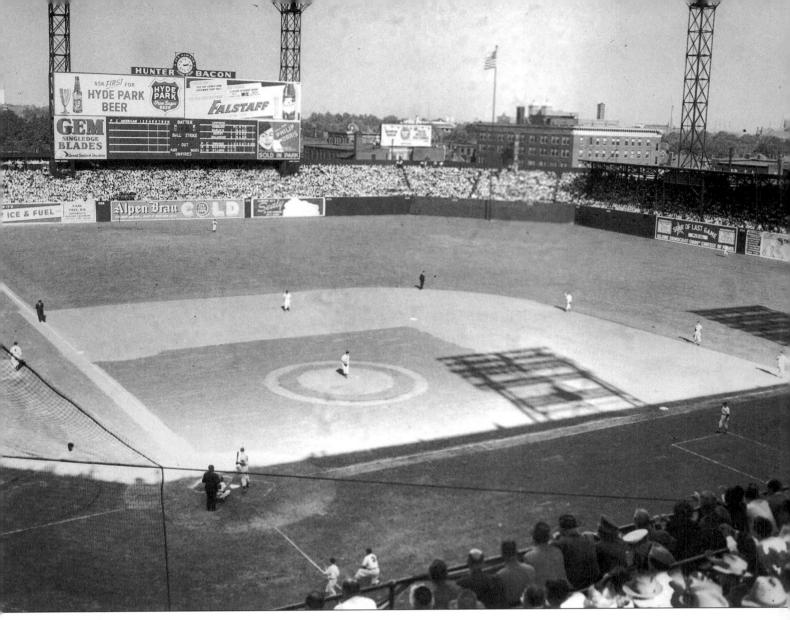

way into what was now called Busch Stadium to see the Browns lose to the White Sox, 2–1, in 11 innings.

The Cardinals, formerly tenants, remained owners and sole occupants of the ballpark for twelve additional years.

Impressions of a ballpark are often best conveyed through the eyes of a child. In 1959, six-year-old Jeffrey Copeland—today a respected professor at the University of Northern Iowa—was taken by his father to his first major league game. In Jeffrey's words:

"Our seats were right on line with the first-base bag, but as soon as I sat down I noticed I couldn't see part of the field because of a huge steel beam right in front of us. My father said the beam was supporting the roof, but by the second inning I

It is the first game of the 1946 World Series and the Cardinals are putting on the "Williams shift" at Sportsman's Park. Ted Williams waits at the plate as pitcher Howie Pollet watches his defense realign itself. Center field is completely deserted and only one player remains on the left side of the infield.

would have voted for tearing it down and risking a small disaster just to be able to see Bill White holding an enemy runner on first.

"Talk about being in Heaven! I was actually at a game watching all my heroes: Bill White, Gino Cimoli, Stan the Man, and Ken Boyer. Boyer hit a homer early and the Cardinals led, 3–0. The game, however, soon became secondary to action in the stands. In an early inning, a high pop foul came right at us. In the excitement, my father stood up,

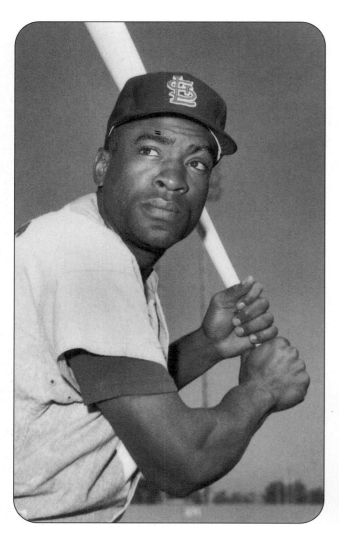

the sides with large red cardinals. After eating the popcorn, a fan could then use the megaphone to shout encouragement to favorite players.

"Anyway, this cone was full, and when the line drive hit smack in the center of it, popcorn exploded all over people sitting as far as fifteen rows away. I was mad about missing the ball, the people around us were very mad about picking popcorn out of their hair, and my father could do nothing but laugh, which certainly didn't help matters.

"In one of the middle innings, I got to see my

LEFT: *Cardinals first baseman Bill White in the early sixties. In 1989 he became president of the National League.*

BELOW: *Stan Musial. His lifetime batting average was .331 over twenty-two years.*

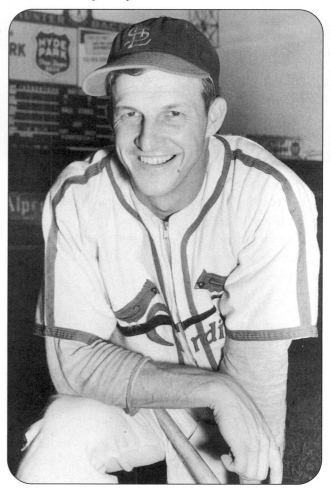

lost control of his full cup of beer, and a stream of liquid shot down the back of the shirt of a man sitting in front of us.

"My father immediately turned around and yelled, 'Hey, who was the jerk who threw that beer?' The man who had been drenched picked up the chant, and they both stood for a few minutes looking for the culprit. My father was always a quick thinker.

"Just when things started getting back to normal, another foul ball—a line drive this time—came right at me. I was ready to snare it, but my father decided to save me from losing a hand. He did the only thing he could—he tried to catch the ball with a popcorn cone he was holding. The popcorn sold at the stadium came in a cardboard container shaped like a megaphone and decorated on

first real fight involving adults. About four rows behind us a friendly discussion about which player should be playing first base for the Cards—Joe Cunningham, Bill White, or Stan Musial—turned into a first-rate brawl. I had seen and been involved in playground fights, but I had never seen anything like this. A group of ushers finally broke it up, but not before one of the fighters started using words I had never heard even my father use.

"I had a difficult time watching the game in the late innings. A lady with a large beehive hairdo about two rows in front of us was hard at work trying to remove popcorn from her hair. Her quick, jerky hand motions reminded me of a cat trying to remove foreign objects from its thick coat of hair. I watched in utter fascination for the better part of two innings until someone lofted a fly ball over the right-field pavilion. I stood with the others and cheered.

"Before leaving the stadium, we had to visit the rest room. I distinctly remember thinking that the rest room smelled exactly like the elephant house at the St. Louis zoo.

"My father tells me I fell asleep during the drive home and had to be carried to bed. The excitement of that first game at Sportsman's Park will always be with me. And I must admit, to this day, even at new Busch Memorial Stadium I'm leery of sitting next to anyone holding a large container of popcorn."

On May 8, 1966, the Cardinals played the last game at what was once called Sportsman's Park: 17,503 spectators saw them lose to the San Francisco Giants, 10–5. At game's end, a helicopter carried home plate downtown to the new 50,000-seat Busch Memorial Stadium.

Cardinals owner August A. Busch, Jr., deeded the land under Sportsman's Park to a local boys' club. The ballpark itself was demolished in 1966 and the site is now a mostly empty field surrounded by a chain-link fence; inside the fence is a low-rise building that houses boys' club activities and a baseball diamond, laid out exactly where it had been in the days of Dizzy and Paul Dean.

An aerial view of Sportsman's Park in 1955 (by then it was called Busch Stadium).

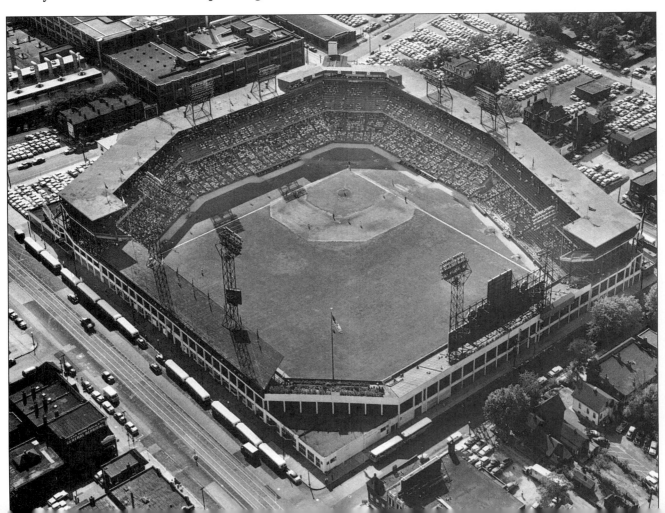

Sportsman's Park's
Ten Most Memorable Moments

1. May 5, 1925: Thirty-eight-year-old Detroit player/manager Ty Cobb hits three home runs, a double, and two singles in six times at bat, driving in five runs, as Detroit defeats the St. Louis Browns, 14–8.

2. October 1, 1944, the last day of the season: The St. Louis Browns win their first and only pennant when they beat the New York Yankees, 5–2, behind the six-hit pitching of Sig Jakucki and two home runs by outfielder Chet Laabs.

3. October 9, 1944, sixth and deciding game of the World Series: In the only all–St. Louis World Series ever played, the Cardinals win by defeating the Browns, 3–1.

4. April 17, 1945, Opening Day: Pete Gray, an outfielder with only one arm, gets one hit in four times at bat in his major league debut and helps the Browns outscore Detroit, 7–1.

5. September 30, 1945, the last day of the season: Detroit's Hank Greenberg hits a ninth-inning grand-slam home run to beat the St. Louis Browns, 6–3, and clinch the pennant for the Tigers.

6. October 15, 1946, seventh and deciding game of the World Series: Cardinals outfielder Enos Slaughter scores the winning run against the Red Sox with a surprise nonstop dash from first base to home on a hit to left-center field by teammate Harry Walker.

7. August 19, 1951: Eddie Gaedel, a midget who is only three feet, seven inches tall, pinch-hits for the St. Louis Browns and walks on four straight pitches.

8. April 23, 1952: Bob Cain of the Browns and Bob Feller of the Indians both pitch one-hitters, with Cain winning, 1–0.

9. May 2, 1954: Cardinals outfielder Stan Musial hits five home runs and a single and drives in nine runs in a doubleheader against the New York Giants.

10. October 15, 1964, seventh and deciding game of the World Series: Bob Gibson wins his second game of the Series as the Cardinals beat the Yankees, 7–5, to become world champions.

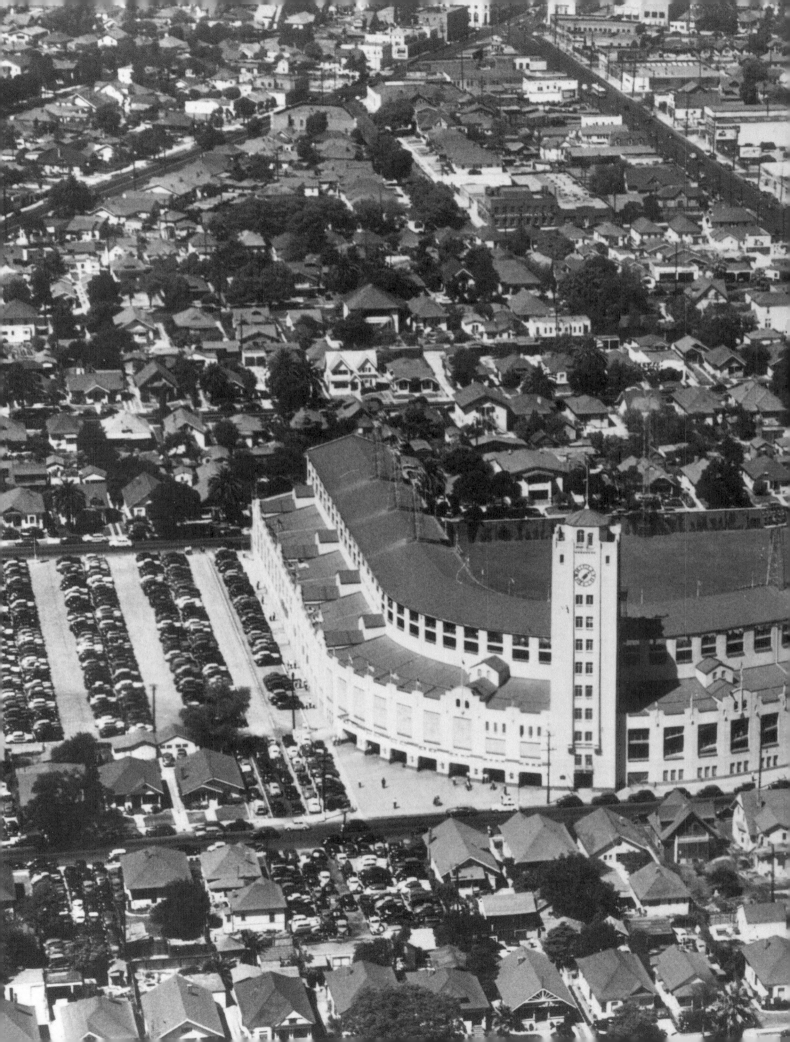

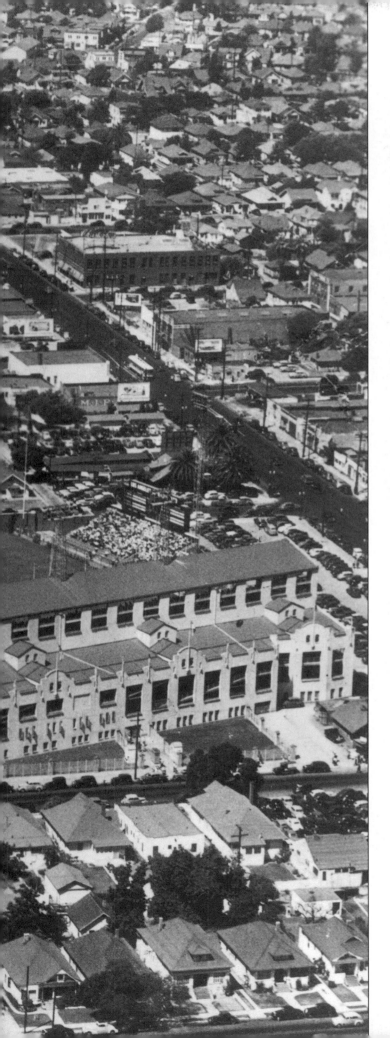

Wrigley Field

LOS ANGELES

LOCATION: In south-central Los Angeles at the intersection of 42nd Place and Avalon Boulevard. The first-base foul line ran parallel to 42nd Place, right field to center field parallel to Avalon Boulevard, center field to left field parallel to 41st Place, while the third-base foul line paralleled San Pedro Street.

HOME OF: The Los Angeles Angels in the Pacific Coast League from 1925 through 1957; the Hollywood Stars in the Pacific Coast League from 1926 through 1935, plus 1938; and the Los Angeles Angels (since 1965 called the California Angels) in the American League from April 27, 1961, to October 1, 1961.

Los Angeles—along with Oakland, Portland, Sacramento, San Francisco, and Seattle—was a charter member of the Pacific Coast League when it was formed in 1903. The Angels played their home games from 1903 through most of 1925 at Washington Park, located downtown at Eighth and Hill streets.

L. A.'s Wrigley Field in the fifties. The clock tower was a well-known local landmark.

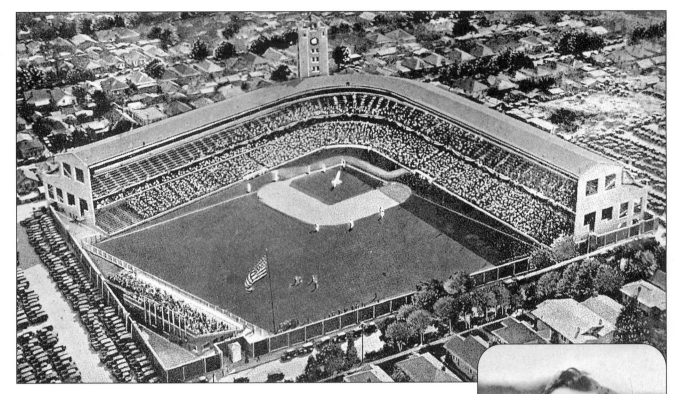

Washington Park had a wooden single-decked grandstand that was roofed around the infield to a little past first base and third base, with uncovered bleachers running the rest of the way down both foul lines. Dimensions were 325 feet from home plate to each foul pole and 411 feet to center field. Seating capacity was 15,000.

William Wrigley, Jr., the chewing-gum man who already owned the Chicago Cubs, purchased the Los Angeles franchise in 1921 for the then substantial sum of $150,000. A few years later, he built a new concrete-and-steel ballpark about three miles south of Washington Park, at what was then practically the edge of town.

The new stadium, named Wrigley Field, was dedicated on September 29, 1925, with a Los Angeles victory over San Francisco, 10–8, before an enthusiastic crowd of 18,000. L.A.'s Wrigley Field was actually the first ballpark to bear that name; its eventual Chicago namesake was still called Cubs Park at the time and was not renamed Wrigley Field until 1926.

Although most minor league teams play in partially covered single-decked ballparks, from the

ABOVE: *Wrigley Field in the twenties.*

RIGHT: *William Wrigley, Jr., for whom the ballpark was named, owned the Angels (and the Chicago Cubs as well) from 1921 until his death in 1932.*

very beginning L.A.'s Wrigley Field had a roofed double-decked grandstand that curved around home plate and extended all the way down both foul lines. By big league standards, it was fairly small, however, seating only 20,500—18,500 in the covered double-decked grandstand, plus 2,000 in an uncovered single-decked stand-alone bleacher section located in right-center field.

There was no seating in left field, just a 15-foot-high concrete wall that ran from the left-field foul pole all the way over to dead center field. In later

years, the left-field wall was covered with ivy, like the outfield wall at Wrigley Field in Chicago.

In right and right-center fields, a 9-foot-high screen fence angled out from the right-field corner on a line past the front of the right-center-field bleachers until it encountered the left-field wall in dead center, 412 feet from home plate.

Wrigley Field's dimensions sound more normal than they really were—340 feet from home plate down the left-field foul line, 412 feet to dead center, and 339 feet down the right-field line.

These measurements are misleading, because in most ballparks distances from home plate rapidly increase as one moves away from the foul lines toward center field. In Wrigley Field, however, the outfield fences were angled slightly *toward* the infield instead of away from it, so there was virtually no difference between the home-run distances to the power alleys in left- and right-center fields as compared with straight down the foul lines. Both power alleys were a cozy 345 feet from home plate,

only a little farther than the 340 feet and 339 feet down the foul lines.

From 1926 through 1935, the Angels shared Wrigley Field with the Hollywood Stars, giving rise to a rivalry between the two that was all the more intense because one or the other was usually in the thick of the Pacific Coast League pennant fight. After the Stars shifted to newly constructed Gilmore Field in 1939, competition between them became the single most important element stimulating attendance at both ballparks.

Helped by their association with the parent Chicago Cubs, the Angels were almost always in pennant contention. They had many stars over the years—including Wally Berger, Frank Demaree, and Max West—but the most popular Angels of all time were undoubtedly outfielder Arnold "Jigger" Statz and first baseman Steve Bilko.

Pregame warm-ups at Wrigley Field in the thirties.

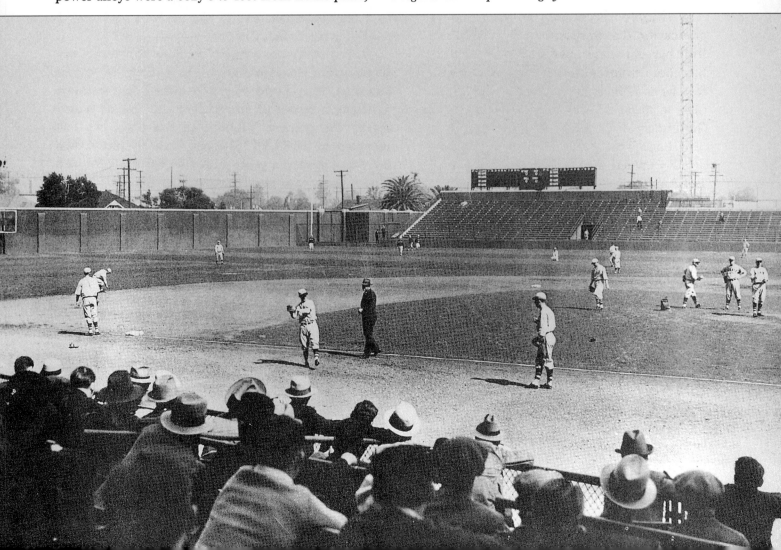

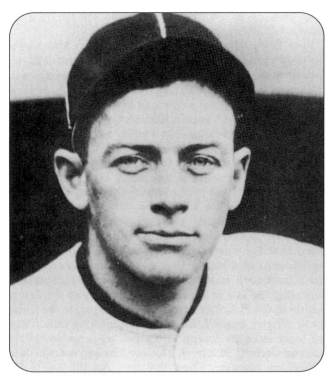

ABOVE: *Arnold "Jigger" Statz played a record eighteen years with one minor league club, the Angels. The Pete Rose of the Minors, Statz played in 3,473 professional games and got 4,093 hits over his twenty-four-year career.*

RIGHT: *Hard-hitting 230-pound first baseman Steve Bilko was voted the Most Valuable Player in the Pacific Coast League a record three times—in 1955, 1956, and 1957.*

Jigger Statz was five feet seven and weighed 150 pounds, but between 1920 and 1942 he played a record *eighteen* years with the Angels, as well as a few years in the big leagues. During his career, he played in 3,473 games and accumulated over 4,000 hits. Records may be made to be broken, but his eighteen years with one minor league club is unlikely ever to be surpassed.

Steve Bilko, six feet one and 240 pounds, was chosen the Pacific Coast League's Most Valuable Player an unprecedented three years in a row—1955, 1956, and 1957. In those three years, the big right-handed power hitter averaged 49 home runs and drove in 143 runs a season, all the while maintaining a .330 batting average.

After the Pacific Coast League Angels disappeared over the horizon, the American League Angels, who took their place at Wrigley Field, had the good public-relations sense to install Mr. Bilko on first base during the 1961 season, their initial year in existence. Stout Steve responded with 20 home runs and a solid .279 batting average.

Jigger Statz and Steve Bilko are among a select group of players who had outstanding minor league careers—but for one reason or another were never as successful in the majors. Others who had similar

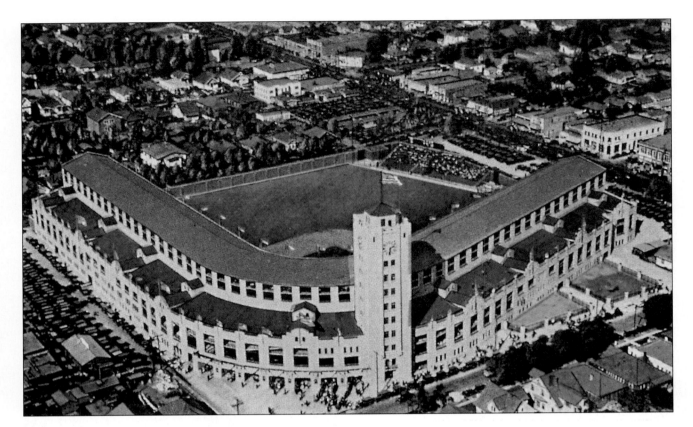

Wrigley Field.

careers and are fondly remembered locally if not nationally include Buzz Arlett, Ike Boone, Bunny Brief, Ollie Carnegie, Ox Eckhardt, Joe Hauser, Smead Jolley, Frankie Kelleher, Rocky Nelson, and Lou Novikoff.

The final Pacific Coast League game at Wrigley Field was a 5–1 Los Angeles loss to San Diego on September 15, 1957, before 6,712 paying customers. Shortly thereafter, to make way for the arrival of the major league Dodgers, the Los Angeles franchise in the Pacific Coast League was transferred to Spokane, Washington. The Dodgers, however, did not replace the Angels at Wrigley Field in 1958; instead, the ex-Brooklynites spent several years at the Los Angeles Coliseum while their own stadium was under construction at Chavez Ravine.

Soon after the 1957 season finale, Wrigley Field served as background for a number of scenes in *Damn Yankees*, the movie version of the Broadway musical. Actually, only non-crowd scenes were shot at Wrigley Field; scenes with crowds in the background were shot at Griffith Stadium in Washington, D.C. In several instances in the movie, a ball hit in one ballpark goes over the fence in the other—a 3,000-mile home run!

It Happens Every Spring, with Ray Milland, was shot in part at Wrigley Field in 1948, and about ten years later the television show "Home Run Derby" was also filmed there.

Wrigley Field came to life for one more season when owner Gene Autry's expansion team in the American League—the reincarnated Los Angeles Angels—made it their home park during 1961, their first year of existence. The big league Angels played their first game at Wrigley Field on April 27, 1961, losing to the Minnesota Twins, 4–2, before a crowd numbering less than 12,000. The Dodgers had already been in Los Angeles for three years, so the novelty of big league baseball had clearly worn off.

The Angels didn't fare too well in their maiden season, losing 91 games while winning only 70, and drawing only 603,510. But it is noteworthy that a total of 248 home runs were hit at Wrigley Field that year, the most ever hit in one park in one season in major league history. Of the 248 homers, 122 were hit by the Angels and 126 by the opposition.

Lost Ballparks

Appropriately enough, home run number 248 came on a pinch-hit drive over the fence by none other than Steve Bilko in the last inning of the last major league game ever played in Wrigley Field. The date was October 1, 1961, and a crowd of 9,868 saw Cleveland beat the Angels, 8–5, despite Bilko's *déjà vu* ninth-inning heroics.

The Angels thereupon shared Chavez Ravine with the Dodgers for four years before moving to Anaheim in 1966 and changing their name to the *California* Angels. With no one calling it home any longer, Wrigley Field lay fallow until it was demolished in 1966.

The site where it once stood is now occupied by a public park and recreation center, a community mental health center, and a senior citizens' center.

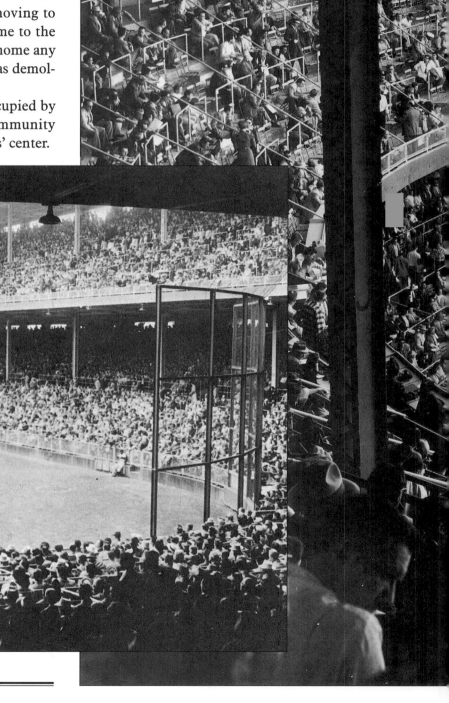

Two views of Wrigley Field in the late forties.

202

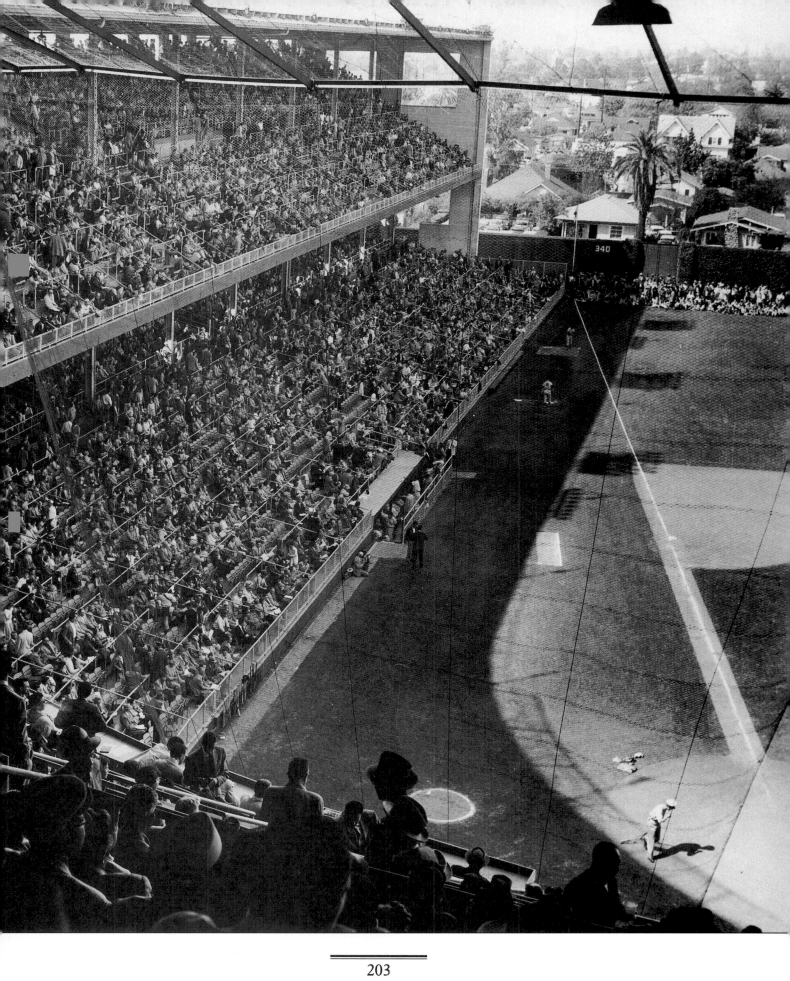

Bibliography

BRJ = Baseball Research Journal
SABR = Society for American Baseball Research

General

Michael Benson, *Ballparks of North America* (McFarland, 1989).

Philip Bess, *City Baseball Magic* (*Minneapolis Review of Baseball*, 1989).

Michael Gershman, *Baseball Stadium Postcard Albums* (Taylor Publishing Company, 1990).

Ralph Graber, "Historic Minor League Parks" (*BRJ*, 1982).

David John Kammer, *Take Me Out to the Ballgame: The Architectural Evolution of the Modern Baseball Stadium* (University of New Mexico, 1982).

Philip J. Lowry, *Green Cathedrals* (SABR, 1986).

Ray Medeiros, editor, *The Ballparks Bulletin* (bimonthly, 1986–88).

———, *Way Back When* Ballparks Postcards (various series, 1991).

Lowell Reidenbaugh, *Take Me Out to the Ball Park*, rev. ed. (*The Sporting News*, 1987).

Steven A. Riess, "Politics, Ball Parks, and the Neighborhood," in *Touching Base* (Greenwood Press, 1980).

Bill Shannon and George Kalinsky, *The Ballparks* (Hawthorn Books, 1975).

Bob Wood, *Dodger Dogs to Fenway Franks* (McGraw-Hill, 1988).

Baker Bowl

Frank Bilovsky and Richard Westcott, *The Phillies Encyclopedia* (Leisure Press, 1984).

Edward F. "Dutch" Doyle et al., "History of Baker Bowl" (*BRJ*, 1982).

Braves Field

Harold Kaese, "Braves Field" (*Sport* magazine, January 1953).

F. C. Lane, "The World's Greatest Baseball Park" (*Baseball Magazine*, October 1915).

Bill Price and Paul Doherty, "Braves Field" (*BRJ*, 1978).

Comiskey Park

Paul Goldberger, "Comiskey: No Field of Dreams" (*The New York Times*, September 30, 1990).

George W. Hilton, "Comiskey Park" (*Baseball Historical Review*, 1981).

Richard C. Lindberg, "Comiskey Park: Baseball's Oldest," in *Baseball in Chicago* (SABR, 1986).

William Nack, "Comiskey Park" (*Sports Illustrated*, August 20, 1990).

Howard Roberts, "Comiskey Park" (*Sport* magazine, August 1953).

Through the Years: History of Comiskey Park (Chicago White Sox, 1990).

Crosley Field

Floyd Conner and John Snyder, *Day by Day in Cincinnati Reds History* (Leisure Press, 1984).

Pat Harmon, "Goodby, Crosley" (*Baseball Digest*, October 1970).

Mark Rohr, *Crosley Field, 1912–1970* (City of Blue Ash, Ohio, 1987).

Lou Smith, "Crosley Field" (*Sport* magazine, March 1953).

Lonnie Wheeler and John Baskin, *The Cincinnati Game* (Orange Frazer Press, 1988).

Baseball in Cincinnati: From Wooden Fences to Astroturf (Cincinnati Historical Society, 1988).

Ebbets Field

John P. Carmichael, "Ebbets Field—Remember?" (*Baseball Digest*, December 1957).

Milton Gross, "Ebbets Field" (*Sport* magazine, November 1952).

Murray Robinson, "The Death of Ebbets Field" (*Baseball Digest*, March 1960).

Bibliography

Forbes Field

Donald G. Lancaster, "Forbes Field Praised As a Gem When It Opened" (*BRJ*, 1986).

Byron Rosen, "Farewell Forbes" (*Baseball Digest*, October 1970).

Gilmore Field

Richard E. Beverage, *The Hollywood Stars* (Deacon Press, 1984).

Stephen M. Daniels, "The Hollywood Stars" (*BRJ*, 1980).

Bill O'Neal, *The Pacific Coast League* (Eakin Press, 1990).

Ken Stadler, *The Pacific Coast League* (Marbek Publications, 1984).

Griffith Stadium

Francis Stann, "Griffith Stadium" (*Sport* magazine, December 1952).

Hilltop Park

Mark Gallagher, *The Yankee Encyclopedia* (Leisure Press, 1982).

Marc Okkonen, "Hilltop Park" (*Yankees Magazine*, June 1989).

Jarry Park Stadium

William Humber, *Cheering for the Home Team: The Story of Baseball in Canada* (Boston Mills Press, 1983).

Dan Turner, *The Expos Inside Out* (McClelland and Stewart, 1983).

League Park

Robert F. Bluthardt, John Pastier, and Robert L. Tiemann, "The Ballparks of Cleveland," in *Baseball in Cleveland* (SABR, 1990).

Peter Jedick, *League Park* (pamphlet, 1978).

Memorial Stadium

James H. Bready, *The Home Team* (1958).

Peter Richmond, "Memorial Stadium" (*The National*, May 29, 1990).

Metropolitan Stadium

Dave Mona and Dave Jarzyna, *Twenty-five Seasons: The First Quarter Century of the Minnesota Twins* (Mona Publications, 1986).

Montreal Stadium

See Jarry Park Stadium, above.

Municipal Stadium

Janet Bruce, *The Kansas City Monarchs* (University Press of Kansas, 1985).

Jack Etkin, *Innings Ago* (Normandy Square Publications, 1987).

Nicollet Park

Eugene Murdock, "They Called Him Unser Choe" (*BRJ*, 1977).

Stew Thornley, *On to Nicollet* (Nodin Press, 1988).

Offermann Stadium

Joseph M. Overfield, "Offermann Stadium in Buffalo" (*BRJ*, 1979).

———, *The 100 Seasons of Buffalo Baseball* (Partners Press, 1985).

Polo Grounds

W. C. Heinz, "Playground for Heroes," in *Esquire's Great Men and Moments in Sports* (Harper, 1962).

Noel Hynd, *The Giants of the Polo Grounds* (Doubleday, 1988).

Jack Lang, "I Remember the Polo Grounds" (*Baseball Digest*, March 1975).

Fred Stein, *Under Coogan's Bluff* (1979).

"The Giants: 100 Years," in *1983 Yearbook* (San Francisco Giants).

Seals Stadium

Bill Graff, "Memories of 16th and Bryant," in *1982 Yearbook* (San Francisco Giants).

John Hibner, "Last Hurrah for the Seals" (*BRJ*, 1989).

David J. Nemec, "A History of Baseball in the San Francisco Bay Area," in *1985 Yearbook* (San Francisco Giants).

Thomas M. Walsh, "Memories of Old Recreation Park" (*The Ballparks Bulletin*, July 1986).

"The Giants: 100 Years," in *1983 Yearbook* (San Francisco Giants).

See O'Neal and Stadler under Gilmore Field, above.

Shibe Park

Jim Barniak, "Memories of Connie Mack Stadium" (*Baseball Digest*, December 1971).

Hugh Brown, "Shibe Park" (*Sport* magazine, April 1953).

Bruce Kuklick, *To Every Thing a Season: Shibe Park and Urban Philadelphia, 1909–1976* (Princeton University Press, 1991).

Allen Lewis, "Memories of Connie Mack Stadium" (*Baseball Digest*, February 1971).

See Bilovsky and Westcott under Baker Bowl, above.

Sportsman's Park

Jeffrey S. Copeland, "A First Trip to Sportsman's Park" (*The Ballparks Bulletin*, March 1987).

Robert Creamer, "Sportsman's Park" (*Sports Illustrated*, July 8, 1963).

George Johnson, "Sportsman's Park" (*Sport* magazine, October 1952).

Ellis J. Veech, "Sportsman's Park" (*Baseball Magazine*, July 1948).

Wrigley Field

Richard E. Beverage, *The Angels: Los Angeles in the Pacific Coast League* (Deacon Press, 1981).

See O'Neal and Stadler under Gilmore Field, above.

Index

Aaron, Hank, 117
Adams, Babe, 70
Adcock, Joe, 61
Agganis, Harry, 27
Alexander, Grover Cleveland, 11, 17
Allison, Bob, 137, 145, 146, 147
Allyn, Arthur C., Jr., 35
American League Park (Highlander Park; Hilltop Park; League Park), 91–99, 160, 161
American League Park (League Park; National Park), 81–82
Antonelli, Johnny, 172
Appling, Luke, 30
Arlett, Buzz, 150, 201
Ashburn, Richie, 183
Astrodome, 6
Atlanta Braves, 27
Austin, Jimmy, 97
Averill, Earl, 89, 170

Baer, Buddy, 86
Bailey, Ed, 49
Baines, Harold, 39
Baker, Frank "Home Run," 180
Baker, William F., 9, 10, 14
Baker Bowl, 3, 9–16, 104, 178, 183
Baldschun, Jack, 116
Ball, Phil, 189
Baltimore Colts, 112
Baltimore Orioles, 88, 111–19, 130, 137, 141, 146, 150
Banks, Ernie, 131
Barber, Red, 55, 57
Barna, Babe, 141
Battey, Earl, 145
Bauer, Hank, 131
Bearden, Gene, 26
Beck, Walter "Boom-Boom," 11–12
Belanger, Mark, 114
Bell, Gus, 49
Bell, Les, 26

Bench, Johnny, 49, 111, 115
Bender, Chief, 167, 180
Berger, Wally, 25, 26, 199
Bernier, Carlos, 78
Berra, Yogi, 68
Bevens, Bill, 61
Bilko, Steve, 199–200, 202
"Black Sox," 30, 33, 39, 44, 48
Blackwell, Ewell, 48
Blades, Ray, 57
Blair, Paul, 114
Blues Stadium (Muehlebach Field; Municipal Stadium; Ruppert Stadium), xi, 108, 129–37, 153
Boddicker, Mike, 118
Boone, Ike, 170, 201
Bossard, Roger, 2
Boston Braves, xi, 17, 19–27, 53, 60, 61, 67, 70, 132, 183
Boston Red Sox, 14, 17, 20, 21, 26, 33, 39, 48, 82, 86, 94, 98, 137, 143, 178, 184, 195
Bottomley, Jim, 17, 61
Boyer, Clete, 35
Boyer, Ken, 192
Braddock, James J., 33
Bragan, Bobby, 59, 77, 78
Branca, Ralph, 57, 94, 123
Braves Field, xi, 19–27, 133
Brewer, Chet, 137
Brief, Bunny, 130, 131, 201
Brooklyn Dodgers, xii, 25, 26, 48, 51–61, 70, 109, 123, 126, 167
Brown, Mordecai "Three-Finger," 167
Brush, John T., 161
Brush Stadium, 161
Buckner, Bill, 94
Buffalo Bisons, 149–55
Buford, Don, 114
Burnett, John, 109
Busch, August A., Jr., 191, 194
Busch Memorial Stadium, 4, 5, 6, 194

Busch Stadium (Sportsman's Park), xi, xii, 187–95
Bush, Donie, 141, 143, 145
Bush, Guy, 67–68

Cadore, Leon, 26
Cain, Bob, 195
California Angels, 118, 202
Camilli, Dolf, 16
Campanella, Roy, xii, 123
Campaneris, Bert, 134, 136, 137, 146
Candlestick Park, 173, 174, 175
Cantillon, Joe, 85, 141, 145
Carew, Rod, 145
Carleton, Tex, 167
Carnegie, Ollie, 150, 152–53, 201
Cerv, Bob, 131, 136
Chance, Frank, 169
Chapman, Ray, 167
Charles, Ezzard, 33
Chavez Ravine, 201, 202
Cheney, Tom, 118
Cheney Stadium, 174
Chesbro, "Happy" Jack, 92, 93–94, 98
Chicago Cardinals, 33
Chicago Cubs, xii, 2, 33, 39, 64, 95, 167, 184, 198, 199
Chicago White Sox, xii, 2, 29–39, 44, 78, 118, 137, 184, 192
Cicotte, Eddie, 33, 44
Cimoli, Gino, 192
Cincinnati Reds, xiii, 33, 39, 41–49, 55, 70, 101, 115, 116, 118, 179
Cleveland Indians, 26, 98, 101–9, 118, 137, 146, 153, 184, 188, 202, 117
Clyman, Bill, 152
Cobb, Robert H., 74, 75, 77, 78
Cobb, Ty, 19, 95–97, 98, 99, 108, 116, 184, 195
Cochrane, Mickey, 27, 180
Colavito, Rocky, 118
Coleman, Jerry, 131

Index

Collins, Eddie, 180
Columbia Park, 178
Comiskey, Charles A., 29, 30, 33
Comiskey Park (new), 7, 38
Comiskey Park (White Sox Park), 2, 19, 29–39, 65, 179
Concepcion, Dave, 6
Connie Mack Stadium (Shibe Park), xi, 16, 19, 32, 65, 177–85, 187
Coogan, James J., 158
County Stadium, 2
Coveleski, Stanley, 109
Crawford, Sam, 85
Creamer, Robert W., xi–xiii
Cronin, Joe, 134, 167
Crosley, Powel, Jr., 43
Crosley Field (League Park; Redland Field), xi, xiii, 19, 41–49, 151
Cubs Park, 198
Cunningham, Joe, 194
Cuyler, Kiki, 53, 67, 70

Daley, Bud, 136
Dandridge, Ray, 145
Day, John B., 158
Deal, Charlie, 181
Dean, Dizzy, 61, 89, 167, 190, 194
Dean, Paul, 46, 61, 190, 194
DeMaestri, Joe, 136
Demaree, Frank, 199
Dempsey, Jack, 165
Dempsey, Rick, 118
Derringer, Paul, 44, 48
Detroit Tigers, 32, 38, 44, 48, 70, 85, 95–97, 102, 119, 137, 184, 189, 195
Devery, Bill, 91, 98
DeWitt, Bill, 116
DiMaggio, Dominic, 171
DiMaggio, Joe, 48, 78, 109, 169, 171, 172, 173
Doby, Larry, 39
Dodger Stadium, xi, 2
Drabowski, Moe, 118
Dreyfuss, Barney, 63
Dropo, Walt, 89
Drysdale, Don, 123
Dunn, "Sunny" Jim, 105
Dunn Field (League Park), 19, 101–9
Durocher, Leo, 58
Dykes, Jimmy, xiii

Easter, Luscious Luke, 152, 153–54
Ebbets, Charles H., 51, 52
Ebbets Field, xii, 3, 19, 51–61, 104, 166
Eckhardt, Ox, 170, 172, 201
Einhorn, Eddie, 38
Elliot, Bob, 26
Ennis, Del, 183

Farrell, Frank, 91, 97, 98
Farrell, Kerby, 152
Feller, Bob, 26, 39, 106, 109, 195
Felsch, Happy, 33

Fenway Park, 1, 3, 4, 10, 19, 20, 53, 82, 123
Ferrell, Wes, 102–4
Ferris, Hobe, 145
Fewster, Chick, 54–55
Finley, Charlie, 129, 134, 135
Firpo, Luis Angel, 165
Flanagan, Mike, 116
Forbes, John, 63
Forbes Field, 11, 19, 32, 63–71, 178, 179
Foxx, Jimmie, 109, 167, 180, 182
Frick, Ford C., 60, 134
Fuchs, Emil, 25
Fulton County Stadium, 4, 5
Furillo, Carl, 53, 123

Gaedel, Eddie, 195
Gaffney, James, 20
Gehrig, Lou, 70, 89, 167, 184
Gentile, Jim, 146
Gibson, Bob, 195
Gibson, George, 161
Gibson, Josh, 84, 86, 108
Gill, Harry, 2
Gilliam, Jim, 123
Gilmore, Earl, 74
Gilmore Field, 73–79, 199
Goslin, Goose, 67
Gowdy, Hank, 86
Grant, Eddie, 163
Grant, Frank, 153
Gray, Pete, 195
Greenberg, Hank, 33, 66–67, 181–83, 195
Greengrass, Jim, 49
Griffith, Calvin, 140
Griffith, Clark, 82, 86, 93
Griffith Stadium, xi, 3, 19, 81–89, 201
Grissom, Lee, 41, 46
Grove, Lefty, 180, 182

Haas, Mule, 184
Hafey, Chick, 17
Hall, Jimmie, 137, 145
Haney, Fred, 78
Harrelson, Ken, 136
Harris, Bucky, 86
Harris, Spencer, 141, 145
Harry S. Truman Sports Complex, 136
Hartnett, Gabby, 66
Hauser, Joe, 140, 141, 145, 146, 201
Hawkins, Andy, 39
Heath, Tommy, 141
Hebner, Richie, 4
Hedges, Robert Lee, 188
Hendricks, Elrod, 117
Henrich, Tommy, 78
Herman, Babe, 46, 54–55, 78
Herrmann, Garry, 179
Hershberger, Willard, 45
Highlander Park (American League Park; Hilltop Park; League Park), 91–99, 160, 161

Hill, Donnie, 117
Hill, Jesse, 152
Hilltop Park (American League Park; Highlander Park; League Park), 91–99, 160, 161
Hodges, Gil, 61
Hollywood Stars, 73–79, 170, 197, 199
Homestead Grays, 84, 86, 137
Hooper, Harry, 14, 17
Hornsby, Rogers, xi, 12
Howard, Elston, 131
Hubbell, Carl, 25, 26, 48, 157, 167
Huggins, Miller, 162
Hughes, Tom, 98
Hunt, Ron, 127
Hunter, Jim "Catfish," 136, 137
Huston, Tillinghast L'Hommedieu, 98

Jack Murphy Stadium, 4
Jackson, "Shoeless" Joe, 30, 33
Jakucki, Sig, 195
Jarry Park Stadium, 121, 126–27
Jennings, Hugh, 97
Johnson, Arnold M., 132, 134, 183
Johnson, Earle, 132
Johnson, Roy, 132, 170
Johnson, Walter, 19, 67, 84, 85–86, 89, 94–95, 98
Jolley, Smead, 170, 201
Jorgensen, Spider, 59
Joss, Addie, 109

Kaat, Jim, 146
Kansas City Athletics, 129, 130, 131–35, 137, 146
Kansas City Blues, 129–32, 133, 137
Kansas City Chiefs, 136
Kansas City Monarchs, 130, 131, 132, 137
Kansas City Royals, 129, 130, 135–37
Kauffman, Ewing, 135
Keeler, "Wee" Willie, 111, 112
Kelleher, Frankie, 75, 78, 201
Keller, Charlie, 48, 78
Kelley, Mike, 143, 145
Kennedy, John F., 85
Kilduff, Pete, 105–8
Killebrew, Harmon, 86, 137, 145, 146
Kiner, Ralph, 39, 66, 67
King, Johnny, 132
Kingdome, 6
Kittle, Ron, 37
Klein, Chuck, 11, 70
Konstanty, Jim, 183
Koufax, Sandy, 146, 147
Koy, Ernie, 17

Laabs, Chet, 195
Landis, Kenesaw Mountain, 122
Lane, Bill, 74
Lane, Frank, xi
Lardner, John, 55
Larsen, Don, 105

Lavagetto, Cookie, 57, 67
Lawrence, Brooks, 49
Lazzeri, Tony, 169, 184
League Park (American League Park; Highlander Park; Hilltop Park), 91–99, 160, 161
League Park (American League Park; National Park), 81–82
League Park (Crosley Field; Redland Field), xi, xiii, 19, 41–49, 151
League Park (Dunn Field), 19, 101–9
Lemon, Bob, 26
Lemon, Jim, 86
Lewis, Johnny, 48
Lindell, Johnny, 78
Lindstrom, Freddie, 86, 89
Liston, Sonny, 33
Lombardi, Ernie, 47, 48, 169
Long, Dale, 70, 78
Los Angeles Angels (American League), 200, 201–2
Los Angeles Angels (Pacific Coast League), 74, 197–201
Los Angeles Coliseum, 201
Los Angeles Dodgers, 39, 118, 147, 166, 173, 174, 201
Louis, Joe, 33, 86
Lowenstein, John, 118, 119
Lueker, Claude, 95

McCarthy, Joe, 143–44
McCarver, Tim, 185
McCovey, Willie, 173, 174
McGraw, John J., 111, 112, 157, 162
Mack, Connie, 16, 132, 177, 179, 180, 182
McKechnie, Bill, 25, 47
McKeever, Ed, 179
McMullen, Hugh, 144
McNally, Dave, 114, 118
MacPhail, Larry, 45, 46
Maloney, Jim, 48
Mansfield, Jayne, 78
Mantle, Mickey, 52, 89, 145
Marichal, Juan, 49
Maris, Roger, 67, 145
Marquard, Rube, 70, 167
Martin, Billy, 61
Mathewson, Christy, 19, 157, 159, 167, 178
Mauch, Gene, 145
May, Lee, 49, 115
Mays, Carl, 167
Mays, Willie, xi, 47, 49, 117, 144, 145, 157, 165, 166, 167, 174
Mazeroski, Bill, 57, 67, 68, 70, 71, 78
Medwick, Joe, 190
Memorial Stadium, 111–19
Merkle, Fred, 157, 167
Metrodome, 6
Metropolitan Stadium, 145–47
Miller, Otto, 105–8
Milwaukee Braves, xiii, 27

Milwaukee Brewers, 2, 39, 118
Minneapolis Millers, 140–46
Minnesota Twins, 88, 137, 146–47, 201
Minnesota Vikings, 147
Minoso, Minnie, 35
Mize, Johnny, 166
Montreal Expos, 124, 126–27, 185
Montreal Royals, 121–26, 151
Montreal Stadium, 121–26
Muehlebach Field (Blues Stadium; Municipal Stadium; Ruppert Stadium), xi, 108, 129–37, 153
Mueller, Emmett, 17
Municipal Stadium (Blues Stadium; Muehlebach Field; Ruppert Stadium), xi, 108, 129–37, 153
Murphy, Eddie, 181
Murray, Eddie, 114
Musial, Stan, 192, 193, 194, 195

National League Park (Baker Bowl), 3, 9–16, 104, 178, 183
National Park (American League Park; League Park), 81–82
Neal, Charlie, 35
Nelson, Rocky, 123, 201
Newark Bears, 137
Newcombe, Don, 123
Newsom, Bobo, 44
New York Giants, xi, xii, 10, 16, 17, 25, 26, 45, 48, 60, 86, 89, 95, 157–67, 173, 178, 184, 187, 195
New York Highlanders, 82, 91–99, 112
New York Mets, 48, 86, 157, 165–67
New York Yankees, xi, 2, 11, 35, 44, 61, 70, 94–98, 112, 130, 145, 157, 160, 161, 171, 183, 187, 195
Nickerson Field, 27
Nicollet, Joseph, 140
Nicollet Park, 139–46
Noren, Irv, 78
Novikoff, Lou, 201
Nuxhall, Joe, 48, 49

Oakland Athletics, 137
O'Connor, Roger, 2
O'Doul, Lefty, 17, 169, 171, 172–73
Oeschger, Joe, 26
Offermann, Frank J., 150, 151
Offermann Stadium, 149–55
Oliva, Tony, 137
Olympic Stadium, 6
O'Neill, Steve, 101, 106, 109
Oriole Park, 7, 119
Otis, Amos, 136
O'Toole, Jim, 49
Ott, Mel, 89, 157, 166
Owen, Mickey, 57, 61

Paige, Satchel, 33, 39, 117, 131, 132, 137
Palmer, Jim, 114, 116, 137
Pappas, Milt, 116
Parmelee, Roy, 167

Patterson, Floyd, 33
Perini, Lou, 27
Philadelphia Athletics, 16, 25, 32, 60, 85, 88, 89, 91, 95, 97, 109, 132, 160, 177–83, 187
Philadelphia Eagles, 185
Philadelphia Phillies, 9–16, 48, 52, 70, 118, 127, 166, 177, 183–85, 187
Pilot Field, 155
Piniella, Lou, 136
Pittsburgh Pirates, 17, 60, 63–71, 86, 166
Plank, Eddie, 180
Pollet, Howie, 192
Polo Grounds, xi, xii, 157–67, 174, 187
Post, Wally, 47
Powell, Boog, 114
Power, Vic, 136
Priddy, Jerry, 131

Rath, Morrie, 44
Raymond, Claude, 127
Recreation Park, 169
Redland Field (Crosley Field; League Park), xi, xiii, 19, 41–49, 151
Reinsdorf, Jerry, 38
Rhodes, Dusty, 163, 166
Rice, Sam, 89
Richards, Paul, 152
Rickey, Branch, 57, 58, 86, 94–95, 98
Rigler, Cy, 89
Rigney, Bill, 141, 145
Ripken, Cal, 114, 117
Riverfront Stadium, 4, 6, 44
Rizzuto, Phil, 131, 133
Roberts, Robin, 61, 183
Robinson, Brooks, 111, 112, 114–15, 118
Robinson, Frank, 112, 114, 115–17, 118
Robinson, Frank DeHaas, 102
Robinson, Jackie, 57, 61, 86, 123, 184
Robison Field, 188
Rochester Red Wings, 130, 144, 146
Rommel, Eddie, 89
Roosevelt, Franklin Delano, 46, 48
Roosevelt Stadium, 123
Rose, Pete, 49, 114
Roseboro, John, 123
Royals Stadium, 6, 130
Ruppert, Jacob, 98, 130
Ruppert Stadium (Blues Stadium; Muehlebach Field; Municipal Stadium), xi, 108, 129–37, 153
Rust, Art, Jr., 64
Ruth, Babe, xi, 17, 25, 26, 39, 42, 43, 66, 67–69, 70, 86, 108, 117, 141, 167, 188
Ryan, Nolan, 85
Ryan, Rosy, 145

Sain, Johnny, 25, 26
St. Louis Browns, xii, 30, 112, 132, 187–92
St. Louis Cardinals, xii, 17, 21, 46, 55, 61, 109, 126, 187–95

Index

St. Paul Saints, 140, 141, 144, 146
Salazar, Luis, 37
Salt Lake City Bees, 74
San Diego Padres, 74
San Francisco Giants, 48, 49, 117, 169, 170, 173, 194
San Francisco Missions, 74, 169, 170, 172
San Francisco Seals, 74, 78, 169–74
Sawyer, Eddie, 183
Schalk, Ray, 152
Schmidt, Mike, 115
Schoendienst, Red, 39
Score, Herb, 145
Seals Stadium, 169–75
Seattle Mariners, 2, 38
Seattle Rainiers, 77
Seeds, Bob, 151
Seerey, Pat, 184
Seminick, Andy, 183
Shamsky, Art, 48
Shea Stadium, 166
Shibe, Benjamin F., 177, 179, 181
Shibe, John, 181, 182
Shibe, Thomas, 181
Shibe Park (Connie Mack Stadium), xi, 16, 19, 32, 65, 177–85, 187
Sievers, Roy, 86
Simmons, Al "Bucketfoot," 32, 167, 180
Simpson, Dick, 116
Simpson, "Suitcase" Harry, 136
Singleton, Ken, 114, 127
Sisler, Dick, 61, 173
SkyDome, 6
Slaughter, Enos, 195
Smith, Al, 35
Smith, Earl, 89
Smith, Elmer, 109
Smith, Red, 10
Snider, Duke, 53, 123

Snodgrass, Fred, 94
Spahn, Warren, 25
Speaker, Tris, 102, 108
Sportsman's Park (Busch Stadium), xi, xii, 187–95
Stanky, Eddie, 48
Statz, Arnold "Jigger," 199–200
Staub, Rusty, 124, 127
Stengel, Casey, xi, 35, 52, 165, 166, 167, 183
Stewart, Bill, 26
Stobbs, Chuck, 89

Tabor, Jim, 184
Taft, William Howard, 83, 85
Taylor, Eddie, 55
Taylor, Tony, 185
Tebbetts, Birdie, xiii
Temple, Johnny, 49
Terry, Ralph, 67, 68
Texas Rangers, 88, 118
Thomson, Bobby, xi, 57, 67, 157, 163, 167
Three Rivers Stadium, 4, 6, 69
Tiger Stadium, 19
Tobin, Jim, 26
Toporcer, Specs, 160
Traynor, Pie, 115
Triandos, Gus, 114

Vance, Dazzy, 53–55
Vander Meer, Johnny, 48, 58, 61
Veeck, Bill, 33–38, 108, 191
Veterans Stadium, 4, 5, 6

Waddell, Rube, 145
Wagner, Honus, 19, 64
Walcott, "Jersey" Joe, 33
Walker, Dixie, 53
Walker, Greg, 37

Walker, Harry, 195
Walsh, Ed, 32, 109, 172
Wambsganss, Bill "Wamby," 105–6, 109
Waner, Paul, 70
War Memorial Stadium, 155
Washington Senators, 81–89, 94–95, 98, 99, 107, 145, 146, 147
Watson, Bob, 117
Weaver, Earl, 114, 117–19
Werden, Perry, 145
Wertz, Vic, 165, 166, 167
West, Max, 199
Wheat, Zack, 19
White, Bill, 192, 193, 194
White Sox Park (Comiskey Park), 2, 19, 29–39, 65, 179
Wilhelm, Hoyt, 145
Williams, Edward Bennett, 119
Williams, Lefty, 33
Williams, Smokey Joe, 137
Williams, Ted, 141–44, 145, 184, 192
Wills, Maury, 116
Wilson, Chief, 64
Wilson, Hack, 11–12
Woods, Doc, 86
Worthington, Al, 145
Wright, Ab, 141, 146
Wrightstone, Russ, 17
Wrigley, William, Jr., 198
Wrigley Field (Chicago), 1, 2, 4, 20, 46, 199
Wrigley Field (Los Angeles), 74, 197–202
Wynn, Early, 137

Yankee Stadium, xii, 157, 161, 163, 185
Yastrzemski, Carl, 117
Young, Cy, 85, 98, 101

Zernial, Gus, 78